Pictorial Composition from Medieval to Modern Art

PICTORIAL COMPOSITION – ERRATA

p. v line 4 Read '"Composition" from Cennini and Alberti to Vasari'.

p. vii line 4 Read 'Sohm'.

p. viii line 11 Read 'Sohm's'.

p. viii The order of essays assumed here does not correspond to the order in the book as printed.

p. 1 n. 2 Read 'Ravensburg'.

p. 6 n. 20 Read 'Barrett'.

p. 18 Read 'Trinity College MS 58'.

p. 33 n. 31 Read 'K. Keuck, *Historia: Geschichte des Wortes und seiner Bedeutungen in der Antike und in den romanischen Sprachen*'.

p. 33 n. 31 Read 'J. Knape, *"Historie" in Mittelalter und früher Neuzeit: begriffs- und gattungsgeschichtliche Untersuchungen im interdisziplinären Kontext*'.

p. 45 n. 2 Read '"Composition" from Cennini and Alberti to Vasari'.

p. 49 ll. 20–25 The quotation marks should be deleted.

p. 49 n. 20 Read 'di tutto'.

p. 53 line 20 Read 'mastering the human figure'.

p. 54. n. 42 Read 'a le volte sono tali'.

p. 55. n. 45 Read 'Chi si ritrae sul letto ...'.

p. 59 n. 5 Read '*Esplorazioni*'.

p. 60 n. 7 Read '*Academia nobilissimae artis pictoriae*'.

p. 61 n. 10 Read 'quell'altro'.

p. 63 n. 20 Read '"Composition" from Cennini and Alberti to Vasari'.

p. 65 n. 31 Read 'plagiarist'.

p. 66 n. 33 Read 'Malvasia turns to a concert metaphor in which figures stand for voices'.

p. 67 line 14 Read 'general'.

p. 73 n. 66 Read '*satirici*'.

p. 78 line 12 Read 'plebeian'.

p. 110 The image is distorted and should look as below:

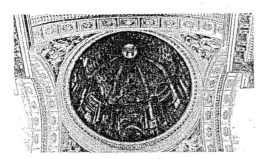

p. 117 line 16 Read 'théorie de la composition'.

p. 118 line 17 Read 'En II, 35, il définissait'.

p. 128 line 19 Read 'les séparent par des espaces'.

p. 131 ll. 9–10 Read '... *ordonnances* that are composées ...'.

p. 133 n. 11 Read 'un Talent naturel'.

p. 134 n. 14 Read 'des figures dans le Dessein'.

p. 134 n. 15 Read 'les principales figures'.

p. 134 n. 16 Read 'de son Tableau'.

p. 135 n. 18 Read 'iudicieusement'.

p. 136 n. 19 Read 'les premières'.

p. 138 line 22 Read 'l'Univers'.

p. 143 n. 45 Read '*Entretiens* (n. 25 above)'.

p. 143 n. 46 Read 'Wolfenbütteler Forschungen'.

p. 145 n. 51 Read 'Du Fresnoy'.

p. 151 n. 24 Read 'see below, p. 161'.

p. 159 n. 47 Read 'B. P. J. Broos,'.

p. 160 ll. 15–20 'in order to please the nature of the arts ... come out towards us' should be indicated as a translation of Van Mander's text.

p. 165 ll. 1–3 Read 'Van Hoogstraeten also says that a good composition possesses harmony in another passage, which must be the most quoted in the whole book ...'.

p. 166 n. 70 Read 'De Grebber'.

p. 168 Read 'Städelsches Kunstinstitut'.

p. 173 line 7 Read 'Madonna dell'Orto'.

p. 173 n. 7 Read 'f. 66r'.

p. 182 ll. 18–20 Read 'In the portrait of Mrs Lloyd (Fig. 10), painted in 1776, the sitter is even more strongly subjected ...'.

p. 185 Read 'f. 66r'.

p. 185 Read 'Madonna dell'Orto'.

p. 196 Read 'Banastre Tarleton'.

p. 219 n. 9 Read '*Whistler on Art* (n. 8 above)'.

p. 219 n. 10 Read 'Whistler was wrong about that (see below, p. 220)'.

p. 221 n. 17 Read '*Whistler on Art* (n. 8 above)'.

p. 229 n. 51 Read 'Kemp, *Desire* (n. 26 above)'.

p. 231 n. 60 Read 'Blanc, *L'Art dans la parure* (n. 59 above)'.

p. 232 n. 66 Read '*Historische Grammatik der bildenden Künste*'.

p. 237 n. 86 Read 'Czapek's book (n. 6 above)'.

p. 241 n. 101 Read 'les préoccupations décoratives'.

Warburg Institute Colloquia
Edited by Charles Burnett, Jill Kraye and W. F. Ryan

6

Pictorial Composition from Medieval to Modern Art

Edited by Paul Taylor and François Quiviger

The Warburg Institute – Nino Aragno Editore
London – Turin 2000

Published by
The Warburg Institute
School of Advanced Study
University of London
Woburn Square, London WC1H 0AB
and
Nino Aragno Editore
Via Bertholet 10/G
10100 Torino

© The Warburg Institute and Nino Aragno Editore 2000
ISBN 0 85481 126 5
ISSN 1352–9986

Designed by and computer set at the Warburg Institute
Printed by Henry Ling, The Dorset Press, Dorchester, Dorset

Table of Contents

Preface

This volume contains most of the papers delivered at a colloquium held at the Warburg Institute in May 1997, together with two additional contributions (by Reiss and Sohms). It provides a study of the concept of composition in European art and art literature from the middle ages to the beginning of the present century.

The contributions are scattered down a methodological spectrum. Towards the one end are authors who view past writings on composition with early twentieth-century concepts at the backs of their minds. That is, they are concerned to show the extent to which writers on art before 1880 would have been able to think of a work of art in the terms put forward by modernist theorists like Maurice Denis, Wassily Kandinsky and Clement Greenberg, as a flat surface, covered with colours, lines and forms arranged in an aesthetically pleasing way.

At the other end of the spectrum are authors who do not approach the problem in so teleological a manner. Their aim is to give us a richer sense of the ways in which artists and theorists conceived of composition before the modern period, by describing some of the implications and connotations of the concept within a broader field of political and religious meanings.

None of the authors, of course, are at the very edges of the spectrum: those who favour the evolutionary approach have much to say about the precise meanings of composition in earlier centuries, and those who wish to place compositional ideas in their full semantic context provide a great deal of evidence to those interested in long-term conceptual change. It becomes clear from the articles presented here that, five hundred years ago, the modernist conception of a work of art would have been almost unintelligible to European art theorists. Pictorial composition only came to be construed as a two-dimensional pattern after centuries of complex visual interaction with narrative and space.

Written documents on the definition and practice of pictorial composition appeared only from the fifteenth century onwards. Thus the first paper, by Athene Reiss, after seeing what can be gleaned from the few suggestive remarks on composition in medieval texts, investigates the extent to which methods of composing in medieval art can be inferred from visual evidence alone.

Charles Hope's contribution examines the use of the Italian term *composizione* from Cennini to Vasari, and establishes that Renaissance writers on art thought of composition as the construction of a figure or of a group of figures, rather than as the overall arrangement of colours or forms on a flat surface.

François Quiviger's paper explores the sixteenth-century commonplace that a painting is initially composed in the artist's mind before its execution, by comparing

the use and processing of mental images in contemporary artistic and meditational practices.

The two following papers, by Paul Taylor and Colette Nativel, investigate northern concepts of composition. Taylor discusses Dutch art theory of the seventeenth century, and focuses on the ways in which Karel van Mander followed and altered the ideas of Alberti and Vasari. Nativel examines the definitions of composition compiled by Franciscus Junius in his influential *De pictura veterum* of 1637.

After tracing the survival of Alberti's *compositio* in the seventeenth century, Baldinucci's dictionary entry for *composizione*, and the semantic wandering of *componimento*, Philip Sohms' essay indicates how these definitions found practical applications in Seicento criticism. It is followed by Thomas Frangenberg's discussion of the compositional requirements of perspectival ceiling painting, as illustrated by the work of Andrea Pozzo in late seventeenth-century Rome.

The next papers focus on composition as defined, taught and practised in seventeenth and eighteenth century art academies. Thomas Puttfarken scrutinizes the fluctuations of the term in late seventeenth-century French art literature, from Fréart de Chambray to Roger de Piles. Harry Mount and Richard Wrigley examine academic doctrines in the context of artistic practice. Mount discusses how Reynolds' travel notes and sketches progressively leaned towards a two-dimensional way of reading and composing pictures. Wrigley assesses how Jacques Louis David applied academic methods of pictorial composition, usually reserved for history painting, to the depiction of contemporary history, in the politically charged event depicted in the *Serment du Jeu de paume*.

The concluding paper by Hubert Locher traces the emergence of the early twentieth-century concept of composition. Locher argues that the scholarly analysis of world ornament by writers like Ruskin and Jones helped to create the intellectual environment in which a new notion of pictorial flatness could germinate.

Pictorial Composition in Medieval Art

Athene Reiss

The problem this paper sets out to explore is not whether medieval pictures can be analysed in terms of pictorial composition, but whether they were meant to be.[1] That they are amenable to such analysis has been demonstrated at least since Johannes Itten's compositional studies of medieval art dating to the early 1920s,[2] but whether indications of a self-conscious concept of pictorial composition existed before 1400 has not been so clearly shown. The question, 'Do such indications exist?' is a difficult one to answer either in the affirmative or in the negative due to a lack of identifiable evidence. We have no theorists to articulate for us how medieval people thought composition should be approached. We have no verbal or visual sketches of a clearly compositional nature that demonstrate the processes artists might have used in thinking about composition. Neither do we have any criticism that tells us how viewers evaluated the compositions of the pictorial arts they viewed. Does this mean that there was no such thing as medieval composition, at least as a self-conscious feature of picture-making? Or does it only mean that there are no records of such a concept, at least in a form that we can still recognize?

Although neither texts nor images from the medieval period explicitly address the composition of pictures, some ideas can be gleaned from those sketches, whether verbal or visual, that do exist. Perhaps the most famous visual sketches are those of Villard de Honnecourt, who drew architectural features, animals, and human figures from existing works of art, in the first half of the thirteenth century.[3] Villard also experimented with geometrical formulae for arranging faces and bodies. These formulae, such as the combinations of triangles that comprise the figures of Adam farming and Eve spinning in the middle of one of his study sheets (Fig. 1), remind us of the flat nature of medieval composition, remaining, as they do, abstractly parallel to the face of the page. However, none of Villard's sketches can really be called compositional in motivation, as they are entirely limited to architectural details and individual figure studies. His drawings never attempt to reproduce or create a pictorial composition as a whole.

The first surviving drawings of a more obviously compositional nature date to around 1400. At about that time, for example, André Beauneveu, or an associate,

1. I would like to thank Elizabeth McGrath, Harry Mount, François Quiviger, and Paul Taylor for their help with the preparation of this essay.

2. J. Itten, *Mein Vorkurs am Bauhaus, Gestaltungs- und Formenlehre*, Ravensberg, 1963. For example, see fig. 124.

3. H. R. Hahnloser, ed., *Villard de Honnecourt: Kritische Gesamtausgabe des Bauhüttenbuches MS. fr. 19093 der Pariser Nationalbibliothek*, Vienna, 1935.

used pen and wash to reproduce the composition of a panel or a painted window representing the Death, Assumption, and Coronation of the Virgin (Fig. 2).[4] The drawing's content and appearance implies that it reproduces a complete painting. However, details are drawn out in full, and there is nothing to indicate that Beauneveu was interested in an abstract notion of the composition as such. The level of detail suggests an interest in the picture as a whole, including its arrangement, but also its iconography and style.

Around the same time, a Tyrolean artist drew a rough sketch of a Crucifixion, imitating compositions of the subject in two late fourteenth-century Paduan frescoes from the circle of Altichiero.[5] This drawing contains less detail than the one by Beauneveu, suggesting that this artist had a greater interest in the composition itself. The interest, however, is limited to the copying of an admired composition, rather than investigating compositional possibilities. The Tyrolean drawing and those by Beauneveu and Villard, demonstrate a desire to repeat pre-existing compositions, an interest to which a long tradition of medieval repetitious design also testifies. However, the repetition identifiable in such isolated drawings as do exist give only vague indications of medieval attitudes towards composition itself. Villard's drawings are fragments only, and the examples of complete compositions by Beauneveu and the Tyrolean artist appear only late in the Middle Ages, and perhaps already display a changed approach from those attitudes that dominated the medieval period more generally.

Compositions were certainly sometimes sketched out in both large and small scale before 1400. However, such drawings rarely display any particular concern for composition as anything other than a clear arrangement of figures. The pre-1400 drawing was, in Michael Evans's words, 'an illustration lacking colour', rather than a study in its own right.[6] It was a staging post rather than an end in itself. Artists laid down the people, objects, and setting indicators in a practical and suitable manner in accordance with the necessary symbolic hierarchy of the subject. Figures were arranged as if existing on a flat plane, with little sense of pictorial depth. Not uncommonly, drastic variations in the figures' scale were introduced in order to fit them all into the picture space, a technique which precluded any post-Renaissance view of composition based on a consistent scheme of proportion and perspective. Unconstrained by visual conventions concerning the proportional sizes of figures and imitation of three-dimensional spatial effects, medieval artists could construct any scene so as to fit into almost any available space. This elasticity of design can be seen in a large number of manuscript illuminations, from the smallest historiated initial to the largest full-page miniature.

4. See the catalogue entry in M. W. Evans, *Medieval Drawings*, London, 1969, no. 120.
5. Ibid, no. 121.
6. Ibid., p. 16.

Such flexibility is similarly present in monumental art, for which we have even fewer surviving sketches than we do for manuscripts. Sinopia, incised lines, and other preliminary work on the walls themselves tell us little about the self-consciousness or otherwise of artists' approaches to composition. They function mainly to establish the outlines and proportions of the figures. Identifiable paper or parchment sketches for monumental art virtually all date from after 1400.[7] Occasional written records do refer to such designs for wall paintings, stained glass, and tapestries. For example, in 1377, the Duc of Angers Louis I paid Jean Bondol fifty francs for designing and preparing a set of cartoons for tapestries of the Apocalypse.[8] Bondol was, in effect, paid to create a composition, as well as to specify details of representation; but we do not know how he thought about the question of putting the figures together, except that the resulting design suggests that he consulted previous representations of the subjects during the process.[9]

Consultation of existing models comprises the primary guiding principle of medieval composition. The constant repetition of tried and true arrangements of figures leaves little scope for discerning artistic attitudes towards the composition of pictures, except that compositional variety was not apparently itself a highly valued characteristic.[10] The relatively standardized compositions of particular scenes could be used as building blocks in larger schemes, a usage that can be seen in the thirteenth-century crossing vault in Braunschweig Cathedral. The vault is painted with six scenes depicting events from the New Testament, arranged in a geometrical pattern derived from the architecture of the vault itself (Fig. 3). The manner in which the scenes are combined into a larger scheme responds to the specific spatial context of the painting, and the orientation of the individual scenes is utterly dependent on the overall schematic pattern. Although all of the scenes broadly conform to well-known compositional types, certain adjustments were made to the usual arrangements in order to fit picture spaces that narrow towards the centre of the vault and the tops of the pictures. The architectural framing devices capping each scene are manipulated as decorative, rather than fictive, structures. In the Supper at Emmaus, for example, several buildings are collapsed into each other at improbably acute angles. The relationships between the figures are likewise adjusted to fit the narrowing picture spaces. In the Pentecost scene, the Apostles tilt precariously, so that their heads squeeze together, forcing their halos

7. A few fourteenth-century figure studies apparently for glass designs do survive on parchment. H. Wentzel, 'Un Projet de vitrail au XIV⁵ siècle', *Revue de l'art* 10, 1970, pp. 7–14.

8. C. Dehaisnes, ed., *Documents et extraits divers concernant l'histoire de l'art dans la Flandre, l'Artois et le Hainaut avant le XV⁵ siècle*, Lille, 1886, pt II, pp. 556–7.

9. Erwin Panofsky discusses Bondol's manuscript sources, *Early Netherlandish Painting*, Cambridge, MA, 1964, I, p. 38 and p. 375, n. 3.

10. Michael Grillo examines the way repetition aids 'legibility' and allows variation in symbolic juxtaposition of conventional scenes, *Symbolic Structures: The Role of Composition in Signalling Meaning in Italian Medieval Art*, American University Studies Series XX: Fine Arts 20, New York, 1977.

to overlap confusingly, but allowing a usually spread-out composition to fit into this restricted space. Given a disregard for a strict inherent regularity of the organization of pictorial space, standard compositions of scenes could be tweaked and adjusted to suit local circumstances.

It is difficult to interpret finished works of art or drawings as visual evidence of ideas about composition without a textually-derived theoretical context. The evidence of medieval writing about art does establish some parameters for analysing the way medieval pictures were composed, but these nuggets of illumination must be searched for among a body of writing in which pictorial composition does not figure prominently. Although there is a substantial amount of writing about the appearance of art by medieval commentators, some of it demonstrating distinctly aesthetic priorities, the large majority of this writing refers not to pictures but to architecture.[11] The terms found in such medieval descriptions of art (primarily buildings) have been analysed by Cyril Barrett.[12] *Compositio*, 'composition', is used to refer to architectural construction considered aesthetically, as opposed to mechanically. Its use by medieval authors suggests as equivalents: design, proportion, and quantitative harmony or symmetry.[13] It is possible that these qualities were also thought to be desirable in figurative art, but the word *compositio* is not used to refer to them in that context.

Figurative art tends to be described by medieval authors at best ambivalently, and often, with unabashed hostility. Frequently cited by modern art historians is Bernard of Clairvaux's contemptuous account of twelfth-century artistic practice. Around 1125, Bernard wrote a letter to the Abbot of St-Thierry, in which he deplored the way that art invites the viewer to become lost in contemplation of itself. He began by condemning the expense of embellishing churches and then went on to give a description of the type of figurative carving typically found in monastic cloisters and manuscripts.[14] Bernard's description is as extraordinary for its vivid evocation of Romanesque figuration, as for its hostility to that imagery. He concludes with this critique:

> In short, everywhere so plentiful and astonishing a variety of contradictory forms is seen that one would rather read in the marble than in books, and spend the whole day wondering at every single one of them than in meditating on the law of God.[15]

11. Many examples of such texts can be found in E. de Bruyne's *Études d'esthétique médiévale*, 3 vols, Bruges, 1946.

12. C. Barrett, 'Medieval Art Criticism', *British Journal of Aesthetics*, 5, 1965, pp. 25–36.

13. Ibid., p. 28.

14. Conrad Rudolph analyses the types of artwork referred to by Bernard, *The "Things of Greater Importance": Bernard of Clairvaux's* Apologia *and the Medieval Attitude Toward Art*, Philadelphia, 1990, pp. 127–57.

15. 'Tam multa denique, tamque mira diversarum formarum apparet ubique varietas, ut magis legere libeat in marmoribus, quam in codicibus, totumque diem occupare singula ista mirando, quam in lege Dei meditando.': J. Leclercq and H. M. Rochais, eds., 'Apologia ad Guillelmum Abbatem', *Sancti*

For Bernard, images are a distraction from a monk's true purpose. The qualities of artfulness, such as variety, that modern viewers admire are the very ones that Bernard attacks as being more tempting than sacred books.[16]

Central not only to Bernard's disgust, but also, on the other side of the argument, to the fundamental medieval justification for imagery, is the analogy between images and texts. The First Commandment's prohibition of making and worshipping images[17] resulted in a simmering unease about the validity and place of images in the Catholic Church, an unease that boiled over repeatedly throughout the Middle Ages. In 600, reacting to one such moment of iconoclasm, Pope Gregory the Great pronounced that the reason for having figurative imagery in churches was to provide books for the illiterate. This became the standard theoretical validation of Christian imagery throughout the Middle Ages and beyond.[18] This justification by literary metaphor may have precluded the development of an articulated visual aesthetic that would enable such a peculiarly visual aspect of art as composition to receive analytical attention. To the extent to which images were looked upon as stories, there was no need to think of them as specifically pictorial constructs.

One of the few approvingly critical descriptions of a work of art by a medieval commentator is found in the writings of Gerald of Wales, a late twelfth-century ecclesiastic and traveller. Having seen either the Book of Kells or a manuscript similar to it in design, Gerald wrote a description as positive in its attention to visual detail as Bernard's critique is negative.

> If you look at them [the drawings] carelessly and casually and not too closely, you may judge them to be mere daubs rather than careful compositions. You will see nothing subtle where everything is subtle. But if you take the trouble to look very closely, and penetrate with your eyes to the secrets of the artistry, you will notice such intricacies, so delicate and subtle, so close together and well-knitted, so involved and bound together, and so fresh still in their colourings that you will not hesitate to declare that all these things must have been the result of the work,

Bernardi Opera, III, *Tractatus et opuscula*, Rome, 1963, cap. xii, § 29, p. 106. Translated by Rudolph, ibid., p. 283.

16. That such figures could be understood to play a positive aesthetic role is demonstrated by Lucas, Bishop of Tuy's assertion that some painted forms in churches, in particular animals, 'are for adornment and beauty only' ('sunt in ecclesia depictae forme bestiarum, volucrum et serpentium et aliarum rerum et pulchritudinem fiunt'). This text and the complementarity of this idea to Bernard's comments, is discussed in Creighton Gilbert, 'A Statement of Aesthetic Attitude around 1230', *Hebrew University Studies in Literature and the Arts*, 13, 1985, pp. 125–52(137–51).

17. According to the Augustinian enumeration used in the Middle Ages, the prohibition against images constitutes part of the First Commandment.

18. The repetition of Pope Gregory's 6th-century defence of pictures in churches, that 'what writing does for the literate, a picture does for the illiterate looking at it', throughout the Middle Ages is surveyed by L. G. Duggan, 'Was Art Really the "Book of the Illiterate"?', *Word and Image*, 5, 1989, pp. 227–51. Its recitation by modern commentators is sampled by C. M. Chazelle, 'Pictures, Books, and the Illiterate: Pope Gregory I's Letter to Serenus of Marseille', *Word and Image*, 6, 1990, pp. 150–51, nn. 1 and 2 and *passim* pp. 138–53.

not of men, but of angels.[19]

If we compare this description to one of the illuminated pages of the Book of Kells (Fig. 4), we immediately recognize the intricate knitting of colour and pattern described by Gerald. With him we can attempt to penetrate with our eyes, and with him we will understand this penetration to be practised across the surface of the two-dimensional page, rather than into any imaginary third dimension behind an imagined picture plane. There is overlapping, but no pictorial space. While demonstrating an attention to the detail of the illuminations and an appreciation of their visual complexity, Gerald's comments do not exhibit any awareness of the flatness of their design. But then, why should they? He had no experience of two-dimensional images attempting to give the illusion of spatial depth. For Gerald, the page's visual flatness is unremarkable, although the superficial design can be penetrated so as to reveal a delicate and subtle intricacy that implies heavenly manufacture.

The remainder of Gerald's description tells us that the manuscript he saw contained representations of the mystical forms of the Evangelists: the eagle, the calf (i.e. ox), the man, and the lion. This attention to subject matter is consistent with most medieval writing about the pictorial arts. Whether describing or prescribing, medieval authors invariably emphasized who is represented, what their attributes are, and, sometimes, the symbolism of such attributes. This approach accords well with the rather pedestrian justification of the pictorial arts as books for the unlettered. In contrast, Gerald's assertion that the gaze can penetrate to the secret of artistry is highly individual.[20]

Much more typical, is the early thirteenth-century prescriptive text *Pictor in carmine*. This consists of a set of descriptions of suitable subject-matter for use by medieval painters of churches. However, as far as the details of the construction of the paintings go, the author relinquishes responsibility:

19. 'Quas si superficialiter et usuali more minus acute conspexeris, litura potius uidebitur quam ligatura; nec ullam prorsus attendes subilitatem, ubi nichil tamen preter subtilitatem. Sin autem ad perspicacius intuendum oculorum aciem inuitaueris, et longe penitus ad artis archana transpenetraueris tam delicatas et subtiles, tam arctas et artitas, tam nodosas et uinculatim colligatas, tamque recentibus adhuc coloribus illustratas notare poteris intricaturas, ut uere hec omina potius angelica quam humana diligentia iam asseueraueris esse composita.': J. J. O'Mara, ed. and trans., 'Giraldus Cambrensis in Topographia Hibernie', *Proceedings of the Royal Irish Academy*, 52.C, 1949, pp. 151–2 and *The History and Topography of Ireland*, Harmondsworth, 1984, p. 84. The word *ligatura* is difficult to translate precisely in this context particularly as Gerald seems to be playing on the assonance between *ligatura* and *litura*. Consequently, one hesitates to place too much significance on the word itself, although he does seem to be using it broadly in the sense of composition. E. H. Alton freely translates *litura* as erasure and *ligatura* as tracery, giving: 'you would think it is an erasure, and not tracery.' *Evangeliorum Quattuor Codex Cenannensis*, III, Berne, 1951, p. 15.

20. Barret, 'Medieval Art Criticism' (n. 12 above) observes that medieval writers find their most developed art critical language when discussing art of the past (p. 33), a tendency that may partially account for Gerald's comments. That Gerald is conscious of the manuscript's antiquity is evident from his report that the book was written according to the dictation and design of an angel during the lifetime of the Virgin Mary. The fact that it is a Christian object being described, rather than an antique one, as the works discussed by Barret are, makes Gerald's articulate critical language even more remarkable.

it was not my business to arrange for those who supervise such matters, all that should be painted; let them look to it themselves as the fancy takes each, or as he abounds in his own sense provided only that they seek Christ's glory, not their own.[21]

The text that follows lists 138 biblical events in a vast typological scheme. Although the subject matter of the scenes is specified in detail, the author of this text was happy to leave the particulars, such as composition, to the artist, so long as he keeps in mind his foremost duty to glorify God. So long as they function as books for the illiterate, medieval commentators were apparently indifferent to the compositional aspects of picture-making.

In the case of *Pictor in carmine*, and in others, verbal accounts are often as much explication of symbolism as actual descriptions of what you might be able to see with your eyes. William Durandus, thirteenth-century Bishop of Mende, wrote a lengthy treatise on the imagery of the Christian Church in which he explains the symbolism of churches and everything in them. What we in the twentieth century might characterize as compositional relationships are explained in primarily symbolic, rather than visual, terms. For example, Durandus notes that the altar cross should be placed between two candlesticks, 'because Christ stands in the church, mediator between two peoples'.[22] This placement of the cross is not insisted upon for the sake of visual symmetry, but because we thus perceive Christ to mediate between the Jews and the Christians. There is a self-conscious purpose to the placement, but it is not, at least primarily, compositional in a visual sense. This does not negate the possibility of visual satisfaction in such an arrangement, but such visual satisfaction does not itself constitute justification of the arrangement.

Perhaps the most striking example of the priority of the symbolic over the visual is the commentary written by Jean Pucelle, the fourteenth-century French artist who reinvigorated the art of northern manuscript illumination with his radically complex arrangements of decorative frames and architectural settings. Around 1325, an artist in Pucelle's workshop painted an elaborate series of images filled with Italianate representations of space to illustrate a Breviary for Jeanne de Belleville (Fig. 5). The Belleville Breviary contains an introduction, probably by Pucelle himself, which describes the importance of the pictures. Its interest is entirely subject-oriented. Nowhere does Pucelle comment on the graceful gothic figures, the intricate interiors, or the complex compositions of his pictorial inventions. Instead he provides an explication of the symbolism of the typological relationships between the figures. He writes that the meaning of the pictures is the

21. M. R. James, ed. and trans., 'Pictor in Carmine', *Archaeologia*, 94, 1951, pp. 141–66 (142–3): 'Ceterum hiis qui talia curant non erat meum pingenda queque disponere, sed disponant ipsi prout trahit sua quemque uoluptas, uel prout unusquisque in suo sensu abundat, dummodo gloriam Christi querant non suam.'

22. 'Inter duo candelabra Crux in altari media collocatur, quoniam inter duos populos Christus in Ecclesia mediator existit.': J. Belethus, ed., *Rationale divinorum officiorum*, Naples, 1859, bk I, cap. iii, § 31, p. 28.

presence, in symbolic form, of the New Testament in Old Testament events.[23]

Occasionally, Pucelle's explanations of the symbolism of his paintings includes an interpretation of the way particular elements are arranged. Thus, in one picture the three nails of the Passion are 'made to attach and to join together', because of 'the number of the three Persons and because Divinity – which is Love – draws and joins together'.[24] Mostly, however, the descriptions elucidate the symbolism of the pictures' elements and details. Pucelle opens his exegesis with a reminder of the importance of understanding what one sees:

> And in what follows to the end of the psalter if there are any obscurely shown figures, I wish to clarify them so that everyone can understand and profit from them.[25]

Pucelle proceeds to give a thorough exposition of the meaning of the book's imagery. The profit, Pucelle implies, will derive entirely from the understanding of the symbolic arrangement of the figures, whatever their composition. Where arrangement of pictorial elements is touched on, as with the nails, the explanation is symbolic rather than compositional, despite the great visual interest of the illuminations. Pucelle describes the meaning of the pictures, rather than their appearance.

If we compare Pucelle's fourteenth-century compositions to those of the ninth-century Book of Kells, several fundamental differences strike us. Instead of a flat design indifferent to three-dimensional pictorial space, we have an overt play of different represented spaces. Mary and the Angel inhabit distinct but communicating interiors, a spatial subtlety that enhances the subtle theology of the Annunciation, whereby the Virgin's bodily space was invaded, but remained intact. The contrast with the older illumination exemplifies Otto Pächt's characterization of the shift that takes place over the course of the Middle Ages, from pictures in which the pictorial fields of action for texts and images are continuous, to pictures in which there is a clear distinction between pictorial and textual fields.[26] Whether self-consciously or not, composition was approached in different ways in the two works. In the Book of Kells it is the page as a whole, including both text and images that is composed into a unified design. In the Belleville Breviary, the pictorial elements are isolated entities. However, despite the great visual differences between the two books, commentators of the time did not remark on such superficial aspects of picture-making, but focus on subject matter and the meaning to be derived from it.

23. 'Lexposition des ymages des figures qui sunt ou kalender et ou sautier et est proprement lacordance du veil testament et du nouvel.' L. F. Sandler, ed. and trans., 'Jean Pucelle and the Lost Miniatures of the Belleville Breviary', *Art Bulletin*, 66, 1984, pp. 73–96; pp. 94–6.

24. '... legle tient a saint jehan les .iii. clous qui senefient la divinite et quant au nombre de .iii. personnes et quant a ceu que si comme la divinite qui est charite attret et ioint ensemble. les cuers': ibid., pp. 95–6.

25. 'Et pour ce qui ci apres iuques a la fin du sautier a aucunes figures oscurement bailliees ie les vueil desclerier si que chacun les puist entendre et faire en son porfit.': ibid., pp. 94–5.

26. O. Pächt, 'The Conflict of Surface and Space: An Ongoing Process', *Book Illumination in the Middle Ages*, London and Oxford, 1986, pp. 173–202.

In the first decade of the fifteenth century, a century after Pucelle elucidated the meaning of his illuminations, an anonymous English writer summarized the medieval theology of imagery in the context of a discourse on the Ten Commandments. The author of *Dives and Pauper* justifies the presence of images in churches despite the Commandment prohibiting the worshipping of images. The eponymous, knowledgable, pauper explains to the ignorant rich man that we have pictures in churches because pictures are the books for the unlearned. The justification of imagery is the traditional one of books for the illiterate, and the description of imagery that follows is typically a subject-oriented one enhanced by a degree of symbolic interpretation. Having been given the standard line, the rich man asks Pauper, 'How should I read in the book of painting and imagery?'[27] Pauper's answer comprises an early introduction to the iconography of medieval art, enumerating and explaining the characteristic appearance and attributes of the Virgin, a series of popular saints, the Apostles, angels, and the Evangelists. The explanations consist of detailed descriptions of medieval pictorial representations. The explication of the attributes of angels, for example, amounts to a vivid description of a painted angel such as the one on the rood screen at the Church of St Edmund, Southwold, Suffolk (Fig. 6). Angels, the pauper tells the rich man:

> are painted like young men without beards in token that they are eternal and that they age not, nor enfeeble, but are always content and constant, always mighty and strong. They are painted with curly hair in token that their thoughts and their love are set always in right order and turn always back up to God, thanking him and worshipping him above all else … They are also painted feathered and with wings in token of skill and agility in their works, for in one twinkle of an eye they might be in heaven and on earth, here and at Rome and in Jerusalem.[28]

Despite the very particular characterization of angels as beardless, curly-haired, befeathered, winged youths, there is nothing about how pictures of angels or any other figures should be arranged. Pauper only tells us what should be represented and with what details. Furthermore, his interest in those details is exclusively symbolic; they are included for their religious meaning rather than for any visual priorities.

Although *Dives and Pauper* does not have anything explicit to say on the matter of composition, its representation of church imagery does capture a predominant trend in the arrangement of figures in medieval art. The description is serial; that is, it recounts one single figure after another. Much of medieval painting in all media also tends to be serial, presenting one standing single figure after another. Medieval windows, for example, are filled with rows of saints. Rood screens, like the one at Southwold, similarly present one figure next to another, not uncommonly the set of Apostles as described in *Dives and Pauper*. Altar panels often show various saints standing in ranks either side of the Virgin and Child. The proportion of medieval

27. P. H. Barnum, ed., *Dives and Pauper*, I, pt 1, Early English Text Society, original series 275, 1976, p. 83.
28. Ibid., pp. 95–6.

pictorial arrangements that fall into this category is very high, and although it seems to be an unexciting compositional principle it is an important one in medieval art.

In order to lend visual and conceptual coherence to serial arrangements, medieval artists made free use of painted, drawn, and sculpted frames. Such frames could be pseudo-architectural, or simply geometrical spatial boundaries that imposed visual uniformity on a series, while also defining a clear pictorial field within which pictures could be composed. Framing of single figures, as well as of compositionally more complex narrative scenes, provides one clearly identifiable aspect of medieval compositional technique.

The mid-thirteenth-century Psalter of Louis IX contains a wide variety of resolutions of the relationship between narrative scenes and the frames that enclose them. The St Louis Psalter is well known for its elaborately painted framework, which crowns its narrative scenes with Gothic edifices that mimic contemporary Gothic architecture, such as Louis's own Ste Chapelle. These constructions, laid on the page before the figurative scenes, create awkward pictorial fields for the biblical events depicted within them. Due to the use of pairs of trefoil arches to define the top border of each illumination, the upper portions of the pictures consist of a maze of blank and decorative spaces (see Figs 8 & 9). The manuscript's artists take a variety of approaches to these difficult areas. Sometimes they simply ignore them and limit the scenes to the more open and regular zone below the arches. In one case, however, Joshua, depicted as a medieval knight, rises up to land a vicious blow with his sword against the Amalekites (Fig. 7). Because Joshua is raised up to full height, the sword he wields conflicts with the framing arches above. The artist does not ignore the frame, but paints the sword as if behind it, suggesting that the frame has a certain physical existence. In addition, the interleaving of the sword with the frame enhances the impression of aggressive strength, for it appears that the sword will have to sever the frame before coming down on the enemy. Thus, the conflict between sword and frame gives a heightened sense of movement and dynamism to the action taking place. The sword will slice through the frame just as it will slash the victim below.

A different approach is taken to the coordination of scene and frame in the representation of the climax of the Old Testament story of Joseph. The moment when Joseph reveals his identity to his brothers is one in which the artist manipulated the use of the picture space to enhance the drama of the moment (Fig. 8). Having flung his cloak to the ground, Joseph stands fully upright, extending his arms above his head in order to display his full figure.[29] As he does so, Joseph's hands extend right into the pair of arches that form the upper boundary of the picture space, adding emphasis to the gesture with a visually arresting composition. As a compositional device, the reciprocity between frame and figure heightens the miniature's impact; by intensifying the visual effect it contributes to the meaning of the image. In the Joseph scene visual effect is heightened by a reciprocity between frame and figure, whereas

29. Meyer Schapiro points out that the picture echoes an earlier image in the manuscript illustrating the throwing of Joseph into the well. In that scene a much smaller Joseph also raises both arms up above his head: *Words and Pictures*, The Hague, 1973, pp. 29–30. Such an echo provides another example of deliberately conceptual use of composition in this manuscript.

in the Joshua scene effect is heightened by a conflict between the two elements, but in both cases the frame is treated almost as a physical object existing in the scene itself, though it can represent no real thing in the scene. Although fictive, the architectural frame takes on an ontologically continuous existence in the representation.

Continuity between frame and subject can be seen to be an aspect of composition in monumental, as well as miniature, painting. An early thirteenth-century wall painting of Adam and Eve labouring after the Fall, from Sigena in Spain (Fig. 9), demonstrates the complementary use of a pre-established framed space, in a similar manner to that of the Joseph scene in the St Louis Psalter. In this spandrel painting, Eve, whose seated form is close in overall shape and pose to the Eve drawn by Villard (Fig. 1), fits neatly into the given triangular space. However, Adam has no room to labour facing Eve as he does in that drawing. Instead, he faces away from Eve, bending into the available pictorial space and tilling the ground that rises up to meet him on the crest of the arch whose spandrel forms the picture's field. Thus, Adam both fills the space and echoes the shape of the picture's framework. This compositional reciprocity heightens the effect of Adam's work in tilling the earth, as Joseph's co-ordination with his frame heightened his imposing structure. The frame, despite its awkward shape, is treated as being continuous with the depicted scene.

In medieval wall paintings, the spaces provided for artists are partially pre-determined by the architecture of the building, as at Sigena. Within that overall structure, wall painters often created further artificial boundaries, resulting in series of painted frames much like those found in other media, as can be seen above the mid-thirteenth-century Passion cycle painted on the nave arcade of St Mary's, West Chiltington, Sussex (Fig. 10). For one scene, however, the West Chiltington artist did not use a painted frame, as a pre-existing structural one, enhanced by decorative borders, suited his purpose amply. Christ's Resurrection is painted in one of the spandrels on the north face of the nave arcade. The scene fits nicely into that space, and the expression of its meaning is enhanced by the opening up of the space from bottom to top, which intensifies the picture's representation of Christ's expansive movement up out of the tomb. We know from Pucelle's and Durandus' writings that placement of figures was understood symbolically, and in this image of Christ rising up out of the funnel of the spandrel, a symbolic relationship with the shape of the wall may have been intended.

A nearly identical use of a spandrel for the same subject is found in a much later wall painting in the church of SS Peter and Paul, Pickering, Yorkshire (Fig. 11). There, the Resurrection was painted in a nave arcade spandrel in the middle of the fifteenth century, when the early thirteenth-century arcade wall was heightened to allow the addition of a clerestory, disrupting the original wall paintings and necessitating the painting of new ones. The fifteenth-century Resurrection spandrel lies directly below a Passion cycle very similar in form and content to the one at West Chiltington. Although compositional similarities between different schemes is not itself unusual given the widespread copying of standard compositional patterns, when compared to the rest of the Pickering paintings, this particular arrangement stands

out as visually incompatible and anachronistic. Throughout the remainder of the church, and typically for the fifteenth century, a wide variety of individual subjects of varying scales are confined by clearly painted frames that are only in the most limited sense dependent on the larger architectural structure of the church.[30] Fifteenth-century compositions tend to be treated more like framed pictures, rather than paintings inserted into available spaces. The difference between the arrangement of the Resurrection and the organization of the rest of the paintings at Pickering highlights the oddness of the Pickering painter's isolation of the Resurrection scene, and thereby draws attention to the use of the identical compositional device as found in the wall painting at West Chiltington painted two hundred years earlier. Possibly, the seemingly old-fashioned composition of the Resurrection represents continuity with the older scheme of wall paintings originally painted on Pickering's early thirteenth-century arcade, one which would have had a close contemporary parallel at West Chiltington. These two thirteenth-century paintings would have been similar not through direct influence, but through mutually partaking of a typically thirteenth-century way of using the wall space to accommodate and enhance pictorial compositions, as seen at Sigena and in the St Louis Psalter. Perhaps the compositional anachronism at Pickering, which we can identify by comparison with the painting at West Chiltington, alerts us to an example of a fifteenth-century artist appreciating and copying a compositional device by an older artist. The copying of compositions may itself be a self-conscious choice reflecting an aesthetic attitude to composition as a visual element of picture making.

At Pickering, frames divide the walls into discrete pictorial fields, a compositional tactic typical of wall paintings all over northern Europe during the later Middle Ages and one that separates late medieval picture-making from the concerns of pre-1400 artists. One final example in considering the composition of medieval pictures returns to the greater consonance between the shape of wall paintings and the shape of the walls they lie on typical of earlier medieval art. The west wall of St George's Church in Trotton, Sussex is covered by a painting from the middle of the fourteenth century (Fig. 12). The painting combines several distinct subjects into a single composition. It incorporates Moses holding the tablets of the law, the Seven Works of Mercy placed around a representative Good Man, the Seven Deadly Sins placed around a representative Bad Man, and Christ sitting in judgement with angels sending one soul away from salvation and accepting another to Christ's side.[31] The painting as a whole

30. There are three exceptions to this rather abstract approach to the walls at Pickering. Two are large-scale images of Saints George and Christopher which conform to the shape of the wall rather than to an imposed regular frame, in part as a result of, and with the effect of emphasizing, their sheer size. The other exception occurs in the spandrel just to the east of the Resurrection spandrel (Plate 12). That space is occupied by the scene of Christ's Descent into Hell. Christ is positioned so as to appear to descend down into the funnel of the spandrel, in contrast to his rising up out of the next one in the series. The equivalent spandrel at West Chiltington has lost its wall painting (Plate 11), but may well have contained the same subject, which neatly complements the Resurrection.

31. The painting is often called a Doom or a Last Judgement, but this designation obscures the complexity of an image that corresponds neither in content nor location to the traditional chancel wall Judgement.

is not rigidly framed, except by the edges of the wall itself and, at the top of the wall, a decorative canopy that embraces all of the figures, holding them together in a single visual and conceptual field. The juxtaposition of the different elements of this painting into a single composition owes something to the kind of typological theology described by Jean Pucelle (Moses is a type for Christ), but the pairing of the Works of Mercy and the Sins is an explicit contrast opposing positive and negative moral values. The overall message is that indulgence in sin will result in being sent away from Christ, whereas the practice of the Works of Mercy will result in salvation.

The differentiation between the two types of activity, desirable mercies and undesirable sins, is expressed visually in several ways. The central figures, representative examples of good and bad people, are wholly different. The Good Man is neatly clothed and stands in a prayerful attitude, looking in the direction of Moses and Christ. In contrast, the Bad Man stands in an open and ambiguous position with his head directed away from the holy personages. Although his naked form is now modestly attired in a loin-cloth, at the time of his discovery in 1904 the figure was 'phallic'.[32] Even more strikingly different is the manner in which the Seven Mercies and Sins are portrayed. The Mercies are neat little scenes displayed in tidily delineated circular picture spaces. The scenes are painted on a ruddy background whose roundness is articulated by a double-band of white and red outline. In contrast, the Sins are represented as emerging from gaping, devilish mouths without any defined picture space to enclose them. They sprawl almost haphazardly against the plain whitewashed surface of the wall, an arrangement that gives them an insidiously uncontrolled air.

The Trotton painting strongly suggests that an untidy composition carried negative overtones in the Middle Ages.[33] While clearly the Trotton painting is symmetrically balanced either side of a vertical axis, the meaning of the painting rests on perceiving the difference between the two sides, not the equivalence between them. The composition juxtaposes different elements on a two-dimensional surface into a symbolic, rather than a narrative, cohesion. Furthermore, those elements represent utterly different temporal moments: Moses is an Old Testament figure from the past who had been superseded by Christ, whose Judgement would come in the future; together, Moses and Christ oversee medieval people being good and bad in the medieval present. Neither spatial depth, nor temporal sequence are necessary in a depiction of universal, rather than individual, truth.

* * *

32. This is reported by E. W. Tristram, *English Medieval Wall Painting of the Fourteenth Century*, London, 1955, p. 259. A pre-restoration photo shows the figure without a loin-cloth, though its details are obscure. D. Percy, ed., *Memorials of Old Sussex*, London, 1909, facing p. 276.

33. This technique of distinguishing Sins from Mercies by the compositional deportment of the figures, loosely placed in dragon mouths or neatly situated in well defined decorative shapes, is not unique to Trotton. A similar mode of distinction is used in other paintings; an example that likewise embodied base behaviour in a phallic figure survives in St Nicholas', Arundel, Sussex. There the Sins, as at Trotton, sprawl uncontained against the blank background of the whitewashed wall, while the Mercies are tidily contained in a wheel-structure.

Although there is too much variety in medieval composition to allow a definitive statement on the subject, some conclusions are possible. Despite the lack of clear, textual articulations of an interest in the composition of pictures by medieval artists or critics, there is evidence that medieval artists did have certain compositional priorities. They worked primarily on a presumed flat picture plane, but did so without negating the possibility of things being specifically located behind or in front. In creating pictures and schemes of pictures, individual elements, such as figures or standardized scenes, could be composed or re-composed to suit wider contexts. Repetition of standard compositional outlines, and the flexibility such standardization afforded in adjusting to local circumstances, was highly desirable. A strong positive value was placed on containment and visual unity, but frames were not inviolable; there are many examples of medieval figures whose feet project over the frame that encloses them. Frames took on an actual presence in the scenes they enclosed allowing them to participate in the construction of meaning in the pictures. As the example at Trotton shows, the manner of framing could have a moral dimension. A vast variety of compositional ploys were possible, either in spite of, or even because of, the lack of explicit ideas about composition. This variety, however incompatible with Renaissance and later theories of composition, does not mean that medieval artists had no sense of composition nor that they did not use it thoughtfully.

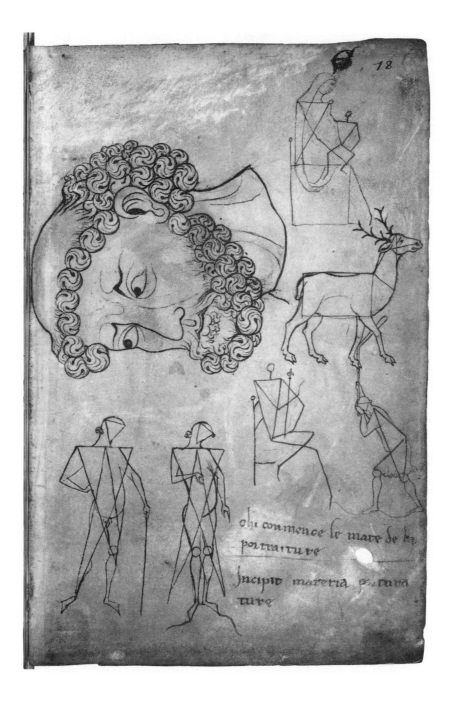

Fig. 1. Villard de Honnecourt: figure studies. Paris, Bibliothèque nationale de France, MS fr. 19093, f. 18r. Photo: Bibliothèque nationale de France.

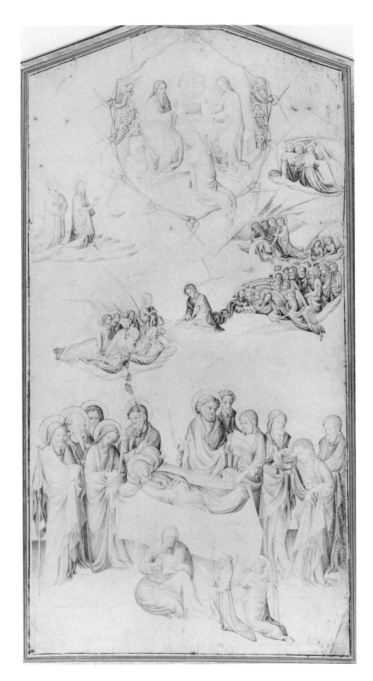

Fig. 2. André Beauneveu or associate: Death, Assumption and Coronation of the Virgin. Paris, Musée du Louvre, Cabinet des Dessins.

Fig. 3. New Testament Scenes. Crossing vault, Braunschweig Cathedral, Niedersachsen.

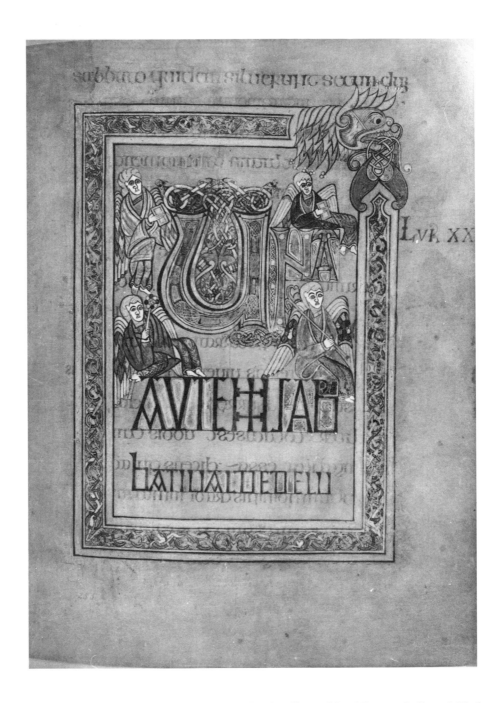

Fig. 4. Ornamental text with angels. Book of Kells, Dublin, Trinity College MS, f. 285ʳ.

Fig. 5. Workshop of Jean Pucelle: Annunciation. Belleville Breviary. Paris, Bibliothèque nationale de France, MS Lat. 10483–4, f. 163ᵛ.

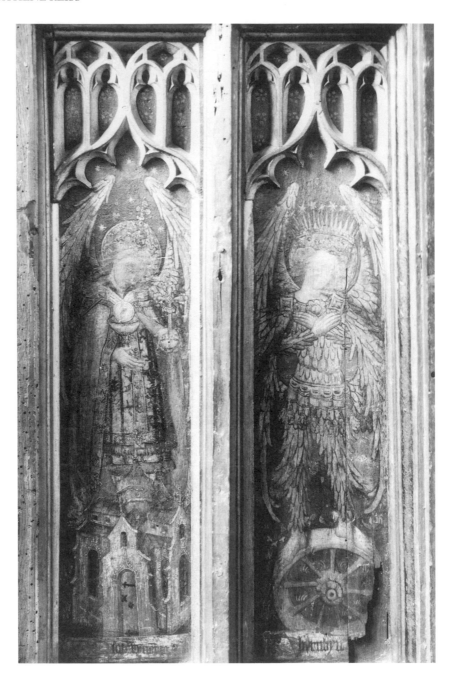

Fig. 6. Archangel Michael. Rood screen, St Edmund's, Southwold, Suffolk.

Fig. 7. Joshua overcomes the Amalekites (Exodus 17:13). Psalter of Louis IX. Paris, Bibliothèque nationale de France, MS Lat. 10525, f. 32r.

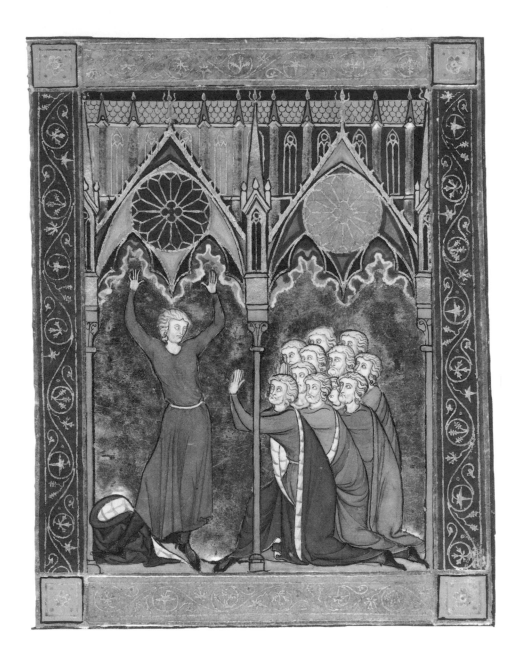

Fig. 8. Revelation of Joseph to his brothers. Psalter of Louis IX. Paris, Bibliothèque nationale de France, MS Lat. 10525, f. 25v.

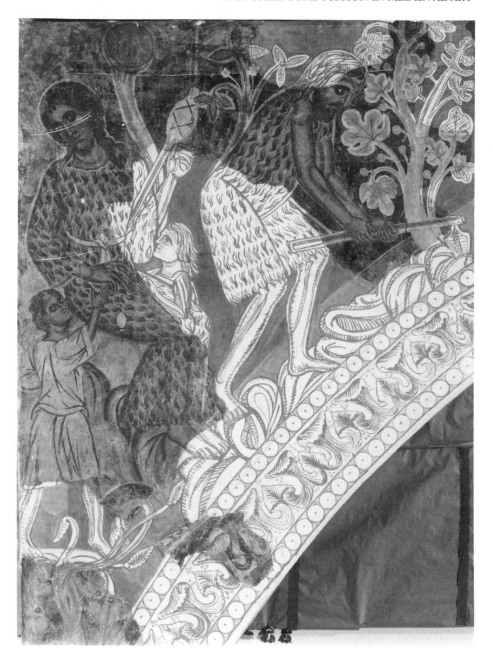

Fig. 9. Labours of Adam and Eve. East face of south spandrel, 2nd arch from the west. Chapter House of the Convent of Sigena, Catalonia, now in the Museu d'Art de Catalunya, Barcelona. Photo: Museu d'Art de Catalunya, Barcelona.

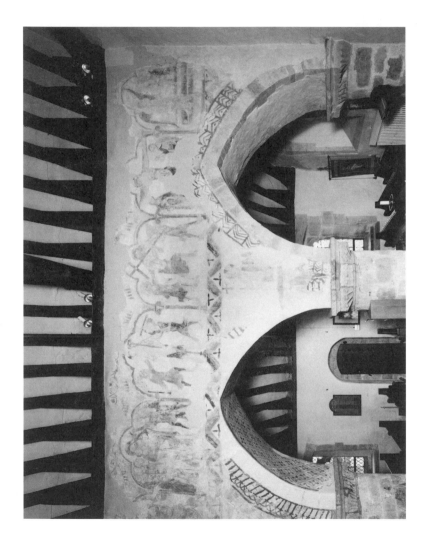

Fig. 10. Passion scenes. North face of nave arcade, St Mary's, West Chiltington, Sussex. Photo: RCME, Crown copyright

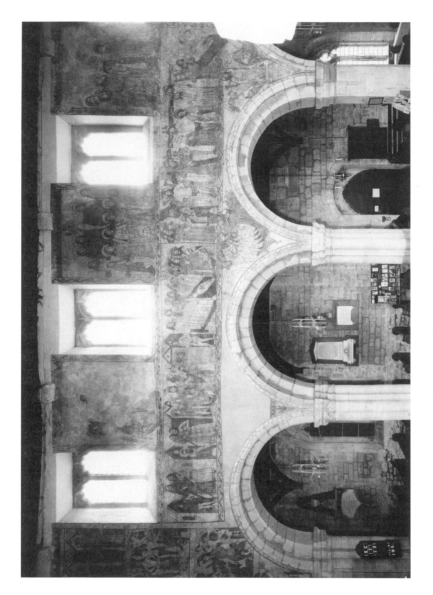

Fig. 11. Passion scenes. South nave arcade, SS Peter and Paul's, Pickering, Yorkshire. Photo: RCME, Crown copyright

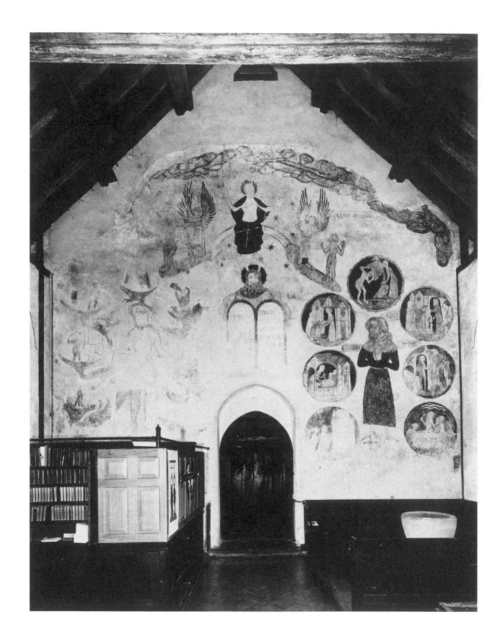

Fig. 12. Christ in Judgement, Moses, Seven Sins and Works of Mercy. West wall, St George's, Trotton, Sussex. Photo: RCME, Crown copyright.

'Composition' from Cennini and Alberti to Vasari

Charles Hope

When applied to paintings, the word 'composition' is used today in several different ways. It can refer to the arrangement of the main elements or areas of colour on the picture plane, as with a work by Mondrian, or alternatively to the disposition of forms, such as figures and architecture, within a fictive three-dimensional space, a kind of proscenium stage behind the picture plane, although here too there seems to be a tacit assumption that these forms will be related not just to one another, but also to the frame. This is the sense in which Raphael, for example, is often characterized as a master of composition. Finally, the term is applied to the process by which a painter organizes the elements in his picture to achieve either of these effects, to the means rather than the end. But regardless of how art historians use the word, they often write as if the creation of a harmonious or expressive arrangement, whether within the pictorial space or on the picture plane, was always central to the concerns of artists, and perhaps also to the expectations of their audience. It is worth asking whether the modern, though ambiguous, use of composition has a counterpart in Renaissance writing on art.

The term itself, or cognates such as *comporre*, *componitore* and *componimento*, appears quite frequently in Renaissance texts. It first occurs prominently in connection with painting, as distinct from literature, architecture or music, in Alberti's *De pictura*, of which the most influential modern study is in the final chapter of Michael Baxandall's *Giotto and the Orators*, entitled 'Alberti and the invention of pictorial composition'.[1] According to Baxandall, 'Book I [of *De Pictura*] sees painting through a Euclidean approach, Book II through a Ciceronian screen'; and, more specifically, 'The central subject of Book II is pictorial composition, the way in which a painting can be organized so that each plane surface and each object plays its part in the effect of the whole. Here Alberti seems to be calling Italian painting back to some standard of narrative relevance, decorum and economy'.[2] Baxandall argues that Alberti was advocating the kind of narrative painting practised

1. M. Baxandall, *Giotto and the Orators. Humanist Observers of Painting in Italy and the Discovery of Pictorial Composition*, Oxford, 1971. For a similar approach, based on ideas derived from rhetoric, see R. Kuhn, 'Albertis Lehre über die "Komposition" als die Kunst in der Malerei', *Archiv für Begriffsgeschichte*, 28, 1984, pp. 123–78; J. M. Greenstein, 'On Alberti's "Sign". Vision and Composition in Quattrocento Painting', *Art Bulletin*, 79, 1997, pp. 669–98. But see also E. Barelli, 'The "Sister Arts" in Alberti's "Della Pittura"', *British Journal of Aesthetics*, 19, 1979, pp. 251–62. For a fuller discussion of *De pictura*, enlarging on some of the ideas discussed here, see C. Hope, 'The Structure and Purpose of *De pictura*', in the *Atti* of the conference *Leon Battista Alberti e il Quattrocento* held at Mantua in October 1998 (forthcoming).
2. Baxandall, *Giotto and the Orators* (n. 1 above), p. 129.

by Giotto and Masaccio rather than Gentile and Pisanello,[3] and he claims that Alberti used the term *compositio* 'in a new and exact sense. By *compositio* he means a four-level hierarchy of forms within the framework of which one assesses the role of each element in the total effect of a picture; planes go to make up members, members go to make up bodies, bodies go to make up the coherent scene of the narrative paintings'.[4] Baxandall draws a parallel here with literary composition. '*Compositio*', he says, '[is] the putting together of the single evolved sentence or period, this being done within the framework of a four-level hierarchy of elements: words go to make up phrases, phrases to make clauses, clauses to make sentences ... Alberti is treating the art of Giotto as if it were a periodic sentence by Cicero or Leonardo Bruni'.[5] He sees a precise application of criteria derived from rhetoric, for example, in Alberti's remark about the need to avoid disagreeable junctions of planes, identified as *asperitates*,[6] and in the recommendation that a narrative painting should contain no more than nine or ten figures, a remark that he likens to Quintilian's limitation on the number of clauses in a sentence.[7]

De pictura is written in the form of a treatise, and more precisely of an ancient treatise such as Quintilian's *Ars oratoria*, with a discussion first of the *ars*, then the *opus* and finally the *artifex*.[8] It is not certain whether the Italian text, dedicated to Brunelleschi and dated 1436 in the only extant fifteenth-century manuscript, or the Latin version, some manuscripts of which include a dedication to Gianfrancesco Gonzaga probably written about 1438, is the earlier of the two.[9] But there can be little doubt that Alberti intended his book principally for humanists, rather than for practicing painters. This is evident from the frequent classical allusions, from the absence of any references to any modern artist or subject-matter, apart from Giotto's *Navicella*, and from the fact that the text provides little in the way of practical information, even though it was ostensibly written as a treatise. Alberti had almost nothing to say about artistic training, or about the materials or techniques of painting, apart from an account of perspective both mathematically incomplete, even within its own terms, and difficult to follow because of a lack of diagrams, which appear in none of the known manuscripts and which are nowhere mentioned in the text. So when he said that he was writing 'as a painter speaking to painters',[10]

3. Ibid., pp. 129f, 139.

4. Ibid., p. 130.

5. Ibid.

6. Ibid., pp. 131f.

7. Ibid., pp. 132f.

8. D. R. E. Wright, 'Alberti's "De pictura": Its Literary Structure and Purpose', *Journal of the Warburg and Courtauld Institutes*, 47, 1984, pp. 52–71.

9. It is normally supposed that the Latin text was the earlier, but Lucia Bertolini has recently argued that it was first written in Italian (see her paper in *Leon Battista Alberti e il Quattrocento*, forthcoming).

10. Alberti, *De pictura*, 23. References and English translations are from Leon Battista Alberti, *On Painting and On Sculpture*, ed. C. Grayson, London, 1972, except that I have translated *historia* as 'story'. The same numbering of paragraphs is used in L. B. Alberti, *Opere volgari*, ed. C. Grayson, III, Bari, 1973,

Alberti did not mean this literally. He was actually writing as a humanist speaking to humanists; and his book was most widely read in Latin, to judge from the survival of ten manuscripts of this version dating from the fifteenth century.

Baxandall locates the intended readership in the milieu of Vittorino da Feltre and his school, in which geometry and perhaps some drawing were taught,[11] but there is no significant evidence that this kind of education would ever have been regarded as a preparation for the activity to which *De pictura* is ostensibly dedicated, the production of paintings, and especially of painted narratives on panel or in fresco. None of the actual or intended early readers of the Latin version so far identified can realistically be regarded as even potential painters. One of these readers was Giovanni Andrea de' Bussi, Bishop of Aleria, whose liking for *De pictura* is mentioned in the dedication of *De statua*. Another was Theodore of Gaza, the dedicatee of the *Elementa picturae*, and the third was Gianfrancesco Gonzaga, the dedicatee of the Latin text of *De pictura* itself (although he would have had great difficulty in understanding the text). In the dedication to Gianfrancesco, Alberti claims that the contents of his book 'may easily please scholars by the novelty of their subject'.[12] Later he argues that the ancients must have written about painting from a point of view different from Pliny's, even though nothing survives, and boasts that 'I was the first to write about this most subtle art'.[13]

All this suggests that Alberti was using the form of a classical treatise to write a book which he hoped would be of interest to readers who had the linguistic and geometric skills to understand his text, but had no intention of painting pictures. Such an audience might have been attracted by a re-creation of a hypothetical lost ancient treatise on painting, but this is not what Alberti set out to provide. His reference to Giotto's *Navicella* would have been anachronistic in such a work, and he remarked at the end of Book I, in connection with his account of constructing a pavement in perspective, that 'As we can easily judge from the works of former ages, this matter probably remained quite unknown to our ancestors because of its obscurity and difficulty'.[14] Alberti wrote not from the viewpoint of antiquity, but of his own day.

Although Baxandall made a clear distinction between the 'Euclidian' Book I, with its account of pictorial perspective, which he does not discuss, and the 'Ciceronian' Book II, which he calls 'the first account of pictorial composition',[15] this is slightly misleading in two respects: the mathematics as presented in Book I is not Euclidian,[16] and in the rest of the text Alberti constantly returns to ideas outlined

which includes the Latin and Italian texts on facing pages.

11. Baxandall, *Giotto and the Orators* (n. 1 above), pp. 127–9.
12. Alberti, 'On Painting' (n. 10 above), p. 34.
13. Ibid., 26, 63.
14. Ibid., 21.
15. Baxandall, *Giotto and the Orators* (n. 1 above), p. 125; cf p. 129.
16. J. V. Field, 'Alberti, the Abacus, and Piero della Francesca's proof of perspective', *Renaissance*

in Book I. They are fundamental, for example, to the discussion of the *velum* in Book II, and even at the beginning of Book III Alberti stresses that 'The function of the painter is to draw with lines and paint in colours on a surface any given bodies in such a way that, at a fixed distance and with a certain, determined position of the centric ray, what you see represented appears to be in relief and just like those bodies',[17] thus reiterating what he had written much earlier. Books II and III, then, have to be understood in the light of what Alberti had written in Book I. This is true not least of his concept of composition, a term already introduced in the first Book, which is the foundation on which everything else is built.

It is also the section of *De pictura* which is probably least read today, except by those with a particular interest in linear perspective, of which Alberti provides the earliest surviving account. His discussion is at first sight a rather odd one. In particular, it is not entirely rigorous, because Alberti does not provide an explicit proof of why orthogonals meet at a point. This may only indicate that his prime purpose was not to write a mathematical treatise as such. Had he wished to do so, he would surely have included diagrams. Indeed, he is quite explicit about the limitations of his approach. As he explains:

> I have set out whatever seemed necessary to say about triangles, the pyramid and the intersection. I used to demonstrate these things at greater length to my friends with some geometrical explanation. I considered it best to omit this from these books for reasons of brevity.[18]

In Book I, too, Alberti introduces ideas and examples that have no obvious place in mathematical demonstrations, alluding, for example, to representations of satyrs embracing the thumb of a Cyclops in his discussion of proportional diminution, and pointing out that if one looks at people standing in a temple, the heads of those in the distance appear on a level with those nearby, but the feet appear almost on the level of their knees.[19]

Alberti begins Book I by explaining that solid bodies consist of individual surfaces. Then he introduces a discussion of optics, explaining how these surfaces, whose appearance is modified by colour and lighting conditions, are perceived by means of rays. What he is doing here is giving his readers a basic understanding of how, in theory, a painter can represent the three-dimensional world on a two-dimensional plane in a geometrically consistent way. He summarizes these early sections as follows:

> since bodies are covered in surfaces, all the observed quantities of bodies will make up a single pyramid containing as many small pyramids as there are surfaces

Studies, 11, 1997, pp. 61–88(62).

17. Alberti, 'On Painting' (n. 10 above), 52.
18. Ibid., 23.
19. Ibid., 18, 20.

embraced by the rays from that point of vision. ... [Painters] should understand that, when they draw lines around a surface, and fill the parts they have drawn with colours, their sole object is the representation on this surface of many different forms of surfaces, just as though this surface which they colour were so transparent and like glass, that the visual pyramid passed right through it from a certain distance and with a certain position of the centric ray and of the light, established at the appropriate points nearby in space.[20]

The idea of a painting being the equivalent of a transparent membrane, or a window, as Alberti says elsewhere,[21] is new in the surviving literature on art. Alberti then explains how the areas on the picture plane occupied by projections of surfaces of different sizes, set at different angles and at different distances behind this plane, are dependent on geometrical rules.

Having said what the painter should be trying to do, in the last part of Book I he starts to explain how the painter should proceed, dealing with the specific problem of representing a chequer-board pavement of squares one *braccio* wide on the picture plane, so that the successive squares recede in a consistent way. This grid makes it possible to represent at the correct scale objects at different distances from the spectator. The principal objects that Alberti has in mind are figures, as he indicates at the very beginning of this section. The method he outlines is based on making a diagram representing a man standing on such a pavement and looking at it through a transparent vertical surface, representing the picture plane, on which the successive transversals of the pavement are then indicated. This makes the basic mechanism relatively easy to understand, but the procedure as described by Alberti would be unnecessarily elaborate in practice. In particular, it is unnecessary to use a separate diagram, as Alberti recommends, since the geometrical construction can be carried out on the picture plane itself.

The construction of the pavement, Alberti tells us, 'pertains especially to that part of painting which, when we come to it, we shall call composition'.[22] Book I itself concludes soon afterwards with the words: 'We will now go on to instruct the painter how he can represent with his hand what he has understood with his mind'.[23] The task now facing the painter is to insert into his perspectival grid the elements of his picture, and particularly bodies. This is the subject of Book II, which begins with a digression on painting in antiquity, after which Alberti returns to his principal theme:

we divide painting into three parts, and this division we learn from Nature itself. As painting aims to represent things seen, let us note how in fact things are seen.

20. Ibid., 12.
21. Ibid., 19.
22. Ibid., 21.
23. Ibid., 24.

In the first place, when we look at a thing, we see it as an object which occupies space. The painter will draw around this space, and he will call this process of sketching the outline, appropriately, circumscription. Then, as we look, we discern how the several surfaces of the object seen are fitted together; the artist, when drawing these combinations of surfaces in their correct relationship, will properly call this composition. Finally, in looking we observe more clearly the colours of the surfaces; the representation in painting of this aspect, since it receives all its variations from light, will aptly here be termed the reception of light.[24]

Book II, then, is concerned with the representation on the picture plane of objects, which can be understood as a combination of surfaces, in accordance with the geometric principles outlined in Book I. But whereas the earlier discussion of vision is based on conventional ideas of optics, the scheme outlined here is different in one important respect. Alberti is now talking about the way in which someone looks at a solid body with a view to representing it; first he considers and draws the basic shape, for example the outline of a head, then he observes and draws the individual elements, such as the eyes, nose and mouth, then adds the modelling and colour. The link with Book I is made explicit in his discussion of circumscription, the establishment of the outlines of surfaces, for which he recommends the use of the *velum*, 'which among my friends I call the intersection ('intercisio')', a term already used extensively in Book I to refer to the picture-plane itself.[25] Alberti does not say how large the veil should be, but he illustrates its utility by the example of the human face. Its primary function, as it was later for Dürer, was evidently to ensure that the painter maintained a consistent viewpoint and especially to assist in foreshortening.[26] But this device could not be used for large surfaces, such as those of buildings or colossi. Here Alberti refers back to the discussion of the pavement in Book I, and to its use in the representation of large objects seen at a distance at the appropriate scale.[27]

Then he turns to composition, of which he writes:

Composition is the procedure in painting whereby the parts are composed together in the picture. The great work of the painter is not the colossus but the story, for there is far more merit in a story than in a colossus. Parts of the story are the bodies, part of the body is the member, and part of the member is the surface. The principal parts of the work are the surfaces, because from these come the members, from the members the bodies, from the bodies the story, and finally the finished work of the painter. From the composition of surfaces arises that elegant harmony and grace in bodies, which they call beauty. The face which has

24. Ibid., 30.
25. Ibid., 31; cf 13 ('picturam diximus esse intercisionem pyramidis').
26. Ibid., 31.
27. Ibid., 33.

some surfaces large and others small, some very prominent and others excessively receding and hollow, such as we see in the faces of old women, will be ugly to look at. But the face in which the surfaces are so joined together that pleasing lights pass gradually into agreeable shadows and there are no very sharp angles ('nullaeque angulorum asperitates extent'), we may rightly call a handsome and beautiful face.[28]

The term *historia*, which is here translated as story, is frequently left untranslated, as if it had no vernacular equivalent, or indeed was a novel concept invented by Alberti himself.[29] Yet he was not reticent about claiming originality for many of the points that he makes, and he generally took care to explain unfamiliar terms, but when he stated that 'the great work of the painter is the *historia*' he did neither of these things. The term was already applied to a painting by Pliny,[30] and in texts about painting throughout western Europe from late antiquity onwards pictures were regularly divided into two broad categories: stories, or representations of historical events, and images or figures, that is to say non-narrative representations of people.[31] There is nothing in *De pictura* to indicate that Alberti employed the word in a novel way. Indeed, it appears already in Book I, where he had explained that he would draw a rectangle on the surface to be painted, 'which I treat as an open window through which the *historia* is seen, and there I determine how large I want the figures in the painting to be'.[32] For Alberti the story was simply the normal context in which the painter would include several figures, arranged in a three-dimensional spatial setting; and his claim that it was the most challenging task for painter, more so than even a colossus, that is to say a very large *imago*, may have been entirely uncontroversial, at least among artists.

Baxandall sees in the final section of the definition of composition in paragraph 35, quoted above, a rather crude 'transfer to painting of the rhetorical notion *structura aspera* ... the disagreeable conjunction of two 'rough' consonants between the end of one word and the beginning of the next', and thinks that Alberti's remark 'is not easy to reconcile with experience'.[33] But the contrast that Alberti makes between the wrinkled, angular faces of old women, as they are typically represented

28. Ibid., 35.
29. K. Patz, 'Zum Begriff der "Historia" in L. B. Alberti's "De Pictura"', *Zeitschrift für Kunstgeschichte*, 49, 1986, pp. 269–87; J. M. Greenstein, 'Alberti on "Historia": A Renaissance View of the Structure of Significance in Narrative Painting', *Viator*, 21, 1990, pp. 273–99.
30. Pliny, *Historia naturalis*, XXXV, 139.
31. See especially Pope Adrian I to Charlemagne, in *Patrologia latina*, 98, cols 1285–7; also K. Keuck, 'Historia: Geschichte des Wortes und sein Bedeutungen in der Antike und in den romanischen Sprachen', Emsdetten, 1934, pp. 32–4, 81–5; J. Knape, '"Historie" in Mittelalter und früher Neuzeit: begriffs- und gattungsgeschichtliche Untersuchungen im interdiszlipinären Kontext', Baden-Baden, 1984, pp. 401–2; C. Hope, 'Altarpieces and the Requirements of Patrons', in *Christianity and the Renaissance*, ed. J. Henderson and T. Verdon, Syracuse, 1990, pp. 535–71.
32. Alberti, 'On Painting' (n. 10 above), 19.
33. Baxandall, *Giotto and the Orators* (n. 1 above), p. 132.

in Renaissance art, and the smoother and more regular features of young women, is scarcely strained. There is no need to see in this a laboured analogy with literary composition. In fact, there is little justification for regarding Alberti's discussion of composition here as somehow distinct from what comes before, in the way that Baxandall implies. From the very beginning of *De pictura* Alberti had stressed that the job of the artist was to represent the projection of surfaces on the intersection, taking into account how their appearance is modified by the position and lighting of the object depicted. In order to represent any object correctly, the painter needs to conceive it as a combination of surfaces, which he must then consider separately. Composition is the process of combining these individual surfaces, 'the principal parts of the work', into larger units, namely members, bodies and, in the case of stories, several bodies. Except in the case of stories, composition is a stage in the creation of the appearance of complex solids on the picture plane. The last section of Book II, concerning the reception of light, deals with the final stage in this process, and once again develops ideas anticipated in Book I.

Under each of the three main topics discussed in Book II, circumscription, composition and reception of light, Alberti also makes recommendations and draws attentions to possible faults. In other words, whereas Book I is devoted to the idea that a painting can be a representation of the world consistent with the laws of optics, in Book II aesthetic criteria are introduced for the first time. Thus under circumscription he advocates the use of the finest possible lines. From the composition of surfaces, as we have seen, 'arises that elegant harmony and grace in bodies, which they call beauty'; and here he warns against sharp transitions ('asperitates').[34] Then he turns to the composition of members, which above all should accord well with one another, so that 'in size, function, kind, colour and other similar respects they correspond to grace and beauty'.[35] Finally he discusses 'the composition of bodies, in which all the skill and merit of the painter lies'. In a story, the bodies, of course, should 'conform in size and function to the subject of the action'.[36] This advice is followed by a series of further recommendations about painted stories, in what is probably the best known section of the entire book. Here Alberti stresses the need for variety and abundance, but adds that 'I disapprove of those painters, who in their desire to appear rich or to leave no space empty, follow no system of composition, but scatter everything about in random confusion ('eo nullam sequuntur compositionem sed confuse et dissolute omnia disseminant; ivi non compositione ma dissoluta confusione disseminano') with the result that their story does not appear to be doing anything but merely to be in a turmoil'.[37] This passage, to which we will return in a moment, is the only place where Alberti makes

34. Alberti, 'On Painting' (n. 10 above), 35.
35. Ibid., 36.
36. Ibid., 39.
37. Ibid., 40.

a recommendation about the arrangement of the figures, but he goes on to remark that 'Perhaps the artist who seeks dignity above all in his story ought to represent very few figures'. He calls for variety in the attitudes and movements of the figures, which should be in keeping with their age and character, the observation of decency and modesty, and the clear representation of feelings by gesture and movement, adding that 'Everything the people in the painting do among themselves, or perform in relation to the spectators, must fit together to represent and explain the story'.[38] Finally under the heading of composition, Alberti moves on to the representation of the movement of drapery.

Then he discusses the reception of light, which includes colour as well as light and shade. The main emphasis, on the need for decorum, restraint and verisimilitude, echoes much that has come before; and although many of Alberti's comments are relevant to images, it is evident that here too he considers stories as better exemplifying what he has in mind. Thus when he talks of a combination of different colours, which 'will enhance the attractiveness of the painting by its variety, and its beauty by its comparisons', he takes as an example a story:

> Such grace will be present when colours are placed next to others with particular care; for, if you are painting Diana leading her band, it is appropriate for this nymph to be given green clothes, the one next to her white, and the next red, and another yellow, and the rest should be dressed successively in a variety of colours, in such a way that light colours are always next to dark ones of a different kind.'[39]

The third book, on the painter, is ostensibly about artistic training and the proper method of working. Interspersed in the text are various reminders about the need for selecting the best models, for following nature, for observing the correct fall of light, and so on: in short, a reiteration of the ideals discussed at greater length earlier in his text. Alberti thus had a clear notion of the qualities desirable in a painting, of which the most challenging type is a painted story, and these were expounded and amplified in the course of his book. The first and fundamental requirement was that the various elements in the painting should be in their correct relationship to one another, in accordance with their location in three-dimensional space, as outlined in Book I. But in the context of the representation of individual figures, and even more of stories, he introduces further ideas, generally related to notions of decorum, grace and the representation of emotions. Taken as a whole, *De pictura*, although written in the form of advice to artists, provides a whole series of criteria for judging paintings, which could readily have been used by any type of reader, and in particular by the humanists who seem to have constituted Alberti's intended audience.

Baxandall, as we have seen, regards composition, 'the way in which a painting can

38. Ibid., 42.
39. Ibid., 48.

be organized so that each plane surface and each object plays its part in the effect of the whole', as the most important of these criteria. But Alberti only uses the term with anything approaching this meaning on two occasions in the entire book. He does so first in his condemnation of painters who

> in their desire to appear rich or to leave no space empty, follow no system of composition, but scatter everything about in random confusion ('qui quo videri copiosi, quove nihil vacuum relictum volunt, eo nullam sequuntur compositionem sed confuse et dissolute omnia disseminant')'.[40]

He does so again in Book III, where he writes that 'When we are about to paint a story, we will always ponder at some length on the order and means by which the composition might best be done ('prius diutius excogitabimus quonam ordine et quibus modis eam componere pulcherrimum sit')',[41] and then recommends that the artist make sketches of the whole story and of the individual parts on paper. In the Italian text the reference to composition is omitted: 'prima fra noi molto penseremo qual modo et quale ordine in quella sia bellissima'. In the Latin version the *ordo* is the arrangement, which one achieves by composing, that is to say by combining the individual elements in a particular way. Given the lack of prominence given to these recommendations, it is difficult to believe that Alberti regarded them as particularly significant.

The principal quality that Alberti was demanding in paintings, whether stories or not, was a geometrically consistent representation of all the objects depicted. For any of his readers unfamiliar with recent Florentine art, such as Gianfrancesco Gonzaga, that must have been the most startling claim in the book. For here Alberti was introducing a novel and fundamental standard which all paintings, in his opinion, were supposed to meet. Composition, in his normal use of the term, was a part of the process by which the painter could achieve this goal. In modern usage composition is most commonly applied to the arrangement of the main elements within the picture, but for Alberti the stress is on the combination of very small elements to form larger ones, because the artist needs to break down each object into individual surfaces; and for him, too, the composition of a story is by definition a combination of bodies, but not, for example, of bodies, buildings, trees and landscapes. The fact that, in connection with stories, he extends the idea of composition to cover the expressive arrangement of bodies in stories does not make this the central thrust of his argument, and there is no reason to suppose that his readers would have understood it as such. The proper term for such an arrangement is *dispositio*, which is used in just this sense by Pliny;[42] but Alberti never uses it, suggesting that the concept was peripheral to the main purpose of his book.

40. Ibid., 40.
41. Ibid., 61.
42. Pliny, *Historia naturalis*, XXXV, 80; also Vitruvius, *De architectura*, I, ii, 2.

In the context of his discussion of composition, Baxandall also observes, as we have seen, that 'Alberti seems to be calling Italian painting back to some standard of narrative relevance, decorum and economy', and suggests that he was advocating the kind of narrative painting practiced by Giotto and Masaccio rather than Gentile and Pisanello. This is certainly true with regard to Masaccio, because he had used perspective more correctly and consistently than any painter before him. But whether Alberti would have classed Giotto with Masaccio, or would have preferred him to Gentile is altogether more questionable. Giotto was praised in *De pictura* specifically because each of the disciples in his *Navicella* in Rome showed 'such clear signs of his agitation in his face and entire body that their individual emotions are discernible in every one of them'.[43] Alberti surely chose this example not because of any particular analogy with the paintings of Masaccio, to which these remarks do not seem particularly apposite, but because they apply well to the *Navicella*, which had the added advantage, unlike most paintings at that period, of being a work that most his readers would have seen. As for Gentile, his paintings would seem more consistent than Giotto's with Alberti's statement that 'I would say a story was richly varied if it contained a properly arranged mixture of old men, youths, boys, matrons, maidens, children, domestic animals, dogs, birds, horses, sheep, buildings and provinces; and I would praise any great variety, providing it is appropriate to the subject'. It is true that he goes on to say that 'Perhaps the artist who seeks dignity above all in his story ought to represent very few figures', and, in the Latin text, that 'In my opinion there will be no story so rich in variety that nine or ten men cannot worthily perform it';[44] but Baxandall himself believes that this was probably just a learned humanist joke.[45] It would be unwarranted to conclude from these remarks that Alberti himself believed that artists ought always to aim for dignity in their stories, a quality that would hardly be appropriate to one of the subjects he mentions just before, of centaurs in an uproar at dinner. Nor, as we have seen, does Alberti extend the notion of composition to cover all the elements in a picture. In the context of the book as a whole, the comments that Baxandall reads as advocating the type of narrative painting favoured by Giotto rather than Gentile are not given much prominence, and they are unlikely to have been understood in that way at the time, because Baxandall's interpretation is based on a notion of composition which does not really correspond to Alberti's.

Baxandall has shown that in the section of *De pictura* about variety, of which an extract has been given in the previous paragraph, Alberti certainly did draw on the terminology of rhetorical criticism, comparing the approach of the painter of a story to that of the writer, in a way that was to become much more common in the

43. Alberti, 'On Painting' (n. 10 above), 42.
44. Ibid., 40.
45. Baxandall, *Giotto and the Orators* (n. 1 above), p. 133.

sixteenth century.[46] The application of the criteria of literary criticism to the discussion of works of visual arts, while not entirely new, is indeed one of the most influential aspects of the book. But, as we have seen, Alberti uses the concept of composition rather differently here from elsewhere in *De pictura*, and in this respect the emphasis of Baxandall's account seems misplaced. This raises the question of the relevance to Alberti's general approach of the technical meaning of *compositio* as 'the putting together of the single evolved sentence or period', to which Baxandall attaches such importance. The parallel he adduces between Isidore's definition of *compositio* – words go to make up phrases, phrases to make clauses, clauses to make sentences – and Alberti's statement that 'parts of the story are bodies, part of the body is the member, and part of the member is a surface' is certainly striking, even though Isidore starts with the smallest unit and Alberti, in his definition, with the largest, whereas in his analysis of the process of composition he too starts with the smallest.[47] But Alberti's notion of painting as a process involving the combination of small elements seems to spring not from his thinking about stories as 'the great work of the painter', but from his notion about the representation of the visible world on a plane surface, a process that involves first distinguishing the separate surfaces that make up any three-dimensional object and then outlining them separately. This initial stage is not present at all in literary composition. Even Baxandall concedes that Cicero used composition in a non-rhetorical sense in *De officiis*, where he defined the beauty of the body as a harmonious composition of members ('pulchritudo corporis apta compositione membrorum movet oculos');[48] he calls the body a composition of members again in *De natura deorum*.[49] If one wants a source for Alberti's notion of composition in texts familiar to humanists, these would seem perfectly adequate.

Given that Alberti took the term *historia* from post-classical discussions of art, both vernacular and Latin, it is worth looking in similar sources for parallels to his notion of composition. In fact, there is an obvious analogy in Cennino Cennini's *Libro dell'arte*, which was almost certainly written before *De Pictura*. At the beginning of his book Cennini, who frequently refers to stories and figures, writes of painting that: 'it deserves to be seated in the second rank of the sciences, and crowned with poetry. This is the reason: because the poet, with the knowledge that he has, is worthy and free to compose and bind together as he pleases, according to his will. Likewise the painter is given the liberty to compose a figure standing, seated, half-man and half-horse, as he pleases, according to his imagination.'[50] The

46. Ibid., pp. 134–8.
47. Ibid., pp. 130f.
48. Ibid., p. 130; *De officiis*, I. xxviii. 98.
49. I, xviii, 47.
50. Cap. I: 'La ragione è questa: che 'l poeta, con la scienza prima che ha, il fa degno e libero di potere comporre e legare insieme sì e no come gli piace, secondo sua volontà. Per lo simile al dipintore dato è libertà potere comporre una figura ritta, a sedere, mezzo uomo mezzo cavallo, sì come gli piace,

ultimate source here of course is the opening of Horace's *Ars poetica*, with its discussion of decorum; but the important thing is that Cennini uses the term *comporre* here in just the sense of Alberti's composition, as the process of creating a figure by the combination of individual elements. And he does so at least twice more in his book. In connection with fresco painting he writes, 'Then, according to the story or figure that you have to do, if the intonaco is dry, take the charcoal and draw and compose'.[51] Later, in his discussion of drawing on a panel, Cennini recommends attaching charcoal to some kind of rod, 'so that you can stand at a distance from the figure, because this is a great help in composing'.[52] It is striking that Cennini uses the phrase 'draw and compose' as if these were somehow distinct operations. Perhaps there is a parallel here with Alberti's circumscription and composition. Be that as it may, Alberti's definition of composition as 'that procedure in painting whereby the parts are composed together in a picture' seems, as far as one can judge, perfectly consistent with Cennini's use of the term. It is also consistent with pictorial practice at the time, to judge from surviving drawings of individual elements such as hands and heads, which could be reused in different contexts.

Cennini's text suggests that Alberti used the term composition because it was already current, even though he gave it a more specific meaning in his discussion of perspective. It remains to be seen whether this was taken up by later writers, or for that matter whether any of them used the term in the sense preferred by Baxandall. The word itself was certainly used by Cristoforo Landino, who admired Alberti and who may have read *De pictura*, in his famous account of the artists of Florence, published in 1481.[53] Here he says: 'Masaccio was an outstanding imitator of nature, "di gran rilievo universale, buono componitore et puro sanza ornato" ... Filippo Lippi was very good in *compositioni* and variety, in colouring, in relief and in all kinds of ornaments. Paolo Uccello was a "buono componitore et vario", a great master of animals and landscapes, while Gentile da Fabriano was excellent in "compositione di cose piccole".' It is not immediately clear from these extracts what Landino meant by composition, but this is clarified by his comment on Donatello, who is 'to be numbered among the ancients, marvellous in composition and in variety, lively and with great vivacity "o nell'ordine o nel situare delle figure", all of which appear to be moving'. Here 'composition' must refer to the creation of individual figures or, conceivably, of groups, as it appears to do in Cennini and, for

secondo sua fantasia.'

51. Cap. LXVII: 'Poi, secondo la storia o figura che de' fare, se lo intonaco è secco togli il carbone e disegna e componi e cogli bene ogni tuo' misura, battendo prima alcun filo, pigliando i mezzi degli spazzi.'

52. Cap. CXXII: 'Ma vuolsi legare il carbone a una cannuccia o ver bacchetta, acciò che stia di lungi dalla figura; ché molto ti giova in nel comporre.'

53. See Ottavio Morisani, 'Art Historians and Art Critics – III: Cristoforo Landino', *Burlington Magazine*, 95, 1953, pp. 267–70(270).

the most part, in Alberti, because it is distinguished from the praise of Donatello's vivacity 'nell'ordine o nel situare delle figure', the arrangement and placing of the figures, which corresponds more closely to our modern conception of composition. Incidentally, Landino's use of 'compositioni' in the plural, apparently referring to the groups of figures created by Filippo Lippi, is new. As we shall see, it seems to be equivalent to Vasari's 'componimenti'.

The other fifteenth-century occurrences of 'composition' can all be understood as referring to the ability to create figures of a particularly admirable kind. This applies, for example, to Ghiberti's praise of Ambrogio Lorenzetti as a 'nobilissimo componitore'.[54] And this is surely why Giovanni Santi singles out the sculptor Andrea Bregno as 'sì gran componitore';[55] it can hardly have been for his skill at composing stories. Leonardo, like Landino, does at least have some concept corresponding to the modern usage of composition, but he too uses different words for it, explaining that in judging a picture: 'You should first consider if the figures have the relief which is required by the site and the lighting that illuminates them. … Secondly that "il seminamento over compartizione delle figure sien compartite secondo il caso nel qual tu vòi che sia essa storia".'[56] Here Leonardo's 'seminamento over compartizione delle figure' corresponds to Landino's 'ordine e situare delle figure', and to Alberti's 'ordo'; and these figures are to be arranged according to the requirements of the narrative.

So much for the fifteenth century. We must now move on to Vasari, since there is so little written on painting in the first half of the sixteenth century; and the main writer, Pino, simply follows Alberti. Various terms related to the word composition appear in Vasari's *Lives*, and these need to be examined individually, first in the context of the 1550 edition and then of the much expanded text published in 1568. We may start with *componimento* and *componimenti*. There are a number of references to architectural *componimenti*, meaning combinations of architectural elements, a usage that goes back to Vitruvius. In painting the term seems to have a quite specific significance, and refers to combinations of figures, as in 'the stoning of St Stephen "con bel componimento di figure"'[57] or 'certain Saints, who around our Lady "fanno bellissimo componimento et ornamento grande"'.[58] But individual pictures can contain more than one *componimento*. Thus among the works of Gozzoli, the *Flood* in the Camposanto at Pisa is said to be 'espressa con bellissimi componimenti e copiosità di figure e con ogni bello ornamento'.[59] Of Ghiberti's

54. *Commentario secondo*, para. 11.

55. G. Santi, *La vita e le gesta di Federico di Montefeltro Duca d'Urbino*, ed. L. Michini Tucci, 2 vols, Città del Vaticano, 1985, II, p. 675.

56. J. P. Richter, *The Literary Works of Leonardo da Vinci*, London, 1883, I, no. 554.

57. G. Vasari, *Le Vite de' più eccellenti pittori scultori e architettori nelle redazioni del 1550 e 1568*, ed. R. Bettarini and P. Barocchi, Florence, 1966–87, II, p. 100.

58. Ibid., II, p. 194.

59. Ibid., III, p. 377.

first doors we read: 'E nel vero i componimenti di ciascuna storia sono tanto ordinati e bene spartiti' that Ghiberti deserved great praise;[60] and of Sarto's *Birth of the Virgin*: 'he showed the Nativity of Our Lady, where one sees "un componimento di figure ben misurate" in a room, representing certain godmothers or relatives who are coming to visit the woman at her confinement, wearing the kind of clothes that they wore at that time; and in addition he showed at the fire the women who are washing Our Lady.'[61] The group of visitors forms a single *componimento*. Then there is an account of the *School of Athens*, of which it is said: 'il componimento di tutta la storia, che certo è spartito tanto con ordine e misura che egli mostrò veramente un saggio di sé'. The text continues: 'Adornò ancora questa opera di una prospettiva e di molte figure'.[62] In other words the 'componimento di tutta la storia' is the principal figure group. Finally, in a passage about drawings, sketches (*schizzi*) are defined as a preliminary type of drawing whose purpose is to establish 'il modo delle attitudini et il primo componimento dell'opra'.[63] *Attitudini* are poses, the *componimento* the figure group.

The term *composizione* is used much less often in the *Lives* than *componimento*. It seems to mean virtually the same thing, and in the same way can also be used for a combination of architectural elements. But there is also a reference to a painting by Ambrogio Lorenzetti, 'nel quale dipinse e finì una storia con nuova e bella composizione'.[64] This is standard, and in this case may simply be a rephrasing of Ghiberti's praise of Ambrogio as a 'nobilissimo componitore'; but in the *Life* of Mino da Fiesole we find the remark that 'even if one chooses the best parts of things [by other masters], one cannot make a 'composizion' di corpo' so perfect that art surpasses nature'.[65] This is the pure fifteenth-century sense of composition, the putting together of a single body.

In Vasari's *Lives*, then, *componimento*, and, more rarely, *composizione*, refers to individual figures or to groups of figures. This is consistent with fifteenth-century usage. But it will be recalled that Landino praised Donatello not just for his excellence 'in compositione et in varietà', but also for his vivacity 'nell'ordine o nel situare delle figure'. In the *Lives* too there are occasional references to the placing of figures, as in the remark that Ambrogio Lorenzetti was 'inventore molto considerato nel comporre e situare in istoria le sue figure'.[66] But the passage is an isolated one. There is very little about the overall design of a picture, or even about the relationship of figures to their setting. A notable exception, however, appears

60. Ibid., III, p. 87.
61. Ibid., IV, p. 352.
62. Ibid., IV, p. 167.
63. Ibid., I, p. 117.
64. Ibid., II, p. 180.
65. Ibid., III, p. 406.
66. Ibid., II, p. 179.

in the technical introduction, where painting is defined as a plane covered with areas of colours, on the surface of a panel or wall or canvas, around various outlines, which by virtue of a good drawing of rounded lines surround the figure.[67] In other words, the main and indeed essential element of the picture is the figure. That this passage recalls *De pictura* so closely is not surprising, given that the introduction was probably written by Cosimo Bartoli, who, as the translator of *De re aedificatoria*, had almost certainly read *De pictura*, which he was later to translate as well.[68] We are then told that the painter should make this plane bright in the middle, but dark in the background and at the edges, these areas being united by an intermediate zone of middle tones. The different tones should be copied by the painter from a cartoon or some other kind of drawing made for that purpose; and 'this should be made with a good collocation and with design based on judgement and invention, since collocation is nothing else in a painting than having arranged things in that place where one makes a figure so that spaces conform to the judgement of eye and are not deformed, so that the field is full in one part and empty in another'.[69]

Whether or not this passage was written by Vasari or Bartoli is of no great importance in this context. What matters is that the word collocation only appears once more in the entire book, concerning the arrangement of frescoes in a cycle, not the composition. It does show that someone in Vasari's circle did think in some way about the organization of the picture plane, in terms of a particular balance of bright and dark, and about the arrangements of elements within the picture space.

67. Ibid., I, p. 113: 'La pittura è un piano coperto di campi di colori, in superficie o di tavola o di muro o di tela, intorno a diversi lineamenti, i quali per virtù di un buon disegno di linee girate circondano la figura.'

68. The style and vocabulary of the introduction is very different from that of many individual Lives, especially the short ones, which have the best claim to be the work of Vasari himself. It is probably no accident that the introduction includes the rare term *disegnatoio* (ibid., I, p. 117), which Bartoli used in his translation of *De re aedificatoria* (Florence, 1550, p. 92). On Bartoli's role in the preparation of the *Vite*, see C. Hope, 'Can You Trust Vasari?', *New York Review of Books*, 5 October 1995, pp. 10–13.

69. Vasari, *Le Vite* (n. 57 above), I, pp. 113f: 'Questo sì fatto piano, dal pittore con retto giudizio mantenuto nel mez[z]o chiaro e negli estremi e ne' fondi scuro et accompagnato tra questi e quello da colore mez[z]ano tra il chiaro e lo scuro, fa che, unendosi insieme questi tre campi, tutto quello che è tra l'uno lineamento e l'alt[r]o si rilieva et apparisce tondo e spiccato. Bene è vero che questi tre campi non possono bastare ad ogni cosa minutamente, attesoché egli è necessario dividere qualunche di loro almeno in due spezie, faccendo di quel chiaro due mez[z]i e di quello scuro due più chiari, e di quel mez[z]o due altri mez[z]i che pendino l'uno nel più chiaro e l'altro nel più scuro. Quando queste tinte d'un color solo, qualunche egli si sia, saranno stemperate, si vedrà a poco a poco cominciare il chiaro e poi meno chiaro e poi un poco più scuro, di maniera ch'a poco a poco troverremo il nero schietto. Fatte dunque le mestiche, cioè il mescolare insieme questi colori, volendo lavorare o a olio o a tempera o in fresco, si va coprendo il lineamento e mettendo a' suoi luoghi i chiari e gli scuri et i mez[z]i e gli abbagliati de' mez[z]i e de' lumi, che sono quelle tinte mescolate de' tre primi, chiaro, mez[z]ano e scuro; i quali chiari, mez[z]ani e scuri et abbagliati si cavano dal cartone overo altro disegno che per tal cosa è fatto per porlo in opra; il qual è necessario che sia condotto con buona collocazione e disegno fondato e con giudizio et invenzione, atteschoé la collocazione non è altro nella pittura che avere spartito in quel loco dove si fa una figura, che gli spazii siano concordi al giudizio de l'o[c]chio e non siano disformi, ch'il campo sia in un luogo pieno e ne l'altro vòto ...'.

But he did not use the word composition at this point; and it should by now be evident that composition, in its modern sense, was not something to which writers on art in the Renaissance devoted much attention.

In Vasari's second edition we find terms like *compositione* and *componimento* most often paired with stories, rather than with figures. But in virtually every case a close examination of the context makes it clear that composition still refers to figure groups. Thus when we are told of the St Francis cycle at Assisi, which is attributed to Giotto, that in that work one sees 'gran varietà non solamente nei gesti et attitudini di ciascuna figura, ma nella composizione ancora di tutte le storie', this means that the invididuals are varied, and so are the groupings.[70] Again, when we read of Pontormo's *Deposition* in Santa Felicita, that 'the *componimento* of this altarpiece is very different from the figures of the vault',[71] this does not mean that the composition of the altarpiece, in our sense, is different from that of the pictures on the ceiling, showing the Evangelists, but that the figures are very different in character. I have not found any instance in the second edition where terms like composition are more readily applicable to an entire picture than to the figures alone. The nearest approach comes in the description of paintings executed for Michelangelo's funeral; but this section of the *Vite* was copied almost verbatim from an an anonymous pamphlet of 1564.[72] It is not typical of the rest of the *Lives*.

In the second edition, incidentally, there are also references to the *disposizione* of figures in a story, a case in point being the Apostles in Giotto's *Navicella*, of which we read: 'in it, besides the *disegno*, there is the *disposizione* of the Apostles who in different ways are struggling on account of the storm.'[73] In a famous passage about the utility of drawing, in the Life of Titian, it is said of Giorgione that 'he did not realise that it is necessary for someone who wants to arrange his compositions well ('a chi vuol bene disporre i componimenti') and to accommodate his inventions, first to put them on paper in several different ways, to see how the whole thing turns out.'[74] In other words, the writer was aware of the need to arrange ('disporre') the *componimenti* of a picture. But he did not see it as obviously problematic or, with very few exceptions, as worthy of comment. If we want to find a modern equivalent to composition, in fact, we should probably look at the use of the word *disposizione*; but that virtually never appears before Vasari, and it is used in the *Vite* no more than four times in the modern sense of composition, and then only in the second edition.[75] It is used in this way more frequently by Raffaello Borghini[76] and

70. Ibid., II, p. 100.

71. Ibid., V, p. 323.

72. See especially ibid., VI, p. 136; and R. and M. Wittkower, *The Divine Michelangelo. The Florentine Academy's Homage on his Death in 1564*, London, 1964, p. 111.

73. Vasari (n. 57 above), II, p. 306.

74. Ibid., VI, p. 155.

75. Ibid., II, pp. 106, 144, 266; III, p. 640.

76. Raffaello Borghini, *Il Riposo*, Florence, 1584, p. 52.

Lomazzo;[77] but it is not clear that even for them it achieved the central importance that composition has today.

It would seem that the modern conception or conceptions of composition became fully established surprisingly late. At any rate, even in Filippo Baldinucci's *Vocabolario toscano dell'arte del disegno*, published in 1681, *composizione* is defined as 'Accozzamento, e mescolanza di cose' (the assembly and combining of things).[78] In Italian dictionaries the unambiguous use of the term *composizione* in the modern sense, in connection with painting, does not appear until the eighteenth century, in Milizia and Algarotti.[79] A possible reason for the late emergence of our notion of composition is that it is intimately related to the idea that the painter typically creates pictures that occupy the whole of a framed and usually rectangular surface. That may be the norm from the sixteenth century onwards, although there are countless exceptions in schemes of frescoed decoration; but it was certainly not so in the fourteenth century. At that time one of the main jobs of artists was to paint figures on areas of gold ground of many different shapes; and their education and working practice encouraged them to see composition as a process of creating those figures by combining subordinate parts. On the evidence currently available, we cannot say whether Alberti was the first to use composition also of the process of combining figures into groups, particularly in narrative paintings, but this sense of the term seems to come to the fore in the sixteenth century. It is the primary sense of composition in Vasari's *Vite*. The process of arranging such groups, as well as other elements of a story such as buildings, to create a coherent whole, which would now be called composition, was scarcely discussed by writers from Cennini and Alberti to Vasari. When they wrote about composition, they normally meant something rather different and more restrictive.

77. G. P. Lomazzo, *Idea del tempio della pittura*, Milan, 1590, in idem, *Scritti sulle arti*, ed. R. P. Ciardi, I, Florence, 1973, p. 295. See also F. Baldinucci, *Vocabulario toscano dell'arte del disegno*, Florence, 1681, p. 52.
78. Ibid., p. 38.
79. S. Battaglia, *Grande dizionario della lingua italiana*, III, Turin, 1964, p. 422.

Imagining and Composing Stories in the Renaissance

François Quiviger

This paper explores the cultural background of the sixteenth-century definition of pictorial composition as a figure or a group of figures acting a narrative rather than an arrangement of forms and colours determined by the confines of the surface as we might think of it today.[1] For this purpose the first section of what follows examines the immediate antecedent of this approach in Christian methods of meditation practised from the thirteenth well into the seventeenth century. In the second part a comparison will be drawn between the conception of the figure in devotional and art literature. The final section examines Agnolo Bronzino's *Capitolo del pennello*, a burlesque poem describing the mind of an artist improvising various figural compositions. Thus through texts from three distinct literary traditions – religious, artistic and burlesque – I propose to examine the methods of imagining human bodies which inform Renaissance compositional practices.[2]

* * *

Most Renaissance art theorists claim that a painting is fully conceived in the mind of the artist before its manual transcription and re-elaboration on to the canvas or panel.[3] By the late seventeenth century this idea had become a commonplace of European art theory.[4] These testimonies reflect the emphasis which painters placed on the intellectual character of their profession, as a means of distancing themselves from other craftsmen and of claiming higher social status and salaries.[5] The idea that composing a picture is primarily an activity of the mind, however rhetorical,

1. I am grateful to Charles Hope, Elizabeth McGrath, Carol Plazzotta and Paul Taylor for their advice and criticism.

2. For the Renaissance definition of composition as construction and arrangement of figures see in this volume Charles Hope's 'Composition from Cennini to Vasari'.

3. See L. Gauricus, *De arte sculptoria*, ed. A. Chastel, R. Klein, Genève, 1969, p. 65; Paolo Pino, *Dialogo di Pittura* in *Trattati d'arte del Cinquecento fra Manierismo e Controriforma*, ed. P. Barocchi, Bari, 1962, I, p. 107 '... la ragione è ch'uno pittore non può nell'arte nostra produrre effetto alcuno della sua imaginativa, se prima quella, così imaginata, non vien dagli altri sensi intrinseci ridotta al conspetto dell' idea con quella integrità ch'ella s'ha da produrre, tal che l'intelletto l'intende perfettamente in sé stesso … onde noi pittore siamo intelligenti nell'arte nostra teoricamente senza l'operare' p. 107; R. Alberti, *Trattato della nobiltà della pittura*, Rome, 1585, pp. 14 ff., G. P. Lomazzo, *Trattato dell'arte della pittura, scoltura e architettura*, in *Scritti d'arte*, ed. P. Ciardi, Florence, 1973, p. 416: '...innanzi a tutte le cose solevano concipere nella sua idea la forma di qualunque cosa si proponevano di fare e, prima che si ponessero a voler disegnare, tutta benissimo vederla con la imaginazione.'

4. See in this volume Colette Nativel's contribution, and note 24 for further references, see also Thomas Puttfarken's contribution.

5. See M. Warnke, *The Court Artist, on the Ancestry of the Modern Artist*, tr. D. McLintock, Cambridge, 1992, pp. 34 ff.

corresponds to one important function assigned to imagination by medieval and Renaissance faculty psychology: that of composing intelligible images out of scattered sensory data. Moreover, the practice of mentally organizing one or several figures acting a specific scene with due regard to anatomy, proportion, gender, age and social status pertains not only to painting but also to a common religious practice, the so-called spiritual exercises.

The term 'spiritual exercise' derives from Saint Paul's *Second Epistle to Timothy* 4, 7–8 ('Exerce autem teipsum ad pietatem').[6] From the twelfth century onwards, it refers to monastic activities related to prayer: reading, meditation, oraison and contemplation.[7] These do not always involve images but the increasing emphasis on the humanity of Christ in late medieval piety promoted exercises of mental visualization of the Gospel's narrative as a prelude to meditation proper.

Such spiritual exercises were broadcast to lay and monastic audiences in manuals such as Iohannes de Caulibus's *Meditatio vitae Christi* (late thirteenth century), Heinrich Suso's *Horologium sapientiae* (1334) or Ludolph of Saxony's *Vita Christi* (c. 1374). This literature pursued its active life throughout the age of printing. The *Meditatio vitae Christi*, for instance, was published fifty-two times in Italy alone between 1465 and 1550.[8] Such a production suggests not only the survival of medieval classics as Renaissance best-sellers, it also indicates the con-tinuity of medieval methods of imagining and praying well into the Cinquecento.

Similar remarks apply to Loyola's *Spiritual Exercises* (Rome, 1541), diffused throughout Europe and Asia and America as a result of the missionary zeal of the Jesuit order, and heavily reliant on medieval spirituality.[9] Furthermore, the sixteenth century witnessed the spread of the most common and popular spiritual exercise: the cult of the rosary, which involved the mental visualization of fifteen episodes, or mysteries, from the life of Christ and the Virgin.[10]

Although such texts addressed different aspects of spiritual life, and promoted different methods of worshipping, they have one thing in common: they taught their readers to compose mental images of Gospel scenes, to the point of imagining themselves present as witnesses. Since these exercises, like painting, relied on the extensive use of mental images it is important to examine the ways in which they

6. See P. Debongnie, C. Schmerber, 'Exercices spirituels' in *Dictionnaire de spiritualité ascétique et mystique*, Paris, 1937–95, 4, pp. 1902–49.

7. Ibid, p. 1908.

8. See A. J. Schutte, *Printed Italian Vernacular Religious Books 1465–1550: a Finding List*, Genève, 1983, pp. 100–104; for a full list of the editions of the *Meditaciones* see M. Stalling-Taney, *Meditaciones de passione Christi olim sancto Bonaventura attributae*, Washington, 1965, pp. 3ff.

9. The history and diffusion of the *Exercises* has been monitored by Ignacio Iparraguire, *Practica de los ejercicios espirituales de San Ignacio de Loyola*, 3 vols, Bilbao, Rome, 1948–73.

10. On the cult of the Rosary see A. Winston Allen, *Stories of the Rose, the Making of the Rosary in the Middle Ages*, University Park PA., 1997 and A. Duval, 'Rosaire' in *Dictionnaire de spiritualité* (n. 6 above) 13, pp. 939–79 and R. J. M. Olson, 'The Rosary and its Iconography' part I & II, *Arte Cristiana*, 86, 1998, pp. 263–76.

were defined and described.

According to medieval and Renaissance faculty psychology, no knowledge is possible without sensation.[11] The common sense, located in the front ventricle of the brain receives the information provided by the five external senses. The *phantasia* retains this sensory data and passes it to the imagination located in the middle ventricle of the brain.[12] From there it takes the form of intelligible images which the intellect can examine and eventually store in the memory, placed in the back ventricle of the brain. To quote Giambattista Gelli's *Capricci del bottaio* (Florence, 1547), a popularizing text, imagination is the book through which the intellect can acquire knowledge of the outside world.[13]

This account of perception and cognition implies that mental images were perceived as compounds of sensations rather than simple visual entities.[14] In this context the function of imagination is not only to present intelligible images to the intellect, but also to compose such images from scattered incoming sensory data. Thus, in the most basic sixteenth-century Aristotelianism the imagination is a faculty which composes. Gregor Reisch's encyclopedia, the *Margarita philosophica* (1495), widely known in several European languages throughout the sixteenth century is unequivocal on this matter:

– What is the function of imagination
– It composes various images of the species … received by the common sense.[15]

Spiritual exercises focused on the Passion exploited the receptiveness of the mind to sensory impressions. Furthermore, as mental images are compounds of sensory impressions they are particularly useful for imagining the Passion. Christ's

11. See K. Park, 'The Organic Soul', in *The Cambridge History of Renaissance Philosophy*, Cambridge, 1988, p. 470 and P. Cranefield, 'On the Origins of the Phrase *Nihil est in intellectu quod non prius fuerit in sensu*', *Journal of the History of Medecine*, 25, 1970, pp. 77–80.

12. On the frequent confusion between *Phantasia* and imagination see E. Garin, '*Phantasia* e *imaginatio* fra Marsilio Ficino e Pietro Pomponazzi', in *Phantasia-imaginatio* (V° Colloquio internazionale, Rome, 1986), ed. M. Fattori, M. Bianchi, Rome, 1988, pp. 3–20(9).

13. G. B. Gelli, *I capricci del bottaio* , ed. I. Sanesi, Florence, 1952, p. 147: 'Ma perchè in quell'instante medesimo ch'ella è creata l'anima nostra si ritrova rinchiusa in questo nostro corpo sensibile non può già mai acquistare cognizione alcuna per altro modo che per quello de le cose sensibili, aiutata non di manco da i sensi esteriori, conoscitivi di quelle, per i quali passando, le loro forme si imprimono ne i sensi esteriori, o, per meglio dire, si scrivono sì nella fantasia e sì nella memoria, come in un libro, dove leggendo poi l'intelletto perviene a la cognizione delle cose intelligibili'.

14. See Aristotle, *De somniis*, 458b and *De anima* 425a.

15. For a good resumé see G. Reich, *Margarita filosofica*, tr. G. P. Gallucci, Venice, 1600 (first ed. Freiburg, 1495), p. 616: 'Quale è l'operatione della potenza fantastica? Maest. – Ella compone diverse imagini delle specie … le quali sono ricevute dal senso comune …' . In the field of art literature see also G. Comanini, *Il Figino ovvero della Fine della Pittura* … in *Trattati d'arte del Cinquecento* (n. 3 above), 3, p. 270 for whom the function of the *virtù fantastica* is '… ricevere le specie apportate dagli esteriori sensi al senso commune, e di ritinerle, et ancora di comporle insieme …' For a full survey of the main sources regarding imagination and art theory see Colette Nativel's commentary to F. Junius, *De pictura veterum*, Genève, 1996, pp. 453–80.

humanity necessarily required a human sensory system without which the Passion would have been painless and therefore meaningless. Indeed, according to Jacobus de Voragine's *Golden Legend*, Christ had the most sensitive body, and suffered intensely through his five senses.[16]

Mental visualization of the Passion narrative amounted to imagining a figure endowed with a sensory system experiencing overwhelming pain, pain which in itself was believed eminently meaningful. The *Meditationes vitae Christi* provide countless examples of this approach. The author, Iohannes de Caulibus, introduces the book as: '… a few meditations according to imag-ined representations, which the soul can comprehend differently, according to how they happened and how they can be credible in a holy manner'.[17]

Each chapter invites the reader to imagine episodes from the life of Christ as the starting point for meditation on an appropriate theme. The Nativity, for example, inspires reflections on poverty, the Baptism of Christ on humility, while the forty day retreat in the desert induces a sermon on fasting and prayer.

Iohannes does not give any suggestions as to the arrangement of the protagonists of a story, although he emphasizes that the reader must imagine himself present at every scene. His prescriptions for visualizing the figure of Christ, however, are far more precise. He proposes, for instance, two appropriate ways of considering the nailing on the Cross. In the first case the Cross is erected and Christ's two arms and his feet stretched as far as possible and nailed. In the second case the nailing takes place with the Cross lying on the ground while the executioners pull Christ's arms as far as possible to either side, to ensure that the body's disposition follows the symmetry of the Cross. The reader may apprehend the scene through either version, whichever conjures up more vividly the pain caused by the brutal stretching of the limbs.[18] In other words the text directs the reader to imagine a figure

16. *The Golden Legend or lives of the Saints*, tr. William Caxton, London, 1900, LII, p. 68. The theme pervades meditational manuals and accounts of meditation see e.g. Iohannis de Cavlibvs, *Meditaciones vite Christi olim S. Bonaventura attributae*, ed. M. Stallings-Stacey, Turnhoult, 1997, VIII, 25 ff, à propos of the circumsicion: 'Ploravit ergo puer Iesus hodie propter dolorem quem sensit in carne sua; nam veram carnem et passibilem habuit, sicut ceteris homines'. See also Angela da Foligno, *Libro utile e devoto nel quale si contiene la conversione, penitentia, tentatione, dottrina, visioni e divine consolationi della beata Angela da Foligni novamente tradutto de latino in volgare* , Genoa, 1536, XLIXv: 'Fu anchora quel dolore più intenso per la nobilita, e delicatezza d'esso corpo virgineo qual fu più nobile d'ogni altro corpo di donna nato, e pero più sentiva e piu era afflito dal predetto dolore.'

17. English translation from *Meditations on the Life of Christ*, ed. and tr. I. Ragusa and R. B. Green, Princeton, 1961, p. 49. Iohannis de Cavlibvs, *Meditaciones* … (n. 16 above), IX, 41–3, p. 41: 'Ego enim in hoc et in aliis uite Christi actibus intendo ut in primo tibi dixi, aliquas meditaciones quas anima diuersimode percipere potest, secundum quod gesta fuerunt per ipsum, uel sic fuisse pie credi possunt.' See also the Prologue, 94f, p. 10, which refers to meditations '…secumdum quasdam imaginarias representaciones quas animus diuersimode percipit.'

18. Ibid. LXXVIII, 47–51, p. 272: 'Quod di hoc magis placet, conspice qualiter ipsum capiunt despicabiliter sicut ribaldum vilissimum et prosternunt super crucem in terra furibunde, brachia ipsius accipientes et post violentam extensionem cruci figentes. Similiter et de pedibus factum intuere quos

stretched in the shape of a cross, both visually, but above all in terms of extreme muscular tension.

Although it is impossible to ascertain how the laity practised such methods, mystical literature provides a vivid model of meditation, itself broadcast through print, and in which the sensitization of the mental image of Christ reaches peaks of intensity.

In her visions the Umbrian mystic Angela da Foligno (1248–1309) compares Christ on the Cross to a stretched skin and imagines the shape and size of the nails in order to apprehend the extent of the wounds they caused.[19] When reaching the descent from the Cross she considers the stretched skin and dislocated bones of Christ's dead body.[20] Like Jacobus de Voragine she emphasizes its tenderness and perfect sensitivity and contemplates how Christ could sharply apprehend every moment of the forthcoming Passion.[21] Such awareness could only occur through Christ's foreknowledge of the Passion, which he represented through his own imagination. It was not, of course, Angela's purpose to comment on Christ's faculties, but these are precisely the terms in which the philosopher Giovanni Pico della Mirandola discussed the Agony in the Garden in his *De imaginatione* of 1500. Christ's anguish came from his imagination affected by the senses. At the same time, however he rejoiced by considering the redemptive purpose of the Passion,

> … for we are of the opinion that in Christ there was more joy than grief at his death, since his sense and imagination were excelled by his reason and intellect, and since by reason and intellect he perceived that through his death mankind was being redeemed' and in doing so 'he freely loosed the reins of grief from the sensory part and the imaginative faculty', thus placing his imagination under the control of reason rather of the senses.[22]

In a very similar way worshippers were taught to grieve on the pain undergone by Christ, using the sensory resources of their own imagination, before considering

traxerunt quantum valuerunt.'

19. Angela da Foligno, *Libro utile* (n. 16 above), f. Lr: '… essi chiodi teribeli, con li quali lo afiseno in la croxe. Essi presero li chiodi grosisimi, scabroxi, quadrati e oribeli, e de li chiodi de cotal forma rexultò pena sopramexura…' and she adds 'Il peso e la grandezza d'tutto il corpo pendeua sopra le mani & sopra I pedi era sostentato accio che piu sentisse la duritia delli chioui e mandasse il sangue, senza intermissione dalle piaghe d'essi chiodi e cosi morisse in grandissimo dolore.'

20. Ibid., f. Clr: 'Apparue anchora nelle gionture tanta dissolutione dalli nervi per le crudeli distrattioni delle estensione fatta sopra la croce che le ossa pareva laxate l'uno dall'altro dal debito loco.' See also Castello's *Rosario della Gloriosa Vergine*, Venice, 1541 (first edn 1521) f. 136r.

21. Angela da Foligno, *Libro utile* (n. 16 above) on Christ's foreknowledge of the Passion see: f. xliv: 'Commincio subito a sentire il sommo dolore: sapendo, vedendo, considerando e intendendo universalmente e singularmente tutte le pene le quali essa anima con la soa carne doueua prouare et per noi sopportare.'

22. G. Pico della Mirandola, *On the Imagination*, ed. H. Caplan, London, 1930, ch. X, p. 70: '…plus enim in Christo laetitiae quam doloris de sua morte fuisse opinamur, quandoquidem sensui et imaginationi ratio et intellectus praevaluit, qua percipiebat et redimi per eam genus humanum'.

general themes such as divine love, redemption, poverty or humility.

In this context mystics merely practised with greater intensity methods recommended in smaller doses to lay audiences.[23] Indeed the theme of the nailing also features in the visualization of the Passion promoted by the cult of the rosary. A popular handbook, like Alberto da Castello *Rosario della gloriosa Vergine Maria*, called to the mind of readers many other tactile details, not present in the Gospel, such as the 6666 blows received during the flagellation, the long sharp thorns of the crown which penetrated Christ's head as far as his brain or the removal of his tunic, shortly before the nailing on the Cross, which caused the tearing of strips of his skin which had stuck to the cloth with clotted blood.[24] The mental image produced is that of a figure whose contours and tactile volume are defined by the many wounds covering the skin.

Since medieval times this type of imaginative visualization constituted the prelude to meditation proper. Loyola's *Spiritual Exercises*, published in 1540 and regularly thereafter, and heavily reliant on medieval spirituality, even provided instructions on how to visualize stories through each of the five senses and called this method 'composition of place'.[25] The term itself reflects the current sixteenth-century conception of imagination as a faculty which organizes sensory data into mental images.

Such compositions are by no means easy to achieve, but images, and especially paintings, were deemed helpful. This is confirmed by the Directory of the *Spiritual Exercises* of 1588, a manual aimed at those monitoring their daily practice. Here the composition of place is compared to the reminiscence of paintings:

> many are those who experience great difficulty and spend considerable energy on the composition of place: those who are found less able at this are advised to remember mentally the painted stories which they saw on altarpieces and in other places such as, for instance, pictures of the Last Judgement, of the Passion ... [26]

23. See for instance Camilla Battista Varana's (1458–1524) recommendation to preachers: 'Nella fine della vostra santa predicazione feste una cordiale exortazione al populo per inducere le anime loro al pianto e memoria della passione di Cristo, pregando omniuno che almanco almanco el venardì se recordasse de questa passione de Cristo e buttare una lacremuccia sola sola per memoria de quella.' in *Scrittrici mistiche italiane*, ed. G. Pozzi, C. Leonardi, Genova, 1988, p. 308.

24. Alberto Da Castello, *Rosario della gloriosa vergine Maria*, Venice, 1541 (first. edn 1521), ff. 112r; 115–6r, 136r. The episode also features in the *Meditaciones Vitae Christi* (n. 17 above), p. 270 (LXXVIII, 10–12).

25. See Ignatius of Loyola, *Exercitia spiritualia*, ed. I. Calveras, C. De Dalmases, *Monumenta Ignatiana, series secunda*, Rome, 1969, I, paragraphs 65–70 for the contemplation of Hell; paragraphs 122–5 for the contemplation of the Incarnation and the Nativity. The term used in all the versions is *compositio loci*. The antecedents of Loyola's method are retraced down to Saint Bernard by J. Maréchal, 'Application des sens' in *Dictionnaire de spiritualité* (n. 6 above), I, pp. 810–28, esp. 823–4.

26. *Directoria Exercitorum spiritualium (1540–1590)*, ed. I. Iparraguirre S.J., Rome, 1955, p. 449: 'Porro quia multi in compositione loci multum laborant, et vim magnam capiti inferunt, moneantur, qui minus ad eam apti comperiantur, ut revocent sibi in mentem historiam aliquam pictam, quam aliquando

The European diffusion of devotional literature and practices run uninterrupted from the Middle Ages well into the Baroque period. Its reliance on real and mental images suggests a parallel between the art of imagining Biblical scenes for the purpose of meditation, and the art of imagining for the purpose of producing images which would in turn serve as aids to meditation.

The first text to discuss at some length how images should be conceived from the artist's point of view is Leon Battista Alberti's *Della pittura* of 1435. Written in Latin and Italian, *Della pittura* is a pedagogical handbook comparable to Quintilian's *Istitutio oratoria*, and is usually hailed by scholarship as the first modern art treatise and as a manifesto of the humanistic theory of art.[27]

In fact Alberti relies on ancient sources. The only paintings he mentions, with the exception of Giotto's *Navicella* to which he briefly refers in connection with the representation of emotions, are lost classical works.[28] Nevertheless, the hub of Alberti's ideas, the concept of *historia* belongs to the medieval vocabulary of painting. There it designates narrative art, sacred or profane. The term appears frequently in religious art to distinguish narrative compositions from single figures. Furthermore, it features prominently in Gregory the Great's eleventh letter, the most influential and quoted text regarding the function of images.

Alberti's assertion that pictures are as intelligible and pleasurable to the learned as the unlearned echoes the Gregorian view of painting as the book of the unlearned.[29] His emphasis on the importance and beneficial use of images in promoting religion,[30] their power to keep the memory of the dead alive, their power to inspire imitation of virtuous men and to arouse in the viewer the emotions which they represent is clearly reminiscent of the didactic, mnemonic and inspirational function assigned to images by the Church.[31]

Alberti likewise treads the familiar humanist path of reconciling Pagan and Christian cultures. Since no Classical treatise on painting had survived, he could

in altaribus, vel aliis locis viderint: ut verbi gratia picturam iudicii vel inferni; item passionis Christi etc...' On the place of images in the Exercises see P. A. Fabre, 'Les Exercices spirituels sont-ils illustrables?' in *Les Jésuites à l'âge baroque*, ed. L. Giard, Paris, 1996, pp. 197–210.

27. See D. R. Wright, 'Alberti *De Pictura*: its Literary Structure and Purpose', *Journal of the Warburg and Courtauld Institutes*, 47, 1984, pp. 52–71 esp. p. 59. See M. Baxandall, *Giotto and the Orators*, Oxford, 1971, pp. 121–39 and H. Damisch 'Comporre la pittura' in *Leon Battista Allberti* ed. J. Rykwert and A. Engel, Milan, 1994, pp. 186–95. For a full review of Alberti see C. Hope's article in this volume.

28. L. B. Alberti, *Della pittura* in *Opere volgari*, ed. C. Grayson, Bari, 1973, 3, p. 74.

29. Ibid., p. 50: ' I prencipi e i plebei e i dotti e gl'indotti si dilettavano di pittura ...'; and later he adds: '... benchè intervenga che questa arte così sta grata ai dotti quanto agl'indotti, qual cosa poco accade in qual altra si sia arte, che quello qual diletti ai periti muova chi sia imperito.'

30. Ibid., p. 44: 'E che la pittura tenga espressi gli iddii quali siamo adorati dalle genti, questo certo fu sempre grandissimo dono ai mortali, però che la pittura molto così giova a quella pietà per la quale siamo congiunti agli iddii, insieme e a tenere gli animi nostri pieni di religione.'

31. The tripartite function of images goes back to the Byzantine period. For its Western re-formulation see J. Wirth, 'Structure e fonction de l'image chez saint Thomas d'Aquin', in *L'image. Fonctions et usages des images dans l'Occident médiéval*, ed. J. Baschet, J. C. Schmitt, Paris, 1996, p. 51.

assemble a mosaic of Latin and Greek quotations to set up a secular theory of art fully compatible with the Catholic doctrine of images and meditational practices. This implies that, transposed to sacred subjects, the type of painting Alberti advocated could suitably sustain the practice of spiritual exercises. Thus his definition of painting, in Book 1, as a cross-section of the visual pyramid – in other words as an illusory reconstitution of visual and spatial perceptions – is entirely in tune with the frequent exhortations of devotional literature that the reader imagine himself present at every scene on which he intends to meditate.[32] Alberti's remarks on the composition of figures offer further kinship between image making and spiritual exercises.

According to Alberti, painters must conceive their figures layer by layer beginning with the skeleton, subsequently covering it with appropriate musculature, skin and clothes to reveal the anatomy, gender, age and social status of the person depicted.[33] Thus, as in the meditations on the Passion, the figure is imagined as a three-dimensional entity, of bones, muscles and skin endowed with sensory, emotional and rational faculties.

In spite of the modest influence of Alberti's *Della pittura*, these views on the composition of figures enjoyed a considerable following, eventually resulting in the introduction of anatomy into the artistic curriculum.[34] Several sixteenth-century artists adopted this method. Leonardo, Vasari, Pino, Francisco da Hollanda, Cellini, Danti, Allori, Armenini and Lomazzo all recommended it.[35]

While there is nothing in Alberti to which a Counter-Reformation critic would have objected, the direction and development of his ideas on the figure were later to inspire very severe criticism.

By the mid-sixteenth century the figure was considered not only the main element of pictorial composition but also the focal point of art appreciation and the display of artistic skill. In his *Dialogo di pittura* of 1548 the Venetian painter Paolo Pino even recommended his colleagues to include in their works:

… at least one figure, all mysterious and contorted, so that through it you will be

32. Alberti, *Della pittura* (n. 28 above), p. 28: 'Sarà adunque la pittura non altro che inter-segazione della piramida visiva …'.

33. Ibid. p. 62.

34. Alberti is the first author to recommend anatomy. See M. Kornell, *Artists and the Study of Anatomy*, PhD, University of London,1992. Esp. Chapter 1.

35. See Leonardo, *The Literary Works of Leonardo da Vinci*, tr. and ed. J. P. Richter, Oxford, 1939, I, 489; P. Pino, *Dialogo di pittura* (n. 3 above), pp. 128–9; Vasari, see infra n. 41. F. De Hollanda, *Da pintura antigua*, ed. J. Vasconcellos, Porto,1918, pp. 85–6, 106–9; G. B. Armenini, *De' i veri precetti della pittura*, Ravenna, 1586, ed. M. Gorreri, Turin, 1988, p. 68; B. Cellini, *Sopra i principi e'l modo d'imparare l'arte del disegno*, *Opere*, ed. B. Maier, Milan, 1968. pp. 871 ff; V. Danti, *Trattato delle perfette proporzioni*, in *Trattati d'arte* (n. 3 above), 2, pp. 211–2; A. Allori, *Le regole del disegno*, in *Scritti d'arte del Cinquecento*, ed. P. Barrocchi, Milan–Naples, 1973, p. 1949, (discussed in Kornell, *Artists and the Study of Anatomy* [n. 35 above], p. 171); Lomazzo, *Trattato dell'arte della pittura* (n. 3 above), 1, p. 276 .

known as a good painter by those who understand the perfection of this art.[36]

Many mid-sixteenth century paintings contain such artistic demonstrations. Their presence as much as their appreciation, suggest an increasing distance between formal and narrative aspects of painting of which Alberti would have undoubtedly disapproved.[37]

The mid-sixteenth-century debate on the merits of painting and sculpture also echoes this art of imagining. Sculptors pointed out that their figures were conceived from several viewpoints to emphasize the intellectual difficulty of their art. One response, attributed by Vasari to Giorgione, claimed the same, if not more for painting: a good story shows 'in una sola occhiata tutte le sorti delle vedute che pùo fare in più gesti un uomo ...'[38]

It seems significant that when Vasari found himself unable to understand the stories depicted in the fresco decoration of the Fondaco de' Tedeschi he concluded that Giorgione had simply wanted to display his skill:

> and so Giorgione put his hand to the work, but thought of nothing save of making figures according to his own fancy, in order to display his art, so that in truth, there are no scenes to be found there with any order, or representing the deeds of any distinguished person, either ancient or modern.[39]

Vasari's introduction to the *Vite* suggests that the training of artists centred on mastering the human figures in order to compose any story. The invention of figures in various positions had almost become a discipline in itself, based on the copying of ancient and modern works of art as well as the nude:

> ... the best thing is to draw men and women from the nude and thus fix in the memory by constant exercise, the muscles of the torso, back, legs, arms and knees, and the bone underneath. Then one may be sure that through much study attitudes in any position can be drawn by help of the imagination without one's having the living forms in view. Again, having seen bodies dissected one knows how the bones lie, and the muscles and sinews, and all the order and conditions of anatomy. so that it is possible with greater security and more correctness to

36. P. Pino, *Dialogo di pittura* (n. 3 above), p. 115: '...e in tutte l'opere vostre fateli intervenire almeno una figura tutta sforciata, misteriosa e difficile, acciò che per quella voi siate notato valente da chi intenda la perfezzion dell'arte.'

37. See Alberti, *Della pittura* (n. 28 above), p. 76: 'Truovasi chi esprimendo movimenti troppo arditi, e in una medesima figura facendo che a un tratto si vede il petto e le reni, cosa impossibile e non condicente, credono essere lodati... e per questo in loro figure fanno parerle schermidori e istrioni senza alcuna degnità di pittura, onde non solo sono senza grazia e dolcezza, ma più ancora mostrano l'ingegno dell'artefice troppo fervente e furioso.'

38. Vasari, *Le vite de' più eccellenti pittori, scultori e architettori nelle redazioni del 1550 e 1568*, ed. R. Bettarini, P. Barocchi, Florence, 1976, 4, p. 46.

39. Ibid, p. 44: 'Giorgione, non pensò se non a farvi figure a sua fantasia per mostrar l'arte, ché nel vero non si ritrova storie che abbino ordine o che rappresentino i fatti di nessuna persona segnalata, o antica o moderna.' English quotation from De Vere's translation, London, 1912–14, 4, p. 112.

place the limbs and arrange the muscles of the body in the figures we draw.[40]

Thus, in sixteenth-century terms, a strictly pictorial composition would unfold as a set of variations on the human figure increasingly indifferent to narrative justification. Very few pictures fit this description, although it can safely be assumed that an influential work such as the *Battle of Cascina* was primarily perceived as a figural composition rather than as the expression of a Florentine military victory over the Pisans. These are precisely the terms in which Vasari refers to the cartoon.[41]

This increasing separation between narrative and pictorial readings could threaten clarity and inspired very severe criticism. Lack of clarity in religious painting was indeed one of the arguments against images raised by northern Reformers. In the Italian context this matter constitutes one of the main themes of Giovan Andrea Gilio's *Dialogo degli errori e degli abusi de' pittori circa l'istorie* (Camerino, 1564) who thus passed on to painters responsibility for Reformist criticism of images:

> When Modern painters have to execute some work their first concern is to twist the head, arms and legs of their figures so that it can be said that they are contorted, and these contortions are often such that it would be far better if they were absent and they have little or nothing to do with the subject of the story.[42]

This point, one of the main theme of the dialogue, only confirms that by the middle of the sixteenth century pictorial imagination had begun to depart from narrative imagination and produced images which no longer fulfilled the didactic requirements of religious art.

* * *

How, then, did sixteenth-century painters compose their works? We may never know precisely, but a burlesque poem by Agnolo Bronzino, the *Capitolo del pennello*,

40. Vasari, *Le vite* (n. 38 above), 1, p. 115: 'Ma sopra tutto, il meglio è gl'ignudi degli uomini vivi e femine, e da quelli avere preso in memoria per lo continovo uso i muscoli del torso, delle schiene, delle gambe, delle braccia, delle ginocchia e l'ossa di sotto, e poi avere sicurtà per lo molto studio che senza avere i naturali inanzi si possa formare di fantasia da sé attitudini per ogni verso...' English translation from *Vasari on Technique...* tr. L. S. Maclehose, London, 1907, p. 210.
41. Vasari, *Le vite* (n. 38 above), 6, pp. 23 f. See. also Vasari's letter to Aretino in *Lettere pittoriche*, ed. Bottari-Ticozzi, Milan, 1822, 3, p. 32: '...ho fatta una zuffa d'ignudi, che combattono, per mostrare prima lo studio dell'arte, e per osservar poi la storia...'.
42. G. A. Gilio, *Dialogo degli errori e degli abusi de' pittori circa l'istorie*, in *Trattati d'arte ...* (n. 3 above): 'I moderni pittori, quando a fare hanno qualche opera, il primo loro intento è di torcere a le loro figure il capo, le braccia o le gambe, acciò si dica che sono sforzate, e quei sforzi a le volte sonotali che meglio sarebbe che non fussero, et al soggetto de l'istoria poco o nulla attendono'. See also Ambrogio Catarino, *De cultu et adoratione imaginum*, Rome, 1552, p. 144: 'Alias autem e contrarió tanta arte compositas, ut quibusdam importunis gestibus interim personarum decorem non servent, nihil gravitatis habentes, nihil devotionis excitantes'.

offers a rare insight into an artist's mind at work.

The text appeared in Florence in 1538, and again in 1542, in an anthology of poems by Giovanni della Casa and others.[43] It begins with an imaginary picture of two nude figures: 'These last few days I saw a fine portrait of a man and a woman; they were naked depicted together in a pleasant act'.[44]

Bronzino notices that the picture contains everything which nature and study can bestow, and endeavours to praise the brush which executed the image. For this purpose he conveys the reader to witness the painterly art of imagining figures in a wide variety of positions:

One is depicted on a bed or adopts a tiring position, upward or seated; one holds something in his hand the other has it hidden; one wants to be seen behind someone else; another wants to be depicted in front; one holds himself, another seems to be falling.

… I myself would not know how to recount the thousand and one extravagant gestures and modes; you should know that variety pleases everyone. Suffice to say that to do it from the front or the back, sideways, in foreshortening or in perspective, the brush can be used for every purpose. [45]

Scholars have identified Pietro Aretino's *Modi* as the source of Bronzino's *Capitolo*. Published in 1525 these sixteen sonnets expanded on engravings by Marcantonio Raimondi after designs by Giulio Romano representing various positions of love-making.[46] Although some of the positions coincide with those suggested by Bronzino, *I modi* constitute more of a parallel than a source. Both

43. *Le terze rime di messer Giovanni della Casa di messer Bino e d'altri*, s. l., 1542. On Bronzino's poetic activity see D. Parker, 'Towards a Reading of Bronzino's Burlesque Poetry', *Renaissance Quarterly*, 50, 1997, pp. 1011–44.

44. Agnolo Bronzino, *Rime in Burla*, ed. F. Petrucci Nardelli, Rome, 1988, p. 23:
Io vidi a questi giorni un buon ritratto
d'un uomo e d'una donna: erano ignudi
dipinti insieme in un piacevol atto

45. hi si ritrae sul letto o faticose
attitudine fa, ritto o a sedere;
chi tien qualcosa in mano, chi l'ha nascose;
chi si vuol dietro ad un altro vedere;
chi vuol essere dipinto innanzi ad uno;
chi s'attien; chi fa vista di cadere.
Io non saprei contarne de'mille uno
de'diversi atti e modi stravaganti;
sapete che il variar piace ad ognuno.
Basta che a fargli o dirietro o davanti,
a traverso, in iscorcio o in prospettiva
s'adopera il pennello a tutti quanti

46. See R. Gaston, 'Love's Sweet Poison: a New Reading of Bronzino's London Allegory', *I Tatti studies*, 4, pp. 247–88, p. 271. On *I modi* see P. Aretino, *I modi*, ed. L. Lawner, Milan, 1984, and B. Talvacchia, *Taking Positions. On the Erotic in Renaissance Culture*, Princeton, 1999.

Bronzino and Giulio demonstrate their ability to devise multiple compositions out of two figures. For this purpose they merely applied criteria of variety and abundance already recommended in Alberti's *Della pittura*: 'In every story variety is always pleasant. First of all a painting in which there are bodies in many very dissimilar poses is always especially pleasing.'[47]

* * *

Is it, then, possible to set both Bronzino's *Capitolo* and Alberti's *Della pittura* within the context of the training of the imagination promoted by meditational literature? The Catholic doctrine of images is concerned with function rather than style; and indeed, over the centuries, images as different as medieval and Baroque altarpieces have fittingly fulfilled its requirements. Thus, its links with Renaissance artistic culture are perhaps best understood in terms of divergence rather than convergence. From the twelfth century onwards the increasing significance of Christ as an incarnated and suffering God prompted meditational exercises which could adequately be represented by images. The emphasis on the human figure, so characteristic of Cinquecento art theory, seems initially congruent with this approach in which images are primarily suitable as aids to prayer and meditation.

Alberti's recommendation on the construction of figures in terms of bones, muscles, and skin may well echo the practices of imagining Christ in terms of dislocated bones, stretched muscles and bruised skin. These same sensory attributes – bones, muscle and skin – are equally essential to access the erotic universe of Bronzino's *Capitolo* .

It was, however, this emphasis on the figure which eventually brought about a conflict between painters and ecclesiastical writers. These writers perceived the display of pictorial skill as potentially threatening to the didactic, mnemonic and inspirational requirements of religious art.

Thus the close associations between concrete and mental images in Renaissance art theory and religious education helped shape a conception of what is purely pictorial in painting. For the sixteenth century the composition of human figures was considered the best means of displaying artistic skill and imagination and rested upon a relationship of equivalence between painted and mental images.

Félibien's canonical definition of the genres, in the preface of the *Conférences de l'Académie royale* of 1668, echoes Renaissance associations between painting and the mind. The hierarchy of the genres – still life, landscape, portrait, sacred and profane

47. Alberti, *Della pittura* (n. 28 above), pp. 68–70: 'Ma in ogni storia la varietà sempre fu ioconda, e in prima sempre fu grata quella pittura in quale sieno corpi con suoi posari molto dissimili.' Bronzino's *Capitolo* is in fact a pastiche of Alberti's text and suggests that it circulated in Florentine circles before the apparition of the book in print. On variety and abundance as stylistic ideals see T. Cave, *The cornucopian text*, Oxford, 1979, pp. 3–34.

history and allegory – follows not only the hierarchy of things, from inanimate objects to human beings, but also the hierarchy of the faculties involved in representation. At the bottom, still life involves only the mechanical reproduction of perception; at the apex, however, history painting requires the artist to conceive and organize in his mind entire compositions of figures making full use of all the faculties of the mind. Such an exemplary synthesis of Renaissance ideas does not, however, reflect artistic practices.[48] Nicolas Poussin, who incarnated Félibien's ideals, composed not only in his mind, but also in boxes, which he used as theatrical sets in which he placed and moved figurines. In the previous century painters traditionally associated with Florentine art theory, such as Pontormo or Bronzino, sometimes reworked entire compositions, not only in their mind but also directly on the panel – as technical examinations have recently revealed.[49] Such discrepancies between art theory and artistic practice suggest a gap between what viewers expected to discover in paintings – the representation of a great mind processing mental images – and the means by which artists manufactured this ideal.

48. A. Félibien, *Les Conférences de l'Académie royale de peinture et de sculpture au XVIIe siècle*, ed. A. Mérot, Paris, 1996, p. 50: 'La représentation qui se fait d'un corps en traçant simplement des lignes ou en mettant des couleurs est considérée comme un travail mécanique; c'est pourquoi comme dans cet art il y a différents ouvriers qui s'appliquent à différents sujets, il est constant qu'à mesure qu'ils s'occupent aux choses les plus difficiles et les plus nobles, ils sortent de ce qu'il y a de plus bas et de plus commun et s'anoblissent par un travail plus illustre.'
49. See C. Plazzotta, L. Keith, 'Bronzino's 'Allegory': New Evidence of the Artist's Revis-ions', *The Burlington Magazine*, 161, 1999, pp. 89–99.

Baroque Piles and Other Decompositions

Philip Sohm

Tommaso Stigliani, ruthless critic of Giambattista Marino, merged the artist's studio and butcher's shop in order to criticize related deformities of painting and poetry in the early Seicento:

> And one can certify the same for painting [as for poetry], even though it appears that there are several talented artists today. However painting has absolutely lost its way once again and being composed only by practice, instead of knowledge, lacking the Albertis, Buonarrotis and Raphaels in Flanders as much as in Italy. The aggregate whole [of painting today] is thus that which, composing with indistinct and indeterminate parts, can be at once diminished and increased or changed without any consideration. It remains always what it was, that is, an imperfect mass ... which was a perfect whole and will become an aggregate if it is to be cut by a butcher into tiny pieces and confusedly arranged into a pile on his board.[1]

Stigliani wrote metaphorically and hyperbolically in condemning painting that was 'cut by a butcher into tiny pieces and confusedly arranged into a pile,' indulging in an inflammatory language that made the *Occhiale* one of the most frequently rebutted books of seventeenth-century literary criticism.[2] The chopped-up pile of

1. T. Stigliani, *Dello occhiale. Opera difensiva in risposta al Cavalier Gio. Battista Marini*, Venice, 1627, pp. 29–30: 'È testificalo similmente la pittura, la quale, se ben pare, ch'oggidì abbia pur qualche valente artefice: hà però perduta affatto ancor'ella la sua scienza, ed essene rimasa colla sola prattica, essendole mancati, così in Fiandra, come in Italia, gli Alberti, i Bonarroti, e i Raffaelli. It tutto aggregato è poi quello, che componendosi di parti indistinte, ed indeterminate, può essere, e scemato, ed accresciuto, e mutato senza riguardo alcuno, che sempre rimane quel, ch'era, cioè una mole imperfetta ... il quale era un tutto integrale, se sarà dal beccaio tagliato in minuti pezzi ed ammassato confusamente in un mucchio sù la sua panca, diverrà un tutto aggregato.' As an example of 'il tutto aggregato' in architecture, Stigliani cites the Vatican compared to 'il tutto integrale' of the Palazzo Farnese. For the context of Stigliani's criticism of Marino, see O. Besomi, 'Tommaso Stigliani: tra parodia e critica', *Studi secenteschi*, 13, 1972, pp. 5–118. For Stigliani's circle of friends, see M. Menghini, *Tommaso Stigliani*, Gênes, 1890 (still the most complete biography). Virginio Cesarini, who had taken Stigliani under his protection in 1621 and is thought to have urged him to write the *Occhiale*, might have been the poet memorialized in Poussin's *Inspiration of the Poet* (Paris, Louvre): M. Fumaroli, *L'École du silence. Le sentiment des images au XVIIe siècle*, Paris, 1994, pp. 108–12.

2. For responses to the *Occhiale*, see G. B. Marino, *La Murtoleide fischiate con La Marineide risate del Murtola*, Spira, 1629; G. A. Barbazza, *Le strigliate a Tomaso Stigliano del Sig. Robusto Pogommega*, Spira, 1629; G. Aleandro, *Difesa dell'Adone ... per risposta all'Occhiale del Stigliani*, Venice, 1629; S. Errico, *L'Occhiale appannato; dialogo, nel quale si difende l'Adone del cavalier Gio. Battista Marino, contro l'Occhiale del cavalier fra Tomaso Stigliano*, Naples, 1629; N. Villani, *Considerazioni di Messer Fagiano sopra la seconda parte dell'Occhiale del cavaliere Stigliano, contro allo Adone del Marino e sopra la seconda difesa di Girolamo Aleandri*, Venice, 1631; A. Aprosio, *La Sferza poetica di Sapricio Saprici. Per risposta alla prima censura dell'Adone del cavalier Marino, fatta dal cavalier Tommaso Stigliani*, Venice, 1643.

meat that stands in for contemporary painting is likened to Marino's epic poem *Adone*, which he described in similar terms as 'that pile of cut-up members'.[3] This latter metaphor refers to the fragmented ('spezzata') episodic structure of the *Adone* that lacks any Aristotelian unity of plot.[4] Because Aristotle thought that epic poetry should be 'a living body', critics of failed composition found the metaphor of dismemberment to be particularly effective.[5] The nature of Stigliani's pictorial analogy may be imprecise, where poetry's plot and painting's composition are taken as equivalents by virtue of lexicography ('comporre') and where the 'beginning, middle and end' of a plot can be translated as 'the head, bust and tail' of a figure.[6] Equally imprecise is the kind of painting or group of painters that he would identify with chopped-up compositions, although, by situating contemporary painting in a larger cycle of renaissance and decline, it does seem that he had particular styles in mind.

Various kinds of piles could have inspired Stigliani's comments: thronged crowds of figures entangled with each other; stacked or serried crowds; conspicuously criss-crossed or truncated figures; figures cut by tenebrist lighting. In other words, 'pile' need not mean just a teeming heap of figures but any kind of fragmented or chopped up composition where the organic coherence and individuality of figures is lost in favour of discontinuous parts. Seicento painters who could be pilers on occasion range from Federico Zuccaro or Giuseppe Cesari d'Arpino to Luca Giordano or Francesco Solimena. Because this essay focuses on the early critical reception of cut or piled compositions, the diversity of pictorial practice can only be addressed selectively. For the moment just one example will be mentioned: Valentin de Boulogne's *Martyrdom of Saints Processus and Martinianus* (Rome, Pinacoteca Vaticana: Fig. 1). Started in 1628 and unveiled in St Peter's one year later along with Poussin's *Martyrdom of St Erasmus*, Valentin's altarpiece quickly achieved considerable fame. Completed about two years after the *Occhiale* it cannot be the object of Stigliani's ire, but it does represent a popular type of tenebrist painting that inspired his invective. Also its enthusiastic endorse-ment by the public represents a division in artistic taste that will be discussed in a later section. The public, a notoriously unreliable judge of art according to most critics, acclaimed Valentin's altarpiece to be better than Poussin's in a judgement reminiscent of an

3. Stigliani, *Occhiale* (n. 1 above), p. 31.

4. For a discussion of these issues in the *Occhiale*, see O. Besomi, *Esplorazioni secenteschi*, Padua, 1975, pp. 210–44.

5. Aristotle, *Poetics* 1459 a 20; C. Pellegrino, *Il Carrafa, o vero della epica poesia*, Florence, 1584; in *Trattati di poetica e retorica del cinquecento*, III, ed. B. Weinberg, Bari, 1970, p. 317: 'Perciò che dovendo egli [Ariosto], sì come richiede la perfezione dell'epopea, da una sola azione formare un sol corpo, il quale (come vuole Aristotele) sia tale che possa comprendersi in una sol vista, in iscambio di ciò formò un mostro di più corpi e di diverse membra non ordinate … .' Discussed by Besomi, *Espolorazioni* (n. 4 above), pp. 240–41.

6. Stigliani, *Occhiale* (n. 1 above), pp. 21–33.

earlier infatuation with Caravaggio.[7] *The Martyrdom of Saints Processus and Martinianus* certainly qualifies as a chopped-up composition with its sharp light and starkly overlapped figures dissecting it into parts. Light slices across the figures, catching a knee while leaving the calf in shadow and creating unexpected pockets of space. Discomforting concealments are created by shadows: a black silhouette of the staff severs a soldier's nose; the executioners' faces, largely hidden from view or obscured in shadows, become anonymous instruments of torture. Valentin is a tenebrist cutter.

The violence of the style and subject suggests one reason why Stigliani pathologized this practice in terms of butchering. I refer to pathology here not just in the general sense of an abnormality or malfunction of a (purportedly) superior system, but in the medical and psychological sense of examining diseased bodies or minds for forensic purposes. Critics pathologized piles and chopped compositions in terms of disease and decay: as sardines rotting in a barrel, maggoty walnuts or body parts strewn on a butcher's block.[8] What is being diagnosed is the decayed spiritual state of contemporary culture. Piles functioned effectively as symptoms of a 'decadent' culture, to use Agostino Taja's term, because they called to mind popular biological models for historical change. Painting and sculpture 'like human bodies, are born, grow up, become old and die,' to recall Vasari's famous simile, or in Giulio Mancini's adaptation they move from 'childhood' and 'adolescence' to 'senility' and 'decrepitude'.[9] Thus piles and tenebrism, when presented as a loss of corporeal integrity, indicated the demise of composition as 'a living body' and served as signifying forms of moral degeneration and cultural decline. Piles and tenebrism, then, may be considered as aberrant versions of more famous (and more

7. For the reception of Valentin's altarpiece, see J. von Sandrart, *Academia Picturae Eruditae*, Nüremberg, 1683, p. 368: 'Juxta supradictam Valentini tabulam, ipse quoque tabulam pingebat aliam in templo D. Petri de S. Erasmo … . Cumque opus Valentini jam collocatum esset, et hoc, suo tempore etiam apponeretur, magna inter spectatores oriebatur judiciorum diversitas, quod alii hoc, alii illud praeferre niterentur: cum veri Artis periti utrumque potius maximi aestimarent, et neutrum alteri praeferendum judicarent.' For Caravaggio's popularity with the public, see G. Baglione, *Le Vite de' pittori, scultori et architetti dal Pontificato di Gregorio XIII del 1572 fino a' tempi di Papa Urbana VIII nel 1642*, Rome, 1642, pp. 137 and 139: ' … da popolani ne fu fatto estremo schiamazzo … . [E] più si pagavano le sue teste, che l'altrui historie, tanto importa l'avra popolare, che non giudica con gli occhi, ma guarda con l'orecchie'.

8. M. Boschini, *Carta del navegar pitoresco*, Venice, 1660; edition cited: ed. A. Palluchini, Venice–Rome, 1966, p. 377: 'L'istorie tute insieme è sì confuse,/ Che a prima vista no se puol con l'ochio/ Distinguer de chi sia brazo o zenochio:/ Infin l'è mercancia de nose buse./ Certo tante sardele int'un baril/ Non è così stivae, così a redosso.' Usually, however, Boschini wanted entwined, groping figures and disliked excessive clarity which anatomized figures into 'heads, arms, knees, legs and feet' by attending too much to details; see, for example, p. 376: 'I fa le cose a parte, a tochi, a pezzi,/ Teste, brazzi, zenochi, gambe e pie,/ Né mai quele figure resta unie.'

9. G. Vasari, *Le Vite de' più eccellenti pittori scultori e architettori*, ed. R. Bettarini and P. Barocchi, II, Florence, 1967, p. 31: 'come i corpi umani, hanno [painting and sculpture] il nascere, il crescere, lo invecchiare ed il morire'. G. Mancini, *Considerazioni sulla pittura*, eds A. Marucchi and L. Salerno, I, Rome, 1957, pp. 103–6 and 295–307.

laudable) signifying forms, such as *sfumato* and the *figura serpentinata*, that have been canonized in modern art history as emblematic of an age and mentality.

This essay is divided into five parts. The first involves definitions: the survival of Alberti's *compositio* in the seventeenth century, Baldinucci's dictionary entry for *composizione*, and the semantic wandering of *componimento*. The following parts indicate how these definitions found practical applications in Seicento criticism: 2) the difficulties faced by critics who wanted to describe a pile of figures; 3) piles as signatures of a decadent or late period style, either Mannerist or Baroque; 4) chopped compositions as an underdeveloped or pre-compositional stage of an artist; and 5) tenebrism as a nonfigural means of chopping up compositions and as an ethically defective style of trickery and deceit.

COMPOSITION DEFINED

In the *Vocabolario toscano dell'arte del disegno*, the first ever art dictionary, Baldinucci defined composition ('composizione') as 'a combination and mix of things'.[10] For a term so central to art, and so precisely applied in a long post-Albertian tradition, it seems odd that Baldinucci chose such a vague and uninflected definition. It is atypically brief and gives no indication of its applicability to art. An easy explanation would be simply to note that Baldinucci repeated the definition in the *Vocabolario degli Accademici della Crusca*.[11] He did this with other terms, particularly those surrounding composition, but only occasionally and normally for terms peripheral to critical discourse. His intention in writing the *Vocabolario* was to correct and expand the Crusca dictionary, not to extract and transcribe those parts of interest to artists. He envisioned his as a challenge to the terms of reference of the Crusca *Vocabolario*, terms that specifically excluded trade or professional terminology, and, judging by the third edition of 1691 that included many of Baldinucci's emendations, it was a successful challenge.[12] He wanted to write 'una proprijssima definizione', that is, proper to art, and to define words as artists used them. Admittedly, as a kind of studio vocabulary, 'composition' falls short of his goal; yet we should assume that he exercised a choice in accepting the Crusca definition. To defer explanation of 'composition' by simply identifying its source does not resolve the acceptance of its seeming banality. Something in it must have struck him as suitable, and what that might have been can be glimpsed within the lexical nexus of

10. F. Baldinucci, *Vocabolario Toscano dell'arte del disegno*, Florence, 1681, p. 38: 'Composizione. Accozzamento e mescolanza di cose.' *Accozzamento* can refer to figures or colours or both; see, for example, Galileo, *Opere scelte*, ed. F. Flora, Milan-Naples, 1953, p. 468: 'Il pittore da i semplici colori diversi, separatamente posti sopra la tavolozza, va, con l'accozzare un poco di questo con un poco di quello e di qull'altro, figurando umoni, piante, fabbriche, uccelli, pesci.'

11. *Vocabolario degli Accademici della Crusca*, Florence, 1612, p. 202.

12. F. Baldinucci, 'L'Autore a chi legge', in *Vocabolario* (n. 10 above), n.p.; S. Parodi, 'Nota critica', in reprint of Baldinucci, *Vocabolario toscano dell'arte del disegno*, Florence, n.d., pp. i–xxxiii; Edward Goldberg, *After Vasari. History, Art, and Patronage in Late Medici Florence*, Princeton, 1988, pp. 110–13.

his *Vocabolario*.

Mescolanza and *accozzamento*, the mixing and combining of his definition, have a semantic undertone that endows composition with elements of disorder. By choosing *mescolanza* as a synonym for composition, Baldinucci recruited associations of confusion and disorder. For the definition of *mescolare*, he appends a neutral description ('to place different things together') to a more allusive and provocative synonym, *confondere* ('to mix up').[13] The polysemous *confondere* is an instructive model for interpreting *composizione*. While it is defined tautologically by reference to *mescolare*, it is also more explicit about its chaotic nature and the notional state that mixing produces: 'To mix different materials together, without distinction and without order, to dissipate, liquify and melt. To convince others with reasons [but] make it remain confusing.'[14] In other words *confondere*, like our expression 'mixed up,' can be value-free (as in: 'the paints are mixed') or narrowly judgmental (confusion). What seems unavoidable from these definitions is that there is something disorienting and chaotic about combining different things. As confirmation, Baldinucci's entry for confusion (*confuso*) should also be noted since it refers back to mixing and confoundment, with the first creating the second.[15] Baldinucci did not define *accozzamento*, but its application by Savonarola and Galileo as a muddled heap and unwholesome combination of different things is consistent with one of its meanings.[16] One more related definition should be mentioned: *gruppo*. William Aglionby defined *gruppo* (left in the Italian) as 'a knot of Figures together' in his 'Explanation of Some Terms of the Art of Painting'.[17] Baldinucci's '*gruppo*' is more dubiously rendered as a tangle, pile or heap ('viluppo, mucchio').[18] It is a compositional form where the artist loses control over his figures, or at least seems to. Antonio Aliense's *Brazen Serpent* (Venice, Chiesa di Angelo Raffaele: Fig. 2) is an example of 'a mass of men and serpents grouped together'.[19]

13. Baldinucci used the Crusca definition, see *Vocabolario* (n. 11 above), p. 525.

14. Baldinucci, *Vocabolario* (n. 10 above), p. 38; using the Crusca definition in *Vocabolario* (n. 11 above), p. 209: 'Mescolare insieme varie materie, senza distinzione, e senz'ordine, per istruggere, liquefare, e fondere. Per convincere altrui con ragioni, far rimaner confuso.'

15. Baldinucci, *Vocabolario* (n. 10 above), p. 38: 'Confuso. da confondere, mescolato in maniera, che più non si riconosca.'

16. G. Savonarola, *Prediche sopra Ruth e Michea*, ed. V. Romano, Rome, 1962, p. 69: 'Quello altro filosofo diceva che erano nel mondo di molti capi e gambe, mani e braccia, e accozzavonsi insieme e facevano gli animali, e tutti si generavono a caso secondo la figura di quelli membri, e però alcuni erano monstri, alcuni in una figura, alcuni in un'altra.' Galileo, as quoted in E. Panofsky, *Galileo as a Critic of the Arts*, The Hague, 1964, p. 18: '[P]erché, essendo le tarsie un accozzamento di legnetti di diversi colori, con i quali non possono già mai accoppiarsi e unirsi così dolcemente che non restino i lor confini taglienti e dalla diversità de' colori crudamente distinti, rendono per necessità le lor figure secche, crude, senza tondezza e rilievo.'

17. William Aglionby, *Painting Illustrated in Three Diallogues*, London, 1685, n.p. The definition may derive from the Latin etymology for *groppo* given in the Crusca *Vocabolario* (n. 11 above) p. 404: *nodus*.

18. Baldinucci, *Vocabolario* (n. 10 above), p. 71. He initially follows the definition of *gruppo* in the Crusca, *Vocabolario* (n. 11 above), p. 404: 'Da aggrupare, viluppo, mucchio. Lat. nodus.'

19. Boschini, *Carta* (n. 8 above), pp. 457–8: 'Forze d'Ercole qua xe bagatele,/ Respeto ai sforzi che

It may be concluded that Baldinucci accepted, along with the Crusca definition, the potential for expressive effects and the possibility (even the desirability) of being confounded. I do not want to overplay this point, making Baldinucci into some kind of purposeful post-structuralist deconstructing Alberti, yet the associations of broken structure and unclear communications of *composizione* does grate against convention. Most Italian writers on art in the seventeenth and eighteenth centuries framed their discussions of pictorial composition within the tradition first articulated by Leon Battista Alberti. Based on rhetoric and extensive in its hermeneutics, Alberti's composition was structured around questions of talent, beauty, decorum, narrative and illusion.[20] Yet its definition is surprisingly restrictive, excluding aspects that we now take for granted as integral to composition including line, light and colour. (Circumscription and reception of light or the colouring of surfaces are not specifically excluded by Alberti from composition, but they are identified with different parts of painting.) Composition was taken to be the joining of the parts into a whole:

> Composition is the rule of painting by which the parts are brought together to form a pictorial work ... The parts of a *historia* are bodies, part of the body is a member, part of the member is a surface. Thus, the prime parts of the work are surfaces, because from them come the members, from the members come the bodies, and from those comes the *historia*, indeed the ultimate and absolute work of painting.[21]

Later writers tended to stay within the narrower confines of Alberti's definition that identified composition most strongly with the individual figure or with groups of figures that tell an *historia*.[22] Albertian composition survived as the dominant

fa ste figure:/ Acion, scurzi, motivi e positure,/ Stridi, che sbigotisse anca le stele./ Quela è una massa ch'è agropada insieme,/ D'Omeni e de serpenti, e tuti ingiuria/ E velen questi, e quei dolor e furia.' Boschini is referring to Aliense's now-lost version of this subject from SS. Apostoli. See also p. 480 regarding the *gropi artificiosi* in Sante Peranda's *Deposition* (lost; formerly Venice, S. Procolo). For Tintoretto's *Brazen Serpent* (Venice, Scuola di San Rocco), see p. 131.

20. Amongst the many discussions of Alberti's composition, see Michael Baxandall, *Giotto and the Orators. Humanist Observers of Painting in Italy and the Discovery of Pictorial Composition*, Oxford, 1971, pp. 121–139; Rudolf Kuhn, 'Albertis Lehre über die *Komposition* als die Kunst in der Malerei', *Archiv für Begriffsgeschichte*, 28, 1984, pp. 123–178; Jack Greenstein, *Mantegna and Painting as Historical Narrative*, Chicago, 1992, pp. 34–58; and in this volume Charles Hope, 'Composition from Ceninni to Alberti'.

21. L. B. Alberti, *De pictura*, II, 35; in *Opere volgari*, ed. C. Grayson, III, Bari, 1973, pp. 61–3: 'Est autem compositio ea pingendi ratio qua partes in opus picturae componuntur Historiae partes corpora, corporis pars membrum est, membri pars est superficies. Primae igitur operis partes superficies, quod ex his membra, ex membris corpora, ex illis historia, ultimum illud quidem et absolutum pictoris opus perficitur.' Translation by Greenstein, *Mantegna* (n. 20 above), pp. 42–3.

22. They did, however, reconfigure the parts of painting with composition generally being subsumed within *disegno*: P. Pino, *Dialogo di pittura*, Venice, 1548: edition cited in *Trattati d'arte del Cinquecento fra Manierismo e Controriforma*, ed. P. Barocchi, I, Bari, 1960, p. 114. Cesare Nebbia set composition within design in a lecture to the Accademia di San Luca on 17 January 1594, quoted in R. Alberti, *Origine, et progresso dell'Academia del Dissegno, de' pittori, scultori, & architetti di Roma*, Pavia, 1604, p. 30: edition cited in *Scritti d'arte di Federico Zuccaro*, ed. D. Heikamp, Florence, 1961, p. 42. Nebbia referred his listeners

model in part because of popular translations by Lodovico Domenichi (Venice, 1547; Florence, 1568) and Cosimo Bartoli (Venice, 1568; adapted by Raphaël Trichet du Fresne, Paris, 1651; Naples, 1733), and in part because it had become integrated so thoroughly into sixteenth-century literature.[23] Just how deeply it had sunk into the collective consciousness is illustrated by a lecture given by Cristoforo Roncalli to the Accademia di San Luca in 1594. There he spoke of the individual figure as 'a fitting and artificial composition' in much the same terms that he saw the *historia* as 'an artificial composition of many bodies corresponding to the same goal of representing every action'.[24] The linguistic underpinnings of Alberti's composition seemed of little interest to a practicing artist like Roncalli, who took care to emphasize that he spoke about composition as a painter, but the literary grounding was not lost on writers trained in the art of writing instead of painting. Daniello Bartoli likened literary composition to an artist designing a human figure in that both required the parts to be unified and rendered as a whole.[25] André Félibien, writing in his journal while visiting Rome in 1647–49, likened the letters of the alphabet to the parts of the human body in that both are composed variously

to G. B. Armenini, *De' Veri precetti della pittura*, Ravenna, 1587, I, iv: edition cited M. Gorreri, Turin, 1988, p. 52. Federico Zuccaro also referred his readers to the same passage from Armenini, see *L'Idea de' pittori, scultori, et architetti*, Turin, 1607, pp. 52–3: edition cited in *Scritti d'arte di Federico Zuccaro*, p. 272. See also Aglionby, *Painting* (n. 17 above), n.p. ('An Explanation of some Terms of the Art of Painting'); G. B. Volpato, *Il Vagante corriero, à curiosi, che si dilettano di pittura, et à giovani studiosi*, Vicenza, 1685, p. 23. Vincenzo Danti, however, maintained the division as *circunscrittione, compositione* and *luce*. see M. Daly Davis, 'Beyond the *Primo Libro* of Vincenzo Danti's *Trattato delle Perfette Proporzioni*', *Mitteilungen des Kunsthistorischen Institutes in Florenz*, 26, 1982, p. 66. For examples of an Albertian tradition in discussing composition in the seventeenth century, see Mancini, *Considerazioni* (n. 9 above), pp. 108–9, 219 and 230; and G. P. Bellori, *Le Vite de' pittori, scultori et architetti moderni*, Rome, 1672: edition cited ed. E. Borea, Turin, 1976, pp. 236, 283–4, 338 and 547.

23. For example, Armenini cited Alberti in his discussion of composition as contingent on decorum, as an articulation of narrative, and as a grouping of figures organized in a rational space: Armenini, *Veri precetti* (n. 22 above), pp. 153–65.

24. C. Roncalli, 'Discorso … del 26 giugno 1594', in R. Alberti, *Origine* (n. 22 above), p. 80: 'Dirò adunque primieramente, che non è altro l'historia, parlando come Pittore, che un'artifitioso componimento di molti corpi corrispondenti ad un fine per rapresentare ogn'attione … . [D]isse poi corrispondente ad un fine, perche se bene il componimento si fà di corpi variati, e differenti, debbano nulladimeno servir tutti ad un proposito di quello che si vol rapresentare, & haver'una concordanza unita, per rapresentare l'intentione del Pittore, & essere in somma tutti corrispondenti ad un'medesmo fine … . Disse … la Pittura di devotione, & ogn'altra inventione del Pittore, ò altri, in somma, come ha preso il Pittore il corpo è un debito, & artifitioso componimento di molte membra, ò parte che vogliamo dire, così l'historia apresso l'istesso è, come io dissi, un artifitioso componimento di molti corpi tutti corrispondenti ad un fine … .' Roncalli, who claimed to be inexpert in theoretical matters, later in his lecture (p. 81) proved himself to be true to his word when he muddled Alberti's discussion of copiousness and variety, showing at once knowledge and confusion of his source. Romano Alberti (*Origine*, n. 22 above, p. 23) recorded a discussion one year earlier where advice was given to 'giovani studiosi' regarding the placement of figures and composition of the subjects where a syntactic link clearly signals the parallel functions of arranging the parts of a figure and composing figures into groups: 'sì al disporre bene la figura al suo effetto, come alla compositione del sugetto'.

25. D. Bartoli, *Dell'uomo di lettere difeso ed emendato*, Rome, 1645; edition cited in *Trattatisti e narratori del seicento*, ed. E. Raimondi, Milan and Naples, 1960, p. 338.

to express thoughts and passions.[26]

Although most Italian writers during the seventeenth century followed Alberti's choice of *compositio* and *composizione* to write about figural composition, there were competing terms. I will briefly present two: *componimento* and *concerto*. Most popular was *componimento*.[27] During the sixteenth century, *componimento* in art literature usually meant surface finish, tonal composition and colour harmony. Giovan Battista Armenini defined it as the fifth and final part of painting, following *disegno*, *lumi*, *ombre* and *colorito*: 'that union and extreme diligence by which means one gives the concluding finish to paintings in such a way that all of the figure comes to be harmonized and replete with the highest union'.[28] When he wanted to write about figural composition, he chose *disposizione* or *composizione*.[29] Vasari made a similar distinction between surface and illusion, between technique and narrative, in his application of *composizione* for figures and *componimento* for the tonal jigsaw of intarsia.[30] Seicento writers, however, absorbed into *componimento* its Cinquecento literary meaning as composition. Bellori actually favoured it over *composizione*. In the seventeenth century what Armenini meant by *componimento* became (more correctly) *compimento* from the verb *compire* (to conclude, complete or perfect). This then freed *componimento* for use as a variant of *composizione*.[31] Because *componimento* and *compimento* were apparently paronyms, and because the former had signified the latter, they were susceptible to semantic slippage, most notably when two scribes confused *compimento* as finish with *componimento* as composition while copying the manuscript version of Bellori's life of Carlo Maratta prior to its publication in 1732.[32]

Concerto as a figural symphony with all the parts harmonized was also used to denote composition. Marco Boschini used it in this way with greater frequency than

26. J. Thuillier, 'Pour un *Corpus Poussinianum*', *Actes du Colloque international Nicolas Poussin*, ed. A. Chastel, II, Paris, 1960, p. 80.

27. In addition to examples discussed below, see the letter from Sisto Badalocchi and Giovanni Lanfranco to Annibale Carracci (August 1607), first published by Bellori, *Vite* (n. 22 above), p. 110; Bartoli, *Uomo di lettere* (n. 25 above), p. 338; F. Scannelli, *Il Microcosmo della pittura*, Cesena, 1657, pp. 102–3; Bellori, *Vite* (n. 19 above), pp. 100, 266–7, 386, 435, 185 ('un ordinato componimento pieno di figure'), 220 ('il componimento e li moti però non sono sufficienti all'istoria') and 626 ('in tante numerose figure di que' gran componimenti'); and F. Baldinucci, *Notizie dei professori del disegno dal Cimabue in qua*, Florence, 1686–1728; edition cited: ed. F. Ranalli, V, Florence, 1845–7, p. 497.

28. Armenini, *Veri precetti* (n. 22 above), p. 59.

29. Armenini, *Veri precetti* (n. 22 above), pp. 85, 153 and 160–63; see p. 126 for an instance of *composizione* used as 'the science of colouring'.

30. Vasari, *Vite* (n. 9 above), I, p. 153; II, pp. 179–80 and IV, p. 206.

31. Scannelli consistently distinguished between *compimento* as a 'delicate union' or final finish and *componimento* as organizing figures in space or telling a story: *Microcosmo* (n. 27 above), pp. 25, 102–3 and 227–8. Armenini's *componimento* did survive into the seventeenth century with Paolo Beni (*Il Goffredo, overo La Gierusalemme Liberata*, Padua, 1616, p. 12) and with Armenini's plagarist Francesco Bisagno (*Trattato della pittura*, Venice, 1642, pp. 123–9).

32. Bellori, *Vite* (n. 22 above), pp. 597 and 650. Borea (in *Vite*, pp. lxvi–ii) states that neither the Rouen (Bibliothèque municipale) nor the Paris (Institut Néerlandais) manuscripts are autograph.

any other critic: 'It is a great composition, a great concert!'[33] *Concerto* allowed him to play with its antonymous near-twin, *sconcerto*, which can be translated as 'decomposition'. In reconstructing the viewing experience of the *Nativity* (Venice, S. Giorgio Maggiore: Fig. 3) by Jacopo Bassano, Boschini first places his reader/ viewer close to the picture where form dissolves and the eye is dazzled.[34] In this liminal stage, the painting appears to be a *sconcerto* because the viewer misapprehends the purposeful illegibility and visual incoherence as 'chaos' when it really is 'perfect artifice'. The transformation of *sconcerto* into a *concerto*, where all the parts cohere clearly and suitably into a whole, comes when the viewer takes a more farsighted approach both mentally and physically, and reflects on the painting from a greater distance. *Sconcerto* might be read as any kind of dissonance or loss of coherence, but for Boschini its meaning hinged on his frequent use of *concerto* as a synonym for composition. Bassano's *Nativity* disconcerts and decomposes before it is composed. Boschini recreated with his diction an analogous experience of surprise and transformation for his readers. First they assume that a *sconcerto* must be defective, reading the term as Agostino Taja used it to damn the Seicento *manieristi*, but then they discover *sconcerto* to be an integral component of appreciating Bassano's achieve-ment.[35] Expectations are overturned, much as when one looks into a *spechio curioso*, a mirror of unpredictable distortions and mystery, that Boschini wanted to hang in the 'Venetian room' of a picture gallery as a suitable companion to paintings by his heroes (Bassano, Tintoretto, Titian and Veronese).[36] Boschini's perplexed viewer, looking at the *sconcerto* of the *Nativity*, has entered the semantic space of Baldinucci's *composizione*.

Composition and decomposition are easily confused. Boschini made this point

33. Boschini, *Carta* (n. 8 above), p. 118 ('L'è un gran componimento, un gran concerto!'). For other examples of concerts as compositions, see also Boschini, *Carta*, pp. 45, 47, 53, 99, 150, 173, 215, 299, 301, 324, 377, 379, 423–4, 438, 455, 556, 718 and 731; and M. Boschini, *I gioieli pittoreschi. Virtuoso ornamento della Città di Vicenza*, Vicenza, 1677, 10 ('E questo copioso di figure ben concertate.'). Scannelli, *Microcosmo* (n. 27 above), pp. 85, 159, 348 and 353. In describing the integration of figures by Lorenzo Garbieri with each figure fulfilling an identifiable function, Malvasia turns to a concert metaphor figures stand for voices: C. C. Malvasia, *Felsina pittrice*, Bologna, 1678; edition cited: ed. G. P. Zanotti et al., II, Bologna, 1841, p. 216. Baldinucci, *Notizie* (n. 27 above), V, p. 108; L. Scaramuccia, *Le finezze de' pennelli italiani*, Pavia, 1673, p. 31.

34. Boschini, 'Breve instruzione', in *Le Ricche minere della pittura veneziana*, Venice, 1674; edition cited: *Carta* (n. 8 above), pp. 726–7.

35. A. Taja, *Descrizione del Palazzo Apostolico Vaticano. Opera postuma*, Rome, 1750 (written c. 1712–22), p. 15.

36. Boschini, *Carta* (n. 8 above), p. 617. Throughout the sixteenth and seventeenth centuries, mirrors were taken to be compositional aids or symbols of composing, a notion whose popularity was revitalized by the publication of Leonardo's *Trattato* in 1651. For example, Scaramuccia cited chapter CCLXXV of the *Trattato* where the mirror is presented as a master painter that artists should emulate when composing ('comporre') lines and shadows: *Finezze* (n. 33 above), p. 215. For mirrors in Dufresnoy and de Piles, see T. Puttfarken, *Roger de Piles' Theory of Art*, New Haven, 1985, pp. 87 and 96–97. For Leonardo on mirrors, see *Treatise on Painting by Leonardo da Vinci*, ed. and transl. A. McMahon, Princeton, 1956, pp. 72 and 432.

with the proverb 'Ogni dreto ha 'l so roverso' ('Every obverse has its reverse'), which he cited to illustrate the difficulty of understanding composition in general.[37] This was also Boschini's point in showing the metamorphosis of *sconcerto* into *concerto*, and in different ways it underlies the definitions of composition by Baldinucci and Giampietro Zanotti (as 'everything placed in a beautiful order, even in a beautiful picturesque disorder').[38]

DESCRIBING PILES

Figural piles can be difficult to disentangle verbally and posed obstacles particularly for writers who liked detailed descriptions. Take, for example, this section from Lanfranco's *Assumption of the Virgin* whose figural cumulus is typical of and suited for its location on the dome of S. Andrea della Valle (Fig. 4). At first glance we might see this painting much as Giovanni Gaetano Bottari regarded the Fontana di Trevi, that is, as an enormous congeries spilling over a small area.[39] Clouds and figures interpenetrate so that limbs appear and disappear into the clouds almost at random. Because it is difficult to extricate individuals from the crowd, a gneral impression may be readily available but a figure-by-figure reading is not. A deliberate ambiguity gives it a sense of limitless expansion wherein resides its visual and spiritual power. Not all critics appreciated this feat of heavenly display. Gasparo Gozzi, possibly thinking of Venetian secular apotheoses like those of Tiepolo complained about paintings where everything 'seems made of those clouds that fly by' where 'one sees it and doesn't see it'.[40] Nor, as the following section will show, was it an issue limited to ceiling painting.

Because Alberti's composition was conceived as an instrument to achieve narrative clarity and was accepted for centuries in that context, piling figures became a useful metaphor for art critics who wanted to evoke a failure of *historia*. Piles could not be 'read,' to adopt Poussin's metaphor for viewing, by using Bellori's descriptive technique of 'describing the paintings figure by figure and part by part'.[41] Bellori moved the viewer through paintings in various ways, but mostly he described figures individually following a spatial logic, either moving across the plane usually from left to right and top to bottom as if it were a book, or organized pictorially using framing devices and axiality.[42] Consequently he preferred those

37. Boschini, *Carta* (n. 8 above), p. 102. Bellori (*Vite*, n. 22 above, p. 23) draws on a related topos to explain how beauty becomes deformed to satiate the viewer's desire for novelty: ' ... alla bellezza sta vicina la bruttezza, come li vizii toccano le virtù'.

38. G. P. Zanotti, *Storia dell'Accademia Clementina di Bologna*, Bologna, 1739, p. 343, s.v. *disposizione*.

39. G. G. Bottari, *Dialoghi sopra le tre arti del disegno*, Lucca, 1754 (written c. 1735), p. 123.

40. G. Gozzi, 'L'Abitazione d'un filosofo creduto pazzo', *L'Osservatore*, 8, Venice, 1768, p. 52.

41. Poussin, letter to Chantelou (28 April 1639); in C. Jouanny, *Correspondance de Nicolas Poussin*, Paris, 1911, p. 21. The review of Bellori's *Vite* appeared in *Il Giornale de' letterati di Francesco Nazari per tutto l'anno 1673*, Rome, 1673, p. 77; quoted by G. Previtali, 'Introduzione', in Bellori, *Vite* (n. 22 above), p. li.

42. For an example of each ekphrastic strategy, see Bellori, *Vite* (n. 22 above), pp. 187–8 and 195–6.

paintings (and gave them the most extensive descriptions) that were composed with clearly legible figures spread across the front plane or in some manner that allows a sequential reading based on physical proximity.[43] The syntax of Bellori's descriptions, often with spatial prepositions opening up each sentence, reveals this cast of mind: 'E dietro … Sotto le ruote del carro … e dietro il caro … Vien tirato il carro … Sopra di uno cavalca … e sopra l'altro … Tiene avanti il freno …'.[44] When he faced the tumult of Lanfranco's *Assumption of the Virgin* (Rome, Sant' Andrea della Valle), his technique of individuation and sequential reading failed him. And so, partly in compensation, partly as a matter of convenience, he decided to plagarize Ferrante Carli who employed a more metaphoric language that could evoke expressive forms and cumulative visual effects more successfully than Bellori's literalist style.[45]

Bellori, like any other writer on art, had available to him literary models that could have helped him appreciate and describe piles and fragmentation. Rhetoric and poetics is full of such figures: *accumulatio*, asyndeton, anaphora, *conglobatio* and parataxis, to mention just a few that were invested with positive functions. Presumably these literary devices could be used, as they were intended, to recreate and praise visual tumult, but more often art critics adopted them to attack piled compositions. Gilio da Fabriano, in complaining about the proliferation of strange figural poses in contemporary painting, effectively mirrored the pictorial problem by devising a mutated lexical redundancy, a rampant epanalepsis: 'figure, figurette, figuraccie e figuroni'.[46] The result is a verbal pile. Critics from Alberti to Galileo to Maffei employed figures of accumulation and fragmentation to blame bad art.[47] They wanted Albertian spatial and narrative clarity in compositions and consequently found only confusion, instability and art mired in the chaos of matter.

43. For related observations on Agucchi's ekphrases, see G. Perini, 'L'Arte di descrivere. La tecnica dell'ecfrasi in Malvasia e Bellori', *I Tatti Studies. Essays in the Renaissance*, 3, 1989, p. 184. Michael Hochman makes this point about ekphrasis in general: 'L'ekphrasis efficace. L'influence des programmes iconographiques sur les peintures et les décors italiens au XVIe siècle', in *Peinture et rhétorique. Actes du colloque de l'Académie de France à Rome*, ed. O. Bonfait, Paris, 1994, pp. 61 and 65.

44. Bellori, *Vite* (n. 22 above), p. 254.

45. N. Turner, 'Ferrante Carlo's *Descrittione della Cupola di S. Andrea della Valle, dipinta dal Lanfranchi*, a source for Bellori's descriptive method', *Storia dell'arte*, 12, 1971, pp. 297–325.

46. G. A. Gilio da Fabriano, *Due dialoghi, nel primo de' quali si ragiona de le parti morali e civili appartenenti a' letterati cortigiani … nel secondo si ragiona degli errori de' pittori circa l'historie*, Camerino, 1564; in *Trattati*, ed. P. Barocchi (n. 22 above), II, pp. 3–4 and 49.

47. For epanalepsis used in the context of composition, see L. B. Alberti, *Della pittura*, transl. L. Domenichi, Venice, 1547, p. 28r: 'Quello dirò io, che sia una historia copiosissima; ne laquale vi saranno a i suoi luoghi mescolati humonini, giovani, garzoni, fanciulli, matrone, vergini, bambini, animali domestici, cagnuoli, uccelletti, cavalli, bestie, edifici, e paesi.' It was used by Galileo as an effective parody of Mannerist pictorial composition and Tasso's anamorphic poetry; quoted by Panofsky, *Galileo* (n. 16 above), p. 18: 'E pecca il nostro poeta in quella maniera che falleria quel pittore, che, dovendo rappresentare una caccia particolare, accastasse nell'istesso quadro conigli, lepri, volpi, cervi, lupi, orsi, leoni, tigri, cignali, bracchia, levrieri, alcuni pardi, e in somma tutte le sorti di fieri animali di caccia con ogni maniera di cacciagione.'

In contrast to critics of piles, many painters, patrons and collectors obviously enjoyed making, buying and looking at figural piles and tenebrist shadows. Critics pathologized piles, while artists painted thousands of them for a public who were happy to collect and admire them. The incongruence of critical distain and pictorial practice suggests that critics were part of an embattled minority in the art world, even if they comprised the majority view within their chosen genre. And even within that genre, there seems to be a divide between humanists and painters. Critics who thematized piles and mistook artists' exploration of unstable forms as unhealthy distortions tended to be historians, literary critics and theologians. On the other hand, the writers who surfaced in my readings as defenders of disintegrated compositions and as semantic innovators (giving terms of fragmentation a positive spin) all happened to be artists. One example will have to suffice. In the final section of this essay, I will show how the ethically and artistically defective meanings of *macchia* were defined and applied mostly by non-practioners to describe paintings that seemed unfinished or that had obscure, disruptive shadows. Artists, on the other hand, understood *macchia* as a compositional device that simultaneously cuts and unifies. Luigi Scaramuccia, a Perugian painter, used it to describe Titian's *Martyrdom of St Peter Martyr* (lost; Venice, SS. Giovanni e Paolo): ' ... being further away, one makes out a beautiful *macchia* or, as we want to say, a mass produced by large areas of light and shadow placed in the right tempo'.[48] His presentation of *macchia* and *massa* as synonyms recalls Chantelou's translation of Bernini's use of *macchia* as a figural group:

> He said that in the composition of the big works it was necessary to think in masses – he said *delle macchie* – it was best to draw the figures on a piece of paper and then cut them out and place the different masses to make a loose composition for the whole, and to create a fine contrast of masses, then to fill in the empty spaces with carefully drawn figures, going into great detail. It was the only way to obtain something grand and well organized; with any other method the details, which are the least significant part, are bound to predominate.[49]

Bernini's *macchia* is a compositional device that required cutting, recomposing and subduing the parts so that the organizing armature is not overwhelmed by detail. Although this is consistent with the meaning of *macchia* as sketch and hence

48. Scaramuccia, *Finezze* (n. 33 above), p. 95.

49. Paul Fréart de Chantelou, *Diary of the Cavaliere Bernini's Visit to France*, ed. A. Blunt, annotated by G. Bauer, transl. M. Corbett, Princeton, 1985, pp. 283–4; L. Lalanne, ed., 'Journal du Voyage du Cavalier Bernin en France', *Gazette des Beaux Arts*, per. 2, XXIX, 1884, p. 266 (October 10): '[E]t a dit que dans la composition de ces grands ouvrages il ne faut faire que des masses, il a dit *delle machie*, comme qui ferait des figures sur une feuille de papier et les couperait avec des ciseaux et placerait ces diverses masses, comme faisant la composition informe d'un tout, afin de lui donner un beau contraste, et qu'après au particulier; que c'était le moyen de faire quelque chose de grand et de concerté, et que ce que l'on ordonne autrement ne se trouvait jamais beau, n'y ayant que le particulier, qui n'est que le moins considérable'.

as a compositional aid, his primary interest was clearly the massing of figures in groups and secondarily the massing lights and shadows ('un beau contraste').[50]

Writers that avoided the pejorative meaning of moralizing values of *macchia* as a furtive style, a messy form or 'contemptible shading' tended to be painters working or writing in a Venetian context (Colombino, Prunati, Boschini, Volpato and Scaramuccia).[51] This suggests some regional specificity but more particularly a separate identity as a workshop term. When Scaramuccia praised the *macchia* in the *Martyrdom of St Peter Martyr*, he preceded his explanation of the term with the phrase 'as we want to say,' the 'we' being painters (both Scaramuccia and Boschini). When Santo Prunati posted on his studio wall the admonition MACCHIAR, it was, according to the painter Giambattista Cignaroli, written 'in the language of painters' and signified 'keep in mind large masses of light and shadow'.[52]

PERIODIZING PILES

> In the style of their compositions, [seventeenth-century painters] abused the rule (best applied in a timely fashion) of making figural groups. Their compositions will be judged shameful also in making isolated figures in large spaces, and they [the painters] will always want to represent tangles and muddles, piles from the bottom to the top that become chimeras and that show nothing true or possible.[53]

For Scipione Maffei, writing in 1731, pictorial piles were symptomatic of a collective failure in Seicento painting that included such 'disfigurations of the human body' as 'stretched members … bestial convulsions … disparately arranged limbs … and drapery that flys without wings'.[54] Although Maffei did not use the term 'baroque' to identify the art that troubled him, and chose not to use Pier Jacopo Martello's designation of Seicento painters as 'manieristi', he nonetheless treated Seicento painters as if they belonged to a single period style whose formal

50. Since Boschini employed this double meaning of *macchia* and *massa* both as figural bunches (Aliense's *Brazen Serpent* or Francesco Maffei's *Paradise*) and as clutches of shadows (Tintoretto's technique for sketches), it is conceivable that another mid-century writer (speaker) could conflate the two: Boschini, *Carta* (n. 8 above), p. 377 ('una massa ch'è agropada insieme,/ D'Omeni e de serpenti') and p. 556 ('Dove se vede scurzi in positure,/ Che la gran massa cusì ben concerta').

51. See below in the final section for these artist-writers on *macchia*. For Boschini and Volpato, both claiming professional insight as painters and praising *macchia* as the painterly brush, see P. Sohm, *Pittoresco. Marco Boschini, his Critics, and their Critiques of Painterly Brushwork in Seventeenth- and Eighteenth-Century Italy*, Cambridge, 1991, pp. 137–45 and 153–5.

52. G. Biadego, 'Di Giambattista Cignaroli pittore veronese. Notizie e documenti', *Miscellanea pubblicata della R. Deputazione Veneta di storia patria*, VI, 1890, p. 34.

53. S. Maffei, *Verona illustrata*, Verona, 1731; edition cited: Milan, 1825, IV, p. 261: 'Della regola, ottima quand'è usata a tempo, di far groppo, abusano in maniera nelle lor composizioni, che stimeranno vergogna anche in ispazio grande il far figure isolate, e vorranno sempre rappresentar viluppi e confusioni, e ammontonamenti dal basso all'alto, che diventino chimere, e che niente dimostrino di vero, nè di possibile.'

54. Maffei, *Verona illustrata* (n. 53 above), IV, pp. 157 and 260–61.

properties were congruent with early usages of 'baroque' and 'mannerist'.[55] According to him, the overelaborated, distorted or twisting forms of the Seicento were symptoms of a general cultural decline, with poetry, architecture and painting in particular lurching dangerously toward 'gothicism'.[56] Painting entered the 'dark ages' ('l'adombramento') later in Verona than elsewhere in Italy. The last lights were extinguished by mid-century with the deaths of Ridolfi (d. 1644) and Orbetto (d. 1650), but the rot had set in earlier:

> But with these two painters the Veronese school finally expired, although already at this time it languished in a much diminished state ... having suffered the same corruption that concurrently ruined poetry and the other fine arts.[57]

Criticisms of compositional piles presuppose a norm which pilers deviate from. Maffei did not identify the 'rule ... of making figural groups,' but he probably had something Albertian in mind, something that took spatial logic and narrative clarity as its standard. Also in mind could have been Lomazzo's warning against the extremes of compositional superabundance and poverty, the first producing confusion, the second aridity.[58] What constituted compositional piling changed along with pictorial practice. As a painter, Lomazzo probably strived to reach his self-prescribed golden mean between superabundance and poverty, but for Scaramuccia, writing a century later, they appeared crowded and confused.[59] Nor is it difficult to find figural piles and flapping drapery in many paintings of Maffei's 'golden age'.

55. For the early etymological history of *baroque*, see O. Kurz, 'Barocco: Storia di una parola', *Letteratura italiana*, 12, 1960, pp. 414–44; B. Migliorini, 'Etimologia e storia del termine *barocco*', in *Manierismo, Barocco, Rococo*, Rome, 1962, pp. 38–43; and R. Bossaglia, 'Un documento per la storia del termine *barocco*', in *Mito del Classicismo nel Seicento*, Messina-Florence, 1964, pp. 81–9. P. J. Martello, *Commentario*, Rome, 1710; edition cited: *Scritti critici e satirici*, ed. H. S. Noce, Bari, 1963, pp. 140–41. For the use of mannerism as a critical topos to condemn seventeenth-century painting, see P. Sohm, 'Seicento Mannerism: Eighteenth-Century Definitions of a Venetian Style', *Treasures of Venice*, eds G. Keyes, I. Barkóczi and J. Satkowski, ex. cat., Minneapolis Institute of Arts, Minneapolis, 1995, pp. 51–66.

56. Ottavio Alecchi wrote that his friend's ambition was to rid Italy of 'gothicisms:' MS Venice, Biblioteca Marciana, It. Cl. X, 100 (7178), f. 53; cited by G. Gasparoni, *Scipione Maffei e Verona settecentesca*, Verona, 1955, p. 141. For Borromini as the 'new Goth', see S. Maffei, 'Elogio del Sig. Abate Filippo Ivara Architetto', *Osservazioni letterarie*, 3, 1738, p. 193. He considered poetry and architecture to be corrupted for the same reasons, that is, a love of novelty and an ignorance of antiquity: Maffei, *Verona illustrata* (n. 53 above), III, pp. 406–7 and IV, pp. 153–4, 160–61 and 258–9; and S. Maffei, 'Parere intorno al sistema dell'Università di Padova, e al modo di restituirle il suo antico splendore e concorso', in *Opusculi e lettere*, Milan, 1844, p. 151 (written in 1715).

57. Maffei, *Verona illustrata* (n. 53 above), IV, pp. 254–5. Maffei saw the decline starting with the deaths of Paolo Farinato (1606) and Felice Brusasorci (1605).

58. G. P. Lomazzo, *Trattato dell'arte della pittura, scoltura et architettura*, Milan, 1584; edition cited in *Scritti sulle arti*, ed. R. Ciardi, II, Florence 1974, p. 244: 'Ma sempre nella composizione si ha da osservare questo, che si fugga la soprabondanza delle parti et ancora la povertà. Imperò che da quella ne nasce la confusione et affettazione e da questa ne risulta l'aridezza e nudità delle opere'

59. Scaramuccia, *Finezze* (n. 33 above), p. 136 (referring to Lomazzo's paintings in Milan, Chiesa di San Marco).

What stands out clearly from the complex history of disordered (or apparently disordered) composites, whether they are grotesques, monsters, piles or other products of unruly imaginations, is how frequently they were identified with a period or a school.[60] Vitruvius' monsters, Vasari's monstrous 'Goths', the 'gothic plague' of the Bamboccianti and the new 'goth' Borromini are famous examples where disorderly composites and piles are presented with reference to a failed period style.[61] Less well known is Agostino Mascardi's description of a 'plague' of modern tombs that bury alive high-minded men in 'a heap of stones' and in tortured labyrinths.[62] Maffei drew on the artless monsterism of the grotesque in his use of *chimere* to describe both the tangled figural piles of Seicento painting and the 'deformed' ornament of Seicento architecture that capped windows with berets and altars with hats.[63] Stigliani saw chopping and piling as another nadir in the artistic cycle – 'painting has absolutely lost its way once again' – either as a return to Gothic or to Mannerist decay. Like so many other early critics of Baroque art, Maffei adopted the terms of reference applied to criticize the Mannerists. He could have had in mind complainers like Scaramuccia, who thought that painting before the Carracci was a 'confusion of thorny, knotty and intricate offshoots,' or like Armenini who identified Perugino, Beccafumi and Pontormo as 'new masters of confusion' because they pile up ('amucchiar') their figures without regard for

60. Composition was thought to be a product of the imagination: G. P. Lomazzo, *Idea del tempio della pittura*, Milan, 1590; edition cited in *Scritti* (n. 58 above), I, pp. 331–2; Mancini, *Considerazioni* (n. 9 above), I, pp. 13 and 108–9. For *istoria* and imagination, see Greenstein, *Mantegna* (n. 20 above), p. 43. For the grotesque as 'un musaico di sproposii insieme commessi', see D. Bartoli, *La Ricreatione del Savio in discorso con la Natura e con Dio*, Rome, 1659, p. 285. See also Boschini, *Carta* (n. 8 above), p. 95 (with reference to Maffeo Venier's use of 'ordine a grotesche' in his satiric poem *Strazzosa* published in 1595). For piles and grotesques, see G. Baruffaldi, *La Tabaccheide*, Ferrara, 1714, p. 130 (with reference to Vasari on Morto da Feltre); G. Baruffaldi, *I baccanali*, Bologna, 1758, I, p.24. For monsters, see A. Payne, 'Mescolare, composti and Monsters in Italian Architectural Theory of the Renaissance', in *Disarmonia, brutezza e bizzarria nel Rinascimento*, ed. L. Rotondi Secchi Tarugi, Milan (forthcoming).

61. Vitruvius, *De architectura*, VII, 5; transl. and ed. F. Granger, Cambridge, Mass., II, 105. For a history of monsters in architectural theory see A. Payne, 'Mescolare, composti and Monsters' (n. 60 above). Vasari, *Vite* (n. 9 above), I, pp. 67–8; on gothic architecture as 'come mostruosi e barbari … una maledizione di tabernacolini, l'un sopra l'altro, con tante piramidi et punte et foglie, che non ch'elle possano stare, pare impossibile, ch'elle si possino reggere'. For a history of the 'Gothic problem', see E. Panofsky, 'The First Page of Giorgio Vasari's *Libro*', in *Meaning in the Visual Arts*, New York, 1955; edition cited: Harmondsworth, 1970, pp. 206–65. For Caravaggio's followers (especially the Bamboccianti) as 'a gothic plague', see Francesco Albani's letter to Andrea Sacchi in Malvasia, *Felsina pittrice* (n. 33 above), II, pp. 180–81. For Borromini as a 'gothic ignoramus', see Bellori's annotation in his copy of Baglione, *Vite de' pittori, scultori ed architetti* (ed. V. Mariani, Rome 1935, p. 180).

62. A. Mascardi, *Discorsi morali*, Venice, 1624, p. 4: 'Ma delle fabriche de' nostri tempi, e de' nostri paesi. Queli pietre, quai marmi nobilitati non si sono, da che prese vigore il morbo di sepellirsi vivi gli huomini d'alto affare dentro ad un mucchio di sassi? … Non s'intricano i Laberinti più tortuosi di quello, che già raviluppò Minosse in Candia.' The context for these remarks concerns the unhealthy taste for luxury goods and overly elaborate dress fashion.

63. Scipione Maffei, review of A. Pompei, *Li cinque ordini dell'architettura civile di Michel Sanmicheli*, Verona, 1735, in *Giornale de' letterati d'Italia*, 1736, p. 216.

composition ('composizione').[64]

The proximity of Mannerist and Baroque congeries is more a critical convention than a precise analysis of pictorial practice (even though artists during both periods do have piling tendencies), and nowhere is that proximity perceived so clearly as in an early eighteenth-century guide to the Vatican. Agostino Taja described two dominant and opposing schools that originated in the sixteenth century but gripped painting after 1590.[65] He labelled them as 'heretical sects,' and hence as coherent, coterminous artistic movements, one of 'manieristi', the other of 'puri puri naturalisti'. The term *manieristi* was taken from Pier Jacopo Martello's *Commentario* of 1710; the 'puri puri naturalisti', with its mincing, mocking reiteration, may have been adapted from Marco Boschini.[66] Like Maffei's painters of the 'dark ages,' Taja's Seicento mannerists were thought to be ignorant of ancient models, ruled by overheated imaginations and hence enamoured of exaggerated, unnatural forms. The results included flying drapery and piled compositions.[67]

UNCOMPOSED BODY PARTS

In a pictorial pile such as that in Lanfranco's *Assumption of the Virgin* (Fig. 4), the fragmentation of composition into body parts is caused by a complex web of truncated figures. By entwining the limbs of different figures, or, more simply, by bringing many figures together into an overlapping group, painters must necessarily fragment whole bodies into parts. This is one kind of truncation that Stigliani could have had in mind when he evoked 'tiny pieces' piled on a butcher's block. Because his metaphor of chopped-up bodies refers to a loss of organic integrity, it calls attention to the dangers of fragmentation and making art in pieces. In Alberti's linguistic model of composition, painting starts with pieces – body parts ('membrae') – and proceeds to give them life and meaning by com-bining them. The story of Leonardo's ghoulish compositional experiment, where he makes a Medusa-like monster by dissecting and reassembling different animals, trades on

64. Scaramuccia, *Finezze* (n. 33 above), p. 77; Armenini, *Veri precetti* (n. 22 above), p. 154: '[N]elle quali, quando si vien poi misurando, riescon novi maestri delle confusioni, perché avend'apena ricevuto il sogetto, si danno a formarlo con l'amucchiar di molte figure, senza riguardo de' termini della composizione ...'.

65. Taja, *Descrizione* (n. 35 above), p. 15. The publishers, Niccolò e Marco Pagliarini, comment that it was written in c.1712 (p. 25). Girolamo Gigli (*Diario Sanese*, Siena, 1722, p. 181) note that Taja was busy 'sta ora per metter fuora la Raccolta delle Pitture del Palazzo Vaticano'.

66. P. J. Martello, *Commentario*, Rome, 1710; edition cited: *Scritti critici e satrici*, ed. H. S. Noce, Bari, 1963, pp. 140–41. He distinguishes between sixteenth-century *manieristi* and the *manieristi moderni* who are identified with the second generation of the Carracci 'school', but both in their styles and their label he makes clear that sixteenth- and seventeenth-century mannerists share much in common. For Boschini, see *Carta* (n. 8 above), p. 374: 'Quel far [by naturalist painters] quele missianze nete nete/ De più colori, e meterli in scancia/ Sula tolela con galantaria', Tridae, come in fesora xe l'erbete.' Boschini must have considered *puro* and *neto* to be synonymous since he liked to pair them: *Carta*, pp. 204 and 578.

67. Taja, *Descrizione* (n. 35 above), pp. 13–15.

the alchemy of making parts whole, or making dead body parts seem to live again.[68] Vasari framed Leonardo's grotesque production within a joke played on Piero da Vinci, hence presenting the story as both a paradigm of artistic illusion and a parody of classical composition. When Boschini retold this story, he deliberately misrepresented Vasari's intentions as part of a continuing *ad hominem* by presenting it as a serious model of Tuscan composition. He dropped all references to the parodic function of monster making and instead exaggerated the stench of rotting animal parts, a 'copia bestiale'. The fetid smell ('fetor'; 'spuzor') in Leonardo's studio is rendered as a judgement of Vasari's foul taste, and the 'composito formal' that resulted from composing in this way conveys the failure of Tuscan art in general. The plague (he uses *morbo* like Mascardi) suggests the diseased state of art that is governed by such principles of Tuscan design: 'And this is the foundation of Vasari's design? Oh artists grounded in stench! To paint a dragon he has to make a smelly pestilence. If this is praise, then I don't have to say anything.' For Vasari, the story spoke of the artist's transformative powers; for Boschini, Leonardo's vivisection showed the limitations of mechanical assembly working too literally with the material world. Leonardo's grotesque composition failed because, being additive and unmediated, it required the presence of natural models. As a reminder of how adaptable and enduring this language is, Maffei's critiques of disorderly heaps may be recalled, where he refers us to grotesques ('chimere') as a metaphor for figural groups and to plague ('morbo') as a conse-quence of living burial.

Vasari and Boschini played on the belief that the integral units of composition are body parts or, in Alberti's grammatical abstraction, 'members'. Dismembered limbs and various extremities were also central images in art pedagogy. Instructional manuals by Alessandro Allori (1565), Odoardo Fialetti (1608) and Giacomo Franco (1611) all featured anatomized images for students and dilettantes to copy (Fig. 5).[69] The body parts in art instructional manuals were intended as building blocks for the initiate, part of a step-by-step method of rote learning. The title page of Giuseppe Mitelli's *Alfabeto in sogno* (Bologna, 1683) calls them an 'Alphabet in Dream' and conveys a somnial process of composition and reconfiguration with its eyes, nose, ear and hand floating around a sleeping figure (Fig. 6). They also presume a dissection of nature whose parts must then be recomposed into a new whole; or as Allori put it: 'And we will now make all of those parts which serve to form a head in profile, detaching one part after another; and after this we will give

68. Vasari, *Vite* (n. 9 above), IV, p. 20.
69. A. Allori, 'Delle regole del disegno', 1565 (MS Florence, Biblioteca nazionale centrale, Fondo Palatino, E.C. 16, 4); partly published by R. P. Ciardi, 'Le regole del disegno di Alessandro Allori e la nascita del dilettantismo pittorico', *Storia dell'arte*, 12, 1971, 267–84; For a discussion of Fialetti and Franco, see D. Rosand, 'The Crisis of the Venetian Renaissance Tradition', *L'arte*, 11–12, 1971, pp. 5–53. See also B. Cellini, 'Sopra i principii e 'l modo d'imparare l'arte del disegno', in *Opere*, ed. G. G. Ferrero, Turin, 1971, pp. 827–35.

the method and rule in order to situate them and place them together, each in its own place'.[70]

Pier Francesco Alberti's engraving of an art studio with the curiously analphabetical title of *Academia d Pitori* (Fig. 7) shows how this kind of hornbook or primer would have been used, with the younger students studying a page of eyes on the left and older students progressing to increasingly complex tasks further to the right.[71] The *Academia d Pitori* also displays sculptural fragments as artifacts of study and emblems of artistic knowledge, much like other representations of art as studio practice.[72] Alberti diverges from that tradition by including a dead body and, most jarringly, an amputated leg that ghoulishly resonates with the missing legs of Christ in the *Crucifixion* conspicuously displayed on the wall.

Since body parts betoken only a rudimentary accomplishment, critics used them to represent a failure of integration. Raffaelle Borghini complained that mid and late sixteeenth-century Florentine painters 'disposed and divided' their figures with rows of disembodied heads ('molti capi sopra capi').[73] Body parts functioned so effectively because they referred to the constituent parts of composition – the members/phrases and figures/clauses – that are to be assembled into full periodic form.[74] Stigliani relied on the Albertian tradition of grammatical and pictorial syntax in order to critique the 'fracta compositio' of Marino by comparing his 'pile of cut members' to contemporary painting's 'imperfect mass ... butchered into tiny pieces and confusedly arranged into a pile'.[75]

THE FURTIVE SHADOWS OF TENEBRISM

In the eighteenth century, tenebrist truncation was taken to be a signature of the Baroque. J. J. de Lalande described Salvator Rosa's *Martyrdom of SS. Cosmas and Damian* (Rome, S. Giovanni dei Fiorentini: Fig. 8) as 'une idée baroque' because he could see only the legs of one figure, the rest being cast into shadow.[76] De Lalande

70. Ciardi, 'Regole del disegno' (n. 69 above), p. 278.

71. For Renaissance instructional techniques of reading and writing that move from recognizing letters to forming words and sentences, see P. Grendler, *Schooling in Renaissance Italy. Literacy and Learning, 1300–1600*, Baltimore, 1989, pp. 142–61.

72. For the engraving by Enea Vico after Baccio Bandinelli, *The Academy of Baccio Bandinelli*, and for etching by Odoardo Fialetti of an artist's studio used as the frontispiece for *Il vero modo et ordine* (Venice, 1608), see C. Roman, 'Academic Ideals of Art Education', *Children of Mercury. The Education of Artists in the Sixteenth and Seventeenth Centuries*, ex. cat., Dept. of Art and Bell Gallery, Brown University, Providence, RI, 1984, pp. 81–95. Evonne Levy kindly pointed out the following examples to me: Michael Sweerts, *Painter's Studio* (Amsterdam, Rijksmuseum) and *Atelier Scene with Embroiderer* (Zürich, Fondation Rau); illustrated and discussed in *I Bamboccianti. Niederländische Malerrebellen in Rom des Barock*, ed. D. Levine and E. Mai, Milan, 1991, pp. 270–72 and 282–4 (ex. cat., Cologne, Wallraf-Richartz Museum).

73. R. Borghini, *Il Riposo in cui della pittura e della scultura si favella*, Florence, 1584, p. 177.

74. Baxandall, *Giotto* (n. 20 above), pp. 130–35.

75. Stigliani, *Occhiale* (n. 1 above), pp. 29–30.

76. J. J. de Lalande, *Voyage d'un françois en Italie fait dans les années 1765 e 1766*, IV, Paris, 1769, p. 74. For criticism of Caravaggio's followers painting only figures without legs, another kind of amputation,

indulged in some exaggeration in order to make his point that the deep cutting shadows perform a kind of visual amputation. The essential is obscured in favour of the incidental. The language of violence that I have used to describe tenebrism originated in the seventeenth century and was seen as particularly fitting for an artist like Caravaggio. For Carlo Cesare Malvasia, ever appreciative of a psychologizing language for style, Caravaggio painted with 'a violent and excessive light' ('un lume violento e strabocchevole') in 'that driven and dark style' ('quella maniera cacciata e scura').[77] The contrast of light and shade is invested with human drama when he has Lodovico Carracci describe it as a 'clash' ('fracasso').[78] The violence of 'amputated shadows' had become such a trite metaphor in seicento poetry that it provided ready material for Salvator Rosa in his *Satira*, describing dawn as the 'executioner who chops the neck of shadows with the axe of rays'.[79] This, then, could have been another kind of compositional fragmentation that Stigliani evoked with his butcher metaphor, one without crowds of figures and indeed achieved by nonfigural means of cloaking shadows. Tenebrist lighting illuminates form selectively and masks pivotal parts of the figures left in shadow. When a focused shaft of light pierces an otherwise dark space, and when reflections are removed or dampened, the deep shadows obscure the continuity or coherence of figural form, fragmenting nature into luminous shards. Writing in Rome in the 1640s, Dufresnoy described the disjointed effect as unpleasant because joints and other bodily extremities are spotlit without any transitional or connective tissue between them.[80]

As a means to structure a complex field of issues, I propose to use a statement ascribed to Annibale Carracci about Caravaggio that illustrates how critics understood the artistic limitations and ethical undertow of fragmenting light:

Is there anything so marvelous here [in Caravaggio's painting]? Did it seem to you that this was something new? ... I would certainly know, he added, another way to make a big hit, and even to beat and mortify him. I would like to counterpose to that bold colouring one that is completely soft. Does he use a slanting and shuttered light? I would like it open and direct. Does he cover up the difficult

see Francesco Albani's letter in Malvasia, *Felsina pittrice* (n. 33 above), II, p. 163. For figures without feet, see Boschini, *Carta* (n. 8 above), pp. 467–8; and Guido Cagnacci, in a now-lost letter from c. 1600–61 quoted by Francesco Algarotti (10 June 1761) in *Raccolta di lettere sulla pittura, scultura ed architettura*, G. G. Bottari and S. Ticozzi, Milan, 1825, VII, p. 484.

77. Malvasia, *Felsina pittrice* (n. 33 above), II, pp. 9 and 13.

78. Malvasia, *Felsina pittrice* (n. 33 above), II, p. 9.

79. For amputated or butchered shadows, see Flaminio Strada who called the sun 'umbrarum carnificem': *Prolusiones academicae*, Venice, 1617, p. 346; discussed by U. Limentani, *La satira nel Seicento*, Milan and Naples, 1961, pp. 149–51. For Rosa, see *Satira*, II (La poesia), vv. 278–9 in *Poesie e lettere edite e inedite*, ed. G. A. Cesareo, Naples, 1892, p. 198.

80. Dufresnoy, *De arte graphica*, Paris, 1667, lines 162–3: 'Praecipua extremis raro internodia membris/ Abdita sinta; Sed summa pedum vestigia nunquam.' According to Armenini, when the whole disintegrates into parts by this deep shadows, the picture is rendered 'senza ordine e senza componimento': Armenini, *Veri precetti* (n. 22 above), p. 62.

parts of art in night time shadows? I would like to reveal the most learned and erudite studies by the bright light of noon.[81]

It seems unlikely that Malvasia had available a written record of this conversation that Annibale had with his cousin Ludovico, so these are probably not Annibale's exact words. Nevertheless in the following discussion I will be referring to the source as 'Annibale,' either as a fictional construction by Malvasia or as a second-hand account of a real conversation that was filtered down to Malvasia by means of an oral tradition. This passage had an afterlife in writings by Antonio Francesco Ghiselli, Pellegrino Antonio Orlandi and Francesco Algarotti, who used the opposition of closed and open lighting in much the same way as 'Annibale,' although substituting Reni for 'Annibale'.[82] Nothing predates the publication of the *Felsina pittrice* in 1678, but 'Annibale' does sound very much like Bellori, who observed that Caravaggio 'never made any of his figures go out into open sunlight but found a style of placing them in the darkness of a closed room'.[83]

The competitive, almost combative, stance shown by 'Annibale' seems to mirror Caravaggio himself, but actually it is a display of humanist erudition that plays against the popular construction of Caravaggio as a painter of little knowledge who appealed only to the ignorant. By virtue of its intertextuality, 'Annibale's' statement demonstrates his superior learning and hence (presumably) his superior art. Algarotti, working from an adulterated version of Malvasia's quotation, recognized Cicero as one source, and it is also not too hard to find Federico Zuccaro's response to Caravaggio and Horace's call for oratory to be exposed to the full light of day lurking beneath 'Annibale's' words.[84] The role that 'Annibale' casted himself is

81. Malvasia, *Felsina pittrice* (n. 33 above), II, p. 9: '[C]he tante maraviglie, disse Annibale ivi presente? … Saprei ben io, soggiuns'egli, un altro modo per far gran colpo, anzi da vincere e mortificare costui: a quel colorito fiero [of Caravaggio] vorrei contrapporne uno affatto tenero: prende egli un lume serrato e cadente? e io lo vorrei aperto, e in faccia: cuopre quegli le difficoltà dell'arte fra l'ombre della notte? ed io a un chiaro lume di mezzo giorno vorrei scoprire i più dotti ed eruditi ricerchi.'

82. Antonio Francesco Ghiselli (1685–1724), 'Annales Memorie antiache manuscritte di Bologna raccolte et accresciute sino ai tempi presenti', MS Bologna, Biblioteca Universitaria, n. 770, vol. xxxviii, f. 780; quoted by G. Perini, 'Biographical Anecdotes and Historical Truth: An Example from Malvasia's "Life of Guido Reni"', *Studi secenteschi*, 31, 1990, p. 150. Ghiselli substituted Guido Reni for Annibale Carracci and elaborated on the stylistic differences, but the structure is essentially that found in Malvasia. For Algarotti, *Trattato della pittura*, Venice, 1764; edition cited: *Saggi*, ed. G. Da Pozzo, Bari, 1961, p. 109: 'Guido Reni … diede alle sue opere gaietà e vaghezza, parve innamorato del lume aperto; e del lume serrato, in contrario, Michelagnolo da Caravaggio, burbero nelle maniere e selvatico.' See also Algarotti, *Opere*, VIII, Venice, 1791, p. 141 (letter to Eustachio Zanotti, 27 September 1760; on Guercino's *lume serrato*); and Algarotti, *Saggio sopra l'Accademia di Francia che è in Roma*, Livorno, 1763; edition cited: *Saggi*, p. 22 ('di stile severo e aspro talvolta, che dietro al Caravaggio cercava di serrare il lume').

83. Bellori, *Vite* (n. 22 above), p. 217.

84. Algarotti *Trattato* (n. 82 above), p. 109 quoted from Cicero (*Orator*, XI, 36): 'In picturis alios horrida, inculta, abdita et opaca: contra alios nitida, laeta, colustrata delectant.' For Algarotti's source for changing Annibale Carracci into Reni, see note 82. For Zuccaro on Caravaggio, see Baglione, *Vite* (n. 7 above), p. 137; and for Carracci's reuse of it, see Charles Dempsey, *Annibale Carracci and the Beginnings of Baroque Style*, Glückstadt, 1977, pp. 24–5. For Horace's contrast of weak art practiced in

similar to that used by Bellori, Malvasia and others as the one who enlightens art after years of Mannerist darkness; in the words of Scaramuccia, the Carracci were 'bright, shining Suns who dispelled every turbid and shadowy (*tenebroso*) suspicion of ignorance'.[85] Malvasia gives 'Annibale' the self-conscious historical positioning that became so commonplace after the artist's death.

'Annibale,' proprietor of an 'open light,' probably chose the term *lume serrato* to evoke an artistic and ethical failure: an abberant light that dissects a dark space; and the pathological intimations that derive from activities in a shuttered place. Within the structure of opposing styles – *fiero/tenero*, *serrato/aperto*, and *cadente/in faccia* – the literal translation of *serrato* as 'shuttered' conveys Caravaggio's infamy of painting in the 'cellar,' which is simultaneously a statement both about art and society, about the murky light of his paintings and about his plebean figures and sensibility.[86] 'Shuttered' conveys a darkened interior that is closed to the world. It might be this mysterious seclusion from the outside world, evocatively titled by Louis Marin as the 'arcane box,' that Giulio Mancini had in mind when he described as 'not natural' Caravaggio's penchant for painting 'a very dark room with one window and the walls painted black and thus with … very deep shadows'.[87]

As an ambient of unnatural confinement, 'Annibale's' *serrato* describes a psychic space as much as a physical one. It brings an interlocking set of associations including morbidity, danger and secrecy, all of which connect to aspects of Caravaggio's psycho-biography. I will take these associations in reverse order. The 'shuttered light' suggested seclusion and secrecy to Orlandi and Ghiselli; both of them subsumed *lume serrato* within the more general category of 'furtive painting' (*un dipingere furbesco*) to which they assigned Caravaggio.[88] According to Malvasia and Scaramuccia, the 'furtive style' was intended to conceal shortcomings of the artist and painting by means of cloaking shadows.[89] As indicated by the root *furbo*,

the seclusion of shade to good exposed to the sun, see W. Trimpi, 'The Meaning of Horace's *Ut Pictura Poesis*', *Journal of the Warburg and Courtauld Institutes*, 36, 1973, pp. 1–31; and W. Trimpi, 'Horace's *Ut Pictura Poesis*: The Argument for Stylistic Decorum', *Traditio*, 34, 1978, pp. 29–72. Bellori, in his *Vite* (n. 22 above), p. 204 contrasts the darkness of a closed room in Caravaggio's painting to the open light of the sun: ' … non faceva mai uscire all'aperto del sole alcuna delle sue figure, ma trovò una maniera di campirle entro l'aria bruna d'una camera rinchiusa …'.

85. Bellori, *Vite* (n. 22 above), p. 231: '… restando [i pittori] ne gli errori e nelle tenebre; finché Annibale Carracci venne ad illuminare le menti ed a restituire la bellezza all'imitazione'. Scaramuccia, *Finezze* (n. 33 above), p. 77.

86. Bellori, *Vite* (n. 22 above), p. 205 ('non sapeva uscir fuori dalle cantine'); Baldinucci, *Notizie* (n. 33 above), III, p. 681.

87. Mancini, *Considerazioni* (n. 9 above), I, p. 108; L. Marin, *To Destroy Painting*, transl. M. Hjort, Chicago, 1995, p. 162. Marin does not discuss the meanings of *serrato*, but his translation of it distorts its meaning.

88. P. A. Orlandi, *Abecedario pittorico*, Bologna, 1704, p. 286, s.v. Caravaggio: ' … l'introdusse a dipingere in pubblico con quel gran tingere di macchia, e furbesco, che non lasciava trovare conto del buon contorno'. And Perini, 'Biographical Anecdotes' (n. 75 above), p. 150.

89. Malvasia, *Felsina pittrice* (n. 33 above), II, pp. 67–8: 'Fu il suo [Giovanni Andrea Donducci] fare una maniera furbesca; perchè non altro meggiormente adoprando che il nero, cacciando il tutto in

it is a cheat because it enables the artist to avoid the difficulties of art (*disegno*, anatomy and perspective) that Caravaggio was notoriously ignorant of. As a dishonest style, it also recalls his many arrests, his fugitive character (Francesco Susinno called him 'Fugiasco', 'the fugitive'[90]), his famous renditions of cheats in the *Fortune Teller* paintings, and the ruffian flavour of his religious works. Of the ethical or psychological dimensions of *serrato*, this was probably the best understood. Algarotti made explicit another aspect by using 'lume serrato' as the visible symptom of Caravaggio's 'surly' ('burbero') and 'wild' ('selvatico') character, thus bringing a serrated edge of menace and danger. And finally *serrato* may evoke disease or death, as in Pietro Aretino's expression, the 'shadows of the shuttered tomb'.[91]

Because *serrato* nearly always signalled some kind of defect, its use by the painter-theorist Giovanni Battista Volpato in praise of Jacopo Bassano is conspicuous. Writing shortly after the publication of the *Felsina Pittrice*, Volpato also juxtaposed 'lume aperto' and 'lume serrato' with Titian, Veronese and the young Bassano representing the former and Tintoretto and the older Bassano representing the latter.[92] The formal qualities intended by Volpato, although approximately those of 'Annibale,' are defined with a painter's eye for visual effects. The serrated light of Bassano's late works rakes across figures, picks out prominences such as the crown of a head, a shoulder or knee, and detaches them from the whole figure. Volpato, a Bassano *manqué* convicted of multiple Bassano forgeries, admired the late works of Bassano above all others and so analysed the effects of serrated light with great respect. It was part of a formal vocabulary, including Z-shaped drapery folds, whose angularity (angled light and spotlit apexes) endowed figures with movement.[93] The *lume serrato* 'cuts' figures and compositions, but intentionally rather than from ignorance and does so for the forceful expression that results.[94]

ombra, veniva a scansare non solo le difficoltà, ma confondere, e a perdere entro quelle oscurità i contorni, onde sopra di essi non si potessero fare i conti; ed ascondendo in tal guisa le scorrezioni e gli errori quando ve ne potessero esser stati, e su que' scuri poi maravigliosamente spiccando le prime piazze de' chiari, che alla prima ferivano la vista, e con estrema vaghezza appagavano il gusto.' This passage was adapted by Orlandi, *Abecedario* (n. 88 above), p. 203. For Scaramuccia, see *Finezze* (n. 33 above), p. 205.

90. F. Susinno, *Le vite de' pittori messinesi*, dated 1724; ed. V. Martinelli, Naples, 1960, p. 115.

91. Mancini, *Considerazioni* (n. 9 above), I, p. 108; P. Aretino, *Le vite dei santi. Santa Caterina vergine. San Tommaso d'Aquino*, ed. F. Santin, Rome, 1977, p. 114 (describing St Catherine's imprisonment).

92. G. B. Volpato, *La verità pittoresca svelata à dilettanti*, MS Bassano, Biblioteca comunale, 31 A 25, ff. 151, 204, 214–5 and 257; E. B. Favero, *Giovanni Battista Volpato critico e pittore*, Treviso, 1994, pp. 411, 414–5, 412 and 420–21. For a discussion of the technique and optics of the *lume serrato* as applied to Bassano's paintings, see Favero, *Volpato*, pp. 68–73.

93. Volpato, *Verità* (n. 92 above), ff. 256–7; Favero, *Volpato* (n. 92 above), pp. 420–21.

94. For Volpato's discussion of cutting (*tagliente*) light, see *Verità* (n. 92 above), f. 259; Favero, *Volpato* (n. 92 above), p. 421. For how and where Bassano used serrated light 'espresso con forza estrema', see Volpato, *La Natura pittrice*, ff. 39–40; in Favero, *Volpato* (n. 92 above), p. 70. For other detailed discussions, see also A. Franchi, *La Teorica della pittura*, Lucca, 1739, p. 72; and Baldinucci, *Vocabolario* (n. 10 above), p. 161: 'Tagliente add. Che taglia. Si dice ad un vizio, che forte imbratta le pitture; ed è quando l'Artefice, nel colorire non osserva la la dovuta degradazione, diminuzione, o insensibile

What I have described as the cloaking, furtive or shuttered shadows of *lume serrato* and *maniera furbesca* are variants of another aesthetically and morally defective style, the form-denying shadows known as *macchia*. In describing Caravaggio's style, Susinno and Orlandi set *macchia* alongside the *maniera furbesco* because both pointed to a kind of concealing shadow that inexpert painters used to disguise their inability.[95] What Susinno and Orlandi meant by Caravaggio's *macchia* is defined by Baldinucci:

> Sign that liquids, colours and dirt leave on the surface of things that they touch or on top of which they fall. Latin *Macula*. Painters use this word to explain the quality of various drawings, and sometimes also paintings, made with extraordinary facility ... so that it almost appears to be made by itself and not by the hand of the artist *Macchia* in stones of various colours, one says that colour which appears on top more than underneath And similar to these, one calls *macchie* those diverent types of colour which sheets of paper are artificially coloured, known as marbled paper. And *macchia* signifies a desnse and frightfully dark forest And from here, in whatever way brutes and thieves hide in the shadows (*macchie*) to engage in their malfeasance furtively, one says, to make whatever it may be *alla macchia* is to make it in hiding, secretly and furtively; thus of printers, counterfeiters and forgers who print amd make money without any authorization, one says to print or mint *alla macchia*. Also amongst painters one uses this term for representations that are made without having the object in front of them, saying to represent *alla macchia*, or this representation is made *alla macchia*.[96]

accrescimento di lumi, e d'ombre, talmente che si passi dal sommo chiaro allo scuro profondo, senza le mezze tinte.' Volpato describes the interceding spaces between light and shadow in Bassano's late work as ashen (*cenerizio*) and thereby unfolds part of the connoted morbidity of *serrato*: Volpato, *Verità* (n. 92 above), f. 159; Favero, *Volpato* (n. 92 above), p. 412. He also finds 'ashes' in the tonalities of Tintoretto, Leonardo Corona and Palma Giovane.

95. Orlandi, *Abecedario* (n. 88 above), p. 286; Susinno, *Vite* (n. 90 above), p. 113: 'In questa tela sta figurato il Natale di Nostro Signore, con figure al naturale, e tra le opere sue a mio credere questa si è la migliore, perché in esse questo gran naturalista fuggì quel tingere di macchia, e furbesco, ma rimostrossi naturale senza quella fierezza d'ombre.' Algarotti discusses 'il lume serrato e la macchia del Guercino:' *Opere* (n. 82 above), VIII, p. 141. See also Baldinucci, *Vocabolario* (n. 10 above), p. 4: 'Affocalistiare. Vale quasi oscurare. Parola usata tra Pittori, per esplicazione d'un certo macchiare, che fanno i poco pratici con matita o colori, disegno or pittura, nelle parti e dintorni piò difficili a circonscriversi in disegno.'

96. Baldinucci, *Vocabolario* (n. 10 above), p. 86: 'Macchia. Segno che lasciano i liquori, i colori, e le sporcizie, nelle superficie di quelle cose, ch'elle toccano, o sopra le quali cadano. Lat. *Macula* I Pittori usano questa voce per esprimere la qualità d'alcuni disegni, ed alcuna volta anche pitture, fatte con istraordinaria facilità, e con un tale accordamento, e freschezza, senza molta matita o colore, e in tal modo che quasi pare, che ella non da mano d'Artefice, ma da sè stessa sia apparita sul foglio o su la tela, e decono; questa e una bella macchia. Macchia nelle pietre di varij colori, dicesi quel colore, che pare di sopra più a quello del fondo; e di qui chiamansi le stesse pietre macchiate; ed è una bella qualità di esse pietre, con la quale si rendono più vaghe. a simiglianza di queste chiamansi macchie quelle diverse sorte di colore con le quali artificiosamente son macchiati i fogli, che si dicono marezzati. E macchia significa bosco folto e orrido, e tal'ora semplice siepe. E di quà, come che in tali macchie si nascondano, e fiere e ladroni a fare furtivamente loro malefizj, dicesi, fare che che sia alla macchia, per farlo nascosamente, furtivamente; così delli Stampadori, Monetieri, o Falsatori di monete, che senza alcuna autorità del pubblico stampano o lavorano, dicesi stampare, o battere monete alla macchia. Anche appresso i Pittori

What is interesting about this definition is how it combines the ethical and the artistic, both involving transgressions and deception. *Macchia* as 'a dense and frightfully dark forest' is a place of malfeasance where counterfeiters mint their coins in secret. The shadows of the forest both protect the illicit activity from public view and emblematize its transgressive nature. *Macchia* is also a form made by chance (a stain) and a form that appears to be made by chance (a quick sketch). A sketch is like a stain because it seems formed by nature's hand instead of the artist's. *Macchia* is a natural form that mimics artistic production (patterns in marble) or an artistic form that mimics nature (marbled paper). Despite this reference to marbled paper, *macchie* do not normally imitate nature but are forms 'made without having the object in front of them'. The one aspect of *macchia* that departs from the semantic range of *lume serrato* is precisely this clandestine exclusion of nature as a model, where forms are 'made without having the object in front of them'. Baldinucci applied this meaning to Cesare Dandini who, grieving for his father, abandoned the natural world in favour of artificial distortions.[97] Mancini is the only early critic of Caravaggio who recognized tenebrism as 'unnatural'.

Co-existing with the clandestine art of *macchia* painters was another kind of *macchia* that simultaneously composed and fragmented pictures by means of large masses of shadows. This positive application of *macchia* developed from its associations with the murky shadows of forests. It might also derive from its more literal denotation as a random form and a 'sign that liquids and dirt leave on the surface of those things they touch' which shares aspects of confusion and liquified forms with Baldinucci's *composizione*.[98] The compositional possibilities of *macchia* are also contained by its meaning as 'sketch,' but when used in this sense it indicated more a heuristic than a pictorial form.[99] What is more interesting is how it was understood as a compositional form used to orchestrate light and integrate space

usasi questo termine ne' ritratti ch'essi fanno, senza avere avanti l'oggetto, dicendo ritrarre alla macchia, ovvero questo ritratto è fatto alla macchia.'

97. Baldinucci, *Notizie* (n. 27 above), IV, pp. 552–3: 'Fece egli nondimeno in questo tempo [1619, at the time of his father's death, which produced in him a 'disordine'] alcune pitture, nelle quali non mai abbandonò una certa sua maniera diligente, nè tampoco il naturale … . Trattennesi anche in tal tempo, con qualche utile, a fare piccolissimi ritratti di femmine sopra rame, in quel modo, che noi dichiamo *alla macchia*, e talvolta dal naturale, come anche fare si costuma in questi nostri tempi da alcuni, per compiacere a certa sorta di persone, le quali, coll'opporsi poi a guisa di specchia concavo al raggio delle proprie pupille quel debole ed offuscato metallo … .' Also in the life of Andrea Boscoli, Baldinucci used *macchia* as 'discostandosi alquanto dal naturale': *Notizie* (n. 27 above), III, pp. 76–77.

98. Crusca, *Vocabolario* (n. 11 above), p. 496; Baldinucci, *Vocabolario* (n. 10 above), p. 86: 'Segno, che lasciano i liquori, e le sporcizie nella superficie di quelle chose, ch'elle toccano, o sopra le quali caggiono.' For composition as a mix, defined as 'Per istruggere, liquefare, fondere'. For examples of *macchia*'s confusion, see V. Giustiniani, *Discorsi sulle arti e sui mestieri*, ed. A. Banti, Florence, 1981, p. 42 ('botte, o in confuso, come macchie'); and Sohm, *Pittoresco* (n. 51 above), pp. 36–43.

99. For *macchia* as a sketch, see Leonardo, *Notebooks*, I, ed. J. P. Richter, London, 1883, n. 59; Vasari, *Vite* (n. 9 above), I, p. 117; Armenini, *Veri precetti* (n. 22 above), pp. 89–90; and for related applications Sohm, *Pittoresco* (n. 51 above), 27–43.

and surface. In his book on graphic and pictorial techniques, the Paduan painter and art dealer Gasparo Colombina described *macchia* not as the drawing or sketch itself but as a graphic technique amongst several others. He considered it to be an extreme form of *sfumato* – an ink wash superimposed like smoke over pencilled lines that had initially defined the forms.[100] What this suggests is that *macchia* could be detached from form, taking on shapes different from those of delineated figures, chopping off a leg or revealing a balding crown (to use two previous examples of Rosa's and Caravaggio's technique).

The technique of *macchia* described by Colombina was used by Veronese, Palma Giovane, Poussin during his Venetian phase and many others. By applying an ink wash across figures and architecture, we seem to see cloudy shadows moving across the scene and fragmenting forms almost at random. The shadows, masses unto themselves, do not always conform to the contours or modelling of the objects represented with lines, but instead can flow and intermingle with them. *Macchie* need not be at the service of articulating individual forms. On the one hand they can be read illusionistically as broad shadows that are seemingly cast by a cloud or some other unseen object outside of the picture frame. Functioning as a massing of shadows, they help compose illusionistic space. On the other hand, they can be read as broad tonal masses produced by applying ink washes to paper, 'a sign that liquids leave and the mess on the surface that they touch' that we see in Poussin's wash, with tonal patches bound to the surface that resemble stains in their indefinite shapes. They adhere to the page and appear to be exactly what they are – applications of tinted liquid to paper. *Macchia* can thus designate both reality and illusion, a complex dialectic or interpenetrability of surface and space.[101]

100. G. Colombina, *Discorso sopra il modo di disegnare, dipingere et spiegare secondo l'una et l'altr'arte gli effetti principali, si naturali, come accidentali nell'huomo secondo i precetti della Fisionomia*, Padua, 1623, p. 3: 'Il secondo [method of drawing] fatti, che si hanno li primi tratti col detto lapis vi si pongono i secondi da que' primi un poco diversi, dopo con un penelletto di vaio si uniscono, e si sfumano convertendo quelli tratti in una macchia, la quale serve come per ombra bene unita, in modo poi che con pochi tratti raggiuntivi di sopra si conduce al suo fine … .' For Colombina, see Ridolfi, *Meraviglie dell'arte, overo le vite de gl'illustri pittori veneti*, Venice, 1648, I, pp. 285, 293 and II, 207; and Rosand, 'Crisis' (n. 69 above), pp. 5–53.

101. For the 'dialectic of light and shade' in Poussin's drawings, see O. Bätschmann, *Nicolas Poussin. Dialectics of Painting*, London, 1990, pp. 3–15.

Fig. 1. Valentin de Boulogne, *Martyrdom of Saints Processus and Martinianus*.
Rome, Pinacoteca Vaticana.

Fig. 2. Antonio Aliense, *Brazen Serpent*. Venice, Chiesa di Angelo Raffaele

Fig. 3. Jacopo Bassano, *Nativity*. Venice, S. Giorgio Maggiore.

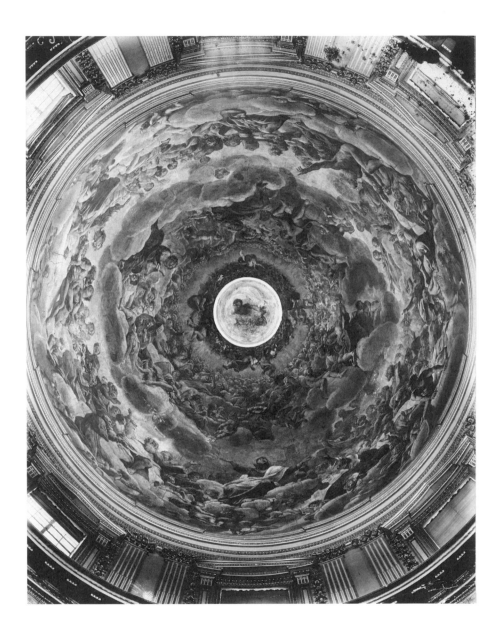

Fig. 4. Giovanni Lanfranco, *Assumption of the Virgin*, detail.
Rome, S. Andrea della Valle.

Fig. 5. Odoardo Fialetti, *Eyes*. Page from Fialetti, *Il vero modo et ordine per dissegnare tutte le parti et membra del corpo*, Venice, 1608.

Fig. 6. Giuseppe Mitelli, *Alfabeto in sogno*, Bologna, 1683, title page.

Fig. 7. Pier Francesco Alberti, *Academia d Pitori*. Engraving, Metropolitan
Museum, New York

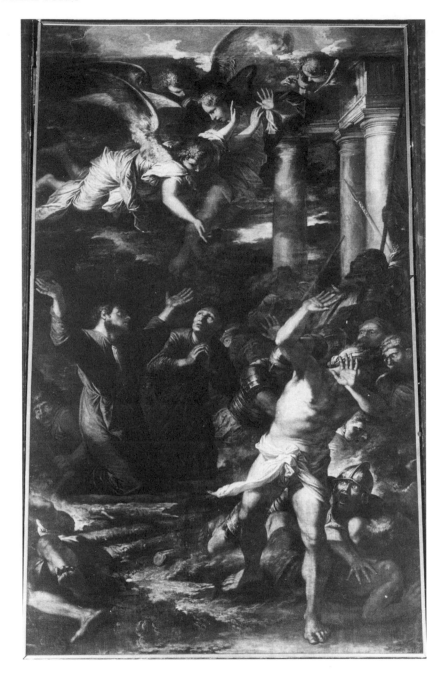

Fig. 8. Salvator Rosa, *Martyrdom of Saints Cosmas and Damian*. Rome, S. Giovanni dei Fiorentini.

Andrea Pozzo on the Ceiling Paintings in S. Ignazio

Thomas Frangenberg

The ceiling paintings created by Andrea Pozzo[1] in S. Ignazio,[2] the chapel of the Collegio Romano, are outstanding in a number of respects. Not only are they among the most spectacular paintings to have been created in the late Seicento. They are also discussed in a substantial number of contemporary texts, of which several were written by the artist himself. Pozzo provided two different accounts of the perspectival composition of the fresco in the nave of S. Ignazio (Fig. 1) in two editions of Book 1 of his treatise on perspective, the *Prospettiva de' pittori e architetti* (of 1693 and 1702 respectively) and he discussed the construction of the illusionistic

1. For Pozzo's early biographies see F. S. Baldinucci, *Vite di artisti dei secoli XVII–XVIII. Prima edizione integrale del Codice Palatino 565*, ed. A. Matteoli, Rome, 1975, pp. 314–37; L. Pascoli, *Vite de' pittori, scultori, ed architetti viventi dai manoscritti 1383 e 1743 della Biblioteca comunale "Augusta" di Perugia*, Treviso, 1981, pp. 199–201; id., *Vite de' pittori, scultori, ed architetti moderni*, ed. C. Alberti *et al.*, Perugia, 1992, pp. 691–715. The most important recent studies of Pozzo's career as a painter are found in R. Marini, *Andrea Pozzo Pittore (1642–1709)*, Trent, 1959; B. Kerber, *Andrea Pozzo*, Berlin–New York, 1971; V. De Feo, 'L'architettura immaginata di Andrea Pozzo gesuita' , *Rassegna di architettura e urbanistica*, 46, 1980, pp. 79–109; id., *Andrea Pozzo. Architettura e illusione*, Rome, 1988; V. De Feo, V. Martinelli eds, *Andrea Pozzo*, Milan, 1996; A. Battisti ed., *Andrea Pozzo*, Milan, Trent, 1996.
2. Of the ample literature on Pozzo' s decoration of S. Ignazio, see E. Feinblatt, 'Jesuit Ceiling Decoration', *Art Quarterly*, 10, 1947, pp. 236–53(246–53); E. Guldan, *Die jochverschleifende Gewölbedekoration von Michelangelo bis Pozzo und in der bayerisch-österreichischen Sakralarchitektur*, Ph.D. diss. University of Göttingen, 1954, pp. 115–19; A. de Angelis, 'La scenografia sacra di Andrea Pozzo a Roma e a Frascati', *Studi Romani*, 6, 1958, pp. 160–70(165–7); L. Montalto, 'Andrea Pozzo nella chiesa di Sant' Ignazio al Collegio Romano', *Studi romani*, 6, 1958, pp. 668–79; W. Schöne, 'Zur Bedeutung der Schrägsicht für die Deckenmalerei des Barock', in *Festschrift Kurt Badt zum siebzigsten Geburtstage. Beiträge aus Kunst- und Geistesgeschichte*, Berlin, 1961, pp. 144–72(149–64); F. Haskell, *Patrons and Painters. A Study in the Relations Between Italian Art and Society in the Age of the Baroque* (London, 1963) New Haven, London, 1980, pp. 89–91; M. C. Gloton, *Trompe-l'oeil et décor plafonnant dans les églises romaines de l' âge baroque*, Rome, 1965, pp. 155–60; G. Martinetti, *S. Ignazio*, Rome, 1967, pp. 42–58; T. Poensgen, *Die Deckenmalerei in italienischen Kirchen*, Berlin, 1969, pp. 39–40, 96; M. H. Pirenne, *Optics Painting and Photography*, Cambridge, 1970, pp. 79–94; P. Wilberg-Vignau, *Andrea Pozzos Deckenfresko in S. Ignazio. Mit einem Anhang: Archivalische Quellen zu den Werken Pozzos*, Munich, 1970; Kerber, *Pozzo* (n. 1 above), *passim*; H. Schadt, 'Andrea Pozzos Langhausfresko in S. Ignazio, Rom. Zur Thementradition der barocken Heiligenglorie', *Das Münster*, 24, 1971, pp. 153–60; P. Vignau-Wilberg, Review of Kerber, *Pozzo* (n. 1 above), *Kunstchronik*, 25, 1972, pp. 73–80; I. Sjöström, *Quadratura. Studies in Italian Ceiling Painting*, Stockholm, 1978, pp. 59–60, 63–7; S. Czymmek, *Die architektur-illusionistische Deckenmalerei in Italien und Deutschland von den Anfängen bis in die Zeit um 1700. Beiträge zur Typologie, Herleitung, Bedeutung und Entwicklung*, Cologne, 1981, pp. 75–6; M. Kemp, 'Perspective and Meaning. Illusion, Allusion and Collusion', in *Philosophy and the Visual Arts. Seeing and Abstracting*, ed. A. Harrison, Dordrecht, Boston, Lancaster, 1987, pp. 255–75; B. W. Lindemann, *Bilder vom Himmel. Studien zur Deckenmalerei des 17. und 18. Jahrhunderts*, Worms, 1994, pp. 109–21; C. Strinati, 'Gli affreschi nella chiesa di Sant' Ignazio a Roma', in De Feo, Martinelli, *Pozzo* (n. 1 above), pp. 66–93; Battisti, ed., *Pozzo* (n. 1 above), *passim*. See also *Malerei aus erster Hand. Ölskizzen von Tintoretto bis Goya*, Rotterdam, 1983, pp. 132–5; P. Fuhring, *Design into Art. Drawings for Architecture and Ornament. The Lodewijk Houthakker Collection*, 2 vols, London, 1989, I, pp. 268–73.

dome (Fig. 2) in Books 1 and 2 of this work.[3] In a pamphlet of 1694, the *Copia d'una lettera*,[4] presumably published on the occasion of the unveiling of the ceiling of the nave, and in the 1702 edition of Book 1 of the *Prospettiva*, he explained its iconography.

This paper will study the approach to questions of composition in ceiling painting in Pozzo's discussions of the S. Ignazio ceilings. None of the writings analysed gives prominence to the term composition, and we shall therefore not be concerned with the history of this word. In his discussions of issues related to composition, Pozzo tends to employ terms denoting the objects of representation such as 'architecture' and 'figures', terms referring to artistic activity such as 'foreshortening' or 'placing', or terms describing the appearance of the work such as 'deceive'. On rare occasions Pozzo also uses 'composition' or 'compose'; these terms, however, are employed to refer only to components of the work in question. The term that in Pozzo's estimation is best suited to encompass pictures in their entirety is 'perspective', as Pozzo's definition of images in the second volume of his *Prospettiva* reveals. Any picture is a 'perspective in colours'. The picture is 'composed' of figures whose size and colour intensity vary in accordance with their position, and it is particularly 'ennobled' by 'beautiful compositions of architecture'.[5]

In writing on the overall construction of a form of imagery where convincing

3. A. Pozzo, *Prospettiva de' pittori e architetti. Perspectiva pictorum et architectorum*, 2 vols, Rome, 1693, 1700; a revised edition of Book 1 was published in Rome in 1702. I have not been able to find the edition of Book 1 dating from 1699, mentioned in Kerber, *Pozzo* (n. 1 above), p. 267. Throughout this paper, I shall use the Italian version of Pozzo's text. On this work see also M. C. Bradley, 'The Perspective of Andrea Pozzo', *Technical Studies in the Field of the Fine Arts*, 6, 1937–8, pp. 2–16; G. Fiocco, 'La prospettiva di Andrea Pozzo', *Emporium*, 97, 1943, pp. 2–9; M. Kemp, *The Science of Art. Optical Themes in Western Art from Brunelleschi to Seurat*, New Haven, London, 1990, pp. 137–40; W. Oechslin, 'Pozzo e il suo Trattato', in Battisti ed., *Pozzo* (n. 1 above), pp. 189–201; L. Salviucci Insolera, 'Le prime edizioni del Trattato', ibid., pp. 207–13. On the publisher, Komarek, who also published Pozzo's own and an anonymous description of the S. Ignazio ceiling (see below), see A. Tinto, 'Giovanni Giacomo Komarek tipografo a Roma nei secoli XVII–XVIII ed i suoi campionari di caratteri', *La bibliofilía*, 75, 1973, pp. 189–225.

4. A. Pozzo, *Copia d' una Lettera scritta da Andrea Pozzo della Compagnia di Giesu Pittore all' Illustrissimo, ed Eccellentissimo Prencipe Antonio Floriano di Liechtenstein Ambasciadore dell' Augustissimo Imperadore Leopoldo Ignazio presso la Santita di Nostro Signore Papa Innocenzo Duodecimo circa alli Significati della Volta da lui dipinta nel Tempio di Sant' Ignazio in Roma*, Rome, 1694. See H. Tietze, 'Andrea Pozzo und die Fürsten Liechtenstein', *Jahrbuch für Landeskunde von Niederösterreich*, 13–14, 1914–15, pp. 432–46 (433–7).

5. 'Mi maraviglio però di alcuni Pittori, che per non voler faticare ad imparar quest' Arte la dissuadono come affatto inutile per le figure. Ma s' ingannano molto importando assaissimo anco per queste, nè vi lasciate però aggirare dalle lor dicerie; se non volete ancor voi incorrere in quelli errori massicci, che nell' opere loro non senza riso si mirano. E pure i Pittori senza accorgersene non altro fanno col loro dipingere, che una colorita prospettiva, ancorche sia composta di figure humane, però conviene ad essi posseder bene queste regole, specialmente à quelli, che hanno occasione di far opere grandi, mostrando il loro sapere nel digradare, e collocare le figure ne' piani, nel dar forza, ò debolezza all' ombre, & à colori, e particolarmente per nobilitar l' opere loro con belle compositioni di architetture; altrimenti non solo non saperanno far queste; ma non potranno far cosa grata à persone intelligenti ne anco nello scorcio di una figura.': Pozzo, *Prospettiva* (n. 3 above), II, 1700, 'Al lettore'.

illusionism was of exceptional importance, Pozzo recreates for us a set of artistic priorities in which the concept of 'composition' as used by many twentieth-century artists could have had little use or meaning. As we resurrect his categories, so we become aware that the task of composing a Baroque ceiling decoration involved difficulties which were not so much aesthetic as optical and practical. In his *Prospettiva*, Pozzo addresses pictorial composition largely with respect to the perspectival composition of architecture and figures, and he employs the vocabulary of linear perspective in doing so. In his *Copia d'una lettera* his statements reveal the extent to which the placing of figures may contribute to their comprehensibility. Even though in his theory the term 'composition' does not hold a central place, we owe to Pozzo some very subtle comments on the characteristics and contradictions of what today can be referred to as pictorial compositions in architectural settings.

It has been implied by a twentieth-century scholar that Pozzo misrepresents the composition of his fresco in the nave of S. Ignazio. In his essay on the importance of oblique views in baroque ceiling decoration of 1961 Wolfgang Schöne argued that this fresco is principally to be viewed from an off-centre position, that is, from near the entrance of the church. When looking at the ceiling from this position, the spectator is, so Schöne claims, made aware of the powerful curvature of the vault, and the illusionistic architecture is embued with dynamism. He moreover points out that many of the figures in the ceiling do not follow the ceiling's perspectival system, but are somewhat inclined forward, and are thus most convincing when perceived from oblique angles of view.[6]

Perhaps the most powerful argument against Schöne's claim is the observation that the illusionistic continuation of the real into the painted architecture, an effect certainly intended by the artist, is lost from oblique viewing positions. But even though one may disagree with his conclusion, Schöne, in turning our attention to the fresco's perspectival and figure composition, opens up the question of the extent to which artists' accounts of their works deserve to be given particular credence.

PERSPECTIVE AND COMPOSITION

The church of S. Ignazio was originally planned with a dome over the crossing. This part of the building, however, met with financial difficulties. The decision was therefore taken to paint an illusionistic dome on a horizontal canvas to be placed at the level of the cornice above the pendentives, and a competition was held, which was decided in Pozzo's favour. His dome (Figs 2, 3), unveiled in 1685, follows the example of the fictive drum Pozzo had painted over the nave of S. Francesco Saverio in Mondovi[7] (Fig. 4) in being designed with an off-centre point of

6. Schöne, 'Schrägsicht' (n. 2 above), p. 152. For an alternative interpretation see Kerber, *Pozzo* (n. 1 above), pp. 98, 105–7; Sjöström, *Quadratura* (n. 2 above), p. 66.

7. On the decoration of S. Francesco Saverio in Mondovi see H. Hammer, 'Andrea Pozzos frühestes Freskowerk', *Monatshefte für Kunstwissenschaft*, 10, 1917, pp. 114–18; O. von Kutschera-Woborsky, 'Zu

convergence: the dome in S. Ignazio is convincing only when viewed from the section of the nave near the dome.[8] Thus, when the fictive dome is viewed from other positions, including the crossing itself, it is distorted to the point of seeming to collapse;[9] it also appears incomplete, since one of its sides is occluded by the cornice.

Throughout his career, Pozzo favoured illusionistic domes seen at oblique angles,[10] even though he acknowledged centrally viewed domes as a possibility. In his discussion of the subject in Book 2 of the *Prospettiva*, Pozzo first provides diagrams and short statements regarding domes constructed for central and off-centre points of observation.[11] All further illustrations and analyses, however, and the discussions of domes in Book 1, are concerned with domes viewed obliquely.[12] In Book 1, Pozzo provides a theoretical justification for this preference:

> I have placed the eye point outside the work, so that the viewer gets less exhausted, and one sees more architecture and artifice, which would not happen if the eye were placed in the centre.[13]

Pozzo adduces both practical and aesthetic considerations to explain the oblique views into his illusionistic domes. Most readers will agree with Pozzo's claim that it is less strenuous to look up at an oblique angle than to study something directly overhead; it is furthermore plausible that one learns more about the architectural details of an illusionistic dome in such an oblique view. The claim of a display of greater art accords with Pozzo's observation in Book 2 that constructions of oblique

Andrea Pozzos Fresken in Mondovì', ibid., pp. 385–8; Kerber, *Pozzo* (n. 1 above), pp. 43–6; G. Dardanello, 'Esperienze e opere in Piemonte e Liguria', in De Feo, Martinelli, *Pozzo* (n. 1 above), pp. 24–41; see also G. Romano, 'Resistenze locali alla dominazione torinese', in *Figure del Barocco in Piemonte. La corte, la città, i cantieri, le provincie*, ed. G. Romano, Turin, 1988, pp. 301–79(374–9).

8. On the illusionistic dome in S. Ignazio see V. Mariani, 'La cupola di Sant' Ignazio nel trattato di prospettiva di Andrea Pozzo', *Roma*, 1, 1923, pp. 432–4; L. Montalto, 'Il ripristino della cupola finta in S. Ignazio nell' idea di Fratel Pozzo', *Capitolium*, 11, 1935, pp. 63–72; id., 'Il problema della cupola di Sant' Ignazio da Padre Orazio Grassi e Fratel Pozzo a oggi', *Bollettino del Centro di studi per la storia dell' architettura*, 11, 1957, pp. 33–62; id., 'La storia della finta cupola di Sant' Ignazio', *Capitolium*, 37, 1962, pp. 393–404; E. Lavagnino, 'Il restauro della cupola di S. Ignazio', *Studi romani*, 10, 1962, pp. 144–50; Kerber, *Pozzo* (n. 1 above), pp. 54–5; M. Carta, 'Le finte cupole', in De Feo, Martinelli, *Pozzo* (n. 1 above), pp. 54–65; P. Vignau Wilberg, 'Le finte cupole e la loro recezione nella Germania meridionale', in Battisti ed., *Pozzo* (n. 1 above), pp. 215–23.

9. Lione Pascoli in his life of Pozzo describes this appearance as 'sformato, e cadente', 'deformed and falling': Pascoli, *Vite* (n. 1 above), p. 696.

10. For discussions of the development of Pozzo's domes see N. Carboneri, 'La finta cupola della chiesa di Badia in Arezzo e le finte cupole di Andrea Pozzo', in *Atti del XII Congresso di storia dell' architettura*, Rome, 1969, pp. 245–59; Kerber, *Pozzo* (n. 1 above), pp. 91–4; S. Casciu, I. Droandi, 'L' inganno e la meraviglia: la finta cupola di Padre Andrea Pozzo nella Badia delle Sante Flora e Lucilla di Arezzo', *Kermes*, 8, 22, 1995, pp. 26–36; Carta, 'Cupole' (n. 8 above).

11. Pozzo, *Prospettiva* (n. 3 above), II, 1700, fig. 49 and the accompanying text.

12. Ibid., I, 1693 edn, Figs 90–92, II, 1700, figs 50–54.

13. 'Il punto dell' occhio l' ho messo fuori dell' Opera, accioche quei che la mirano si stracchino meno, e si scopra più d' architettura e d' artifitio; il che non seguirebbe se la veduta fosse nel mezzo.': Pozzo, *Prospettiva* (n. 3 above), I, 1693 edn, text accompanying fig. 90.

views into domes present greater difficulties than depictions of domes viewed from the centre.[14]

On its unveiling, the dome encountered both fervent admiration and a good deal of criticism, reported by Pascoli.[15] It was observed that the columns resting on corbels are not properly supported, and that the dome is too harshly shaded. Pascoli himself was convinced that the fragility of the chosen medium was the work's main shortcoming, and he foresaw that the surface was likely to turn 'darker than coal', a fear to some extent borne out by the work's later history. One further objection is particularly pertinent in the present context:

> And finally, others criticized his lack of judgement in his choice of the arrange-ment ('partito'), and they said that he should have used figure painting, and should have made it appear concave and visible from everywhere in such a way that it did not seem to collapse from any direction; and he could well have done so, had he thought of it and wanted it.[16]

Pascoli suggests that some viewers would have preferred a dome that did not require an off-centre point of observation, and he points to figurative decoration as one way of achieving this goal. In a dome exclusively painted with figures floating on clouds it can be expected that the decoration will look satisfactory from all directions. The problems Pascoli addresses are germane to Pozzo's chosen specialization, that is, *quadratura*.

In *quadratura* painting, that is, in the depiction of illusionistic architecture in architectural settings, the question of where the point of observation should be placed was affected by mutually contradictory requirements: on the one hand the rules laid out in general terms in treatises on linear perspective, and on the other the desire that decorations should look good within particular buildings and under particular viewing conditions.

Most fifteenth- and sixteenth-century *quadratura* decorations, such as the oculus in Andrea Mantegna's Camera degli Sposi in Mantua (1465–74), the individual bays of Raphael's Logge in the Vatican (1518–19), Cristoforo and Stefano Rosa's ceiling in the Libreria di S. Marco in Venice (1560), Tommaso Laureti's lost ceiling in the Palazzo Vizzani, Bologna (recorded in an engraving of 1562), and Ottaviano Mascherino's decoration in the Sala Bologna in the Vatican (1575), are designed to

14. Pozzo, *Prospettiva* (n. 3 above), II, 1700, text accompanying fig. 49.

15. Pascoli, *Vite* (n. 1 above), p. 696.

16. 'Ed altri finalmente biasimavano il poco giudizio dell' elezione del partito, perchè dicevano, che l' avrebbe dovuto istoriare, e farlo comparir concavo in cotal guisa, e visibile da per tutto senzachè da niuna parte fosse caduto, che ben l' avrebbe potuto fare, se v' avesse pensato, ed avesse voluto.' Ibid. The fact that Pascoli does not comment on the angels floating within the dome, blowing tubas and displaying the escutcheon with the monogram of Christ, suggests that Pascoli, or the critics he quotes, were proposing as an alternative to Pozzo's dome a system of decoration predominantly involving figures instead of *quadratura*.

be viewed from the centre of the respective spaces.[17] This practice was endorsed by contemporary writers on perspective. Egnatio Danti, whose commentary in his edition of Giacomo Barozzi da Vignola's *Due regole della prospettiva pratica* of 1583 was the first text to address *quadratura* decoration of ceilings, maintains that perspectival decorations should always be constructed for central points of observation.[18]

In the seventeenth century, most *quadratura* decorations over the naves of churches were constructed with central points of convergence, be it with regard to the entire nave, or with regard to individual sections of the vault.[19] Such centric compositions could also be employed over crossings, as is documented by the decoration in S. Girolamo degli Schiavoni in Rome, executed to the design of Giovanni Guerra, probably before 1590.[20] Over the crossing of this church, a circle of illusionistic 'Salomonic' columns constructed for a central point of observation surrounds a view into heaven through a circular opening in a flat ceiling.

Gioseffe Viola Zanini, who in his *Della architettura* of 1629 advocates a 'softened' perspective system for perspectival ceilings which avoids steep foreshortening by not employing a single, centrally positioned point of convergence,[21] remained isolated in Italian perspective theory, if not in pictorial practice. The vast number of *quadratura* decorations constructed without recourse to (only) one, centrally positioned, point of convergence left surprisingly little trace in contemporary perspective literature. Among the prominent uncanonical decorations that were discussed in perspective literature we find Baldassare Peruzzi's Sala delle Prospettive in the Farnesina Villa in Rome (c. 1517/19), which was praised by Danti as one of the outstanding achievements of its kind, even though Danti criticised the

17. For brief discussions of these decorations see Sjöström, *Quadratura* (n. 2 above), *passim*, and Kemp, *Science* (n. 3 above), pp. 42–3, 70–72, 82.

18. E. Danti, ed., *Le due Regole della Prospettiva pratica di M. Iacomo Barozzi da Vignola. Con i comentarij del R. P. M. Egnatio Danti dell' Ordine de Predicatori, Matematico dello Studio di Bologna*, Rome, 1583, pp. 86–7.

19. For a very useful survey of Italian baroque church ceilings see Poensgen, *Deckenmalerei* (n. 2 above).

20. See Gloton, *Trompe-l'oeil* (n. 2 above), p. 146 n. 1, pl. XLVIII (with an attribution to Paolo Guidotti); G. Koksa, *S. Girolamo degli Schiavoni (Chiesa nazionale croata)*, Rome, 1971, pp. 127–9 (with an attibution to Andrea Lilio); E. Parma Armani et al., *Libri di immagini, disegni e incisioni di Giovanni Guerra (Modena 1544–Roma 1618)*, Modena, 1978, pp. 23–4, 80 (Guerra is credited with the design, the execution is ascribed to Paris Nogari, with the possible assistance of Guerra himself). On Guerra see also C. Monbeig Goguel, 'Giovanni Guerra da Modena, disegnatore e illustratore della fine del Rinascimento', *Arte illustrata*, 7, 1974, pp. 164–78. The appearance of the decoration does not suggest that the figures and the *quadratura* were executed by the same hand. Paolo Guidotti may have been involved in the execution of the architectural components (which were retouched in the nineteenth century; Koksa, *S. Girolamo*, as above, p. 31). On Guidotti see I. Faldi, 'Paolo Guidotti e gli affreschi della "Sala del Cavaliere" nel Palazzo di Bassano di Sutri, *Bollettino d' arte*, 42, 1957, pp. 278–95; F. d' Amico, 'Su Paolo Guidotti Borghese e su una congiuntura di tardo Manierismo romano', *Ricerche di storia dell' arte*, 22, 1984, pp. 71–102.

21. On G. Viola Zanini, *Della architettura*, Padua, 1629, pp. 34–7, see Sjöström, *Quadratura* (n. 2 above), p. 52; Kemp, *Science of Art* (n. 3 above), p. 137.

fact that the decoration is constructed for an off-centre viewing position.[22] In Peruzzi's case, this position was chosen presumably because beholders were intended to view the decoration primarily from positions along the main axis of movement through the room, that is, the axis linking two doors near the window wall. During the following centuries, off-centre points of convergence in the *quadratura* decorations of secular buildings were on occasion chosen for similar reasons; usually they take account of, or establish, privileged viewing positions. Agostino Tassi's *quadratura* on the ceiling of the Casino delle Muse of the Palazzo Pallavicini-Rospigliosi in Rome (1611–12) is designed to be viewed from near the arches opening onto the garden, thus affording the viewer the double pleasure of nature and art.[23]

In ecclesiastical settings, figurative decorations are frequently designed for off-centre viewing positions. Well-known examples are the ceilings of Giuseppe Cesari's Olgiati Chapel in S. Prassede, Rome (1592–3) and Pietro da Cortona's frescoes in the Chiesa Nuova in Rome (1647–65), each of which is meant to be viewed from a position near the entrance to the interior.[24] In these decorations, the off-centre viewing positions increase the legibility of the depicted narratives because the figures are not foreshortened too steeply. Even in the concentric arrangement of groups of figures that was popular in the decoration of seventeenth-century domes, a main, oblique, viewing direction is usually established by placing the principal figures in such a way that they are best visible from the direction of the nave. In ecclesiastical *quadratura* decorations, on the other hand, off-centre viewing positions are usually chosen only in decorations comprising several illusionistic openings,[25] or in cases where most viewers are not in a position to view the fresco from directly underneath, that is, in the ceiling decorations of family chapels and choirs. Among the decorations of spaces not usually accessible to the common viewer, we find a number of oculus windows crowned by balustrades (e.g. in the first bay of the choir of S. Silvestro al Quirinale, painted by the Alberti brothers in c. 1601)[26] and drums (e.g. Marco Tullio Montagna's decoration above

22. Danti, *Regole* (n. 18 above), pp. 1, 87; see T. Frangenberg, 'Egnatio Danti on the History of Perspective', in *La propettiva. Fondamenti teorici ed esperienze figurative dall'antichità al mondo moderno*, ed. R. Sinisgalli, Florence, 1998, pp. 212–23(214).

23. See Sjöström, *Quadratura* (n. 2 above), pp. 50–51; see also H. Hibbard, 'Scipione Borghese's Garden Palace on the Quirinal', *Journal of the Society of Architectural Historians*, 23, 1964, pp. 163–92 (169–70); I. Mussa, 'L' architettura illusionistica nelle decorazioni romane. Il "Quadraturismo" dalla scuola di Raffaello alla metà del' 600', *Capitolium*, 44, 1969, pp. 41–88(59, 81); T. Pugliatti, *Agostino Tassi tra conformismo e libertà*, Rome, 1977, pp. 21–4.

24. See Schöne, 'Schrägsicht' (n. 2 above), pp. 147–8, 164–72.

25. Sjöström, *Quadratura* (n. 2 above), p. 51.

26. F. Würtenberger, 'Die manieristische Deckenmalerei in Mittelitalien', *Römisches Jahrbuch für Kunstgeschichte*, 4, 1940, pp. 59–141(111–13); M. C. Abromson, 'Clement VIII's Patronage of the Brothers Alberti', *Art Bulletin*, 60, 1978, pp. 531–47(533); K. Herrmann-Fiore, *Disegni degli Alberti. Il Volume 2503 del Gabinetto nazionale delle stampe*, Xenia Quaderni 4, Rome, 1983, pp. 93–6.

the choir of S. Sebastiano al Palatino of 1631).[27]

This short review of the tradition of ceiling decoration allows us to assess in what ways Pozzo's illusionist dome in S. Ignazio departs from tradition. A centrally constructed dome would have been an option, as Pozzo's *Perspettiva* attests and the decoration in S. Girolamo degli Schiavoni further documents. Off-centre views onto balustrades placed above oculus windows, or onto drums (but not the depiction of complete domes), were common in spaces that were not generally accessible, and therefore had to look convincing from oblique viewing directions. In S. Francesco Saverio in Mondovi, Pozzo adopted this latter visual convention in his illusionist drum over the centre of the nave (Fig. 4), a part of the church accessible to everyone. This drum, and the apotheosis within it, are to be viewed from a point near the entrance to the church; as we have seen, such a viewing position is indebted to a number of earlier, predominantly figurative, ceiling decorations. In S. Ignazio, Pozzo depicts an off-centre view onto an entire dome over the easily accessible crossing of the church. In doing so, Pozzo makes it impossible to enjoy the benefit of perspectival illusion from vantage points underneath the painting itself, but on the other hand makes the artifice of the dome visually accessible to viewers in the nave of S. Ignazio, an area of the church that Pozzo may well have hoped to decorate in the future when he was working on the dome in 1685.

In spite of the criticism levelled at his illusionistic dome, Pozzo was awarded the commission to paint the conch of the apse and the pendentives of the dome, frescoes executed between 1685 and 1688.

27. L. Gigli, *S. Sebastiano al Palatino*, Rome, 1975, pp. 100–104; see also Gloton, *Trompe-l'oeil* (n. 2 above), pp. 135n. 1, 145, pl. LI. This decoration is commonly ascribed to Bernardino Gagliardi. However, none of the discussions of the authorship of this decoration refers to the following text: P. A. Uccelli, *La chiesa di S. Sebastiano M. sul Colle Palatino e Urbano VIII P. M.*, s.l, s.d. [last quarter of the nineteenth century; a copy in the Bibliotheca Hertziana, Rome], p. 9: 'Sopra si veggono belle pitture a fresco: tra le altre una assai espressiva rappresentante Irene che cava le frecce dal corpo di san Sebastiano, del Montagna, scolaro del Zuccari, come risulta da una iscrizione sotto i medesimi affreschi nella cupola: Marchus Tullius Montagna pictor fecit anno Domini 1631.' The inscription is no longer visible, but its content is entirely plausible. The church was restored on order of Urban VIII, and under the patronage of Taddeo Barberini, in 1630–1 (see Gigli, *S. Sebastiano*, as above, pp. 45–6; O. Pollak, *Die Kunsttätigkeit unter Urban VIII.*, 2 vols, Vienna, 1928–31, I, pp. 193–5). During a restoration campaign on behalf of another member of the same family, Cardinal Francesco Barberini, Montagna decorated the clerestory and ceiling of the church Santi Cosma e Damiano in Rome between 1632 and 1635; see Pollak, *Kunsttätigkeit*, as above, pp. 122–3; G. Matthiae, *SS. Cosma e Damiano*, Rome, [1960], p. 38; P. Chioccioni, *La Basilica e il Convento dei Santi Cosma e Damiano in Roma*, Rome, 1963, pp. 125–6, 132. In the immediate topographical vicinity to these buildings Montagna executed further decorations, including the extant wall and ceiling decorations in the oratory and sacristy next to S. Giuseppe dei Falegnami of 1631–7; see G. Zandri, *S. Giuseppe dei Falegnami*, Rome, 1971, pp. 31, 33–4, 65. The stylistic proximity of all these decorations further confirms Montagna's authorship of the frescoes in S. Sebastiano. On Montagna see M. L. Pozzi, 'Riscoperta di un pittore velletrano: Marco Tullio Montagna', in *Seicento e Settecento nel Lazio* , ed. R. Lefevre, Lunario Romano, 10, Rome, 1980, pp. 111–27; D. J. Johnson ed., *Old Master Drawings from the Museum of Art, Rhode Island School of Design*, Providence, Rhode Island, 1983, pp. 36–40.

We are well informed about the circumstances under which Pozzo received the commission to paint the vault over the nave of S. Ignazio (Fig. 1). A document of 1688 in the Jesuit Archive in Rome records the deliberations as to whether the church ceiling should be decorated, and if so, by what painter.[28] After it was decided that the commission should be awarded to Pozzo, the panel agreed on the following:

> Brother Pozzo will adhere to that theme which will be judged best among those suggested; he will prepare the design on an image 16 spans long and 8 wide, and in such a way that one enjoys the beauty of the figures and of the architecture not only from one point, but from all sides; and it will not be executed, if not approved beforehand by the principal painters and the Father General.[29]

It is interesting that during the lengthy considerations regarding the ceiling the assembled Jesuits addressed questions relating to the composition, and in particular the perspectival composition, but did not think it necessary to decide upon the iconography, even in a preliminary form. Several of Pozzo's statements reveal that the iconographic programme later employed for the decoration was devised by the painter himself.[30] The requirement of a *modello*, to be inspected by both experts and the patron, was common in the relation of painters and patrons in the seventeenth century. The stipulation that the work should be beautiful from all points of view, however, is unusual; it is most probably a reaction to Pozzo's recently completed illusionistic dome.

In his nave ceiling, unveiled in 1694, Pozzo conformed with and contravened the stipulations formulated by the committee in equal measure. In accordance with the tradition of *quadratura* decorations in church naves, a central vanishing point is chosen, and the depicted architecture is thus complete from wherever it is beheld; furthermore, of all possible points of convergence, a central vanishing point introduces the least possible distortion. However, it is unavoidable even in decorations constructed with one central point of convergence that the depicted architecture is the more conspicuously distorted, the more the viewer walks away from the predetermined viewing position.[31]

Pozzo's first statements about the fresco in the nave of S. Ignazio and its

28. Wilberg-Vignau, *Deckenfresko* (n. 2 above), pp. 33–5.

29. Ibid. p. 35: 'Il fr. Pozzo si fermarà sul pensiero, che sarà giudicato tra quanti si proporranno il migliore; ne farà il disegno in un quadro longo sedici palmi, e largo otto, e in tal modo che non da un solo punto, ma da ogni parte si goda il bello delle figure e dell' Architettura; non si porrà in opera, se prima non sarà approvato da primarij Pittori, e dal P. Generale.' On this *modello* see *Malerei aus erster Hand* (n. 2 above), pp. 132–5.

30. See below.

31. Vignau-Wilberg's contention in his review of Kerber's monograph (n. 2 above, p. 75) that the request of a beautiful appearance 'da ogni parte' relates principally to the representation of figures is implausible in the light of the quotation (n. 29 above), in which both figures and architecture are referred to.

composition appear in the first edition of Book 1 of the *Prospettiva*, published in 1693 when the ceiling was not yet completed. In the context of his analysis of the ceiling's perspective scheme, Pozzo underlines the necessity of one central point of convergence in ceiling decorations as long as they depict one continuous space which is to be taken in by the eye in one glance.[32] If more than one point were employed, the decoration could not be viewed from any one point, and viewers walking through the nave would gather no more than a succession of plausible fragments that never assemble into one convincing whole. Pozzo is convinced that since perspective decorations are no more than fiction ('mera fintione del vero'), they fulfil their purpose when they work from one point of observation; they do not need to look successful from all angles as is required of real buildings.

This is not to say that all decorations in a church building must be constructed for only one viewing position. Since the length of buildings is often such that comfortable viewing would not be possible from one standpoint, Pozzo recommends that the individual sections such as the apse, the dome and the nave vault should be constructed for separate viewing positions. However, Pozzo's dome, intended to be viewed from a position in the nave near the crossing, reveals that even in such cases Pozzo attempts to place the points of observation as close to one another as possible. Subdivision into independently constructed sections is recommended also for long, low rooms, even though in the 1702 edition of Book 1 of the *Prospettiva* Pozzo points out that 'it would create a much more ingenious effect even in such situations to employ a single point, as I did in the Corridor of the Gesù in Rome' (Fig. 5).[33]

Pozzo maintains that the convergence towards the centric point must govern all elements of the composition:

> Lastly, if you do not wish to incur errors which cannot be corrected, bear in mind that the rule of the *sotto in su* is necessary no less for figures of men or animals than for columns or cornices.[34]

32. Pozzo, *Prospettiva* (n. 3 above), I, 1693 edn, text following fig. 100. We have no clear indication that Pozzo understood the perspective construction he employed in the nave of S. Ignazio, and in particular the point of convergence, in a specific metaphoric or symbolic way, as is suggested in Kemp, 'Perspective' (n. 2 above), p. 262. The one time Pozzo does provide such a reading, he speaks of any perspective operation and indeed any other action that the reader and apprentice perspective practitioner may undertake, rather than of his own work, or even the fresco in S. Ignazio: 'Cominicate dunque o mio Lettore allegramente il vostro lavoro; con risolutione di tirar sempre tutte le linee delle vostre operationi al vero punto dell' occhio che è la gloria Divina.': Pozzo, *Prospettiva* (n. 3 above), I, 1693 edn, Al Lettore. Only in the very general sense that Pozzo wished to do in honour of the Lord whatever he did (and encouraged others to do likewise) can this passage be adduced in an interpretation of the S. Ignazio fresco. Similarly, the very general moral assertion originally engraved on the marble disc (see n. 42 below) hardly documents an intended symbolic level of meaning of the ceiling.

33. 'molto più ingegnoso effetto farebbe ancor' in simili occasioni constituir un sol punto, come fec' io in un Corridore del Gesù in Roma.': Pozzo, *Prospettiva* (n. 3 above), I, 1702 edn, text accompanying fig. 101. On the Corridor see below.

34. 'Per ultimo, se non volete incorrere in errori da non poterli emendare, persuadetevi, che la regola

Pozzo's emphatic statement is directed at the many painters who applied perspective constructions only to straight-edged objects, and in particular to pavements and other architectural elements, leaving the depiction of irregular bodies such as human figures to rule of thumb and visual estimate. There was wide agreement among theorists and painters that perspective allowed the practitioner to depict figures in a size appropriate to their position in the picture. Very few theorists or practitioners, on the other hand, maintained that the foreshortening of individual human figures seen from beneath required a construction involving linear perspective. In fact, during Pozzo's lifetime the *quadratura* and the figures of large-scale decorations were frequently executed by different artists, a perspective specialist and a figure painter.

The conventions of perspective theory contributed to these developments: with very few exceptions perspective treatises, including Pozzo's own, illustrate and discuss inanimate objects, usually characterized by simple geometrical shapes, rather than human bodies. When, later in his treatise, Pozzo returns to the discussion of figures subjected to correct perspectival construction, he again gives the reader no guidance as to how his suggestion should be implemented:

> every section of the perspective representation, be it of architecture or figures, must necessarily on all sides be foreshortened towards this point [of convergence].[35]

A look at Pozzo's earlier works, as far as they are extant today, may give us some impression of the artistic experiences on which such statements were based. In Mondovì, Pozzo had painted St Francis Xavier baptising in the apse, and the glory of the same saint in the illusionistic opening surrounded by an ornate drum over the nave (Fig. 4).[36] As both of these works are designed to be viewed from off-centre positions, the architecture is shown at oblique angles no less than the figures. The legibility of the latter is therefore entirely satisfactory. Likewise, the earliest decorations in S. Ignazio, the dome, the conch of the apse, and the spandrels, are designed to be viewed along oblique lines of sight.[37]

The corridor in front of the rooms of St Ignatius in the Casa Professa (Fig. 5), painted between 1682–5, is constructed for a central point of observation,[38] marked

del sotto in su, non è meno necessaria per le figure d' huomini o d' animali, che per le colonne o cornici.': Pozzo, *Prospettiva* (n. 3 above), I, 1693 edn, text accompanying fig. 100.

35. 'è necessario che à questo punto debba da ogni parte ridursi ogni tratto di prospettiva, siasi di architettura, ò di figure.': ibid., text following fig. 100.

36. See n. 9 above.

37. Kerber, *Pozzo* (n. 1 above), pp. 54–62; Strinati, 'Gli affreschi' (n. 2 above), *passim*.

38. Kerber, *Pozzo* (n. 1 above), pp. 50–54; M. De Luca, 'Gli affreschi di Andrea Pozzo nella Galleria del Gesù a Roma: confronto tra pittura e trattatistica', *Kermes*, 5, 14, 1992, pp. 27–31; D. Gallavotti Cavallero, 'Gli esordi pittorici a Roma: il Corridoio del Gesù e la Cappella della Vigna', in De Feo, Martinelli, *Pozzo* (n. 1 above), pp. 42–53; T. Lucas, 'La Galleria del Pozzo nella Casa Professa a Roma', in Battisti, ed., *Pozzo* (n. 1 above), pp. 141–3; M. De Luca, 'Gli affreschi della Galleria del Gesù a Roma',

by a richly adorned marble disk inserted into the floor. When viewed from off-centre positions, the architectural elements of the decoration assemble into absurd configurations. The same holds for those figures that are to be read as three-dimensional, and are positioned in the sections of the decoration furthest removed from the central point. Whereas window grilles, and the depicted pictures decorating the corridor, are undistorted, to be seen foreshortened as they would be in reality under similar circumstances, the geometry of anamorphosis demands that three-dimensional objects must be distorted to the extent that the surfaces bearing them are positioned at oblique angles to the axis of sight. They are contracted and perceived as naturally proportioned when they are looked at from the pre-determined point (Figs 6–8).[39] No decoration created by Pozzo more emphatically subjects both architecture and figures to the geometry ensuing from the centrally placed eye point.

Perhaps in response to the deliberations of 1688, and no doubt with the spectacular success of his corridor in mind, Pozzo claims that distortion is a virtue:

> If because of the irregular surface the architecture looks somewhat deformed when viewed from positions other than the main point, and if the figures appearing within the architecture also display some deformations when viewed from a position other than the common point, this is excused by the reasons already adduced; it is furthermore not a defect, but confirms the merit of the art which from its [correct] point [of observation] makes appear proportional, straight, flat or concave what is not so.[40]

In this interesting sentence Pozzo defines the success of perspective decorations in terms of spectator behaviour and spectator response. Pozzo – entirely plausibly – assumes a viewer who is moving through the building, observing the fresco decoration from a variety of points, perceiving distortion, and responding to such distortion with even greater admiration for the artistry involved when he accepts the rules of the game and seeks out the correct point of observation.

Towards the end of his *Copia d'una lettera*, Pozzo confirms the importance of the central point of observation in somewhat less emphatic terms. Here he states that the S. Ignazio ceiling looks more beautiful ('si mira più vagamente') from the centre

ibid., pp. 145–52.

39. On anamorphosis and the geometry of the visual angle see J. Baltrušaitis, *Anamorphoses ou perspectives curieuses*, Paris, 1955; T. Frangenberg, 'The Angle of Vision: Problems of Perspectival Representation in the Fifteenth and Sixteenth Centuries', *Renaissance Studies*, 6, 1992, pp. 1–45.

40. 'Se poi à cagione del sito irregolare l' architettura fuori del punto si deformi(no) alquanto: e se le figure tramezzate nell' architettura fuori del punto commune havrann' anch' esse qualche deformità; ciò oltre che è scusato dalle ragioni già dette, non è difetto mà lode dell' arte, che dal suo punto fà parer proportionato, diritto, piano, ò concavo ciò che tale non è.': Pozzo, *Prospettiva* (n. 3 above), I, 1693 edn, text following fig. 100. On this section see Kemp, 'Perspective' (n. 2 above), p. 258 and *passim*; on the question of distortion see also De Feo, 'L'architettura' (n. 1 above), pp. 88, 96.

of the nave than from any other position.[41]

In spite of their initial stipulation in the document of 1688, the Jesuits endorsed the central viewing position in the nave of S. Ignazio. A marble disc inserted into the floor marks the centre of the nave. The disc is first mentioned by an early-eighteenth-century tourist to Rome,[42] and it is probable that it was put in place during Pozzo's lifetime, perhaps at his instigation.

Pozzo's bold claim that the distortion of figures and architecture contributes to the artistic success of the decoration, as long as the viewer eventually seeks out the privileged point, was written down before the ceiling painting was completed. Only during the execution of the nave fresco does Pozzo appear to have recognized that a strict adherence to his own rules was not necessarily desirable in a church decoration designed for a central point of observation. It has frequently been observed in recent scholarship that many of the main figures in the S. Ignazio fresco are inclined forward, that is, that they are not foreshortened in accordance with the central point of convergence.[43] This oblique position, particularly obvious in the figures surrounding St Ignatius and in the allegories of the four continents, guarantees that we see more of the numerous floating figures than the soles of their feet. The reduced degree of foreshortening contributes to both legibility and decorum, and can also be seen as a further response to the stipulation of 1688 that the fresco should be beautiful not only from one viewing position. There is no point in the nave of S. Ignazio from which one does not have a plausible view onto at least some figures.

In the 1702 edition of Book 1 of the *Prospettiva*, Pozzo devotes several paragraphs to the description of the composition and iconography of his fresco. In one of these he states that the fresco suggests the destruction of the vault above the level of the windows. Above the springing of the vault Pozzo devised what he calls a 'noble architecture' through which the viewer's glance penetrates heaven.[44] The illusionist negation of much of the vault does not, however, exclude an impact of

41. Pozzo, *Copia* (n. 4 above), n.p.

42. Ibidem [in S. Ignazio] humi in lapide rotundo centrali:
 In medio virtus sua sic miracula pandit
 Ars melius medium sic tenet illa suum.

J. C. Nemeitz, *Inscriptionum singularium, maximam partem novissimarum, Fasciculus*, Leipzig, 1726, p. 137. See also Kerber, *Pozzo* (n. 1 above), p. 95. Pozzo does not refer to the marble disk himself. Notes referring to the disk in later editions of Pozzo's *Copia d' una Lettera* (*Significati delle Pitture fatte nella Volta della Chiesa di S. Ignazio di Roma dal celebre Pittore P. Andrea Pozzi della Compagnia di Gesù spiegati dal medesimo Autore in una Lettera ...*, Rome, 1828, p. 6; *Sui significati delle pitture esistenti nella volta della chiesa di S. Ignazio in Roma*, Rome, 1910, p. 7) were added by the editors.

43. E.g., see Schöne, 'Schrägsicht' (n. 2 above), p. 152; Wilberg-Vignau, *Deckenfresko* (n. 2 above), pp. 12–14; Kerber, *Pozzo* (n. 1 above), pp. 104–5.

44. 'Immaginiamoci dunque che sia gettata à terra mezza la volta, cioè quella che appoggiavasi sopra le finestre, e si veda il cielo, e che sopra i vivi di quelle muraglie e risalti avanzati da l' istessa volta si voglia con ottima regola distribuire la pianta d' una nobil' Architettura.': Pozzo, *Prospettiva* (n. 3 above), I, 1702 edn, text accompanying fig. 95.

the vault's curvature on the perception of the painted architecture when it is viewed from off-centre positions. Rephrasing the section on distortion, Pozzo in the 1702 edition of Book 1 writes:

> Bear in mind that such works, in order to deceive the eye easily, must have a fixed and predetermined point from which they must be viewed, so that the viewer does not perceive the deformations and distortions which the curvature and irregularity of the vault tend to cause; thus all the displeasure such works could generate in the viewer when looked at from the wrong position, is compensated for by an equal amount of pleasure when they are beheld from the correct and single point.[45]

In rewriting this section, Pozzo no longer emphasises the importance and value of distortion perceived by the viewer. Admiration for the artistic merit of the decoration which Pozzo predicted in 1693, before he had tackled the problems posed by the S. Ignazio ceiling, gives way to 'displeasure' when the fresco is viewed from off-centre positions, and in fact he no longer implies that viewers will look at the ceiling from a variety of points. The behaviour Pozzo now envisages is that of a visitor immediately searching out the required point of observation to avoid viewing distortion.

The rephrasing of the statement on distortion in ceiling painting is revealing also in that Pozzo no longer maintains that figures should be foreshortened in the same way as architecture. For the beginning of Book 2 of his treatise, first published in 1700, Pozzo had written another, more general discussion of figures in perspective pictures where he makes no reference to ceiling painting,[46] and in 1702, in the second edition of Book 2, he omitted any reference to figures in his discussion of the central point of convergence in ceiling paintings. There can be little doubt that this change of attitude towards the way figures should be depicted on ceilings is a pragmatic response to the experience of executing the fresco. He came to understand that close adherence to perspective rules may not be feasible when an iconographic programme is to be conveyed clearly.

Such pragmatism is not isolated in Pozzo's treatise, and even affected Pozzo's understanding of the relation of artist and client. If the viewing distance with regard to a particular decoration is too short, and the *modello* will therefore look distorted, Pozzo suggests that the patron should be shown a drawing constructed for more normal conditions, and thus lacking distortion, but that the painter should secretly

45. 'E persuadetevi, che simili opere, accioche possino facilmente ingannar l' occhio devono havere un punto stabile, e determinato, onde siano rimirate, accioche non appariscano al risguardante quelle deformità, e storcimenti, che la curvità & irregolarità delle volte suole far nascere, e così tutto quel dispiacere, che potrebbono cagionar nello spettatore simili lavori rimirati dal punto non suo, sarà compensato con altretanto diletto, qualhora saranno risguardati dal suo vero, & unico punto.': Pozzo, *Prospettiva* (n. 3 above), I, 1702 edn, text accompanying fig. 101.

46. See n. 5 above.

employ a mathematically correct drawing.[47]

Pozzo's two versions of Book 1 of the *Prospettiva* reflect the tensions implicit in the painting of a perspectival ceiling. Although it is designed to be viewed from one point, it is not usually viewed from this point by the majority of viewers. Furthermore, if it is constructed coherently, it runs the risk of endangering the legibility of the figures. In omitting his positive comments on the effects of off-centre views and in eliminating references to figures in ceiling painting from the 1702 edition, Pozzo indicates that he increasingly learnt to accept the fact that the conflicting demands of perspectival ceiling painting cannot be fully reconciled.

DESCRIPTIONS

As much as Pozzo's understanding of perspectival composition, his approach to the task of describing his work changed over time.

The *Copia d'una lettera* of 1694 seems to be the earliest description of the S. Ignazio ceiling to have appeared in print. The pamphlet consists of a letter to Prince Anton Florian of Liechtenstein, Imperial Ambassador to the Holy See,[48] who had taken an interest in Pozzo's fresco even before its completion, and wished to be informed about the iconography ('significati') of the work.

In the opening words of his description, Pozzo makes it clear that he was the author of the programme:

> The first inspiration I had to devise this idea [i.e. programme] came to me from these sacred words: 'I have come to set fire to the earth, and how I wish it were already kindled!'[49]

This Bible quotation (Luke 12, 49) is incorporated into the fresco itself: it appears, spread over two cartouches, in the centres of each of the short sides, above the arch leading to the crossing and above the façade respectively. Pozzo does not, however, refer to these escutcheons, but begins his description with the iconographic and compositional centre of the fresco: 'in the middle of the vault' Christ sends a light ray to the heart of St Ignatius, and from there it is reflected to the allegories of the four parts of the world placed at the springing of the vault ('nelle quattro Imposte della Volta'); a second ray is sent by Jesus towards a shield bearing His name. The description makes clear that central placing is one of the principal devices in the ceiling's composition to assist the viewer's understanding of the iconography. Pozzo then turns the reader's attention to the short sides of the vault, where he depicts the flames of Divine love towards the crossing, and the flames of

47. Pozzo, *Prospettiva* (n. 3 above), I, 1693 edn, text accompanying fig. 88.

48. See J. von Falke, *Geschichte des fürstlichen Hauses Liechtenstein*, 3 vols, Vienna, 1868–82, III, pp. 4–13; Tietze, 'Pozzo' (n. 4 above).

49. 'Il primo lume che hebbi a formar questa Idea mi venne da quelle Sacre parole: *Ignem veni mittere in terram, & quid volo nisi ut accendatur*': Pozzo, *Copia* (n. 4 above), n.p.

the fear of Divine punishment on the side of the entrance wall.

Up to this point, Pozzo's references to the composition of the fresco focused on the figures, suggesting that the placing at the centre, along the springing of the vault, or at either end along the central axis clarifies or even constitutes the meaning of figures or figure groups. Only towards the end of the description does he address the architectural framework that provides a setting for the configuration of figures: 'The body that encloses figures so varied is an artful architecture in perspective which serves as background for the entire work'.[50]

The few descriptions of Roman ceilings that were published in the form of pamphlets during the seventeenth century do not provide a clear model regarding the manner in which ceiling paintings should be discussed. Rosichino's explanation of Pietro da Cortona's Barberini ceiling, published a year after the fresco's completion, in 1640, begins with the remark that the fresco is subdivided into five sections; the description then turns to the iconography of the individual parts in turn, starting with the field in the centre of the ceiling.[51] Francesco Zanoni's account of Filippo Gherardi's ceiling in S. Pantaleo, written in 1690, opens with general statements about the main subject of the ceiling, and then continues with a very detailed description of the architectural structure of the church and the illusionistic architecture of the fresco before turning to the iconography.[52] Lodovico David's explanation of the dome he had painted in the Collegio Clementino, published by Komarek in 1695, on the other hand, starts with comments on the iconography of the fresco and touches upon matters of composition only regarding individual sections of the fresco.[53] This order of the description is perhaps due to the fact that the dome displays the figures in a conventional circular configuration which David perhaps considered too obvious to require any analysis; his dome lacks the *quadratura* framework so prominent in Cortona's, Gherardi's and Pozzo's ceilings and in their descriptions.

That the order of Pozzo's description was perceived as disadvantageous is revealed by a second description of the S. Ignazio ceiling published in the same year and by the same publisher, Komarek,[54] and by Pozzo's own response to this text.

50. 'Il Corpo poi che racchiude in sè tanto varie Figure si è un' artificiosa Architettura in Prospettiva, che serve di campo a tutta l' Opera.': ibid.

51. M. Rosichino, *Dichiaratione delle Pitture della Sala de' Signori Barberini*, Rome, 1640, pp. 5 ff.; repr. in *Il Voltone di Pietro da Cortona in Palazzo Barberini*, Quaderni di Palazzo Venezia 2, Rome, 1983, pp. 109–10, and J. B. Scott, *Images of Nepotism. The Painted Ceilings of Palazzo Barberini*, Princeton, NJ, 1991, pp. 216–19 (for an analysis of Rosichino's text see ibid., pp. 136–45 and *passim*, and M. A. Lee, '*Hic Domus*: The Decorative Programme of the Sala Barberina in Rome', PhD diss., The Johns Hopkins University, 1993, pp. 12–25, *passim*.

52. F. Zanoni, *La nuova Pittura, Opera del Signor Filippo Gherardi da Lucca, sù la Volta, e Tribuna della Chiesa di San Pantaleo de Chierici Regolari Poveri della Madre di Dio delle Scuole Pie di Roma*, Rome, 1690.

53. See T. Frangenberg, 'The Geometry of a Dome: Ludovico David's *Dichiarazione della Capella del Collegio Clementino di Roma*', *Journal of the Warburg and Courtauld Institutes*, 57, 1994, pp. 191–208, for a transcription and discussion of this text.

54. *Breve Descrittione della Pittura fatta nella Volta del Tempio di Sant' Ignazio scoperta l' Anno*

The second description was not written by Pozzo – references to his authorship of the iconographic programme are entirely absent – and probably not even by an artist. Art theoretical terms employed by Pozzo such as 'imposte' (springing) and 'campo' (background) are avoided, even though numerous parallels reveal that the second writer was well-acquainted with Pozzo's description which he apparently aimed to make more commonly accessible. Perhaps the writing of the second pamphlet was instigated by Komarek, when the notoriety of Pozzo's fresco became obvious.

The second account introduces a number of clarifications. Most importantly, the author revises Pozzo's way of verbalising the relation of architectural and figurative elements of the composition: after a reference to the overall theme of the ceiling, that is, the work of St Ignatius and his followers, the main body of the description begins with a comment on the illusionistic architecture, and only then addresses the iconography, proceeding from the centre outwards:

> On the vault of the church the author forms a building in perspective with an opening, in the middle of which appear the Eternal Father, the Divine Spirit, and the Word Made Man from whose chest a living source of splendours gushes forth...[55]

Later in his description, the anonymous author reflects the appearance of the fresco more closely than Pozzo in referring to Luke 12, 49 only when talking about the short sides of the fresco, and in discussing the positions and subjects of the medallions and other decorations surrounding the windows.[56] The anonymous author closes his text with an appeal to the readers' piety, and their creative intelligence: from the few details that are mentioned in the description one may arrive at an understanding of the many elements contained in the work.[57]

The second description of the S. Ignazio ceiling published by Pozzo in the 1702 edition of the *Prospettiva*[58] provides striking evidence to the effect that Pozzo did not consider an artist's account of his own work as unassailable – he adopted in his new text all the important changes introduced by the anonymous author. Following a short reference to the overall subject, a comment on the visual organization of the fresco is now placed at the beginning of the description itself. Pozzo states: 'Firstly, I embraced the entire vault with a building in perspective';[59] he closes his text with an appeal to the intellectual participation of the reader modelled on that of the

MDCXCIV per la Festa del medesimo Santo, Rome, 1694.

55. 'Forma adunque l' Autore nella Volta del Tempio un Edificio in Prospettiva con un apertura, in mezzo della quale compariscono l' Eterno Padre, il Divin Spirito, e l' Humanato Verbo, dal di cui petto scaturisce una viva sorgente di splendori ...': ibid. pp. 1–2.

56. Ibid., pp. 2–3.

57. Ibid. p. 3.

58. Pozzo, *Prospettiva* (n. 3 above), I, 1702 edn, text accompanying fig. 100.

59. 'In primo luogo abbracciai tutta la volta con un Edifizio in Prospettiva.' Ibid.

anonymous author.

In Pozzo's second description, the reader's understanding is helped by introductory information on the compositional framework of the fresco. Of Pozzo's descriptions, only the second adequately reflects the degree to which the painted architecture determines the viewer's impression of this work.

An analysis of Pozzo's statements about his ceiling decorations in S. Ignazio is interesting not only because they provide more information than is available for any other decoration painted in Rome during the seventeenth century, but also because they demonstrate changes in Pozzo's understanding of his artistic and literary means. The experience of painting the nave of S. Ignazio changed his assessment of viewer responses to architectural composition, and his approach to figure composition. The reading of the contemporary description of the ceiling taught him how best to communicate in his own description the impact on the viewer of the architectural and figurative elements of this work. The increasing sophistication of Pozzo's approach to the composition of ceiling decorations becomes apparent only by 'reading', to coin a phrase, 'between the texts'.

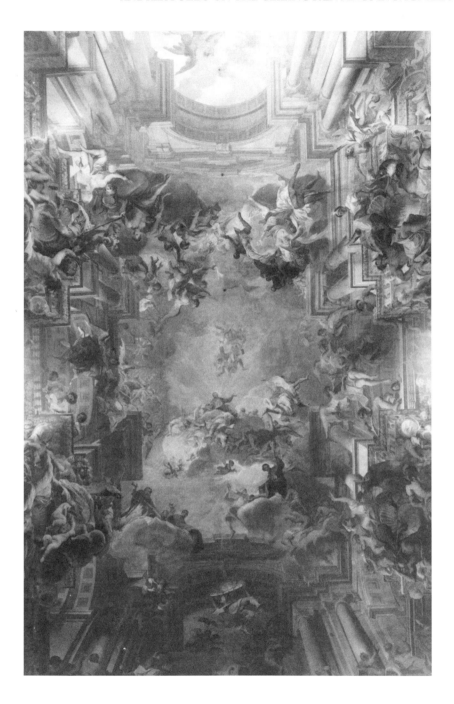

Fig. 1. Andrea Pozzo, ceiling fresco over the nave, S. Ignazio, Rome.

Fig. 2. Andrea Pozzo, illusionist dome over the crossing, S. Ignazio, Rome.

Fig. 3. Andrea Pozzo's dome viewed from below, the viewer facing the nave.

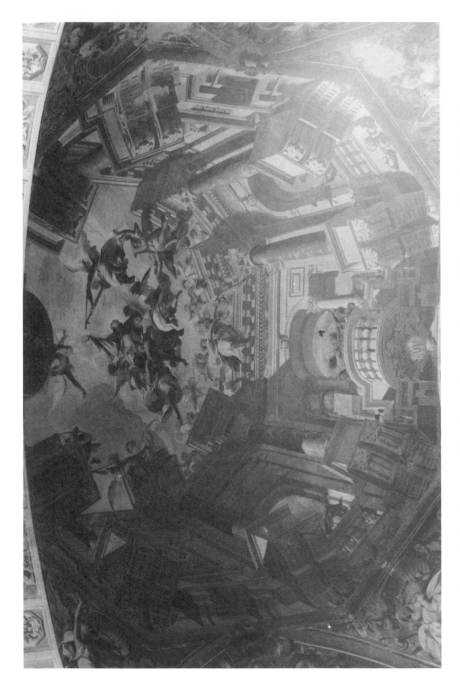

Fig. 4. Andrea Pozzo, ceiling decoration over the nave, S. Francesco Saverio, Mondovi.

Fig. 5. Andrea Pozzo, fresco decoration. Corridor, Casa Professa, Rome

Fig. 6. Andrea Pozzo, two angels (compare Fig. 5) viewed head-on.
Corridor, Cas Professa, Rome

Fig. 7. Andrea Pozzo, detail of the ceiling decoration viewed from below,
Corridor, Casa Professa, Rome.

Fig. 8. Andrea Pozzo, detail of the ceiling decoration (compare Fig. 7) viewed from the correct point, Corridor, Casa Professa, Rome.

La Théorie de la composition dans le *De pictura veterum* de Franciscus Junius: une transition entre Alberti et l'Académie

Colette Nativel

Publié à Amsterdam en 1637, le *De pictura veterum* de Junius[1] est, comme le remarquait Jacques Thuillier[2] dans un article déjà ancien, exactement contemporain du moment où, à Rome, Poussin commence à peindre *Les Israélites recueillant la manne*. Certes, à cette date, le Français n'avait pas entre les mains le *De pictura* qu'il ne mentionnera que bien après, en 1665, dans une lettre fameuse à Fréart de Chambray.[3] Il n'en reste pas moins que l'année 1637, en même temps qu'elle marque un tournant important dans la pensée de l'art, est celle d'une exceptionnelle rencontre entre une théorie et une pratique picturale. L'apport du *De pictura* à la théorie de la composition qui se mettra en place dans la seconde moitié du XVIIe siècle n'a pourtant pas été assez souligné. Or, il est remarquable aussi que, trente ans après sa publication, exactement, Le Brun reprendra justement les mots de Junius pour analyser *Les Israélites recueillant la manne* devant l'Académie et exposer une méthode de lecture et un exemple de composition qui étaient devenus la vulgate de la théorie de l'art moderne.[4]

Je tenterai donc de montrer l'apport spécifique du *De pictura veterum* à la théorie de le composition telle que les théoriciens de l'art français – et en particulier Roger de Piles[5] – purent la formuler à la fin du XVIIe siècle.

1. *De pictura veterum libri tres*, Amstelaedami, 1637; 2e éd., *De pictura libri tres, tot in locis emendati, et tam multis accessionibus aucti, ut plane novi possint videri: accedit Catalogus, adhuc ineditus, architectorum, mechanicorum, sed praecipue pictorum, statuariorum, caelatorum, tornatorum aliorumque artificum, et operum quae fecerunt, secundum seriem litterarum digestus*, Roterodami, 1694 (= *De pictura veterum*). C'est à cette édition que je renvoie, sauf pour le livre I, que je cite dans mon édition: Genève, 1996 (= *De pictura veterum* [1996]). Traduction anglaise: *The painting of the ancients, in three bookes: declaring by historicall observations and examples, the beginning, progresse, and consummation of that most noble art. And how those ancient artificers attained to their still so much admired excellencie. Written first in latine by Franciscus Junius, F. F. And now by him englished, with some additions and alterations*, London, 1638. Je cite de l'édition Keith Aldrich, Philipp and Raina Fehl, *The Literature of Classical Art; According to the English Translation (1638)*, Berkeley, 2 vols, 1992.

2. Jacques Thuillier, 'Temps et tableau: la théorie des péripéties', dans *Stil und Überlieferung in der Kunst des Abenlandes. Akten des 21. Internationalen Kongresses für Kunstgeschichte in Bonn, 1964*, Berlin, 1967, III, pp. 196–206.

3. Nicolas Poussin, *Lettres et propos sur l'art*, textes réunis et présentés par A. Blunt, Paris, 1964, pp. 163–5.

4. André Félibien, *Entretiens sur les vies et les ouvrages des plus excellens peintres anciens et modernes. Nlle édition, revue, corrigée et augmentée des Conférences de l'Académie royale de peinture et de sculpture*, 4 vols, Londres, 1705. J'utilise la commode édition d'Alain Mérot, *Les Conférences de l'Académie royale de peinture et de sculpture au XVIIe siècle*, Paris, 1996, pp. 98–112.

5. Roger de Piles, *Cours de peinture par principes*, Paris, 1708. Je renvoie à l'éd. préfacée par Jacques Thuillier, Paris, 1989.

COMPOSITION ET DISPOSITION: LE LEXIQUE

Le premier problème qui se pose au lecteur moderne est lexical. Junius écrit en latin, langue dans laquelle les mots *compositio* et *dispositio*, malgré quelques flottements, possèdent un sens précis; ils appartiennent tous deux au vocabulaire rhétorique que notre théoricien, dans son effort pour élaborer un langage critique, transpose systématiquement à la peinture.

Or, ce que l'ancienne rhétorique appelle *compositio* (en grec, σύνθεσις ou συνθήκη) concerne, le plus souvent, l'arrangement des mots et des sons et ne désigne pas l'ensemble du discours comme notre moderne composition littéraire. Sans rappeler dans le détail ce qu'en disaient Cicéron, dans le *De oratore* III, 171–87 et l'*Orator* 140–236, et Quintilien, dans le chapitre 4 de l'*Institution oratoire* IX, je soulignerai seulement que ces deux auteurs exposaient la façon dont on doit agencer les sons et les mots, afin qu'ils produisent un certain effet sur l'auditeur, que ce soit un plaisir artistique, ou un sentiment moral.

C'est encore en ce sens qu'Alberti[6], transférant à la peinture ce terme, employait le mot *compositio*, encore qu'il n'en envisageât pas, dans le *De pictura*, la finalité extérieure à l'œuvre (l'effet produit), mais sa finalité interne (in opus: en vue de l'œuvre). En. II, 35, il définissait ainsi la composition:

> Est autem compositio ea pingendi ratio qua partes in opus picturae componuntur … Historiae partes corpora, corporis pars membrum est, membri pars est superficies.

> (La composition est cette méthode de peinture par laquelle les parties de la peinture sont composées en vue de l'œuvre … Les parties de l'histoire sont les corps, la partie du corps est le membre, la partie du membre est la superficie.)[7]

La composition consiste donc, chez Alberti, à lier entre eux des éléments singuliers jusqu'à aboutir à l'histoire. Elle est «une réunion de surfaces» ('superficierum coniunctiones') (II, 30).[8]

Le terme *compositio* apparaît chez Junius au chapitre 2 du livre III qui porte sur le dessin et la proportion. Junius l'emploie pour expliquer ce qu'est la *summetria*. Il ne l'emprunte d'ailleurs pas, en l'occurrence, à un contexte rhétorique ('compositio verborum'), mais à une analyse de Cicéron concernant l'*honestas*, la

6. Comme Alberti, Junius emprunte à la rhétorique son vocabulaire. On ne peut dire dans quelle mesure il s'est inspiré de son prédécesseur italien: si le traité d'Alberti ne fut publié à Amsterdam qu'en 1649, Junius put avoir une ancienne édition italienne entre les mains. Mais ce qui empêche de trancher, c'est qu'il suit les mêmes sources qu'Alberti – Cicéron et Quintilien, sans que pourtant les mêmes mots recouvrent les mêmes réalités chez les deux auteurs.

7. Leo Battista Alberti, *De pictura, praestantissima et nunquam satis laudata arte, libri tres absolutissimi … Iam primum in lucem editi*, Basileae, Thomas Venatorius, 1540. J'utilise la traduction de Jean Louis Schefer, Alberti, *De la peinture. De pictura (1435)*, Paris, 1993, p. 159.

8. Voir l'analyse de la *compositio* albertienne dans Michael Baxandall, *Giotto and the Orators: Humanist Observers of Painting in Italy and the Discovery of Pictorial Composition 1350–1450*, Oxford, 1971, pp. 129–35, et Alberti, *De la peinture*, préface de Sylvie Deswarte-Rosa, pp. 23–62.

beauté morale et le *decus*, le convenable. Cicéron établissait une analogie entre la beauté morale et la beauté physique en transposant dans le champ éthico-esthétique le vocabulaire de la rhétorique. Dans le *De officiis*, comparant l'effet du *decus*, à celui que produit sur l'œil un beau corps, il choisissait comme seul critère de beauté la 'compositio membrorum':

> Pulchritudo corporis apta compositione membrorum movet oculos et delectat hoc ipso quod inter se omnes partes cum quodam lepore consentiunt.

> (La beauté d'un corps attire les yeux par la composition adaptée de ses membres et charme précisément parce que toutes ses parties s'accordent entre elles avec un certain charme.)[9]

Junius associe ce passage à un second extrait du *De officiis*:

> Eorum quae adspectu sentiuntur, nullum aliud animal pulchritudinem, venustatem, convenientiam partium sentit.

> (Et de ces objets qu'on perçoit par la vue, aucun autre animal [que l'homme] ne perçoit la beauté, la grâce, la convenance entre les parties.)[10]

Il réunit, enfin, les deux expressions pour définir la *summetria*: 'Cicéron l'appelle la convenance entre les parties et la composition adaptée des membres' ('Tullius eam uocat conuenientiam partium et aptam compositionem membrorum'). Le mot *compositio* désigne donc, chez Junius, comme chez Alberti, l'assemblage – bien proportionné et convenable – des parties d'un corps prises isolément. Mais, à la différence de l'Italien, Junius n'envisage pas cet assemblage *in opus*, seulement, mais en fonction de l'effet produit sur le spectateur ('delectat, sentit').

Le mot *dispositio*, s'il appartient au lexique de la rhétorique, se rencontre aussi dans le *De architectura* (1, 2, 1) de Vitruve et dans les chapitres que Pline consacre à la peinture (*Historia naturalis*, 35, 80), sans qu'on puisse affirmer quel fut son premier domaine. Il désigne l'action de répartir des arguments dans le discours, les éléments dans l'ensemble de l'ouvrage architectural, les figures dans le tableau – bref, ce que nous appelons justement la composition.

Au début du chapitre V Junius rappelle les emplois anciens de ce terme et en donne une sorte d'histoire. Il est remarquable qu'il choisisse de relever d'abord son emploi dans un passage attribué par Stobée à Démocrite et dont il donne cette traduction:

> Democritus contendebat colores natura sua nihil esse: quae vero ex iis coagment-antur, colorari dispositione (διαταγῇ) dimensione (ῥυθμῷ), ac prominentia (προτροπῇ); quarum prima quidem est collocatio (τάξις), secunda vero figura (σχῆμα), tertia denique positio (θέσις).

9. *De pictura veterum* (n. 1 supra), 3, 2, 1; Cicéron, *De officiis*, I, 98.
10. *De pictura veterum* (n. 1 supra), 3, 2, 1; Cicéron, *De officiis*, I, 14.

(Démocrite prétendait que les couleurs ne sont rien par nature, mais que les assemblages [d'atomes] sont colorés par leur disposition, leur rythme, et leur modalité relative: le premier de ces éléments est l'ordre, le second la figure, le troisième la position.)[11]

En ouvrant le chapitre consacré à la disposition sur cette citation, Junius semble donc faire de cette terminologie, issue de la philosophie naturelle, la source de la terminologie technique – rhétorique aussi bien qu'architecturale – puisqu'il trouve dans les divisions de Quintilien et de Vitruve des traces de la démarche démocritéenne. Il s'appuie d'abord sur le chapitre 3, 59 du livre VIII de l'*Institution oratoire* qui traitait de l'ornement:

Quod male dispositum est, id ἀνοικονόμητον, quod male figuratum, id ἀσχῆματον, quod male collocatum, id κακοσύνθετον vocant,

(Ce qui est mal disposé, ils l'appellent ἀνοικονόμητον, ce qui emploie mal les figures, ἀσχῆματον, ce qui est mal mis en place, κακοσύνθετον.)

Puis il cite un passage du *De architectura* (I, 2), où Vitruve distingue dans le travail de l'architecte six parties. Il n'en retient que trois – celles qui concernent plus directement la structure de l'œuvre: l'ordonnance, τάξις ('ordinatio'), la disposition, διάθεσις ('dispositio') et la distribution, οἰκονομία ('distributio'), laissant de côté l'eurythmie, la symétrie et la convenance. Ce choix n'est pas arbitraire, les trois parties ici omises renvoyant finalement à la *compositio* telle qu'il l'a définie au chapitre II.

Le relevé de Junius contribue aussi à souligner le flottement de vocabulaire chez les Anciens – et en particulier chez les Latins, le grec τάξις pouvant être traduit par *ordinatio*, tantôt par *collocatio*. Or, le mot *collocatio*, s'il signifie 'mise en place', peut s'employer, à son tour, pour désigner la mise en place des mots ou des figures dans la phrase – et il appartient alors au même champ que le mot *compositio*[12] -, tantôt celle des idées – il est alors lié au mot *dispositio* qui renvoie au plan d'ensemble du discours, à l'ordre des parties, des arguments.[13] Si chacun des deux mots concerne donc, le plus souvent, l'un (*dispositio*) l'ensemble du discours, l'autre (*compositio*) un élément de cet ensemble (la phrase), dès l'antiquité, comme ces rapides exemples auront suffi à le montrer,[14] leurs emplois connurent quelques

11. *De pictura veterum* (n. 1 supra), 3, 5, 1; Stobée, *Eclogae Physicae*, I, 16, 1 (je donne entre parenthèses les mots grecs traduits par Junius. La traduction 'modalité relative' est empruntée à Jean-Paul Dumont, *Les Écoles présocratiques*, Paris, 1991, p. 459).

12. Ainsi, chez Cicéron, on lit, dans le *De oratore*, III, 171 : '... conlocationis est componere et struere verba' ('... le rôle de la collocatio est de disposer et d'assembler les mots.'). Cf. aussi *Orator*, 140.

13. Quintilien, par exemple, écrit dans *l'Institution oratoire*, VII, 1, 1: '... ordo recta quaedam conlocatio prioribus sequentia adnectens, dispositio utilis rerum ac partium in locos distributio' ('... l'ordre est certaine mise en place correcte qui lie ce qui suit à ce qui précède, la disposition une utile distribution de la matière et des parties en leur lieu').

14. On se contentera de ces remarques générales, car il ne s'agit pas ici d'étudier ces notions dans l'Antiquité, mais d'envisager la façon dont Junius les appréhende pour élaborer sa propre théorie de la

flottements dont la tradition latine moderne, puis les langues vernaculaires porteront trace.

Tout en mettant ainsi en évidence la diversité, voire les hésitations du lexique, Junius, sans pousser plus avant l'étude lexicale, prend bien soin de préciser la signification qu'il donne aux mots qu'il emploie. Ainsi, il explicite, afin d'éviter toute ambiguïté, le mot *collocatio* par la glose 'siue œconomica totius operis dispositio', en empruntant une formule de Quintilien qui parlait de 'la disposition ordonnée de la cause dans son ensemble' ('totius causae')' – (on pourrait traduire, à la manière de Roger de Piles,[15] 'du tout-ensemble de la cause').[16] Il associe donc clairement la *dispositio* à l'ensemble de l'œuvre – et toujours à l'ordre, à la *cohaerentia*, à la *concinnitas*.

A côté de ces difficultés inhérentes au lexique rhétorique, il en est une autre d'importance. Faire passer ces notions du discours à la peinture soulève un certain nombre de problèmes, qu'avait d'ailleurs déjà perçus Plutarque dans son fameux parallèle, problèmes qui se complexifient si l'on considère que l'on peut aborder l'œuvre de deux points de vue – celui de sa production ou de celui de sa réception. Si, en effet, le spectateur perçoit, dans un premier temps du moins, une peinture dans sa globalité, l'auditeur – ou le lecteur – découvre le discours dans le fil du temps, de son début à sa fin. En revanche, le procès de l'écriture semble ne guère se distinguer de celui de la peinture, dans les deux cas, il faudra bien commencer par un élément avant d'arriver au tout. Cela pose la question des parties de la peinture, des *partes pingendi*.

LE PROCÈS CRÉATIF: LES *PARTES PINGENDI*

Dans le livre III, Junius élabore une partition picturale à partir de laquelle Fréart organisera, vingt-cinq ans plus tard, en 1662 son *Idée de la perfection de la peinture*.[17] S'inspirant de la rhétorique antique, si ce n'est de traités plus proches, Junius systématise les divisions de ses prédécesseurs et distingue cinq parties dans le procès créatif – autant qu'en comportait l'art oratoire: l'invention ou histoire ('inuentio, siue historia', qu'il traduit dans sa version anglaise[18] par 'historicall argument'), la proportion ou symétrie (en anglais 'proportion', dans laquelle il étudie le dessin – 'delineatio'), la couleur ('color' – qui contient la lumière et l'ombre, la blancheur et les ténèbres), le mouvement ('motus' – action et passion) et, enfin, une dernière partie qu'il désigne ainsi: 'collocatio, siue œconomica totius operis dispositio. Ces deux mots, qu'il traduit lui-même par 'disposition, or

composition. Pour plus de précisions, on se reportera à Heinrich Lausberg, *Handbuch der literarischen Rhetorik. Eine Grundlegung der Literaturwissenschaft*, München, 1960, 2 vols.

15. Piles, *Cours* (n. 5 supra), p. 65.

16. Quintilien, *Institution oratoire*, VII, 10

17. Roland Fréart De Chambray, *Idée de la perfection de la peinture démontrée par les principes de l'art*, Le Mans, 1662, p. 9.

18. *The Literature of Classical Art* (n. 1 supra), I, p. 195.

œconomical placing and ordering of the whole worke', Fréart les traduit dans l'*Idée* par 'collocation, ou disposition régulière des figures en tout l'ouvrage'. A tout cela, Junius ajoute la grâce.

A y regarder de plus près, cependant, cette division est plus complexe qu'il n'y paraît. En effet, dans le chapitre V du livre III, Junius distingue encore deux sortes de dispositions:

> Caeterum hic distinguenda videtur Dispositio, quae ex ipsa inventione promanat; ab altera illa, quae accuratam iustae Proportionis observationem sequitur. Prior ista, ut quae ex ipsa inventione ortum ducat, nihil est aliud quam naturalis quaedam inventarum rerum series, prout eam sollers exercitati Artificis animus in ipso delineandae materiae contextu perspicit.

> (D'ailleurs, il semble qu'il faille ici distinguer la disposition qui découle de l'invention même, de cette autre qui procède de la soigneuse observation d'une juste proportion. La première, en tant qu'elle tire son origine de l'invention même, n'est rien d'autre qu'une suite naturelle d'inventions, selon que l'esprit habile de l'artiste exercé la perçoit dans la contexture même de la matière à dessiner.)[19]

La seconde *dispositio* procède donc de 'la diligente observation d'une exacte proportion', de la *summetria* à laquelle Junius a déjà consacré de longs développements au chapitre 2 du livre III, à propos du dessin. Elle se distingue très peu, écrit-il, de la proportion.[20] Il n'y reviendra que dans le dernier paragraphe de ce chapitre, pour souligner qu'elle consiste à ménager entre les figures des espaces tels que les ombres d'une figure ne nuisent pas aux autres. S'il ne développe pas plus ses remarques, c'est que les règles de proportion qui concernent une seule figure sont applicables à l'ensemble du tableau. C'est-à-dire que les figures, dans l'ensemble de l'œuvre, entretiennent un rapport de proportion comparable à celui des membres dans l'ensemble de la figure ('apta compositio membrorum'). L'analogie que pose Junius entre le rapport de proportion qui organise les divers membres d'un corps et celui qui existe entre les différentes figures d'un tableau, fait donc de la *dispositio*, prise dans ce sens, un équivalent de la *compositio* albertienne.

La première sorte de *dispositio* qui 'découle de l'invention' est d'une tout autre nature:

> Solam Dispositionem in plurium figurarum tabula praecipue curabant, ut ipsa variorum schematum apta collocatio lucem aliquam adderet diversissimis rebus hinc inde, pro argumenti natura, in unum corpus congestis.

> (Ils [les anciens] veillaient surtout à la seule disposition dans les tableaux à plusieurs figures, de sorte que la mise en place bien adaptée de figures variées, à

19. *De pictura veterum*, 3, 5, 4.
20. *De pictura veterum*, 3, 5, 13: 'Videtur tamen haec Dispositio … parum admodum ab ipsa Proportione discrepare …'.

elle seule, ajoutât quelque lumière aux objets très divers pris de çà et de là et réunis en un corps unique, conformément à la nature de l'argument.)[21]

Ce sommaire apporte deux éléments importans:
– La disposition permet de passer du multiple à l'un ('plurium figurarum tabula; uariorum schematum apta collocatio, diuersissimis rebus; in unum corpus'); elle est porteuse de sens ('ut … lucem aliquam adderet rebus'). Nous reviendrons plus bas sur ces deux éléments qui concernent la fonction de la disposition.
– Liée à l'invention, la disposition est antérieure à l'œuvre, l'artiste accompli devant, selon Junius, concevoir en esprit, avant même de prendre le pinceau, l'ensemble de sa disposition, l'"œconomica totius operis dispositio'. Elle est donc, d'abord, mentale. Elle vient, écrit Junius, comme naturellement à l'esprit de l'artiste qui médite sa matière et dessine d'abord 'en son esprit la vivante image de l'ensemble mis en place' ('vivam totius Collocationis imaginem').[22] L'artiste doit donc concevoir en esprit ce que Roger de Piles appellera, dans le *Cours de peinture par principes*, le 'tout ensemble'.[23] C'est le travail de l'imagination qui permet à l'artiste de concevoir son tableau dans une sorte de vision qu'il reproduira sur sa toile. Cette démarche suppose une théorie de l'imagination exposée dès le premier livre et que j'ai souvent étudiée.[24] Je n'y reviendrai pas.

Un tableau avant d'être peint est donc un tableau mental, mais, les images arrivant à l'esprit de façon désordonnée, l'artiste doit opérer un choix et une mise en ordre, une sorte de *dispositio* mentale.[25] Et Junius loue la méthode de ceux

> … qui totam rei gestae seriem iterum atque iterum ratione animoque lustrantes, ita se in rem praesentem veluti deduci patiuntur, ut, quidquid uspiam est in tota re, suo statim loco occurrat atque incidat.
>
> (… qui passant en revue, encore et encore, par la raison et par l'esprit, la suite de l'action dans son ensemble, se laissent comme emporter en présence de leur matière, de sorte que tout ce qui se trouve quelque part dans l'ensemble de leur matière se présente et arrive aussitôt en son lieu.)[26]

Et il répète à plusieurs reprises la nécessité de cette mise en ordre.[27] C'est, dit-il, le devoir d'un bon artiste:

21. *De pictura veterum* (n. 1 supra), 3, argumentum.
22. *De pictura veterum* (n. 1 supra), 3, 5, 4.
23. Piles, *Cours* (n. 5 supra), pp. 65–70.
24. Voir en particulier *De pictura veterum* [1996], pp. 453–80.
25. *De pictura veterum* (n. 1 supra), 3, 5, 4.
26. *De pictura veterum* (n. 1 supra) 3, 5, 3.
27. *De pictura veterum* (n. 1 supra), 3, 5, 5 (sommaire): 'Ante omnia tamen circumscribitur mente inventio, confestimque schemata hinc inde concurrunt ; quae mens eadem … ita statim disponit, ut suo quoque loco respondeat' ('L'invention est avant tout circonscrite par l'esprit, les figures arrivent toutes ensemble en un instant, de çà, de là et ce même esprit doit aussitôt … les mettre en place, de manière que chacune se trouve en son lieu').

… ut inventae materiae partes, quas primo confuse et permiste concepit, postea descripte atque electe, prout cuique parti convenit, ex hac copia digerat.

(… de tirer de cette abondance les parties de la matière qu'il a trouvées et conçues d'abord de façon désordonnée et confuse et de les distribuer ensuite d'une manière précise et choisie, selon que cela convient à chaque partie.)[28]

Cette analyse pose donc le problème des *partes pingendi*. En distinguant deux sortes de dispositions, dont l'une se rapporte à l'invention, l'autre au dessin et en soulignant, dans la transition du chapitre 3 au chapitre 4, que le mouvement dépend du dessin aussi bien que de la couleur – donc qu'il n'est pas en lui-même une partie – Junius ramène sa propre division en cinq parties à la traditionnelle division tripartite, ce qui m'incite à penser que le choix initial d'une répartition en cinq parties n'a d'autre fonction que de souligner les rapports entre la rhétorique et la peinture. En associant, d'autre part, disposition et invention, Junius adopte une démarche sensiblement différente de celle d'Alberti qui n'abordait pas la question du passage de l'*inventio* à la *circumscriptio*. Bien plus, la division tripartite de ce dernier – circonscription, composition et réception des lumières – excluait en quelque sorte de la peinture l'invention, ce qu'Alberti formulait d'ailleurs au livre III en ces termes:

Les écrivains qui fournissent d'abondantes connaissances seront utiles pour bien agencer la composition de l'histoire ('historiae compositionem'), dont le mérite réside essentiellement dans l'invention ('in inventione'). Car l'invention a ce pouvoir de réussir à plaire indépendamment de la peinture ('ea quidem hanc habet vim, ut etiam sola inventio sine pictura delectet').[29]

Au contraire, Junius annonce la répartition que Piles formulera dans le *Cours de peinture par principes* – composition, dessin, coloris. Pour le théoricien français, en effet, la composition associe invention et disposition:

Dans la division que j'en ai faite, j'ai dit que la composition qui en est la première partie contenait deux choses, l'invention et la disposition. En traitant de l'invention, j'ai fait voir qu'elle consistait à trouver les objets convenables au sujet que le peintre veut représenter. Mais, quelque avantageux que soit le sujet, quelque ingénieuse que soit l'invention, quelque fidèle que soit l'imitation des objets que le peintre a choisis, s'ils ne sont bien distribués, la composition ne satisfera jamais pleinement le spectateur désintéressé et n'aura jamais son approbation générale. L'économie et le bon ordre est ce qui fait tout valoir, ce

28. *De pictura veterum* (n. 1 supra), 3, 5, 3 (sommaire). Cf. *De pictura veterum* (n. 1 supra), 3, 5, 5: 'Nemo felicius manum admovet dispositioni, quam qui veluti in rem praesentem perductus, omnes propositae materiae circumstantias accurate percenset' ('Nul ne met plus heureusement la main à la disposition que celui qui, conduit comme en présence de sa matière, examine exactement toutes les circonstances du sujet qu'il se propose).

29. Alberti, *De la peinture* (supra n. 7), III, 53, pp. 212–13.

qui dans les beaux-arts attire notre attention, et ce qui tient notre esprit attaché jusqu'à ce qu'il soit rempli des choses qui peuvent dans un ouvrage et l'instruire et lui plaire en même temps. Et c'est cette économie que j'appelle proprement disposition.[30]

Piles soulevait d'ailleurs un autre problème connexe, celui de la différence dans l'ordre des parties selon qu'il s'agit du débutant qui apprend les rudiments de l'art et du peintre exercé qui en possède la pratique. Il justifie ainsi l'ordre suivi dans le *Cours*:

> Si on la [la peinture] regarde de la manière dont elle s'apprend, on doit commencer par s'entretenir du dessin, puis du coloris, et finir par la composition: parce qu'il est inutile d'imaginer ce qu'on voudrait imiter si on ne le sait pas imiter et que la représentation des objets ne peut se faire que par le dessin et par le coloris. Mais à regarder cet art dans sa perfection et dans l'ordre dont il s'exécute, … la première partie qui se présente à nous est l'invention. Car pour représenter des objets, il faut savoir quels objets on veut représenter.[31]

L'ordre que Piles a choisi concerne donc l'artiste accompli – or, c'est celui aussi dont traite précisément Junius dans le livre III où le même ordre est suivi. La construction albertienne, au contraire, partait, au livre I, des *rudimenta*, avant d'apprendre au peintre 'comment sa main peut traduire ce que son esprit aura conçu' ('quemadmodum qua mente conceperit ea manu imitari queat')[32], puis d'envisager l'*inventio*, dans les termes que nous avons rappelés, au livre III consacré au *perfectus pictor*.

FONCTION DE LA DISPOSITION: LE SPECTATEUR

L'étude de la disposition est associée par Junius à celle de l'histoire qu'il étudie à deux reprises dans le livre III. Au chapitre premier, dont elle constitue à elle seule la matière, elle est synonyme d'invention – 'inuentio, siue historia', écrit-il. La seconde étude de l'*historia*, dans le chapitre consacré à la disposition, s'explique parce que Junius y envisage l'histoire comme une suite d'inventions ('inuentarum rerum seriem'), l'importance de la disposition étant néanmoins rappelée même dans le cas de peintures qui ne comportent qu'une figure.

Dans les peintures à plusieurs figures, la *dispositio* donnera au spectateur l'illusion d'unité:

> Singulae totius operis partes tam apte inter se connexae compositaeque esse debent, ut non partes amplius, sed cohaerentia cum omni corpore membra esse videantur.
>
> (Chacune des parties de l'ensemble de l'œuvre doit être liée et assemblée aux

30. Piles, *Cours* (n. 5 supra), p. 49.
31. Ibid. p. 29.
32. Alberti, *De la peinture* (n. 7 supra), I, 24, p. 127.

autres de façon si bien adaptée, qu'elle ne doit plus sembler être une partie, mais un des membres qui forment un ensemble avec tout le corps.)[33]

D'autre part, tout, dans l'image, doit faire sens.[34] La disposition, elle-même signifiante, se conçoit dès lors en termes de lisibilité. Présentant chaque chose à sa place, elle induit la lecture ('perlegere oculis')[35] de l'image conçue comme un discours muet ('mutum alloquium')[36] ou une narration – 'l'artiste fait une sorte de narration' ('quasi narrat').'[37]

La *dispositio* picturale même si elle obéit à une logique narrative, dispose cependant, du fait de sa spatialité, d'une syntaxe spécifique qui joue, au besoin, de la condensation ou de la dilatation:

> Hic tantum in transitu observa pictam historiam minime teneri iisdem legibus, quibus obstricta est historia scripta, quum praecipuum sit munus historicorum rem omnem a principio ad finem usque prosequi, observata ubique temporis atque omnium circumstantiarum vera serie; Pictores vero consulto saepe, prout e re sua esse iudicant, in medios irrumpunt actus, ad antecedentia exinde et consequentia, cum opportunum erit redituri; siquidem perfacilem iis est una eademque tabula praeteritarum, praesentium futuramque rerum imagines complecti.

> (L'histoire peinte n'est pas astreinte aux mêmes lois qui enchaînent l'histoire écrite. Alors que l'historien a charge de suivre tout son sujet du début à la fin, en respectant partout l'authentique enchaînement des temps et de toutes les circonstances, les peintres souvent à dessein, selon qu'ils jugent que cela est conforme à leur sujet, font irruption au milieu de l'action pour revenir de là, lorsque cela est opportun, à ce qui la précède ou la suit; puisqu'il leur est très facile de ramasser sur un seul et même tableau les images de choses passées, présentes et à venir.)[38]

On retrouvera l'esprit de cette analyse dans le commentaire que Le Brun fera du tableau de Poussin, *Les Israélites ramassant la manne*.[39]

Cette possibilité offerte au peintre de réunir dans un même espace ce qui s'écoulait dans le temps suppose qu'il porte une attention particulière à la clarté de sa disposition. Junius s'appuie alors sur Quintilien pour recommander au peintre

33. *De pictura veterum* (n. 1 supra), 3, 5, 2 (sommaire).
34. *De pictura veterum* (n. 1 supra), 3, 5, 7: '... inanem Arti laborem impendisse iudicatur Artifex, cuius tabulae in schematum copia sensus laborant inopia' ('... on estime qu'un artiste a perdu sa peine dont les tableaux, malgré l'abondance de figures, souffrent d'un manque d'idées').
35. *De pictura veterum* (n. 1 supra), 3, 5, 6.
36. *De pictura veterum* (n. 1 supra), 3, 5, 7.
37. *De pictura veterum* (n. 1 supra), 3, 5, 6.
38. *De pictura veterum* (n. 1 supra), 3, 5, 6: voir Louis Marin, 'La Lecture du tableau d'après Poussin', *Cahiers de l'AIEF*, 24, 1972, p. 261–6 et Marc Fumaroli, 'Muta eloquentia. La représentation de l'éloquence dans œuvre de Nicolas Poussin', *Bulletin de la Société de l'histoire de l'art français*, année 1982, 1984, pp. 29–48.
39. *Les Conférences* (supra n. 4), pp. 101–3.

la même recherche de la *perspicuitas* que celui-ci exigeait d'une bonne *narratio*. Et il cite aussi Lucien: '… la clarté repose sur les liens réciproques qu'entretiennent les choses …'.[40] Le point de vue du spectateur est de ce fait inclus dans le processus créatif, l'économie de l'œuvre étant conçue en fonction de son regard.

Ainsi Junius souligne la double articulation de l'image qui, parce qu'elle est narrative, est diachronique, mais se donne d'abord dans la synchronie d'un regard – à la différence du discours qui se déploie dans le temps. Ce n'est que dans un second temps que l'œil en découvre le déroulement logique – condition nécessaire à sa compréhension – ce qui pose la question du rapport entre la partie et le tout.[41] Il s'agira de produire, au-delà de la diversité de ses composants, une impression d'unité, propre à créer l'illusion et que seule une bonne ordonnance peut réaliser:

> In omni opere potentissima est ea quae vere dicitur Œconomica totius operis Dispositio, quae constitui nisi velut in re praesenti non potest: praesertim cum in hac partium dispositione, universa materia recte atque ordine pertentata expensaque, semper occurrat primus aliquis sensus et secundus et tertius: qui non modo sint ordine collocati elaborandum est, sed ut inter se ita sint iuncti atque cohaerentes, ne commissura appareat. Corpus sint, non membra … .

> (Dans toute œuvre, ce qui a le plus de puissance, c'est ce qu'on peut vraiment appeler la disposition économique de l'œuvre dans son ensemble. Elle ne peut être bien constituée que si l'on est comme en présence de sa matière, d'autant que dans cette disposition des parties, une fois l'ensemble de la matière éprouvé et pesé avec exactitude et ordre, il se présente toujours une pensée qui vient la première, une qui vient la seconde, une la troisième; il ne faut pas seulement travailler à les mettre en place dans leur ordre, mais encore à les joindre et les lier les unes aux autres, de manière que la commissure n'apparaisse pas. Qu'elles forment des corps, non des membres …).[42]

Et Junius transpose à la disposition picturale les qualités de la *compositio verborum*, telles que Cicéron et Quintilien les avaient énoncées. L'artiste doit:

> … oblatarum rerum imagines sic componere et struere, ut neque asper sit earum concursus, neque hiulcus, sed cum decore quodam coagmentus et laevis …
> (… composer et assembler les images de ce qui s'offre au regard de sorte que leur jointure ne montre ni aspérité ni vide, mais qu'elle soit, avec certaine convenance, bien liée et lisse …).[43]

Tout doit répondre à tout dans le respect de la diversité:

40. *De pictura veterum* (n. 1 supra), 3, 5, 12; Lucien, *Historia quomodo conscribenda*, 55 (je cite la traduction de Junius: '… perspicuitas, ex mutua rerum connexione constans …').

41. *De pictura veterum* (n. 1 supra), 3, 1, 6.

42. *De pictura veterum* (n. 1 supra), 3, 5, 5 (paraphrase de Quintilien, *Institution oratoire*, VII, 10, 11 et 16).

43. *De pictura veterum* (n. 1 supra), 3, 5, 2.

> … passim in eorum operibus admirando quodam diversissimarum rerum contextu extrema primis, media utrisque, omnia omnibus respondere deprehenduntur.

> (… partout dans les œuvres [des anciens], grâce à certaine admirable contexture des objets les plus divers, on observe que les éléments derniers répondent aux premiers, ceux du milieu à ceux des deux extrémités, et tout à tout.)[44]

Cela suppose des choix et une hiérarchie: refus du détail inutile[45], adaptation du détail à l'ensemble, assez précise pour que tout semble nécessaire[46], mise en place qui privilégie les principales figures[47], telles sont les qualités majeures de la bonne disposition. D'où l'importance encore de l'autre disposition, celle que Junius a associée à la proportion et qui devra mettre en valeur les figures les plus importantes en évitant le trop-plein et le vide, en dosant savamment les ombres et les lumières:

> Non eminet pictura, in qua nihil circumlitum est. Ideoque artifices etiam, cum plura in unam tabulam opera contulerunt, spatiis distinguunt, ne umbrae in corpora cadant.

> (Une peinture n'a pas de relief dans laquelle les contours ne sont pas soulignés. C'est pourquoi les artistes même, lorsqu'ils ont réuni plusieurs œuvres dans un seul tableau, les séparent pas des espaces, afin que les ombres ne tombent pas sur les corps.)[48]

C'est encore dans la rhétorique cicéronienne que Junius trouve les principes de ce langage pictural dont la dynamique procède de la conciliation d'éléments antithétiques – abondance et variété, ordre et unité – et qui suscite le plaisir en même temps qu'il instruit. Car la variété charme – 'gaudent homines uarietate, écrit Junius en commentant Quintilien'[49], pour ajouter aussitôt 'adsit modo debitus ex ipso ordine cultus': elle ne plaît qu'accompagnée d'ordre. Cicéron, dans le *De oratore*,[50] insistant sur les fondements naturels de ce plaisir, avait montré que la beauté du monde procède de l'accord harmonieux et nécessaire de toutes ses parties entre elles et de ses parties au tout.

Cette exigence de clarté dans la *dispositio* est enfin étroitement associée à une

44. *De pictura veterum* (n. 1 supra), 3, 5, 8.

45. *De pictura veterum* (n. 1 supra), 3, 5, 8: 'Non decere historiam producere per minutias ignobiles …' ('Il ne convient pas de conduire l'histoire à travers d'obscures minuties …').

46. *De pictura veterum* (n. 1 supra), 3, 5, 4: '… usque adeo apte collocet et disponat ne quid uspiam in opere universo perturbatum, ac discrepans aut praeposterum occurrat' ('… qu'il mette en place et dispose [les éléments de l'argument] de façon si adaptée que, nulle part dans l'ensemble de l'œuvre, il ne se rencontre rien de désordonné, de discordant ou d'hors de propos.').

47. *De pictura veterum* (n. 1 supra), 3, 5, 7: '… principalioribus figuris … principem locum tribuit Artifex' ('… l'artiste attribue aux figures les plus importantes le premier lieu.').

48. *De pictura veterum* (n. 1 supra), 3, 5, 13, citation de Quintilien, *Institution oratoire*, VIII, 5, 26.

49. *De pictura veterum* (n. 1 supra), 3, 5, 2 (Quintilien, *Institution oratoire*, IX, 2, 63).

50. *De pictura veterum* (n. 1 supra), 3, 5, 2; Cicéron, *De oratore*, III, 179.

nouvelle définition de l'histoire. Dans le chapitre premier, Junius donne un commentaire capital du mot latin *argumentum* qu'il donne comme un synonyme du mot *historia*. Il en justifie l'emploi par le sens du verbe dont il est dérivé, *arguere*, qui signifie montrer et rendre clair avant d'exposer en ces termes ce qu'est l'histoire:

> ... sed omnes hae denominationes locum habent in tabula in qua perspicuum statim est quid sibi velit Artifex: ubi vero id minus apparet, sed coniectura indiget, iam non amplius ijstoriva, sed ai[nigma th' grafh' uocatur.

> (... mais toutes ces dénominations [les noms grecs et le mot argumentum] ont leur place quand il s'agit d'un tableau où est aussitôt évidente l'intention de l'artiste; lorsque celle-ci apparaît moins, mais suppose une conjecture, on ne parle plus d'histoire, mais d'énigme.)[51]

Ainsi, Junius aboutit à une nouvelle définition de l'histoire qui sera celle de Roger de Piles:

> l'invention simplement historique est un choix d'objets qui, simplement par eux-mêmes, représentent le sujet. Cette sorte d'invention ne regarde pas seulement toutes les histoires vraies et fabuleuses telles qu'elles sont écrites dans les auteurs ou qu'elles sont établies par la tradition: mais elle comprend encore les portraits des personnes, la représentation des pays, des animaux et de toutes les productions de l'art et de la nature.

Au contraire, l'invention allégorique est

> un choix d'objets qui servent à représenter dans un tableau, ou en tout, ou en partie, autre chose que ce qu'ils sont en effet.[52]

Le *De pictura veterum* propose donc une théorie cohérente de la composition qui marque une transition entre la théorie albertienne et la théorie française moderne. Sur deux points, en particulier, il se distingue de son grand prédécesseur: d'abord, en soulignant l'importance du tout-ensemble, notion qui ouvre et achève le processus créateur, puisqu'il est lié à l'invention comme à la lecture du tableau, ensuite, et de façon corrélative, en insistant sur le rôle de l'invention. Ce que Junius a nettement formulé, c'est, sur ce point encore, la spécificité du langage pictural. Le détour par la rhétorique lui permettant d'aborder la peinture comme un langage doté de ses signes propres, les formes et les couleurs, il dépasse ainsi le traditionnel *ut pictura poesis* – et il prépare en cela la démarche d'un Lessing – en s'intéressant à l'histoire non pas tant du point de vue de l'invention que de la disposition. L'histoire, ce n'est plus le sujet sur lequel repose le tableau – ce qui explique en particulier le manque d'intérêt de Junius pour la fable – mais le moteur

51. *De pictura veterum* (n. 1 supra), 3, 1, 6.
52. Piles, *Cours...* (n. 5 supra), p. 31.

qui suscite, par sa disposition, la dynamique de l'image. Une belle peinture n'est pas seulement celle qui traite un beau sujet, même si ce choix est préférable, mais c'est celle qui traduit le plus exactement, dans le langage qui lui est propre des formes et des figures, ce qu'a conçu l'artiste, de telle sorte qu'elle suscite chez le spectateur les mêmes images.

Composition, Disposition and Ordonnance in French Seventeenth-Century Writings on Art

Thomas Puttfarken

This paper started from the assumption that a closer investigation of the use of terms like *composition*, *disposition* or *ordonnance* in the seventeenth century would yield reasonably clear and workable definitions. This was expected to give sharper focus to an underlying belief that pictorial composition as a critical concern, rather than as a practical reality, was discovered by French critics in the second half of the seventeenth century. Unfortunately, clear definitions have not been forthcoming. It seems that each critic at the time insisted on defining his own terms, but then refused to be bound by them, – often for reasons merely of style or just plain thoughtlessness. We find compositions that are *ordonnées* or *disposées*, *ordonnances* that are *composée* or *disposées*, and *dispositions* that are *ordonnées* or *composées*.

Partly this may be the result of the sheer volume of written criticism and theory produced in France in the years after 1660. It was not only felt that there was some catching-up to do compared to Italy; it was also the case that the young Academy of Painting and Sculpture was required to establish the permanent rules of its arts. This was to be done by critical analysis of exemplary works, and it was to be done by the academic artists themselves in public conferences. The conferences of 1667, published the following year by André Félibien, were the first result, although from the point of view of the academy they were not entirely successful.[1]

Yet practising artists were not always the best theorists nor necessarily the most willing ones. And whether it was wanted or not, help was at hand. *Littérateurs* and intellectuals, used to acrimonious debates about the precise interpretation of Aristotle's *Poetics*, quickly discovered that painting provided a whole new field for critical exercise and posturing.

One reason for the lack of coherence in terminology may be that artists and theorists were pulling in opposite directions. Practising academicians needed to 'reduce' the theory of art to simple rules which could be presented to young students as eternal and infallible laws to be followed in practice. That is what Henri Testelin's *Tables des preceptes* of 1696 were meant to be.[2] Ambitious intellectuals, on

1. A. Félibien, *Conférences de l'Académie royale de peinture et de sculpture pendant l'année 1667*, Paris, 1668, quoted here from the Trévoux, 1725, edition. Shortly after the first publication, Félibien was relieved of his duties as editor of the academic conferences. On Félibien see now Stefan Germer, *Kunst – Macht – Diskurs. Die intellektuelle Karriere des André Félibien im Frankreich von Louis XIV*, Munich, 1997. More generally on this topic see my *The Discovery of Pictorial Composition Theories of Visual Order in Painting 1400–1800*, New Haven, Conn., and London, 2000.
2. H. Testelin, *Sentimens des plus habiles peintres sur la pratique de la peinture et sculpture, mis en tables de preceptes, avec plusieurs discours académiques, ou Conférences tenuë en l'Académie Royale desdits Arts, en*

the other hand, were more likely to relate their theorizing to wider concerns, to questions of artistic creation, to comparisons with other forms of intellectual and artistic pursuit, and to the education of the general public. That is what writers like Roland Fréart de Chambray, André Félibien and Roger de Piles were doing.

However, even if the aims were different, there were similarities of procedure. Following the model of Aristotle's *Poetics*, the rudiments of which could be regarded as general cultural property, almost any writer on art felt obliged to break down the art into its constituent parts and to deal with these in a more or less orderly fashion one after the other. This had been done by earlier Italian writers, like Alberti and Dolce, yet only in France ensued what I would call a systematic fragmentation either of the whole art, or in the process of a critical analysis, of an individual work. Testelin's *Tables des preceptes* was one of the most radical examples of this, dealing with *le Traict, les Proportions, l'Expression, le Clair-Obscur, l'Ordonnance, la Couleur*. De Piles's *Balance des peintres* is another, perhaps the most notorious, example, awarding points out of twenty for each of *composition, dessein, coloris* and *expression*.[3]

De Piles was not the first to combine fragmentation with evaluation. The academy was still, more than two hundred years after Alberti and one hundred years after Vasari, embroiled in a battle over the liberal status of its art, and that meant that the mental, intellectual and theoretical parts of the art claimed precedence over the manual and practical ones.[4] The part most heavily charged with defending the liberal nature of painting was, not surprisingly, invention. Under this heading, our French critics could invoke such undoubtedly liberal categories as *costume, vraisemblance, bienseance* etc., the subject-matter treated by the history painter being the same as that treated by the poet or the historian. If invention occupied one end of the liberal-manual spectrum, the other end was occupied by the actual execution, the wielding of the brush, the application of pigments to canvas. The placing of drawing and colouring in between these extremes was to give rise to endless arguments,[5] and the same is true of *composition, disposition* and *ordonnance*.

However, much of the best theorizing in France had to do with two aspects of painting which were difficult to reduce to fragmentation: the first was the integrity and fluidity of artistic creation, epitomized by the *feu céleste*, the divine inspiration of poet or painter, and the second was the totality and unity of a work's overall effect on the viewer. Both cut across virtually all parts of painting, and composition, order and coherence were of crucial importance to both.

I cannot attempt here to cover the whole of the period from 1660–1708. Instead

presence de Monsieur Colbert ..., Paris, 1696.

3. R. de Piles, *Cours de peinture par principes*, Paris, 1708, pp. 489–93.

4. See D. Posner, 'Concerning the *Mechanical* Parts of Painting and the Artistic Culture of Seventeenth-Century France', *The Art Bulletin*, 75, 1993, pp. 583–98.

5. See J. Montagu, 'The Quarrel of Drawing and Colour in the French Academy', in *Ars naturam adiuvans. Festschrift für Matthias Winner*, Mainz, 1996, pp. 548–56.

I shall concentrate on the years 1662–8. *In nuce* that should provide us with the major models of thinking about pictorial order developed over the whole period. It is important to bear in mind that few texts of this period are systematic, in the modern philosophical and aesthetic sense of the word.

The first major treatise on painting in France is Chambray's *Idée de la perfection de la peinture* of 1662.[6] Chambray humbly – and misleadingly – claims that his little treatise is nothing but an elaboration of the basic definition of painting given by Franciscus Junius in his *De pictura veterum* of 1637:

> Les anciens, dit-il [Junius], observoient exactement dans leurs Tableaux ces cinq Parties: l'Invention, ou l'Histoire; la Proportion, ou la Symetrie; la Couleur, laquelle comprend aussi la iuste dispensation des lumieres et des ombres; Les Mouvemens, où sont exprimées les Actions et les Passions; et enfin la Collocation, ou Position regulière des Figures en tout l'Ouvrage.[7]

This does indeed sound like Junius at the beginning of Book III:

> Observabantur itaque ab antiquioribus in Pictura quinque haec capita: Inventio sive Historia: Proportio sive Symmetria: Color, & in eo Lux & Umbra, Candor & Tenebrae: Motus, & in eo Actio & Passio: Collocatio denique sive oeconomica totius operis Dispositio.[8]

Junius's remarks look like a true case of fragmentation, but he gets around that in two ways: 'collocatio' or 'oeconomica totius operis dispositio', is, as implied in the latter, not only a separate part; it pervades the whole and enters into all the other parts; it is intimately linked with invention and proportion, and it needs to be considered in the management of colouring and movement. And then there is, beyond *dispositio* or *collocatio*, yet another part or quality of even more consequence, which needs to be present in every part and the whole, and that is grace ('gratia').[9]

If we read more of Junius's amazingly detailed and erudite work, and compare his with Chambray's definitions, we find that the latter probably has not read much beyond the introduction and the opening lines of each of Junius's sections. For Junius, for instance, *invention* is based on learning, erudition in the widest sense, even wisdom, to be acquired through the careful and unending study of the ancients, their arts, their literature, music, geometry etc.[10] For Chambray, *invention* is – at least initially – 'a natural talent that cannot be acquired, neither by study, nor by work; it is properly the fire of the spirit ('le Feu de l'esprit') that excites the imagination and makes it work'.[11] Compared to the heavily intellectual nature of

6. R. Fréart Sieur de Chambray, *Idée de la perfection de la peinture demonstrée par les principes*, Le Mans, 1662.

7. Ibid., p. 10.

8. Franciscus Junius, *De pictura veterum*, 1637, quoted here from edition Rotterdam, 1694, p. 137.

9. Ibid., p. 197.

10. Ibid., pp. 137–40.

11. Chambray, *Idée de la perfection de la peinture* (n. 6 above), p. 11: 'L'Invention ...est un Talent aturel

invention in Junius's scheme, Chambray's version appears like an instantaneous inspiration, an almost romantic affirmation of individual genius and fire and a rejection of rules and systems. Yet, as we shall see, nothing could be further from the truth.

Junius's all-pervading 'dispositio oeconomica totius operis' is equally transformed by Chambray: it is immediately reduced to 'la position regulière des figures'. This is followed by a few more or less verbatim quotes from Junius, extolling the overriding importance of this part of painting, before we come to its actual definition – and there we find that Junius's 'dispositio' becomes Chambray's 'perspective', all-pervading, but concerned with optical correctness, the perspectivally accurate positioning of figures and objects.[12]

Junius distinguishes between two sub-sections of *dispositio*, disposition as related to, or derived from, invention and subject-matter, and disposition as concerned with proportion and symmetry, including the clear spacing of figures.[13] It is an interesting distinction which, in different forms and variations, influences much of the thinking about art in France. That is true also of Chambray, though in an unexpected way: having transformed Junius's *dispositio* into perspective, he re-introduces disposition or *ordonnance*, with slight variations, as a subsection of invention: 'Let us start with our first part, which is invention, that is to say, the *ordonnance* of figures *dans le Dessein*'. What he means by 'dessein' in this context is not entirely clear, yet 'ordonnance' is reasonably obvious: 'one of the most important rules of it is to place the figures with that discretion, that the main figure of the subject is always to be found towards the centre of the *tableau*, or in the most apparent place'.[14] This point is made earlier in the book in Chambray's discussion of the print after Raphael of the *Judgement of Paris*: 'where, for a general and almost always necessary reason, he has placed the principal figures of the subject at the centre of his *ordonnance*'.[15] Or later, when he observes that Raphael, in the *School of Athens*, had put, 'as he had to, *ces deux principaux Coriphées des Philosophes sçavants* at the most obvious place of his picture'.[16]

It is clear, then, that *composition*, *disposition* and *ordonnance* do play an important part in Chambray's scheme, and that there are rules, even *important* rules governing

qui ne s'acquiert ny par l'estude, ny par le travail: C'est proprement le Feu de l'esprit, lequel excite l'Imagination et la fait agir.'

12. Ibid., pp. 17–21.

13. Junius, *De pictura veterum* (n. 8 above), p. 190.

14. Chambray, *Idée de la perfection de la peinture* (n. 6 above), p. 51: '… (l'ordonnance des figures ans le Dessein) dont l'une des plus considerables maximes est de les placer avec cette discretion, que la principale figure du Subject se trouve toujours vers le milieu du Tableau, ou dans le lieu le plus apparent.'

15. Ibid., p. 26: '… ou, par une consideration generale, et presque toujours necessaire, il a placé es principales figures du Subject au milieu de son Ordonnance.'

16. Ibid., p. 111: 'Aprés avoir donc placé, comme il falloit, au lieu le plus apparent de son ableau, ces deux principaux Coriphées des Philosophes Sçavants …'.

them. How do we relate that to the earlier statements that *ordonnance* was part of invention, and that invention was that rule-less *feu de l'esprit*, that natural talent that could not be learned?

To understand this relationship we have to look at yet another term which is central to Chambray's thinking, and which was to become central to academic doctrine. All that knowledge and learning which Junius has associated with invention was, as we have seen, removed by Chambray and made into a new, additional and over-arching sixth part. As in Junius the mastery of all five parts was not much good if the artist lacked grace, so in Chambray all five parts are incomplete without full knowledge of *costume*.

Costume is not a term specific to painting; with its connotations of historical correctness, verisimilitude, appropriateness, or *decorum*, it is common also to poets and historians, who say the same things which painters paint. It is the foundation of the liberal, intellectual status of painting. *Costume*, properly speaking, is 'generally common to our five principles, of which it is a kind of Eurythmics, which one should regard as the whole of these five parts.'[17] What *costume* does to each of the five parts is explained elsewhere: a work will never contribute to the reputation of its author among *les Sçavans*:

> if the invention of the subject ... is not well-reasoned; if the figures are not judiciously *ordonnées dans le Tableau*; and with an appropriate expression; if the story does not have all the necessary circumstances; if the regularity of the perspective is not precisely observed throughout in the position and the aspect of the figures, and consequently also in the shades and the lights, and if finally the costume ... is not precisely observed[18]

There is then another side to invention which must be *raisonée*; and another side to *ordonnance* which must be judicious. Perhaps it would be best to explain Chambray's thinking by saying that, insofar as *ordonnance* is *merely* a part of invention, it is fired *only* by natural talent etc., yet insofar as *ordonnance also* comes under the rule of *costume*, it has to respect certain rules and is subject to study, learning etc. This goes to the heart of the whole question of artistic inspiration. Indeed, Chambray goes so far as to distinguish a mere first idea, 'la première Idée', from sustained subsequent thinking:

> ... the second thoughts of people of spirit are normally more judicious than the first: from that one must conclude that *ceux-là entre les Peintres*, to whom all sorts

17. Ibid., p. 57: '... le Costume ... est generalement commun à nos cinq principes fondamentaux, il en compose l'Eurithmie de telle sorte, qu'on doit le considérer comme le Tout de ces cinq parties.'
18. Ibid., pp. 62–3: '... si l'Invention du Subject ... n'est bien raisonnée; si les Figures ne sont udicieusement ordonnées dans le Tableau, et avec une expression convenable; si l'Histoire n'est suffisament remplie de toutes ses Circonstances necessaires; si la regularité de la Perspective n'est précisément gardée par tout dans la position et dans l'aspect des figures, et consequemment aussi dans les Ombres et dans les Lumieres, et enfin si le Costume ... n'y est encore exactement observée ...'.

of subjects appear so similar and so equal ... and who, after they have had their first idea for a *tableau* ... never change or adjust anything; those painters, I say, only have superficial *genies*, and their works never inspire the curiosity of intelligent people, who find nothing to study in them, and are satisfied with having seen them in passing.[19]

Without precise consideration of *costume* intelligent people will be content to look at these works only once, as in passing. This passage leaves us in little doubt that Chambray's interest in visual or specifically pictorial aspects is extremely limited.[20] The romantic *feu de l'esprit*, the natural talent, the *première idée*, may all be necessary, but on their own, unsupported and undeveloped by *costume*, they only lead to trivial effects. In other words: invention and *ordonnance per se* are without value or meaning, no more than a flash in the pan and a visual pattern, if they are not directed and strictly in conformity with the *costume* of the subject-matter. Artists who disregard the concerns of *costume*, 'ces Peintres-là', are the *cabalistes*, artists who have acquired their reputation not by merit but by fortune or *cabales*, which include, among others, Rosso, Tintoretto, Veronese, Parmigianino and, above all, Michelangelo. True masters include, not surprisingly, Raphael, Domenichino, and Poussin, 'un grand Aygle dans sa profession', the true heir of Apelles, Timanthes, Protogenes, and the most perfect among the moderns.[21]

How then do terms like *ordonnance* and *disposition* work in Chambray's treatise? Are there differences of meaning and application? We have already come across one rule of *ordonnance*, namely that the main figure of the subject should always be at or near the centre of the *tableau*. This was to remain a central plank of academic doctrine.[22] In Chambray it is not a formal or visual requirement, but one of *costume*. If your subject is the *Deposition* or *Crucifixion*, Christ must be at its centre; a centralizing *ordonnance*, if it is to be meaningful and *estudié*, must be used to express a centralized hierarchy present in the subject.

The same example can alert us to one or two more precise distinctions. While it seems to be true, of Chambray as of most other writers of the period, that they use the main terms of pictorial ordering without clearly distinguishing between them, in Chambray both *disposition* and *ordonnance* seem to be primarily concerned

19. Ibid., p. 118: 'les secondes pensées des gens d'esprit sont d'ordinaire plus iudicieuses que les remières: d'ou l'on doit aussi conclure que ceux-là d'entre les Peintres à qui toutes sortes de Subjects semblent si indifferents et si égaux ...et qui après la premiere Idée qui leur est venüe pour un Tableau ... n'y changent n'y adjoustent aucune chose; ces Peintres-là, dis je, n'ont que des Genïes superficiels, donts les Ouvrages ne donneront iamais guère de curiosité aux Intelligents, qui n'y trouvant rien de rare n'y d'estudié, seront assez satisfaits de les avoir vûs une fois comme en passant'.

20. It seems to me more than likely that Chambray is here, in 1662, already attacking a theory which de Piles was to formulate much later, yet which in rudimentary form was probably circulating in artistic and literary circles in Paris much earlier, in Dufresnoy's *De arte graphica*.

21. Chambray, *Idée de la perfection de la peinture* (n. 6 above), pp. 121–2.

22. See T. Puttfarken, 'David's *Brutus* and Theories of Pictorial Unity in France', *Art History*, 4, 1981, pp. 291–304.

with figures and their arrangement. That this is particularly true of *ordonnance* is made very clear in Chambray's brief account of Raimondi's *Deposition* after Raphael:

> ... the composition of that *tableau* is unique in that it contains two diverse *ordonnances* of figures, of almost equal weight or consideration, one of men, the other of women; of which the first ..is entirely in the air ... For the other *ordonnance*, which is disposed in the normal way on the ground, it consists of four women ...[23]

'Ordonnance', here, is identical with a group of figures. This 'tableau' has two 'ordonnances', two groups; and perhaps we can best translate 'ordonnance' in this sense as the co-ordination of figures in relation to each other to form groups appropriate to the subject: and as normal disposition takes place on the ground we can define it as the distribution of figures and groups on the ground or in the 'tableau'.

And the phrase 'cette composition de Tableau' points to Chambray's repeated use of composition as being synonymous with the work, the 'tableau'. Raphael's *School of Athens* is described not as *having* a noble composition but as *being* one, with 'l'ordonnance des figures' being part of that composition and being grander and more magnificent than that of some other works by Raphael (or rather engravings after them).[24] So the mental work of composing the action becomes the overall quality of the 'tableau'; yet its mental or spiritual nature remains such that – for Chambray at least – there does not seem to be much difference between looking at the actual work or looking at a small engraving after it.

André Félibien, in his *First Entretien* of 1666, gives an outline of a hypothetical treatise on painting. This would have been divided into three principal parts, namely *composition*, *dessein* and *coloris*. It is a division we are somewhat familiar with from Alberti. But it is itself subsumed in another, more fundamental division, even more strongly emphasized than in Chambray: that between theory and practice. *Composition* contains all the theory of art, because its operation takes place in the imagination of the painter, who must have disposed his whole work in his mind and must have a full grasp of it, before he turns to its execution.[25] (Previously we have been told that Poussin had 'formé les ordonnances dans son esprit').[26] The means of execution are 'dessein' and 'coloris', which are only concerned with practice. That makes them less noble than composition, which is entirely liberal, and which

23. Chambray, *Idée de la perfection de la peinture* (n. 6 above), pp. 52–3: 'Or cette composition de Tableau a cela de singulier, qu'elle contient comme deux diverses ordonnances de figures, presque également considerables, l'une d'hommes, et l'autre de femmes; dont la première ...est toute en l'air ... Pour l'autre ordonnance, qui est disposée à la maniere ordinaire sur le Plan, ce sont quatre femmes ...'.
24. Ibid, preface, n.p.
25. A. Félibien, *Entretiens sur les vies et sur les ouvrages des plus excellens peintres anciens et modernes*, I, Trévoux, 1725, pp. 92–4.
26. Ibid, p. 23.

one can know ('sçavoir') without being a painter.

In order to compose his *tableau* well – in his mind or imagination – the artist must have a precise knowledge ('science') of all its parts. That includes all natural bodies, but above all the most perfect ones; and a clear knowledge of beauty, in particular of the human body, based on proportion. A 'tableau' is an image of a particular action (that implies that only history paintings qualify as 'tableaux'), and the artist must order ('ordonner') his subject and distribute ('distribuer') his figures according to the nature of the action. The subject itself must be expressed via the movements of the body and of the minds; the passions of the soul ('des Passions de l'Ame'), while dependent on 'dessein', must also be entirely within the mind of the painter, ('dans l'idée du Peintre') as they cannot be copied from natural models.

In order to observe 'la convenance' in all sorts of subjects (and this is Félibien's equivalent to Chambray's 'costume'), the artist must have knowledge of history and poetry, of ancient religion, of the customs and forms of living of different nations, of their gods, their temples, their buildings; also their sacrificial and funerary ceremonies, triumphs and games; their different costumes/habits in peace and war, their weapons and and furniture.

Ordonnance of subject and distribution of figures are hence part of this mental composition of the tableau and are determined by the nature of the subject. *L'ordonnance*, as part of a mental or intellectual order, can take on wider connotations: 'L'ordonnance d'un beau tableau nous fera penser à ce bel ordre de l'Universe'.[27]

This is all part of the composition in the mind or the imagination, the theoretical, intellectual activity which we can engage in without being painters. It may well be worth our while to stop briefly and ask what it is that our mind is engaged with. What is it that we imagine? As we are not painters, or at least not necessarily so, it is *not* the picture we want to paint. It is the action, the event, the history or fable, that we call up before the eye of our mind and that we compose and order by endowing it with all the knowledge, the conviction, the clarity etc. that we can muster. It is perhaps worth stating what by now must be obvious, namely that composition, and probably also disposition, are strictly speaking of use only in respect of history painting, not of the lower genres which imitate *le natural*, i.e. which merely copy what is present in front of the eye.

Yet if we happen to be not only artists of the mind, but also practising painters, we will have to translate that composition into practice. H. Körner, in his recent book on *Ganzheitsvorstellungen*, attempted to define the relationship of *composition* and *ordonnance* in Félibien: 'composition' is purely the activity of the mind, *ordonnance* is its realization in the painting.[28] It is an attractive interpretation yet

27. Ibid., p. 101.
28. H. Körner, *Auf der Suche nach der 'wahren Einheit'. Ganzheitsvorstellungen in der französischen Malerei und Kunstliteratur. Poussin David Delacroix Diderot Baudelaire*. Munich, 1988, pp. 34–5.

probably far too clear-cut. We have already seen that 'ordonnance' is part of the mental 'composition' and conversely Félibien, like Chambray, also refers to the whole work, the 'tableau' as 'composition' and in that sense it must be the visual realization of the 'composition' in our mind. Elsewhere 'composition' is *of* the *ordonnance*.[29] 'Composer', as verb, but also 'composition' as noun, is also used in a less exalted way, simply as 'putting together'.

Sometimes *ordonnance/disposition* seems to be the same as in Chambray, i.e. the coordination of figures into groups and the central placing of the principal ones; yet sometimes, in the cases of *composition* and *ordonnance*, the former seems to mean the fully studied, knowledgeable composition of the subject, while the latter seems to refer to the overall visual effect of the painting, perhaps irrespective of its subject-matter. This may even be outside the rule of *convenance* or *costume*: it is impossible to reduce to rules everything that is necessary 'pour bien ordonner les figures qui composent un tableau', – because *ordonnance* is a part which depends on the genius and judgement of the painter; similarly it is difficult to teach precisely how to dispose the colours.[30] To this use of *ordonnance* as visual effect I shall return. We are back again to *génie* and divine fire.

Like Chambray, Félibien feels the need to deal with the problem of conception and realization: 'When a painter wants to undertake such things he must employ all the force of his mind to represent to himself the action he wants to paint, as if, in fact, he saw it in front of his eyes; and when he comes to the execution, that he employs all the science he has got, breaching the dyke (or breaking the banks), so to speak, of his rich imaginations, thus letting them expand like water which, having been held back, spreads itself with impetuosity and inundates the land.'[31]

The watery metaphor here seems to disguise the major problem of Félibien's scheme: what the artist has in his mind, based on knowledge, the *génie* of *ordonnance*, and fired by the fire of invention needs to be translated into practice, it needs to become a *tableau*, it needs to be drawn and painted. And in the end, all the marvellous theory is no good if the practice, the powers of execution, are not adequate. Yet what constitutes adequacy, apart from merely technical dexterity? As Chambray has to control his fiery, romantic first invention by calculating second

29. See Félibien, *Entretiens* (n. 25 above), II, p. 294: 'la composition des ordonnances' (on Raphael), or IV, p. 369: 'composer l'ordonnance d'un tableau'.

30. Ibid., V, p. 99: '... l'ordonnance est une partie qui dépend du génie & du jugement du Peintre: de même, il est difficile d'enseigner précisément de quelle sorte il faut disposer les couleurs'. Yet in the case of colour composition *convenance* prevails: 'il faut que le jugement de celui qui travaille, ordonne toutes ses couleurs selon son subject, selon la disposition de ses figures, & selon les lumieres qui les éclairent' (V, p. 29, on Titian).

31. Ibid., III, pp.186–7: 'quand un Peintre en veut entreprendre de semblables, il faut qu'il employe toutes les forces de son esprit pour se bien représenter l'action qu'il veut peindre, comme s'il la voyoit en effet devant ses yeux; et quand il vient à l'exécution, qu'il deploye tout ce qu'il a de science, rompant la digue, s'il faut ainsi dire, à ses riches imaginations, & les laissant répandre comme un eau, qui après avoir été retenuë, vient à se déborder avec impétuosité, & inonde la campagne'.

thoughts, so Félibien now suggests that the violence of the artists' first fire ('la violence de leur premier feu') must be tempered by subsequent patience and hard work:

> Virgil, it has been said, composed the beautiful works he left us *dans sa chaleur poëtique*, yet he waited to polish his verses until all of them were produced; after that he perfected them.[32]

And the greatest painter of them all never got too hot in the first place: whatever work Poussin did 'he never became too violently agitated: he acted with moderation' because the beautiful fire which warmed his imagination was always of the same force'.[33] Moderation will keep reason in control, in mental composition as well as in actual composition.

In 1668 Félibien publishes the academic conferences delivered during 1667 and adds his own preface. Shortly afterwards he is dismissed from his position as the editor of these conferences. There are one or two possible reasons why. The preface starts again, perhaps even more aggressively, with the distinction between theory and practice, liberal art and mechanical art. This is the first time the academy itself goes public, and its image has to be convincingly different from that of the *maîtrise*.

Again, the principle is stated clearly that the composition in the mind must be completed before the work is executed: 'One needs a perfect knowledge of the thing one wants to represent.' And this now becomes the very essence of the art: 'that knowledge … of which one establishes the rules, is in my view that which one can call art'.[34] This is confirmed later, when Félibien refers to 'ce grand art' as 'cette connoissance toute spirituelle'.[35] I have always suspected that the academicians, as practising and skilled painters, did not like this very much.

However, yet again the term composition is carried over into actual painting; it is not, as Körner's thesis would imply, transformed into *ordonnance* or disposition. Talking 'en général de la composition d'un Tableau', Félibien now states that it has two parts, 'raisonnement ou théorie', and 'la main ou la pratique'.[36] Unlike its treatment in the *Entretiens*, where it is identical with theory, composition now covers both, theory and practice. And so he can describe Poussin's *Rebecca* as having a rich and agreeable composition, both for the 'magnifique disposition des figures' as for all the other knowledgeable things, the faces, actions, dresses, etc.[37] Yet he

32. Ibid., IV, p. 374: 'Virgile, à ce qu'on dit, composoit dans sa chaleur poëtique les beaux Ouvrages qu'il nous a laissez, attendant à polir ses Vers, qu'ils fussent tous enfantez; après quoi il les perfectionnoit …'.
33. Ibid., VIII, p.156: '… il ne s'agitoit point avec trop de violence: il se conduisoit avec modération … parce que le beau feu qui échaufoit son imagination, avoit toûjours une force pareille'.
34. Ibid., V, pp. 307–8: '… il faut avoir une connoissance parfaite de la chose qu'on veut représenter … Et cette connoissance … dont l'on fait des règles, est à mon avis ce que l'on peut nommer Art.'
35. Ibid., V, p. 309.
36. Ibid., V, p. 312.
37. Ibid., V, p. 318.

fails to explain how this is meant to work. Dividing the parts of painting systemati-cally between theory and practice, he comes up with a surprising account. Neither composition nor invention are mentioned; theory consists of the knowledge the subject, of history or fable, of costume, and of 'la beauté des pensées dans la disposition'. Practice now includes not only *dessein* and *couleurs*, but also *ordonnance* and the expressions.[38]

I must confess that it is not at all clear to me what Félibien means by 'la beauté des pensées dans la disposition', and why that should be part of *théorie*, while *ordonnance* is now firmly relegated to mere practice. And the immediate context does not provide an explanation either. It would be wrong even to assume that Félibien was trying to establish a distinction between *ordonnance* as practical, and *disposition* as theoretical. It is the *belles pensées* that are theoretical; while 'la manière de disposer son subject, & de bien mettre chaque corps en sa place', is part of *pratique*. And as in his *Entretiens*, the facility of *ordonnance* is a natural talent, 'un don tout particulier de la nature'.[39] There are inconsistencies here which are hard to resolve.

An explanation of sorts, however, may be provided by some of the conferences themselves. Félibien, in his preface, refers to the fifth conference as that on *ordonnance*. It is Jean Nocret talking about Veronese's *Supper at Emmaus*, praising as its most admirable part 'la grandeur de l'ordonnance': '..its figures are disposed in such a noble fashion that there is nothing which does not immediately surprise the view and does not charm the mind.'[40] I cannot detect, in Nocret's account, any differentiation between *ordonnance* and *disposition*. He talks about 'la disposition des grandes parties' or 'la disposition avantageuse' as meaning exactly the same as *ordonnance*. Yet it is stressed several times that *ordonnance* and *disposition* in Veronese's case are not connected to a learned composition of the subject-matter; the Venetians, as we all know, were not sufficiently learned. Veronese's *ordonnance* is the overall visual effect of the whole that I mentioned earlier.

The following conference is Lebrun's on Poussin's *Manna*. We tend to think of this, quite correctly, as one of the most persuasive and sophisticated examples of seventeen-century practical criticism. What I am suggesting is that it is also an attempt by the leading artist of the day, who also happens to be one of very few practising painters to be interested in theory, to simplify and to regulate the language of that theory. With the exception of a brief reference back to the previous lecture, I have not found the term *ordonnance* used in Lebrun's text. Nor does he use the term *composition* to describe the whole work. He talks of 'disposition en general & de chaque figure en particulier'. And this is considered in three parts,

38. Ibid., V, p. 312.
39. Ibid., V, p. 319.
40. Ibid., V, p. 389: '… les figures sont disposées d'une maniere si noble qu'il n'y a rien qui d'abord ne surprenne la vûë & ne charme l'esprit'.

the 'composition du lieu', 'la disposition des figures', and 'la couleur de l'air'.[41] From its lofty position in Chambray and Félibien, composition is literally brought down to earth. Disposition is of figures. There is an immediate logic in the use of these terms that would have appealed to practising artists: you first put together your place, you *compose* your landscape as the overall and unifying setting, in which you then *dispose* your figures. According to Chambray or Félibien that disposition of figures might well be called *ordonnance*. Not according to Lebrun. He produces a new term, *groupe*, which he defines as 'l'assemblage de plusieurs figures jointes les unes aux autres'; its task is to tie together the main subject and to arrest, to attract, the view.[42]

Lebrun leaves his audience in no doubt about the importance of learning, erudition, precise *costume* etc.; in that respect he does not differ from the other writers. Yet he does not enter into that dubious area where true theorists like Chambray or Félibien would distinguish between mental ordering and pictorial ordering and between inspired invention and lengthy elaboration. Lebrun clearly holds the view that the true order of any subject has to be found in its own nature, but that it is not the task of academic artists to speculate about composition as a purely mental or intellectual exercise. To compose a landscape, to dispose within it the figures and groups of the action in such a way that the viewer's eye and mind are lead to a clear and full understanding of the event and its 'expression generale et particulière' – that is what academic theory should be about. In an implicit yet nevertheless biting attack on Veronese and his supporters, Lebrun distinguishes true disposition which serves the understanding of the subject from *disposition* which only aims to fill the space of the *tableau*.[43] Mere visual effect, – that is what Lebrun thinks of Veronese's *ordonnance*. I cannot help feeling that Lebrun's refusal to embrace the grand scheme of mental composition and his dismissal of *ordonnance* may well be related to Félibien's curiously mixed-up and curtailed preface. And Félibien's failure to adapt to Lebrun's scheme in a satisfactory way, and in particular his inclusion of *expression* in *pratique*, may well have accelerated his early departure.

Finally I shall look briefly at another text published in the same year as the conferences, – or, perhaps, I should say two texts as there are two authors. This is Alphonse Dufresnoy's *De arte graphica*, in the translation by Roger de Piles and with his extensive remarks. Thuillier has discovered an early manuscript sketch for Dufresnoy's poem, dated 1649, and written in all likelihood in Rome. Here Dufresnoy divides the art of painting, like Félibien later, into *composition*, *dessin* and *coloris*. And like Félibien, he makes a sharp distinction between theory and practice, or, as he put it: 'le discours ou raisonnement de l'entendement' and 'l'operation manuelle'. It is worth keeping in mind that Félibien has just been to Rome and

41. Ibid., V, p. 402.
42. Ibid., V, pp. 406–7.
43. Ibid., V, p. 413.

would have met Dufresnoy in the circle of Poussin (that he knew him is clear from the last *Entretiens*).[44]

> That *discours* is what we call composition, which some have also called invention ... composition includes the distribution of figures, the choice of attitudes, *l'accommodement* of clothes and drapery ... *ornemens*, the building (*fabrication*) of locations, buildings, towns[45]

It is also worth noticing that after writing this draft, Dufresnoy went to Venice in 1653 where he stayed for eighteen months. While there, he would certainly have read Pino and Dolce, both of whom divided the art of painting into invention, *disegno* and *colorire*.[46] And in his final, published version, Dufresnoy substituted invention for composition. Yet his discussion of invention differs in a very significant way from any other definition of that term. Having talked about the subject (*De argumento*) with its beauties and charms of form and colour etc., he then refers to the white ground on which the *machina* is to be disposed as bringing into play invention. That a knowledge of poetry and history is also required, is expressed very elegantly: invention is a muse which having been instructed in the arts of her sisters, and inflamed by the fire of Apollo, shines even brighter. Yet from the start there is another major concern, and that is to anticipate, while searching for *posituras*, (probably not poses or attitudes, as in de Piles, but positions of things, i.e. while disposing), the future lights and shadows and colours on which will depend the harmony and charm of the picture. This is Dufresnoy's fourth rule, headed 'Dispositio, sive operis totius oeconomia'. The debt to Junius is obvious. Only in rule V, 'Fidelitas argumenti', does Dufresnoy insist on ancient texts being followed precisely, and on decorum being preserved in all parts. After the example of the tragic Muse, painting, too, must concentrate its highest powers on the place where the highest action takes place.[47]

Rule IV on 'disposition' or 'oeconomia' of the whole work, is commented on by de Piles at some length for obvious reasons:

> This is the most important of all the rules of painting. It belongs properly only to the painter, while all the others are borrowed, from literature, medicine, mathematics, or the other arts: because it is sufficient to have spirit and learning

44. J. Thuillier, 'Les *Observations sur la peinture* de Charles-Alphonse Du Fresnoy', in *Festschrift für Walter Friedlaender*, eds G. Kauffmann and W. Sauerländer, Berlin, 1965, pp. 193–209, p. 199: 'Or le discours s'apelle entre nous la composition ... que quelques uns ont encore nommée invention ... La composition comprent la distribution des figures, l'élection des attitudes, l'accommodement des vestemens ou draperies, le choix et convenances d'ornemens, la fabrication des cites, édifices, villes ...'.

45. Félibien, *Entretiens* (n. 26 above), X, p. 421.

46. See T. Puttfarken, 'The Dispute about *Disegno* and *Colorito* in Venice: Paolo Pino, Lodovico Dolce and Titian', in *Kunst und Kunsttheorie 1400–1900*, Wolffenbütteler Forschungen, 48, ed. P. Ganz, Wiesbaden, 1991, pp. 75–99(81).

47. C.-A. Du Fresnoy, *De arte graphica*, transl. and ed. R. de Piles, Paris,1668, here quoted from the third edition, Paris, 1684, pp. 12–17.

in order to produce a pretty invention ..., but only the painter understands the *Oeconomie du Tout-ensemble* ... A painting may make a bad effect, even though it has a learned invention, correct drawing, and the most beautiful and fine colours; and conversely, despite a bad invention, bad drawing and the most common colours, some paintings make a very good effect ... Nothing pleases man as much as order. ... this rule is properly the use and application of all the others'.[48]

Painting, in this long commentary by de Piles, becomes identical with disposition. And what needs to be complete in the artist's mind before he starts to paint, is not the action or event to be represented, with all its necessary circumstances, but the *tableau* he wants to paint. 'Invention simply finds the things and chooses in accordance with the story that one treats; and disposition distributes each to its place and accommodates the figures and groups in particular and the Tout-ensemble of the Tableau in general; in such a way that that Oeconomie produces the same effect for the eyes which a concert of music creates for the ears.'[49]

And the comparison with music leads to the obvious conclusion that the proper appreciation of painting as *disposition* or *composition* is not careful attentive study, but the immediate effect, the *coup d'oeil*. This comment on Dufresnoy's rule IV contains *in nuce* the whole of de Piles's theory of painting, as he was going to develop it over the next forty years.

If composition, for Félibien and most other early critics, was an intellectual, mental art which all intelligent people could pursue, because we can all imagine actions and events, disposition for de Piles becomes the typical and specific activity of the painter. And it is on that basis that he develops what I regard as the first notions of formal, pictorial composition; – as when he recommends that the whole tableau should be disposed in the same manner as a single head, that it should imitate the appearance of things in convex or concave mirrors, or the famous *grappe de raisins*, attributed to Titian. All this, plus the all-embracing effects of *coloris* and *clair-obscur*, was to make up the *oeconomie du Tout-ensemble*.[50]

48. Ibid., pp. 132–3: 'Voicy le plus important Precepte de tous ceux de la Peinture. Il appartient proprement au Peintre seul, & tous les autres sont empruntez, de belles Lettres, de la Medicine, des Mathématiques, ou enfin des autres Arts: car il suffit d'avoir de l'esprit & des Lettres, pour faire une très-belle Invention ... Mais pour l'oeconomie du Tout-ensemble, il n'y a que le Peintre seul qui l'entende ... Un Tableau peut faire en mauvais effet, lequel sera d'une sçavante Invention, d'un Dessein correct, & qui aura les Couleurs les plus belles & les plus fines: Et au contraire, on en peut voir d'autres mal inventez, mal Dessinez, & peints de Couleurs les plus communes, qui feront un très-bon effet ... *Rien ne plaist tant à l'homme que l'Ordre* ... Ce Precepte est proprement l'usage & l'application de tous les autres ...'.

49. Ibid., pp. 134–5: 'L'Invention trouve simplement les choses, & en fait un choix convenable à l'Histoire que l'on traite, & la disposition les distribuë chacune à sa place quand elles sont inventées, & accommode les Figures & les Groupes en particulier, & le Tout-ensemble du Tableau en général; en sorte que cette Oeconomie produit le même effet pour les yeux, qu'un Concert de Musique pour les oreilles.'

50. Ibid., pp. 199–201. For a more detailed discussion, see T. Puttfarken, *Roger de Piles' Theory of Art*, New Haven and London, 1985.

If I may finish with one last observation: In rule XIV Dufresnoy talks about 'Tabulae libramentum', the equilibrium of the picture; there must be a balance between the two sides of a picture. In his commentary, de Piles refers to this as 'cette espece de Symetrie'.[51] To my knowledge this is the first time that the concept of bilateral symmetry appears in discussions of painting, and it is perhaps worth observing that de Piles's use of the term symmetry precedes Claude Perrault's famous correction of Vitruvius by five years:

> The word symmetry has another meaning in French, for it signifies the correspondence in a building between right and left, high and low, front and back … and it is rather odd that Vitruvius never spoke of this kind of Symmetry, which accounts for much of the beauty of Buildings.[52]

51 Du Frenoy, *De arte graphica* (n. 47 above), pp. 24 and 157.

52. C. Perrault, *Les dix livres d'Architecture de Vitruve corrigez et traduits nouvellement en François, avec des Notes & des Figures*, Paris, 1673, here quoted from the second edition, Paris, 1684, p. II, n. 9: 'on entend autre chose par le mot de Symmetrie en François; car il signifie le rapport que les parties droites ont avec les gauches, & celuy que les hautes ont avec les basses, & celles de devant avec celles de derrières ...; & il est assez étrange que Vitruve n'ait point parlé de cette sorte de Symmetrie qui fait une grande partie de la beauté des Edifices.'

Composition in Seventeenth-Century Dutch Art Theory

Paul Taylor

'It is a commonplace that few words were wasted on art in seventeenth-century Holland,' wrote Svetlana Alpers in her *Art of Describing*.[1] Compared to the art theoretical production of Italy, France, Spain, or even England, art literature in the northern Netherlands between 1600 and 1700 was scant. If we leave to one side those who produced model books[2] and technical manuals,[3] then only four seventeenth-century Dutch authors could be said to have written substantial books about the visual arts: Karel van Mander, Philips Angel, Willem Goeree and Samuel van Hoogstraeten.[4]

The distances in time between the books is considerable. Van Mander's work was published in 1604,[5] Angel's in 1642,[6] Goeree's (two) works in 1668,[7] and Van

1. Svetlana Alpers, *The Art of Describing*, Chicago, 1983, p. 1.
2. The most interesting of these from an art theoretical point of view, i.e. the ones with the least short portions of text, are Chrispijn van de Passe, *'t Light der Teken en Schilderkonst*, Amsterdam, 1643–4, (facsimile edition with introduction by J. Bolten, Soest, 1973) and the two books by Jan de Bisschop, *Icones*, The Hague, 1668–9, and *Paradigmata*, The Hague, 1671 (published together in a facsimile edition with commentary by J. G. van Gelder and I. Jost, Doornspijk, 1985). For a study of Dutch model books see J. Bolten, *Dutch and Flemish Drawing Books. Method and Practice 1600–1750*, Pfalz, 1985.
3. Geerard ter Brugge, *Verlichtery kunst-boeck*, Leiden, 1616; Karel Baten, *Secreet-boeck van diversche en heerlijcke konsten*, Amsterdam, 1656; Willem Beurs, *De groote waereld in 't klein geschildert*, Amsterdam, 1692. The book by Ter Brugge was republished in an expanded version by Willem Goeree as *Verlichterie-kunde, of regt-gebruyck der water-verwen*, Middelburg, 1668. For the facsimile of a later edition of this text see n. 7 below.
4. A Dutch translation of Franciscus Junius's *De pictura veterum* appeared in 1641. For more on Junius and composition, see the article by Colette Nativel in this volume. Shorter texts on art, of thirty pages and less, were written by Jaques de Ville (*T'samen-spreeckinghe betreffende de Architecture, ende Schilderkonst*, Gouda, 1628), Cornelis Biens (*De Teecken-Const*, Amsterdam, 1636; printed in E. A. de Klerk, '*De Teecken-Const*, een 17de eeuws Nederlands Traktaatje', *Oud-Holland*, 96, 1982, pp. 16–60) and Pieter de Grebber (*Regulen*, Haarlem, 1649; printed in P. J. J. van Thiel, 'De Grebbers regels van de kunst', *Oud-Holland*, 80, 1965, pp. 126–31). More writing on the visual arts can be found in city eulogies, diaries, autobiographies, poems and so forth. For an extensive list of writings on art in Dutch in the seventeenth century, see L. de Pauw-de Veen, *De begrippen 'schilder', 'schilderij' en 'schilderen' in de zeventiende eeuw*, Brussels, 1969, pp. xvii–xxii. Little work has been done to date on poetic responses to painting; a welcome exception is the analysis of poems by Jan Vos in G. Weber, *Der Lobtopos des 'lebenden' Bildes*, Hildesheim, 1991.
5. K. van Mander, *Het Schilder-Boeck*, Haarlem, 1604 (facs. ed. Utrecht, 1969).
6. P. Angel, *Lof der schilder-konst*, Leiden, 1642 (facs. ed. Utrecht, 1969). Angel's book has recently been translated into English: 'Philips Angel, *Praise of Painting*. Translated by Michael Hoyle, with an introduction and commentary by Hessel Miedema', *Simiolus*, 24, 1996, nos 2/3, pp. 227–58.
7. W. Goeree, *Inleydingh tot de practijck der algemeene schilderkonst*, Middelburg, 1668, idem, *Inleydinge tot d'al-ghemeene teycken-konst*, Middelburg, 1668 (this last has now appeared in a facsimile with introduction and commentary: Michael Kwakkelstein, ed., *W. Goeree, Inleydinge tot de al-ghemeene teycken-konst. Een critische geannoteerde editie*, Leiden, 1998). Both books were reprinted twice in Dutch during the seventeenth century, in 1670 and 1697; they also appeared in German and English editions (see Kwakkelstein, ibid., pp. 152–5). The differences between the three editions are quite considerable:

Hoogstraeten's in 1678.[8] The last two authors were writing as the Dutch school was beginning to wane: while Angel's work, the only one made at the zenith of the Golden Age, is just fifty-eight pages long.[9]

The rarity and infrequency of Dutch art theory means that it is hard to find a sustained discussion of topics such as composition. This is in part because there are too few printed pages; but it is also because Dutch art theory never really evolved into an organic whole. Italian and French authors argued with one another in print, and by so doing, advanced debates on numerous topics. The quarrel between the Rubénistes and the Poussinistes may seem unilluminating in retrospect, but one wonders if an art critic as perceptive as Roger de Piles could have emerged in seventeenth-century France if there had not been a lively literary argument to help sharpen his thought. In the Netherlands, the authors of art theoretical texts never engaged with one another in this profitable way. To be sure, Angel, Goeree and Van Hoogstraeten all mentioned Van Mander,[10] Van Hoogstraeten did not mention but probably had read Angel,[11] and Goeree mentioned Van Hoogstraeten,[12] but mentions are the most we get; there is no sense of an ongoing discussion between the authors, with attempts to reformulate ideas expressed at earlier times. As a result, no real conceptual momentum is achieved in Dutch art theory. The open competition of art theorists in France spurred them on to

Goeree kept rewriting the book (Kwakkelstein, ibid., pp. 159–63 provides a concordance). Goeree also wrote a book on the proportions of the human body, *Natuurlyk en schilderkonstig ontwerp der menschkunde*, Amsterdam, 1682, which was in theory meant for the use of artists. The illustrations from Leonardo's *Trattato* which were concerned with proportion reappeared in the *Menschkunde*, and Goeree also cannibalized parts of Leonardo's text. However, Goeree did not follow his model very closely, and it is not fair to list his book amongst the printed editions of the *Trattato*, as was done by K. Trauman Steinitz in her *Leonardo da Vinci's Trattato della Pittura: a Bibliography of the Printed Editions 1651–1956*, Copenhagen, 1958, pp. 155–7. On this, see the discussion in Kwakkelstein's *Goeree*, p. 15. The portions of Leonardo's text which deal with painting are omitted by Goeree; so it seems to me that the *Menschkunde* does not really count as a treatise on art. The third editions of the *Schilderkonst*, the *Teyckenkonst* and the *Verlichterie-kunde* (n. 3 above) were reprinted, together with the *Menschkunde*, in a facsimile edition at Soest in 1974. In what follows I refer to this facsimile edition, except where otherwise indicated.

8. Samuel van Hoogstraeten, *Inleyding tot de hooge schoole der schilderkonst*, Rotterdam, 1678 (facsimile edn, Soest, 1969).

9. The question of why the Dutch should have produced so little art literature has not received much discussion. Alpers suggests above that they were simply not interested in such a task. This may be right; but it is also possible that Dutch art theory is thin on the ground for reasons of economics. The costs of typesetting a book were similar throughout Europe, but Dutch booksellers were not able to generate as much turnover to cover their outlay; there were only about 1.5 million readers of Dutch in the seventeenth century, and to make a reasonable profit from the sales of a specialized book in such a small market cannot have been easy. It is probably indicative that Van Hoogstraeten's book was printed by his brother, and the books by Van de Passe and Goeree were printed by themselves.

10. Angel, *Lof der schilder-konst* (n. 6 above), pp. 7, 12, 20, 22, 32, 36; Goeree, *Teykenkonst;* (n. 7 above), pp. 51, 138; Van Hoogstraeten, *Inleyding* (n. 8 above), pp. 2, 5–6, 22–4, 26, 39, 103, 114–15, 149, 187, 189–90, 194, 227, 230, 256, 273, 288, 295, 302–3, 331–3.

11. Van Hoogstraeten, *Inleyding* (n. 8 above), p. 2, seems to be taking information from Angel, *Lof der schilder-konst* (n. 6 above), p. 32.

12. Goeree, *Schilderkonst* (n. 7 above), p. 65.

intellectual invention, while art theorists in Holland stagnated for want of debate.

This isolation of individual authors would not have mattered, if the Dutch had been reading their fellow European art theorists avidly; but of the four authors in question, only Karel van Mander had a reasonable knowledge of art literature outside the Netherlands. Van Mander made an abridged translation of Vasari into Dutch,[13] read Alberti and Rivius,[14] may have read Dolce's *Aretino* and Borghini's *Riposo*,[15] and was aware of Dürer's writings.[16] Philips Angel makes mention of three modern, non-Dutch authors of books about art in his *Lof der schilder-konst*: Leonardo da Vinci, Albrecht Dürer, and Sebald Beham.[17] Whether he had read, or just browsed through the illustrations in, Dürer and Beham is impossible to say –

13. *Het leven der moderne oft dees-tijtsche doorluchtighe Italiaensche schilders*, published as part of *Het Schilder-boeck* (n. 5 above). This is analysed by Hessel Miedema in his *Karel van Manders 'Leven der moderne oft dees-tijtsche doorluchtighe Italiaensche schilders' en hun bron: een vergelijking tussen van Mander en Vasari*, Alphen aan den Rijn, 1984.

14. Gualbertus Rivius (Walther Ryff) published his *Newe Perspectiva* as part of his book *Der furnembsten, notwendigsten, der gantzen Architectur angehörigen mathematischen und mechanischen Künst eygentlicher Bericht*, Nuremberg, 1547. The *Perspectiva* is in part an unacknowledged, loose translation of Alberti's *De pictura*. As Hessel Miedema has noted (in his edition of Van Mander's *Den Grondt der edel-vry schilder-const*, Utrecht, 1973, pp. 456, 633–4, 645–6), Van Mander seems to have had both books open on his desk, but it seems that he was unaware of Rivius's plagiarism. Rivius worked from the Latin edition of *De pictura*, printed at Basle in 1540; it is not known in which language Van Mander was reading Alberti. (In what follows I refer to Leon Battista Alberti, *On Painting and On Sculpture: the Latin texts of De Pictura and De Statua*, ed. and trans. Cecil Grayson, London, 1972.) Van Mander tends to use his Albertian material fairly freely, so it is usually impossible to decide whether he is following Alberti or Rivius or both.

15. He never mentions either author by name, but in his life of Gillis van Coninxloo he writes: 'I have seen dialogues as well as other kinds of writing by two or three Italian authors in which the two arts of painting and sculpture are discussed …' (K. van Mander, *Lives of the Illustrious Netherlandish and German Painters*, ed. Hessel Miedema, trans. J. Penniall-Boer and C. Ford, Doornspijk, 1994, I, f. 267 v.), and certain passages in his writings resemble statements in both authors. See Van Mander, *Grondt*, ed. Miedema (n. 14 above), p. 638, and notes 34, 42 and 49 below. The resemblances are not as close as those between Van Mander and Alberti/Rivius, so it seems unlikely that Van Mander actually owned copies of Dolce or Borghini, and we might take his rather vague remark about having 'seen' some writings as evidence that he did not remember all that much of what he had read. Dolce he could have consulted whilst in Italy. Borghini, however, was not published until after Van Mander's return to the Low Countries, so it is perhaps less likely that he had read *Il Riposo*. He could of course have been shown a copy by someone returning from Italy in the late 1580s or 90s (his friend Goltzius for example), but it does seem possible also that resemblances between Van Mander and Borghini stem from a common artistic milieu, rather than from direct consultation. *Il Riposo* does not seem to have been very well known in the Netherlands; there are no copies recorded in Bredius's *Künstler-Inventare*.

16. Van Mander, *Grondt*, ed. Miedema (n. 14 above), p. 638. It should be added that there are some similarities between certain passages in Van Mander and in Leonardo; for a discussion of this, see Miedema, ibid., pp. 640–41. Miedema believes that Leonardo's ideas may have seeped into Italian studios, and so to Van Mander, by word of mouth. It seems to me that Leonardo's writings may have formed part of a broader oral tradition: that Leonardo received ideas too.

17. Angel, *Lof der schilder-konst* (n. 6 above), p. 32. On p. 33 he also refers to two foreign writers on perspective: Giacomo da Vignola and Sebastiano Serlio. He may have derived both their names from Samuel Marolois, *Perspective*, Amsterdam, 1638; Serlio was translated into Dutch by Pieter Coeke (see n. 21 below). As Hessel Miedema has observed, there is no evidence that Angel knew any languages other than Dutch: H. Miedema, 'Philips Angels *Lof der schilder-konst*', *Oud-Holland*, 103, 1989, pp. 181–222(194).

nothing in the *Lof* owes anything to either;[18] but he could not have read Leonardo – even if he had the linguistic ability – since the latter's *Trattato della pittura* was not published until 1651.[19] Willem Goeree, however, had read the *Trattato* – in fact he pirated many of its illustrations and some of its text for a book he wrote on human anatomy[20] – but the only other post-antique foreign writers on art he seems to have read or browsed were Dürer (in Dutch) and Lomazzo (in French).[21] Van Hoogstraeten, who was clearly an erudite man in other respects, seems not to have read any modern art literature besides Van Mander, Junius, and (probably) Angel.[22] All four authors knew a great deal about ancient art theory, and would happily tell anecdote after anecdote about Apelles or Protogenes; but they were near oblivious to the thought of their contemporaries in Paris or Rome.

All in all, then, it is fair to say that Dutch art theory was an intellectual backwater. Even Vasari was little read; writers such as Armenini, Baglione and Fréart were unknown. To be sure, new ideas entered the Netherlands by word of

18. Dürer's *Vier Bücher von menschlicher Proportion* had been translated into Dutch twenty years earlier (*Beschryvinghe van de menschelijke Proportion*, Arnhem, 1622), which would have made things easier if he had decided to read it. However, he could just as well have derived the information that Dürer wrote on art from Van Mander, *Het Schilder-Boeck* (n. 5 above), f. 208v. Beham's *Kunst und Lerbüchlin*, Frankfurt, 1546, went through seven editions between 1546 and 1605 (1546, 1552, 1557, 1565, 1566, 1582, 1605; the 1565 edition is reproduced in *The Illustrated Bartsch*, New York, 1978, XV (B. VIII), pp. 220–72), and a copy may have reached Angel. It is essentially a model book based on pilfered parts of Dürer's writings on proportion. Over half of the 52 pages in the book are given over to illustrations.

19. Angel knew that Leonardo had written on art from Van Mander, *Het Schilder-Boeck* (n. 5 above), f. 113v; Van Mander derived his information from Vasari: G. Vasari, *Le vite de' più eccellenti pittori scultori e architettori*, editions of 1550 and 1568, edited by R. Bettarini with commentary by P. Barocchi, Florence, 1976, text vol. IV, p. 28.

20. See n. 7 above. He also relied on Leonardo's text in his treatises on painting and drawing; see Kwakkelstein, ed., *W. Goeree, Inleydinge*, pp. 156–8.

21. Kwakkelstein, ed., *W. Goeree, Inleydinge*, pp. 75–8, 150–51; Goeree, *Menschkunde* (n. 7 above), pp. 70–75, 83–4. Goeree tells us that he read Dürer in Dutch, and he mentions Hilaire Pader, Lomazzo's French translator, on p. 71 of the *Menschkunde*. Amongst foreign writers on perspective, he refers to Desargues and Serlio (*Schilderkonst* (n. 7 above), p. 73; Kwakkelstein, ed., *W. Goeree, Inleydinge*, pp. 90–91), although he could have read both of these authors in Dutch (Abraham Bosse, *Algemeene manier van de Hr. Desargues … uyt het Frans vertaalt van J. Bara*, Amsterdam, 1664; Sebastiano Serlio, *Den eersten (-vijfsten) boeck van architecturen. Over gesedt wten Italiaensche duer Peeter Coecke van Aelst*, Antwerp, 1553 (further editions, Amsterdam, 1606 and 1616). Goeree may also have known Jean Cousin the Younger's *Livre de pourtraiture* (Paris, 1560) although it is hard to be certain: he claims that 'a certain Pieter Couzijn' had written a book on proportions (Kwakkelstein, ed., *W. Goeree, Inleydinge*, p. 149). For Goeree's sources in general, see Kwakkelstein, ibid., pp. 35–42.

22. He refers to Junius on pp. 2, 72, 75, 79, 93, 179, 184, 245, 293, 305 and 332 of the *Inleyding* (n. 8 above) and makes heavy use of him elsewhere. He also mentions Pieter Coecke's translation of Serlio (n. 21 above) on p. 127. His many anecdotes about Italian artists almost all derive from Van Mander's Italian *Lives*. There are a few exceptions – he knew something of Bernini and Pietro da Cortona for example – but he probably picked up his information about these artists during his stay in Italy, rather than from contemporary Italian texts. On his Italian trip, see M. Roscam Abbing, *De schilder en schrijver Samuel van Hoogstraten*, Leiden, 1993, p. 44; C. Brusati, *Artifice and Illusion: the Art and Writings of Samuel van Hoogstraten*, Chicago, 1995, pp. 74–6. Van Hoogstraeten was aware of two Italian authors whose writings pertained to the visual arts in slightly different ways: he refers to Vincenzo Cartari on pp. 5, 85, 99, 101, 141, 174, 233, 244, 278 of the *Inleyding* and to Cesare Ripa on pp. 92, 111, 223; but the latter he could have read in the Dutch translation of D. P. Pers, published in Amsterdam in 1644.

mouth, since Dutch artists travelled to Italy and, increasingly as the century wore on, to France; but this could never be enough to plug the intellectual gap. Good art theory, after all, is more than an inventory of the latest ideas of artists. The systematic precision needed to write intelligently about the arts is unlikely to be developed purely by word-of-mouth debate; literary activities need literary examples. In Holland, there were few examples to be had.

As the century wore on, so Dutch art theory declined in quality. Van Mander's didactic poem addressed to young artists, *Den grondt der edel-vry schilder-const*, contains numerous interesting, original and clearly expressed ideas; but the works of Angel, Goeree and Van Hoogstraeten, which take Van Mander as their inspiration, get lost in mazes of convoluted grammar and rambling classical anecdote, and make revealing remarks about artistic practice with some infrequency. In what follows therefore, Van Mander will take up most of our attention.

KAREL VAN MANDER

Van Mander's poem *On the Foundation of the Noble Free Art of Painting* was published as part of his *Schilder-boeck*, or *Painter's Book*, in 1604.[23] It is divided into fourteen chapters, each with its own principal subject. One is devoted specifically to composition: or, as Van Mander puts it, to 'the Ordering and Invention of Histories'. Van Mander's chapter can be split into two halves, the first dealing with the arrangement of figures in pictorial space, the second with the choice of subject matter from literary sources.[24] In this article we will be concerned exclusively with

23. A photographic reprint of the *Grondt*, with a translation into modern Dutch and a commentary by Hessel Miedema, was published at Utrecht in 1973 (n. 14 above). No one can safely read the *Grondt* without taking Miedema's commentary as their guide; the reader will see from my footnotes that I have relied heavily on his research.

24. Hessel Miedema has suggested that we should think of the first half as being concerned with 'ordering', the second with 'invention' (Van Mander, *Grondt*, ed. Miedema (n. 14 above), pp. 460–62). It is not clear to me, however, that Van Mander was quite as crisp in his structure and his use of language as this might suggest. In the second verse of the chapter he writes: 'For painters, ordering is also highly necessary, for in it is combined both the excellence and the power of art: not just perfection and spirit, but also thorough understanding, attentiveness and universal experience. Which is why we seldom hear of people so perfectly capable in invention that they are praised for having surpassed others in fame.' ['De Schilders is d'Ordinanty bevonden/ Oock hooghnoodigh, want daer in d'Excellency/ En cracht der Consten t'samen leyt ghebonden,/ Soo perfecty, gheest, als verstandts doorgronden,/ Aendacht, universael experiency,/ Daerom zijnder soo weynich van Invency/ Volmaeckt, bequame, die wy hooren loven,/ In famen ander gheclommen te boven.'] In this passage, the words 'invention' and 'ordering' seem to have very similar meanings. The same might be said of verse 7, where he writes: 'Always keep yourself free within the [pictorial] space, and don't overload your ground plan. And, as you put your invention into the work, consider first, profoundly and with close attention, the significance of your intended subject, by reading and rereading …' ['Houdt u altijts liber binnen den percke,/ En wilt u gronden niet te seer beladen:/ Maer als ghy u inventy stelt te wercke,/ Wilt eerst wel grondich met goeden opmercke/ Op dijns voornemens meyninghe beraden,/ Met lesen, herlesen, ten mach niet schaden, Vastelijcken drucken in uw memory/ Den rechten aerdt der voorhandigh' History.'] 'Invention' here does not, I think, mean the same thing as 'choice of subject matter'. Philips Angel, *Lof der schilder-konst* (n. 6 above), p. 36, seems to give the words 'ordering' and 'invention' slightly different weights; he censures artists who steal the orderings of others and pass them off as their own inventions. I think that

the first half of the chapter.

Van Mander usually writes of 'ordering', '*ordinanty*'; but on three occasions he uses the word 'composition', '*composity*'. When he uses this latter word he is taking his cue from a well-known passage in Alberti:

> For the composition of a model or figure consists of the many limbs in a body, all considered within the outline: but a history, given its nature, has its composition built up of the models or figures it requires.[25]

However, whereas for Alberti the word *compositio* simply refers to the putting together of parts, either of a figure or of a group of figures, for Van Mander *composity* has begun to shift in sense. When he writes '… let us pay attention to ordering in our principal composition, whether it be out of doors, in a house or a hall, or wherever we have set our models …', he is apparently beginning to think of a 'composition' as the arrangement of an entire history painting.[26]

Van Mander uses 'ordering' both as a verb and a noun. 'To order' (*ordineren*) is, as one might expect, to impose order; this is an activity carried out by sentient beings, from God down to ants. The result of their activity is considered to be (noun) 'ordering' (*ordinanty*) or 'order' (*ordeningh*). As Van Mander puts it:

> Every thing that exists displays a customary, considered regularity, or ordering: God's creatures both on high and on low, as well as kingdoms, lands, free towns, households, and diverse practices which inventive humans bring into being. One also sees order in dumb beasts, like useful bees and industrious ants.[27]

for Angel, and probably for Van Mander, the word 'invention' had many of the same connotations that it has for us today. In these passages, it seems to mean something along the lines of 'an ordering which has been thought up by a particular individual'. W. S. Melion, *Shaping the Netherlandish Canon: Karel van Mander's Schilder-Boeck*, Chicago, 1991, p. 51, argues that Van Mander uses the terms *inventy* and *ordinanty* interchangeably in the *Grondt*. For more on this subject, see below, p. 16.

25. 'Want eenes bootsen oft Beeldts composicy/ Is van veel leden in eenen Lichame/ Al begrepen binnen de superficy:/ Maer de History heeft (nae haer condicy)/ Van bootsen oft Beelden daer toe bequame/ Haer compositie ghevoeght te same …': *Grondt*, (n. 14 above), V, 4. Alberti, *On Painting* (n. 14 above), p. 71: 'Composition is that procedure in painting whereby the parts are composed together in a painting. The great work of the painter is the 'historia'; parts of the historia are the bodies, part of the body is the member, and part of the member is the surface.' It is clear from this that Van Mander was not very interested in the finer strands of Alberti's thought. As Hessel Miedema has noted in Van Mander, *Grondt*, ed. Miedema (n. 14 above) p. 463, Van Mander may have taken this passage from Rivius *Newe Perspectiva* (n. 14 above), f. aaa4r, rather than direct from Alberti. For Rivius and Alberti, see n. 14 above.

26. 'Laet ons dan op Ordinantie letten,/ In onse composity principale,/ T'zy op buyten gronden, in huys oft sale,/ Oft waer wy ons bootsen hebben te setten …': Van Mander, *Grondt*, ed. Miedema (n. 14 above), V, 3. See Hessel Miedema's discussion of this passage, ibid., p. 462. The passage quoted here is not entirely unambiguous as it stands – Van Mander could be thinking of a composition as a group of figures (see Charles Hope's discussion of *componimento* in his paper in this volume) – but from the way the argument proceeds it seems likely that he is thinking in terms of the whole painting. At the beginning of verse 7, as noted in n. 24 above, he writes: 'Always keep yourself free within the space, and don't overload your ground plan …'.

27. 'In gheschickte gheregheltheyt vol zeden,/ Oft Ordinanty, bestaen alle dinghen,/ Soo wel Gods schepselen boven, beneden,/ Als Coninckrijcken, Landen, vrye Steden,/ Huysghesinnen, en diversch'

A composition can be either consciously ordered or just haphazard. 'An ordering', therefore, is a composition which has been planned by the artist.[28] Since, in this chapter of the poem, Van Mander is giving us rules for arranging the lay-out of pictures, he can largely dispense with the word 'composition' and refer throughout to 'ordering' instead.

A quarter of the verses Van Mander devotes to ordering are given over to praise of variety and abundance. In this he is following Alberti, as he explicitly acknowledges:

> Besides landscape and architecture, there are decorations, harnesses and ornaments, many a lovely fantasy in abundance [*copia*], and it makes a beautiful harmony of appearance in the tents of Pictura, according to the testimony of modern writers, like Leon Battista Alberti and Rivius,[29] who also held such things dear.[30]

It may well be that Van Mander believed all he wrote on variety and abundance, but it should be noted that many of his comments are little more than translations from Alberti:

> Van Mander: … good masters avoid abundance or Copia in their principal subjects, and revel in perfecting the pared-back and simple. Masters of this kind, to speak in similes, do not copy attorneys or advocates, who use many words when pleading, but rather imitate great sovereigns, kings and powerful potentates, who let little speech fall from their lips, but with their mouths or pens allow their opinions to be understood in few words. And such simple statements do their reputations far greater honour than a surfeit of babbling and prattling, just as empty vessels make the loudest noise. Thus, it seems, our great masters learn to turn their attentions toward simplicity, and, with a few figures, can give their things a beautiful and graceful appearance. And they do this by the great perfection of their figures, which seem to move as if they are alive. They seem to be building on the foundations of poets, who began putting few characters into their Comedies or Tragedies; or they are following Varro, who did not want the loud noise of a horde of guests when he threw an aristocratic dinner party. But in order to make a pleasant event he would only invite a moderate number of well-chosen people to his meal; nine or ten, so that no one would prevent the others

oeffeninghen,/ Die de vernuftighe Menschen by bringhen,/ Oock sietmen ordeningh, in stomme Dieren,/ Als nutsame Bien en vlijtighe Mieren.': Van Mander, *Grondt*, ed. Miedema (n. 14 above), V, I.

28. Van Mander does not set up the distinction so explicitly, but I take him to have this underlying notion when he writes: 'let us pay attention to ordering in our principal composition …': see n. 26 above.

29. See n. 14 above.

30. 'Daer beneffens Landtschap, en metserije,/ Oock cieraten, ghetuygh, en ornamenten,/ Menigherley aerdighe fantasije/ Der copia, en t'maeckt schoon Harmonye/ Der welstandicheyt in *Picturams* tenten,/ Nae t'ghetuyghen van moderne Schribenten,/ Als *Leon Baptistae* de *Albertis*, / En *Rivius*, van wient oock nae behert is.' Van Mander, *Grondt*, ed. Miedema (n. 14 above), V, 26; Alberti, *On Painting* (n. 14 above), p. 79; Van Mander, *Grondt*, ed. Miedema (n. 14 above), pp. 473–4.

from being contented …[31]

Alberti: Perhaps the artist who seeks dignity above all in his 'historia', ought to represent very few figures; for as paucity of words imparts majesty to a prince, provided his thoughts and orders are understood, so the presence of only the strictly necessary number of bodies confers dignity on a picture. I do not like a picture to be virtually empty, but I do not approve of an abundance that lacks dignity. In a 'historia' I strongly approve of the practice I see observed by the tragic and comic poets, of telling their story with as few characters as possible. In my opinion there will be no 'historia' so rich in variety of things that nine or ten men cannot worthily perform it. I think Varro's dictum is relevant here: he allowed no more than nine guests at dinner, to avoid disorder.[32]

Nevertheless, Van Mander was no slavish copyist, and he introduced some interesting concepts into the discussion of variety. He made, for example, a direct comparison between compositional variety and musical harmony:

… it further strengthens the good appearance of a work when the ordering contains similar parts which suit one another, and just as, in music, the different sounds of singers and players make harmony, so in the art of painting do many various figures.[33]

31. '… goede Meesters van den principalen/ D'overvloet oft *Copia* veel vermijden,/ En in't weynich eensaem, weldoen verblijden.// Sulcke (by ghelijckenis) conterfeyten/ Niet de Procureuren oft Advocaten,/ Die veel woorden ghebruycken in het pleyten,/ Maer bootsen nae groote Majesteyten,/ Sommighe en machtighe Potentaten,/ Die niet veel sprake van hun uyt en laten,/ Maer gheven mondelijck, oft metter Pennen,/ In weynich woorden hun ghemoedt te kennen.// En soo eensaem redenen verselschappen/ Hun reputaty met veel meerder eeren,/ Dan overvloedich rammelen en snappen,/ Als ydel vaten, die ten meeste clappen:/ Dus schijnet dat ons groote Meesters leeren,/ Hun oock veel totter eensaemheyt te keeren,/ En met weynich beelden weten te gheven/ Hun dinghen een schoon bevallijck aencleven.//En dat door groote perfecty bevonden/ In hun Beelden, die schier levende roeren,/ Schijnende bouwen op Poeetsche gronden,/ Die Comedy oft Tragedy bestonden/ Met weynich Personnagen uyt te voeren,/ Oft volghen *Varro*, die het groot rumoeren/ Van veel Gasten ter taf'len niet en sochte,/ Als hy heerlijck maeltijdt te houden plochte.// Maer om verblijden nae zijnen opsette,/ Een tamelijck ghetal volcx uytghelesen/ En liet hy maer roepen t'zijnen banckette,/ Neghen oft thien, op dat niet en belette/ Dan een den anderen vroylijck te wesen …': Van Mander, *Grondt*, ed. Miedema (n. 14 above), V, 27–31.

32. Alberti, *On Painting* (n. 14 above), p. 79. Again, Van Mander may have taken this from Rivius *Newe Perspectiva* (n. 14 above), f. bbb4v: see Van Mander, *Grondt*, ed. Miedema (n. 14 above), p. 474. See too M. Baxandall, *Giotto and the Orators*, Oxford, 1971, pp. 135–9.

33. 'T'is seer lovelijck der Beelden playsancy/ Te soecken, en gheensins daer van te wijcken:/ Maer het gheeft noch een meerder abondancy/ Van welstandicheyt, wanneer d'Ordinancy/ Daer wel med' over een comt van ghelijcken, En als veelderley gheluydt der Musijcken/ Maeckt Harmonie, van die songhen en speelden,/ Alsoo doen hier oock veel verscheyden Beelden.': Van Mander, *Grondt*, ed. Miedema (n. 14 above), V, 19. Miedema (ibid. p. 472) claims that this passage comes from Rivius/ Alberti, but does not give a precise reference. I assume he is referring to the passage of Rivius which he quotes further down his p. 472, which in Alberti (*On Painting*, n. 14 above, p. 79) reads as follows: 'Just as with food and music novel and extraordinary things delight us for various reasons but especially because they are different from the old ones we are used to, so with everything the mind takes great pleasure in variety and abundance.' It seems to me that Van Mander is making a more interesting use of his metaphor; he is making an analogy between two kinds of harmony, the compositional and the musical. Alberti is just saying that monotony is dull. Alberti's metaphor goes back to Cicero's *De oratore*:

The use of music as a simile when talking about pictorial composition has had a long life: see the comments by Hubert Locher on pp. 219ff below. Van Mander's comparison is certainly a very early one. So far as I am aware, only Raffaello Borghini preceded him in this particular use of metaphor,[34] and it is not certain that Van Mander had ever read Borghini.[35] It is possible that both authors were expressing ideas which were quite common in artistic conversation at the end of the sixteenth century, but which rarely cropped up in the few European art theoretical treatises.

Van Mander's remark about harmony stands at the beginning of a long tradition, and so too does his comment on the expressive nature of the composition:

> Paint the imagined scene first in your mind, with spirited, suitable parts, so that you express your subject nobly, artistically, ably and (as good Orators do with their oratory) with beautiful grace … .[36]

Of course, Van Mander's use of the verb 'express' here (*uytdrucken*, which means both 'press out' and 'express') leaves him a long way from any modern theory of artistic 'self-expression'; but he clearly did feel that a composition could enshrine a story aptly or otherwise, and this sense of rightness, when combined with his remark about harmony, does seem to suggest that his response to a composition went beyond the purely functional. He wanted a narrative to be well told; but he could derive an aesthetic satisfaction from the telling itself.

Van Mander's aesthetics are also revealed in his awareness of the need to space figures in such a way that they form visually pleasing wholes. He writes:

see Baxandall, *Giotto and the Orators* (n. 32 above), p. 137.

34. R. Borghini, *Il Riposo*, Florence, 1584, p. 179: 'Bisogna al fine sì fattamente disporre ogni cosa che ne nasca una concordanza, & unione, che come da varie voci, e da diverse corde ne risulta concento che diletta all'orecchie, così dalle molte parti disposte nella pittura, dimostrando vaghezza, e giudicio, ne nasca à gli occhi piacere, e contento.' I am grateful to Thomas Puttfarken for drawing this passage to my attention. Cf. n. 33 above. Alberti compared architectural variety to musical harmony in his *De re aedificatoria*. See L. B. Alberti, *L'architettura*, ed. and trans. G. Orlandi and P. Portoghesi, Milan, 1966, bk I, ch. 9, p. 68 (f. 14v). D. Koenigsberger, *Renaissance Man and Creative Thinking: a History of Concepts of Harmony 1400–1700*, Hassocks, Sussex, 1979, p. 29.

35. See n. 15 above.

36. 'Beschildert eerst ws sins imaginacy/ Met gheestighe byvoeghelijcke stucken,/ Om u materie met schoone gracy/ (Als goed' Oratoren doen hun oracy)/ Heerlijck, constich, en bequaem uyt te drucken …': Van Mander, *Grondt*, ed. Miedema (n. 14 above), V, 8. Hessel Miedema translates the word I render here as 'parts' (*stucken*) as 'details'. It is not clear to me how suitable details could allow an artist to express a subject nobly and with beautiful grace. Miedema also suggests that Van Mander is here following Rivius, but it seems to me that the passage of Rivius is less interesting: 'So wir nun furhaben ein Histori künstlichen zu malen, ist von nöten, das wir mit gantzem fleisz gantz eygentlichen bey uns selber betrachten in was ordnung, form und gestalt wir dieselbig am aller besten und wolgeschickisten stellen wöllen.' Rivius, *Newe Perspectiva* (n. 14 above), f. ddd4r, quoted by Miedema, ibid., p. 465; Alberti, *On Painting* (n. 14 above), p. 103: 'When we are about to paint a "historia", we will always ponder at some length on the order and the means by which the composition might best be done [prius diutius excogitabimus quonam ordine et quibus modis eam componere pulcherrimum sit].' There is no mention in either Rivius or Alberti of the subject being 'expressed' in the composition.

In the ordering one should not weave arms and legs together nor allow them to become confused, as if they seemed to fight; rather, they should follow one another in the proper direction, flowing as one, in equality[37]

Those formalist art historians who have superimposed 'flow diagrams' onto Renaissance paintings are not, perhaps, being anachronistic. Can we be sure that Van Mander did not think through the limb connections shown here (Fig. 1), on his *Before the Flood*?[38] From his own words, it seems quite possible that he *did* plan his compositions in this way.

An idea Van Mander returns to at various points in the chapter reveals the extent to which he thought of his picture as bounded by a frame. It is clear that he conceived of the painting as being of a certain shape, and knew that the composition would have to be arranged to suit that shape. He writes:

... but at all times arrange things in accordance with the size of the space available, and make sure that the figures neither support the frame, nor lie cramped as if in boxes. Put your people in loosely, for a pleasant effect; don't allow your spirit to get so carried away that you make your things so large that hands and feet have to run into the frame, or lie uselessly twisted because you were constrained by the space; rub it out and rearrange it, in accordance with art. You are free, so don't turn your people into slaves.[39]

It is not immediately clear how 'aesthetically' Van Mander intends this advice. Is he just concerned lest the composition look ridiculously cramped, or does he have

37. 'In d'Ordinanty en salmen niet vlechten,/ Noch seer laten haspelen d'een door d'ander,/ Armen en beenen, schijnende te vechten,/ Maer eenvloedigh, ghelijckelijck, in rechten/ Ganck laten die dinghen volghen malcander ...': Van Mander, *Grondt*, ed. Miedema (n. 14 above), V, 39. Miedema (ibid. pp. 480–81) suggests a parallel between these remarks and the passage concerning confusion from Borghini quoted in n. 49 below; but it seems to me that Van Mander is saying something slightly different. Van Mander's word 'eenvloedich', 'flowing as one', is an allusive neologism which goes beyond Borghini's concern with compositional legibility. Cf. De Grebber, *Regulen* (n. 4 above), p. 126 (rules VII and VIII).

38. Städelsches Kunstinstitut, Frankfurt, inv. no. 2088. K. van Mander, *Lives of the Illustrious Netherlandish and German Painters*, ed. Hessel Miedema, Doornspijk, 1995, II, p. 110, fig. P15.

39. '... doch t'allen tijden/ Hem nae des percks grootte schicken, en mijden/ Dat de Beelden de lijsten niet en draghen,/ Oft datse benouwt als in kisten laghen.// Stelt u volcxken wat los, om een versoeten,/ Laet uwen gheest soo wijdt niet zijn ontspronghen,/ U dinghen soo groot te maken, dat moeten/ In de lijsten loopen handen oft voeten,/ Oft onbequamelijck ligghen gewronghen,/ Om dat ghy door de plaetse zijt ghedwonghen:/ Vaeght uyt, en verstelt, nae der Consten gaven,/ Ghy zijt doch vry, en maeckt u volck geen slaven.':Van Mander, *Grondt*, ed. Miedema (n. 14 above), V, 5–6. Cf. De Grebber, *Regulen* (n. 4 above), p. 131 (rule IX). Hessel Miedema in Van Mander, *Grondt*, ed. Miedema (n. 14 above), p. 463, draws a parallel between this passage of Van Mander and one in Rivius *Newe Perspectiva* (n. 14 above), f. bbb4r: 'Es ist auch nit wenig spötlich, sonder höchlichen zu schelten (wie etliche Maler zu thun pflegen) die possen in die geheusz oder gemach, zuverschliessen vnnd ein zusperren, wie in einen kasten, das jn nit müglich wer, sich darin auffzurichten, sonder nit wol krum, sitzendt, oder zusamen gewunden, sich darin behelffen möchten.' (Alberti, *On Painting* (n. 14 above), p. 77: 'Another thing I often see deserves to be censured, and that is men painted in a building as if they were shut up in a box in which they can hardly fit sitting down and rolled up in a ball.') However, neither Rivius nor Alberti are talking here about the constraints of the frame; it is precisely the fact that Van Mander does mention the frame which makes this passage so interesting.

the subtler sense that a composition must live in harmony with its enclosing contour? One wonders if he would he have understood the following statement, made by Henri Matisse:

> Composition, the aim of which is expression, alters itself according to the surface to be covered. If I take a sheet of paper of given dimensions I will jot down a drawing which will have a necessary relation to its format – I would not repeat this drawing on another sheet of different dimensions, for instance on a rectangular sheet if the first one happened to be square. And if I had to repeat it on a sheet of the same shape but ten times larger I would not limit myself to enlarging it: a drawing must have a power of expansion which can bring to life the space which surrounds it. An artist who wants to transpose a composition onto a larger canvas must conceive it over again in order to preserve its expression; he must alter its character and not just fill in the squares into which he has divided his canvas.[40]

I think Van Mander would have understood these comments, even if he would have been incapable of coming up with them himself given the art theoretical tradition in which he was working. In fact, he makes remarks about drawing on a large scale which echo the spirit of Matisse's remarks:

> Let your spirit flow. To make your art flourish, you can go on to do what the Italians do, and use your sketches to draw cartoons, as large as your work; but do this boldly, freely and fearlessly. I must exhort you like this so that you will avoid a manner which is heavy and ill-sorted, too *stentato*, difficult or tormented.[41]

It does seem here as if Van Mander is aware, like Matisse, of the difficulties involved in sizing up from sketches. 'Filling in the squares' will not do, one needs to be bolder to capture the success of a small drawing on a large canvas. It also seems that we would not be reading too much into Van Mander's words if we supposed that he, like Matisse, had a delicate sense of the aptness with which a drawing can play against its edges.

Most of Van Mander's other remarks about composition reveal his preferences for particular kinds of pictorial arrangement. He tells us, for example, that he likes to see pictures which have a space in the middle of the foreground, so that the beholder can enjoy a view over distant landscape:

> … you can give your ordering a well-founded good appearance by skilfully filling your space on both sides with boldly set-forth foreground figures, architecture or other scenery; if you want the completely open space in the centre to win a good

40. Henri Matisse, 'Notes of a Painter', as translated in Herschel B. Chipp, ed., *Theories of Modern Art*, Berkeley and Los Angeles, 1968, p. 132.

41. 'Laet vloeyen uwen gheest, om Const vergroenen,/ Meucht oock nae desen, als d'Italianen,/ Wt u schetsen teyckenen u Cartoenen/ Alsoo groot als u werck, doch met vercoenen,/ Vry en onbeschroemt, dit moet ick vermanen,/ Op dat ghy u vermijdet van soodanen/ Maniere die swaer is, en niet wel stellijck,/ Al te ghestenteert, moeyelijck oft quellijck.': Van Mander, *Grondt*, ed. Miedema (n. 14 above), V, 9. See Miedema's comments on *stentato*, ibid. pp. 466–7.

appearance you should fill it with as little as you can. For our ordering must enjoy a beautiful nature, to the pleasure of our senses, if we allow it to have an in-view or through-view, with small figures in the background and distant views of landscape through which the sight can plough its way. And so we may also sometimes make our figures kneel down in the centre foreground, and let a number of miles be seen over them.[42]

Van Mander often followed his own advice here; in a painting like *Before the Flood* the figures carefully keep to the sides, so we can see Noah building his ark in the middle ground, and the looming storm clouds in the distance (Fig. 1). A painting like this also shows us, perhaps, why Van Mander was attracted to pictures in which the landscape played such an important part: his figures were rarely as successful as his hills or trees.

The concept of the through-view was apparently not peculiar to Van Mander. He tells us that Michelangelo's *Last Judgment* had been criticized by some for not providing a view into the distance:

> … some besmirch [Michelangelo's] honour … because his stress on the figures led him to fall short in something which may be of importance to the ordering: there are no in-views. He does not allow us to see, as some would, a through-view of a Heaven, with something large in the foreground, as his detractors would want; but who will not hold it to be for the best, when looking at this work which is so drenched with artistry from the learned hand of Buonarotti, with so many poses of different forms of nude; and this was what concerned him.[43]

This is an example of one of Van Mander's pleasing traits as a thinker; his ability to undermine his own theories. Unlike later writers, for example Gerard de Lairesse, he rarely believes that his rules of art are universally applicable. It may be pleasant to add a through-view, but for a great artist like Michelangelo, it is not essential.

42. 'Eerst suldy bevinden uyt ondersoecken/ In u ordinancy welstants fundacy/ Wanneer ghy u perck alle beyde hoecken/ Bequamelijck vervult met uwen cloecken/ Voorbeelden, bouwingh', oft ander stoffacy,/ En dan de middelste vry open spacy/ Gh'en sult soo weynich daer niet brenghen binnen,/ Of ten sal stracx eenen welstandt ghewinnen.// Want ons ordinancy moeste ghenieten/ Eenen schoonen aerdt, naer ons sins ghenoeghen/ Als wy daer een insien oft doorsien lieten/ Met cleynder achter-beelden, en verschieten/ Van Landtschap, daer t'ghesicht in heeft te ploeghen,/ Daerom moghen wy dan oock neder voeghen/ Midden op den voorgrondt ons volck somwijlen,/ En laeten daer over sien een deel mijlen.':Van Mander, *Grondt*, ed. Miedema (n. 14 above), V, 11–12. There are some resemblances between this passage and one from Borghini's *Riposo*, quoted in n. 49 below.

43. 'T'is veel t'ghebruyck gheweest van Tinturetten/ T'ordineren, soo met groeppen oft knoopen,/ En *Angelus* oordeel is oock veel metten/ Hoopkens gheordineert, maer doch besmetten/ Eenighe zijn eere, niet om de hoopen,/ Maer dat hy om de Beelden hem verloopen/ Heeft, in t'gheen d'ordinanty mach belanghen,/ Datter niet en zijn insichtighe ganghen.// Niet latende sien, als eenighe souden/ Een insien van eenen Hemel ontsloten,/ En voor aen yet groots, soo sy't wenschen wouden:/ Maer wie en sal dit niet ten besten houden,/ Siende dit werck al vol Consten doorgoten,/ Van de gheleerde handt des *Bonarroten*, / Soo veel acten verscheyden van fatsoene/ Der naeckten, daer het hem om was te doene.': Van Mander, *Grondt*, ed. Miedema (n. 14 above), V, 16–17. It is not clear who these detractors were: Miedema (ibid. p. 470) discusses the various possibilities.

A compositional idea of Van Mander's which he may well have picked up during his stay in Italy in the 1570s[44] concerns the desirability of clumping figures together into groups. This he seems to think of as a particularly Italian practice:

> ... the Italians ... greatly praise ordering in different groups, that is with piles or troops of people, some standing, some lying and others sitting. Here will be a group clashing in fearful battle, elsewhere a group fleeing into the distance, in the foreground horses and riders falling over one another, some beautifully foreshortened; here there will be a group wrestling farcically, and there a group sighing in defeat ... Tintoretto was much in the habit of ordering in this way with groups or knots, and Michelangelo's *Last Judgment* is also ordered in large part with piles ...[45]

In his paper earlier in this volume, Philip Sohm writes at length on the phenomenon of 'piles' in Italian art and theory, and it would seem that Van Mander was probably right in claiming that the concept was indigenous south of the Alps. Nevertheless, one can see a self-conscious piling in the work of some of his contemporaries, as for example in Abraham Bloemaert's drawing of the Golden Age (Fig. 2).[46]

Van Mander also recommends to his readers that they put the central figure of a history in the midst of a ring of spectators:

> Many orderers are also convinced of the value of something which I would not want to decry; that is, they put that which is clearly the principal part [Scopus] of their histories into the midst of an imaginary circle, so that a number of figures ring the history, which remains the central point in the middle, as a figure which many behold or worship.[47]

44. On Van Mander's Italian journey, see Hessel Miedema's remarks in Van Mander, *Lives* (n. 38 above), pp. 48–56.

45. '... d'Italianen ... veel roepen/ Van t'ordineren met verscheyden groepen,/ Welck sijn hoopkens oft tropkens volck, te weten,/ Hier ghestaen, gheleghen, en daer gheseten.// Hier in Bataille sullen vreeslijck horten,/ Eenen hoop in't verschieten elders zijn vluchtich,/ Voor aen sullen over malcander storten/ Peerden en Ruyters, som aerdich vercorten,/ Hier een hoopken ligghen wrastelen cluchtich,/ En daer oock een hoopken verslaghen suchtich,/ Dus met hoopkens t'ordineren verhal' ick,/ Als ick heb ghesien, niet te staene qualick.// T'is veel t'ghebruyck gheweest van Tinturetten/ T'ordineren, soo met groeppen oft knoopen,/ En *Angelus* oordeel is oock veel metten/ Hoopkens gheordineert ...': Van Mander, *Grondt*, ed. Miedema (n. 14 above), V, 14–16. Hessel Miedema believes that 'the composition in groups is closely related to the cavalry battle' (ibid. p. 469) but I am not sure this is right, for Van Mander at least: Tintoretto's oeuvre is short on cavalry battles, and there are no horses in Michelangelo's *Last Judgment*.

46. Städelsches Kunstinstitut, Frankfurt, inv. no. 2878. *Dawn of the Golden Age: Northern Netherlandish Art 1580–1620*, exh. cat. Rijksmuseum Amsterdam, 1993, cat no. 224.

47. 'Veel Ordineerders op een dingh oock gissen,/ Daer ick mede niet teghen en wil dringhen,/ Te weten, dat sy sullen den ghewissen/ Gantschen Scopus hunner gheschiedenissen,/ Als besloten in een Cirkels beringhen,/ Op dat alsoo een deel bootsen bevinghen/ d'History, die als t'Centre punct in't midden/ Blijft staend', als Beeldt, dat veel aensien oft bidden.': Van Mander, *Grondt*, ed. Miedema (n. 14 above), V, 23. Cf. ibid., V, 36: 'The noble figures should be the most prominent, either by standing higher or sitting raised up above the others; and those who address them should give humble signs of

It might seem that it would be hard to combine this recommendation with the advice concerning the 'through-view'; but Van Mander was able to follow both prescriptions in a number of works, as we can see for example in a drawing of Pan and Syrinx in the Uffizi (Fig. 3).[48] It is almost as if the artist is trying to give us value for money here – a clearly legible composition *and* a beautiful landscape. This mercantile urge to fill the pictorial space with visual attractions becomes explicit in his advice concerning the 'stacked-up' composition:

> ... there are some [histories] which are much easier to order if one follows the example of the vendor, who shows his wares to wonderfully good effect on high boards, at the sides and below. Thus one may introduce some people, who are watching the history unfold, on hills, in trees, or on stone steps, or holding onto columns in the architecture; and others, at the front, down on the ground ...[49]

Again, we can see Van Mander putting his own ideas into practice; his drawing of *Ecce Homo* (Fig. 4) shows the players spread over five or six different levels, standing on blocks of stone which look most implausible from an architectural point of view.[50] Van Mander's compositions are usually replete with visual incident. When he observed, as we saw above, that 'our great masters learn to turn their attentions

obedience, looking downcast, in a lowly position. And so it should be with all the other characters, who should be placed on all sides gesturing towards this event, like actors.' ['De heerlijcke Beelden sullen uytsteken,/ In hoocheyt staend' oft sittende gheresen,/ Boven die ander: en die hun aenspreken,/ Vernedert, bewijsen ghehoorsaem treken,/ Ter verworpelijcker plaets' en verknesen,/ Soo voorts als ons personnagen, tot desen/ Sy ghestelt zijn sullen aen alle canten,/ Hun acten doen, als sijn Comedianten.'] This passage is discussed in the context of works by Lastman and Rembrandt by B. P. J., 'Rembrandt and Lastman's Coriolanus', *Simiolus*, 8, 4, 1976, pp. 202–3. Cf. De Grebber, *Regulen* (n. 4 above), p. 126 (rule III).

48. Uffizi, Florence, inv no. 8602 S. Van Mander, *Lives* (n. 38 above), p. 128, fig. D34.

49. 'Dan sommigh' Historien wel eensamer/ Als ander vereysschen te zijn bysonder,/ Oock zijnder om ordineren bequamer,/ Daer men mach doen ghelijck den Cramer,/ Die zijn goet ten tooghe stelt schoon te wonder,/ Op hooghe borden, ter sijden en onder,/ Soo maecktmen d'History beschouwers eenich,/ Op heuvels, boomen, oft op trappen steenich.// Oft houdend' aen colomnen der ghestichten,/ Oock ander voor aen op den grondt beneden ...': Van Mander, *Grondt*, ed. Miedema (n. 14 above), V, 34–35. B. P. J. Broos discusses this passage in 'Rembrandt and Lastman's Coriolanus' (n. 47 above), pp. 202–3. Hessel Miedema in his edition of Van Mander cited above (p. 477, n. 136) has noted that the passage has a certain resemblance to one in Borghini's *Riposo* (Florence, 1584, pp. 177–8): 'Dee dunque con molta avertenza quando egli fa una historia andar disponendo, e compartendo le figure, i casamenti, & i paesi faccendo che si veggano piu figure intere che sia possibile, e non intrigarle talmente insieme che paiano una confusione: e non imitare alcuni, che volendo mostrare di far molte figure in una tavola dipingono due, ò tre figure grandi innanzi, e poi molti capi sopra capi, la qual cose non contiene in se arte, e non da piacere à riguardanti, anzi bisogna fuggire di metter nel primo luogo figure grandi, e dritte; perche tolgono la vista delle seconde, & occupano gran parte del campo, però dee il pittor giudicioso cercar di far le prime figure, ò chinate, ò a sedere, ò in qualche attitudine bassa, acciò vi rimanga spatio per altre figure, casamenti, e paesi ...' In Van Mander, *Grondt*, ed. Miedema (n. 14 above) V, 39 Van Mander writes: 'I have also heard it much praised when the figures of a history are mostly shown whole, entirely unbroken' ['Oock heb ick veel hooren prijsen, als van der/ History de Beelden veel t'eender sommen,/ Gants onghebroken gheheel moghen commen'], which seems to echo Borghini's 'figure intere'. On Van Mander and Borghini see n. 15 above.

50. Museum Boymans-van Beuningen, Rotterdam, inv. no. K. van Mander 1. Van Mander, *Lives* (n. 38 above), p. 122, fig. D15. The drawing was preparatory to an etching by Zacharias Dolendo, ibid., p. 150, fig. E66.

toward simplicity', he clearly did not mean to include himself amongst their number.

Van Mander consistently thought of the pictorial space as a stage set, a fictive three-dimensional area in which compositional relationships had to take account of before and behind, as well as up/down, left/right. His approach is quite similar to that of a modern theatre director who 'blocks' a scene in a play, trying to intensify the drama of any particular theatrical moment by expressive groupings of personnel. At no point does he give us the impression that formal harmonies on the picture surface were of interest to him. This is not to say that he did not think that a framed view into deep space could be pleasing or displeasing – we have already seen him express concern that the narrative should fit the frame (p. 6 above) – but he seems to have thought of pleasing pictorial arrangements as invariably three-dimensional, like a graceful grouping of dancers on a stage framed by curtains.[51] Indeed, he tells us to construct our space in such a way as to stress apparent three-dimensional relations: in order to please the nature of the arts we should, whenever possible when making an image of a figure or a face, make it so that one can see another behind, even if almost nothing is needed or required there. For then (for example in a dark stable) the shadowed figure in the rear will seem to recede, and our foreground figure to come out towards us.[52]

Van Mander also recommends that we group our lights and shades in different areas of the painting, presumably so as to create a forceful visual effect of three dimensions. At the same time, he is concerned that this contrast of light and shade should not lead to stark discontinuities; everything should seem unified to the eye:

> We should also take particular care in our history … to bring a great deal of shadow together in one place, without letting our unmodulated dark colours push forcefully up against pure light, but rather against half-tints. Then we should also let a large amount of plain light group together, letting it flow off, like the darks, into half-tints. For a long time there used to reign a disorder amongst painters, as erring souls, that their histories looked from a distance like marble, or chessboards, bringing black against white, like the productions of printmakers. But now mezza tinte have come into use from Italy, soft middling tints of mixed colours, which gradually fade and blur away into the distance.[53]

51. I should make it clear that neither of these analogies appears in Van Mander's own writing.

52. 'Om den aerdt der Consten houden te vriende,/ Makende Beeldt oft troeng' alst mach ghevallen,/ Soo sullen wy maken, datmen is siende/ Een ander daer achter, jae al en diende/ Oft en behoefde daer schier niet met allen,/ Want dan sal moghen (als in doncker stallen)/ Den beschaduwden achterstant te wijcken,/ En ons voorbeeldt uyt te comen ghelijcken.': Van Mander, *Grondt*, ed. Miedema (n. 14 above), V, 40. As Hessel Miedema has observed (ibid., p. 481), Van Mander could have picked up this idea from Vasari, *Le vite* (n. 19 above), text vol. I, p. 116 (1566 edn, I, 45); or from Italian or Netherlandish oral tradition. For more on three dimensions in Dutch art theory see my article 'The Concept of *Houding* in Dutch Art Theory', *Journal of the Warburg and Courtauld Institutes*, 55, 1992, pp. 210–32, and Ernst van de Wetering, *Rembrandt: the Painter at Work*, Amsterdam, 1997, pp. 149–90.

53. 'Oock behoorden wy sonderlingh te wachten/ In d'History, soo wy elders ontblooten,/ Dat wy

Like his fellow Dutch art theorists, Van Mander tends to be anti-analytic; that is, he blends concepts which in recent times have been kept separate, such as form/content, beauty/illusion, composition/narrative. This tendency is not the result of imprecise thought: rather, it emerges from a holistic way of looking at and thinking about pictures. The aim of art, for Van Mander, is to provide us with striking depictions, and all the elements in the painting must combine and support one another if this aim is to be achieved. We should not be surprised when Van Mander talks of narrative and representational requirements in a chapter on composition, because a good composition, in his eyes, will never be beautiful if story and illusion are ignored. We should not suppose, either, that talk of narration and depiction undercuts Van Mander's interest in the formal aspects of art. To create a vivid and memorable history painting, the figures must be striking, they must form gracefully intertwined groups, and the groups must suit the space that holds them. There is no room, in this interlocking aesthetic, for a split between the subject of a painting and its mode of depiction.

PHILIPS ANGEL

As we noted above (p. 3), Van Mander's chapter on 'ordering' can be split into two halves, one dealing with the spatial arrangement of a painting, the other with the choice of subject matter. It would seem that, in his view, 'ordering' contained within it both composition and invention.[54] Philips Angel, in his *Lof der schilder-konst*, seems to have used the word with a similar range of meaning. He tells us that the artist should have 'a flowing Spirit' so that he may 'order correctly'.[55] It transpires that the notion of ordering used here is close to what we would now think of as invention:

> … whoever is flowing in ordering, need never again stand embarrassed before a ponderous composition, since his *fecund spirit* will pour forth thousands of different conceptions …[56]

over hoop veel schaduwen brachten,/ Sonder soo schielijck te laten met crachten/ Ons herde bruyn teghen claer licht aenstooten,/ Maer wel teghen graeuwen, dan eenen grooten/ Deel vlack licht sullen wy oock t'samen hoopen,/ Doent oock als bruyn in't graeu verloren loopen.//Langh' heeft voortijts gheregneert een disorden/ Onder Schilders, als dwalighe ghesinten,/ Dat hun historien van verre worden/ Aenghesien oft Marbre waer, oft schaeck-borden,/ Bringhende swart op wit, soo Druckers printen:/ Maer nu comen d'Italy Mezza tinten/ In usoo halfverwighe soete graeuwen,/ Die't achter allencx bedommelt verflaeuwen.': Van Mander, *Grondt*, ed. Miedema (n. 14 above), V, 41–2. The three-dimensional implications of these verses become apparent when compared to a passage in Philips Angel's *Lof der schilder-konst*, pp. 39–40, which I discuss in my article on *houding* (n. 52 above), pp. 219–20. Cf. also De Grebber, *Regulen* (n. 4 above), p. 126 (rule VI).

54. For Hessel Miedema's differing view, see n. 24 above.

55. Angel, *Lof der schilder-konst* (n. 6 above), p. 34.

56. '… wie vloeyend' in't ordineren is, sal nimmermeer voor een sware t'samenschickinghe verlegen staen: aenghesien sijn *vruchtbare gheest* duysenden van veranderlijcke bedenckinghen uyt stort …': ibid., p. 38. Hessel Miedema discusses this passage briefly in 'Praise of Painting' (n. 6 above), p. 254.

'Ordering' in this context would seem to mean something like 'the invention of compositions'.

Apart from this passage there is little in Angel's book which has any evident bearing on the subject of composition. He tells us, like Van Mander, to group our lights and shadows, but he seems more interested in the forceful sense of three dimensions which such an arrangement would bring about, than in the overall pictorial harmony of compositions ordered in this way.[57]

The *Lof* is a short text, just fifteen thousand words in length, and over half of it is devoted to a lengthy and learned encomium of the antiquity and excellence of painting; so that Angel never really gets the chance to develop his ideas on any subject. It may well be that he had intuitions about the interlacing of figures and the compositional implications of the frame which were just as interesting as those of Van Mander: but he never committed them to paper.

WILLEM GOEREE

Goeree is the odd man out amongst the four authors considered in this article, in that he was not by profession a painter. He was instead a bookseller, who published his own books on art.[58] That two of these, his introductions to drawing and painting, went through three Dutch editions each between 1668 and 1697, may tell us less about their quality or real popularity than about their author's skill as a salesman.

Goeree has little to say on the subject of composition. The only discussion he gives to the topic is a short passage in which he compares 'ordering' to geometry. This sounds promising, and may suggest that he had some perceptive notions in reserve, but the passage itself is too brief to tell us much:

> Ordering [we compare] to *Geometry*, not because there is a perfect agreement between the two, but because Mathematical measurement must make an arrangement from all kinds of incidental things, whatever they may be; and from a confusion of angles, or whatever parts are available, one can bring together an attractive clump of a square shape. Through good Ordering one must, if one wishes to please others, set together the confused fantasies of our own thoughts into the ordered conception of an elegant, noble and well-arranged Ordering.[59]

It is clear from this passage that Goeree thought an ordering could be attractive,

57. See n. 53 above.

58. See Kwakkelstein, ed., *W. Goeree, Inleydinge* (n. 7 above), pp. 17–27, for Goeree's biography.

59. 'De Ordineering der Inventien by de *Geometrie*, niet soo seer om de juiste over-een-koming van die beide, als wel om dat de Wis-kundige meting, zig na alle voorvallen, sy zijn dan soo alsze willen, moet schikken, en men uyt verwarde hoeken, of gegeven deelen, een behoorlijke klomp van een vierkanten inhoud t'samen brengen kan: Soo moetmen ook door de goede Ordineeringe, de verwarde fantasien, soo van ons eigen bedenkingen, als ten believen van andere, hare ordentelijke invallen, in een çierlijke, grootse, een welgeschikte Ordinantie t'samen setten.' Goeree, *Schilderkonst* (n. 7 above), pp. 66–7. The grammar and vocabulary are unusual in the original too.

elegant and well-arranged, so he must have had some sense that good compositions were aesthetically pleasing, in some way. Unfortunately, he does not tell us which way; neither here, nor elsewhere in his writings.

SAMUEL VAN HOOGSTRAETEN

Van Hoogstraeten's *Inleyding tot de hooge schoole der schilderkonst*, or *Introduction to the Academy of Painting*, is easily the longest art theoretical treatise written in Dutch in the seventeenth century.[60] Unfortunately, it is also very digressive. Like Angel, Van Hoogstraeten is concerned to show that painting was venerated in antiquity, and so nearly half of his book is devoted to learned anecdotes of events in Greece and Rome. However, whereas Angel deals with these matters in one long, sustained discussion, Van Hoogstraeten scatters his antique anecdotes evenly throughout the book.[61] No matter what topic he is discussing, we may be sure that a learned reference to the ancient world is just around the corner; and we can usually feel confident that Van Hoogstraeten will lose interest in the matter in hand once he has the bit of erudition between his teeth.

In theory, an entire book of the *Inleyding*, forty pages long, is devoted to the subject of composition.[62] The chapter headings of the book sound promising, at first: titles like 'Of ordering in general', 'How to begin ordering', and 'Restraint in ordering' seem very much to the point. Unfortunately, the headings become less promising as the book proceeds: the last four of the nine chapters are called: 'How to make use of other peoples' work', 'Publicizing your work', 'On relaxation', and 'Continuation of the proceeding'. Most of the chapter on relaxation is taken up with two long poems by the author, the first being a travel account of his journey from Dordrecht to Vienna in 1651, and the second being a list of useful tips for travellers. Both are fairly pleasant to read, but they tell us little about pictorial composition.

Even in the chapters with the promising titles, extracting useful information is not always easy. His second chapter, for example, is called 'How to begin ordering'. In it, he touches on the subject of how the artist should choose the moment from a narrative which he wishes to depict, and then discusses the matter of how grandiose one's style should be: he then says that you shouldn't worry too much about this, but get on with the job in hand, and cites Descartes's maxim from the *Discourse on Method*, that he wished to be as firm and resolute in his actions as he could. This leads him onto a consideration of Horace's advice that you should put

60. Van Mander's *Schilder-boeck* is longer overall, but most of the book is taken up with artists' lives. On Van Hoogstraeten and his *Inleyding*, see the books by Roscam Abbing and Brusati (n. 22 above). I have reviewed Brusati's book in *Art History*, 21, 1, March 1998, pp. 140–45.

61. Just to give an idea: he refers to Plutarch by name on pp. 12, 21, 35, 44, 46, 77, 83, 103, 128, 143, 144, 163, 167, 184–5, 187, 226, 230, 236, 239, 240, 246, 260, 280, 282, 293, 301, 304, 310, 315, 324, 343, 346–8 and 358 of his 361-page *Inleyding*.

62. Van Hoogstraeten, *Inleyding* (n. 8 above), pp. 173–213.

your work aside for nine years before publishing it: Van Hoogstraeten is of the view that you should instead bring your work to perfection now, and hope to do something better in nine years' time. He then goes on to say that you might find it useful to ask a friend to give you advice on the way your painting is proceeding, but that you certainly should not do what Pontormo did, and worry so much about your work that you never pluck up the courage to change it at all. During the course of this three-page chapter Van Hoogstraeten mentions by name Amphion, Apelles, Seneca, Theon, Junius, Longinus, Zeuxis, Apollodorus, Horace, Cicero, Phidias, Lysippus, Praxiteles and Nicias, so it is hardly surprising that he has little space for revealing remarks about composition.

Nevertheless, there are some interesting ideas buried in Van Hoogstraeten's scholarship, albeit that many of them are clearly derived from Van Mander. He favours a 'through-view', and cites Van Mander's *Grondt* in support of his preference.[63] Van Mander is also cited as an authority when he tells us to place the most important figure in the narrative in the most prominent position in the painting.[64] Van Hoogstraeten feels, like Van Mander and Alberti, that variety is an essential embellishment of art, and he censures a still-life painter from his home town of Dordrecht, who had painted a plateful of peaches: why not please the eye with a variety of fruits, he asks.[65] He speaks too in favour of 'trooping', mentioning Michelangelo's *Last Judgment* as he does so.[66] Whilst developing his thoughts on this subject, Van Hoogstraeten – again like Van Mander[67] – compares the harmony of a composition to music:

> Let your trees, buildings and figures troop freely, and break your work up into elegant groups. That which is planted here and there gives a bad appearance to the whole, even if each part be good in itself. Not that your figures should seem packed together, but you should leave them a free sway … This important aspect of art was well understood by Leonardo da Vinci in his famous Cartoon of the Battle. Tintoretto and Paolo Veronese were masters in this: and the graceful Raphael wonderful. Rembrandt often understood this virtue well, and the best pieces of Rubens, and his follower Jordaens, have a wonderfully successful disposition and trooping. This art, of pleasing order and artistic arrangement, seems to me in truth to be a form of music or measured song. Just as the melody of a well-made song embellishes the words, so too this art greatly improves things, and graces them with a fine appearance.[68]

63. Ibid., pp. 189–90.

64. Ibid., pp. 189 and 198.

65. Ibid., p. 181. The Dordrecht painter Abraham van Calraet painted a still-life of a plate of peaches, so may well be the artist in question. I illustrate the painting whilst discussing this passage of Van Hoogstraeten in my *Dutch Flower Painting 1600–1720*, New Haven and London, 1995, pp. 85–6.

66. Van Hoogstraeten, *Inleyding* (n. 8 above), pp. 189, 190–91.

67. See p. 8 above.

68. '*Geboomt, gebouw, en beelden laet vry troepen,/ En deel uw werk in sierelijcke groepen./ 't Geen hier en daer gezaeit is, schoon elk deel/ Wel goed is, geeft geen welstand aen 't geheel.// Niet dat uwe beelden op*

Van Hoogstraeten also says that a good composition possesses harmony. In another passage, which must be the most quoted in the whole book, his brief discussion of Rembrandt's *Night Watch*:

> Art is no more than an imitation of natural things, but arrangement and ordering issue forth from the spirit of the artist, who ponders the parts which are presented to him, at first confusedly, until he has formed them into a whole, and can arrange them together in such a way that they make a figure: and often he arranges a number of figures into a history so that none of them seems to be too much or too little. And this is rightly called a perception of Symmetry, Analogy, and Harmony. It is not enough for a painter to line up his figures in rows next to each other, as one sees only too often in militia portraits in Holland. True masters make their whole work into a unity … Rembrandt did this very well in his piece for the musketeers' militia at Amsterdam, but in the opinion of many he did it too well, putting more effort into the great image he wanted to make, than into the individual portraits which he had been paid to produce. Nevertheless, that same work, however much blame it might earn, will in my opinion outlive all its competitors, being so pictorial in thought, so swaying in disposition, and so forcefully three-dimensional, that, in the opinion of some, all the other pieces there stand like playing cards next to it. Although I do wish that he had thrown more light onto the scene.[69]

Van Hoogstraeten clearly felt that those militia painters who lined their figures up in rows were very culpable, since he returned to them later in the book to lambast

elkanderen gepakt schijnen, maer gy moetze een vrye zwier laten … Dit hooftdeel heeft *Leonardo da Vinci* in zijn beroemden Carton van de Bataelje verstandichlijk waergenomen. *Tintoret* en *Paul* van *Verone* waren hier meester in; en den begrasiden *Rafaël* verwonderlijk. *Rembrandt* heeft deeze deugd dikmaels wel begrepen, en de beste stukken van *Rubens*, en zijn navolger *Jordaens*, hebben een byzonder welstandige sprong en troeping. Deeze konst, van behaeglijke ordre en konstige schikking, dunkt my te recht te zijn een muzyk of maetzang, die, eeven gelijk de vois van een welgemaekt liedeken, de woorden versiert, de dingen ook grootelijx vordert, en met welstandt vereert.': Van Hoogstraeten, *Inleyding* (n. 8 above), p. 191.

69. 'Al wat de konst stuk voor stuk vertoont, is een nabootsing van natuerlijke dingen, maer het by een schikken en ordineeren komt uit den geest des konstenaers hervoor, die de deelen, die voorgegeven zijn, eerst in zijne inbeelding verwardelijk bevat, tot dat hyze tot een geheel vormt, en zoo te zamen schikt, datze als een beelt maken: en dikwils een menichte beelden eender Historie zoodanich schikt, dat'er geen de minste te veel noch te weynich in schijnt te zijn. En dit noemtmen met recht een waerneming der *Simmetrie, Analogie,* en *Harmonie.* Ten is niet genoeg, dat een Schilder zijn beelden op ryen nevens malkander stelt, gelijk men hier in Hollant op de Schuttersdoelen al te veel zien kan. De rechte meesters brengen te weeg, dat haer geheele werk eenwezich is, gelijk *Clio* uit *Horatius* leert: *Brengt yder werkstuk, zoo't behoort,/ Slechts enkel en eenweezich voort.// Rembrant* heeft dit in zijn stuk op den Doele tot Amsterdam zeer wel, maer na veeler gevoelen al te veel, waergenomen, maekende meer werks van het groote beelt zijner verkiezing, als van de byzondere afbeeltsels, die hem waren aenbesteet. Echter zal dat zelve werk, hoe berispelijk, na mijn gevoelen al zijn meedestrevers verdueren, zijnde zoo schilderachtich van gedachten, zoo zwierich van sprong, en zoo krachtich, dat, nae zommiger gevoelen, al d'andere stukken daer als kaerteblaren nevens staen. Schoon ik wel gewilt hadde, dat hy 'er meer lichts in ontsteeken had.': ibid., p. 176. This passage has been discussed a great deal. See E. Haverkamp-Begemann, *Rembrandt: The Nightwatch*, Princeton, 1982, pp. 3, 66–7; J. Bruyn *et al.*, *A Corpus of Rembrandt Paintings*, Dordrecht, 1989, III, pp. 481–2.

them again. He wrote that the artist should try to make his composition 'seemingly unmade', unlike the militia painters, with their lines of people who could all be beheaded with one blow.[70]

The word which I translated in the passage above as 'swaying', *zwierich*, is as vague and allusive in Dutch as it is in English. Van Hoogstraeten seems to want to say that the composition of the *Night Watch* is graceful, unified and coherent, held together with a light floating sway.[71] There can be no doubt that he thought the arrangement of a painting could add greatly to its success, and it is clear also that he thought Rembrandt's *Night Watch* was one of the artist's most successful works.

Rembrandt, however, could offend him in other ways. Much of Van Hoogstraeten's book on composition is devoted to the subject of decorum, and in this regard he felt that Rembrandt sometimes fell short. Van Hoogstraeten was shocked in particular by the artist's grisaille of *St John the Baptist Preaching in the Wilderness*:

> There was a certain piece by Rembrandt of John the Baptist preaching, which had a handsome ordering, and I remember gazing at the wonderful attentiveness of the listeners, from all ranks of society; this was praiseworthy in the extreme, but you could also see a dog, which in a most unedifying manner was mounting a bitch. Granted that this is an everyday and natural occurrence, I nevertheless say that it was an unseemly abomination in this narrative; and that from this addition it would be better to say that the piece depicted the preaching of the doggish Diogenes than the saintly John.[72]

The concerns voiced here take up a great deal of Van Hoogstraeten's attention. He spends some of his first and most of his third chapters on composition criticizing artists real and imaginary for encumbering narratives with unnecessary or lewd additions. Don't let young girls cuddle serpents, don't allow lions to listen to shepherd's songs, don't put left arms on right shoulders, don't put slimy haddocks on velvet tablecloths, don't represent the filthy things that Tiberius did on Capri, and so on. One of the ways Van Hoogstraeten uses the word 'harmony' is to refer to this sense of pictorial fitness, and it would seem that it could ruin his enjoyment of a work if it displayed the slightest indecorum.

70. Van Hoogstraeten, *Inleyding* (n. 8 above), p. 190. Cf. Grebber, *Regulen* (n. 4 above), p. 126 (rule IIII).

71. For Van Hoogstraeten's use of the words *zwierich* and *zwier* in other contexts, see ibid., pp. 27–31, 146–7, 173, 191, 193, 229, 234, 293 and 296.

72. ''t Gedenkt my dat ik, in zeker aerdich geordineert stukje van *Rembrant*, verbeeldende een *Johannes* Predicatie, een wonderlijke aendacht in de toebehoorderen van allerleye staeten gezien hebbe: dit was ten hoogsten prijslijk, maer men zach'er ook een hondt, die op een onstichtlijke wijze een teef besprong. Zeg vry, dat dit gebeurlijk en natuerlijk is, ik zegge dat het een verfoeilijke onvoeglijkheyt tot deze Historie is; en dat men uit dit byvoegzel veel eer zou zeggen, dat dit stukje een Predicatie van den Hondschen *Diogenes*, als van Heyligen *Johannes* vertoonde.': Van Hoogstraeten, *Inleyding* (n. 8 above) p. 183. For a discussion of this passage, see J. Kaak, *Rembrandts Grisaille 'Johannes der Taüfer predigend'*, Hildesheim, 1994, pp. 16–17.

Van Hoogstraeten's worries about decorum may seem a long way from any modern notion of composition, but again, we need to remember that the art theorists of his time thought of a painting as a narrative in a pictorial space, and anything which marred the pleasure of beholding this narrative could be considered a failure of 'composition', understood in the broadest possible sense. Indeed, one of the words he uses when discussing composition is *medevoeglijkheit*, 'compatibility', and this is both etymologically and semantically close to the word he uses for 'decorum': *voeglijkheit*.[73]

* * *

It is clear that, of the four Dutch art theorists considered here, it was the first, Karel van Mander, who discussed composition at greatest length and with most perception. And yet it is unlikely that his insights were in any way unusual or peculiar when he wrote them down (he does not strike one as a very original thinker). They were probably fairly widely disseminated amongst his contemporaries, and were probably passed on to later generations as part of a broad oral tradition. The fact that Angel, Goeree and Van Hoogstraeten did not get round to discussing such matters is not likely to be revealing. These three men were not able writers, and one could certainly not rely on them to cover the most important topics of any particular subject, even if they were aware that said topics were of importance. Writing is not very easy, after all, and one often ends up feeling that one failed to say what one wanted.

Van Mander himself rarely alludes to the success or failure of a painting's composition in his *Lives*, but we know from his chapter in the *Grondt* that he thought such things mattered a great deal. Perhaps he felt, given how little space he had for each artist's biography, that complex subjects like composition had to be sacrificed. Books like Gombrich's *Story of Art* and Honour and Fleming's *World History of Art* have found the need to be similarly brief; with only a few lines for each painting one can rarely discuss much more than the iconography. The limitations of a literary genre can quickly simplify the intricacies of experience.

We should not, therefore, fall into 'the archival fallacy',[74] and assume that the historical evidence which happens to be at our disposal gives us a well-balanced picture of the period that interests us. Dutch art theory is far from being a complete summary of contemporary aesthetic attitudes.

73. 'This art of ordering we will call, using Germanic words, a perfect attainment of compatibility, agreement, and proportion; without which everything is confused and full of strife.' ['Deze kunst van ordineeren zullen wy met Duitsche woorden noemen, een wisse treffing der medevoeglijkheyt, overeendracht, en maetschiklijkheyt; zonder welke alles verwart en vol strijt is.']: Van Hoogstraeten, *Inleyding* (n. 8 above), p. 176.

74. David N. Keightley, *Sources of Shang History: the Oracle-Bone Inscriptions of Bronze Age China*, Berkeley, Los Angeles and London, 1985, p. 135.

Fig. 1. Karel van Mander, *Before the Flood*. Stadelsches Kunstinstitut, Frankfurt. (Photo: Museum)

Fig. 2. Abraham Bloemaert, *The Golden Age*. Städelsches Kunstinstitut, Frankfurt. Photo: Museum.

Fig. 3. Karel van Mander, *Pan and Syrinx*. Uffizi, Florence. Photo: Gabinetto fotografico nazionale

4. Karel van Mander, *Ecce Homo*. Museum Boymans-van Beuningen, Rotterdam.
(Photo: Museum)

Reynolds, Chiaroscuro and Composition

Harry Mount

Several art historians have recently alerted us to the dangers of assuming that artists and writers on art in the past shared the modern tendency to think of pictorial composition as the organization of shapes and colours on a two-dimensional plane. According to Jeroen Stumpel, 'the twentieth-century interest in the formal organization of painted images on the flat plane has no equivalent in Cinquecento writings on art.'[1] Paul Taylor has argued that for seventeenth-century Dutch writers and painters compositional harmony was less 'a function of the arrangement of lines and colours on a plane surface' than of the organization of the objects portrayed in 'a plausible illusion' of space.[2] Such findings beg the question of when and why it was that the modern capacity to understand composition in two-dimensional terms first began to emerge.

This development was, no doubt, a gradual process, and it would be unwise to place too much stress on any one moment. Particular account must be taken of Roger de Piles's theory of 'the unity of the object', which, as Thomas Puttfarken has shown, added to the notion of composition as the arrangement of objects in illusory space the requirement that the painter harmoniously order the *tout ensemble*, using chiaroscuro to unify the whole through the massing of light and shade. This idea, according to Puttfarken, entails an attention 'to forms and their relationships on a two-dimensional plane'. He admits, however, that this is not yet the modern attitude to composition, as de Piles also required an attention to the illusion of space and depth created by a picture.[3] As Puttfarken shows, de Piles's recipe for composition was contested by later French theorists who felt that it implied a neglect of subject matter. It was, however, also taken up and developed further by other writers, notably the Abbé Laugier, who encouraged spectators to assess the arrangement of colours in a picture regardless of what they represented.[4]

Puttfarken suggests that Laugier's argument may have been influenced by the British theorist, Jonathan Richardson.[5] And indeed, a parallel, if rather different, change in attitudes to composition was taking place concurrently in Britain. While

1. 'On Grounds and Backgrounds: Some Remarks about Composition in Renaissance Painting', *Simiolus*, 18, 1988, pp. 219–43(219). On Renaissance art see also J. Elkins, 'The Case Against Surface Geometry', *Art History*, 14, 1991, pp. 143–74.

2. 'The Concept of *Houding* in Dutch Art Theory', *Journal of the Warburg and Courtauld Institutes*, 55, 1992, pp. 210–32(214).

3. T. Puttfarken, *Roger de Piles' Theory of Art*, New Haven and London, 1985, pp. 80–105(88).

4. Abbé M. A. Laugier, *Manière de bien juger des ouvrages de peinture*, Paris, 1771, p. 237, cit. Puttfarken, *Roger de Piles Piles' Theory of Art* (n. 3 above), p. 136.

5. Puttfarken, *Roger de Piles' Theory of Art* (n. 3 above), p. 136, n. 53.

Richardson, as we shall see, played a significant role in this change, a far more important figure in the development of attitudes to pictorial composition, in both theory and practice, was Sir Joshua Reynolds.

Reynolds first showed a novel approach to understanding composition in some sketches made in 1752 during his youthful tour of Italy.[6] Most of these were made in Venice, including one after Tintoretto's *St Agnes Raising Licinius* in the church of the Madonna del Orto (Fig. 1).[7] Reynolds felt that the method he had used in these sketches was of sufficient interest to warrant description in a published work thirty years later:

> When I observed an extraordinary effect of light and shade in any picture, I took a leaf of my pocket-book, and darkened every part of it in the same gradation of light and shade as the picture, leaving the white paper untouched to represent the light, and this without any attention to the subject or to the drawing of the figures.[8]

Aside from the vestigial indications of figures, Reynolds's sketch does indeed reduce the picture to a pattern of light and shade. Most of the earliest sketches of this sort by Reynolds are not copies of pictures but depictions of landscapes, sketched while he was en route from Rome to Venice between May and July in 1752 (Fig. 2).[9] Many of these landscape sketches seem to have been made at dusk, when colours and shapes would have been reduced to patterns of light and shade,[10] and Reynolds perhaps realised that the same approach might be profitably applied to the compositions of Venetian paintings seen in gloomy churches.

6. Reynolds's Italian sketchbooks are discussed by G. Perini, 'Sir Joshua Reynolds and Italian Art and Art Literature', *Journal of the Warburg and Courtauld Institutes*, 51, 1988, pp. 141–68.

7. British Museum, MS 201 a 9, sketchbook used in Italy in 1752, f. 66v. Tintoretto's picture, still in this church, is reproduced in R. Pallucchini and P. Rossi, *Tintoretto: Le opere sacre e profane*, II, Milan, 1982, fig. 479. For another example of a chiaroscuro sketch from this sketchbook see Perini, 'Reynolds and Italian Art' (n. 6 above), pl. 10c, see also pp. 146, 154.

8. 'The Art of Painting of Charles Alphonse Du Fresnoy; Translated into English Verse by William Mason, MA, with Annotations by Sir Joshua Reynolds' (1783), in *The Works of Sir Joshua Reynolds*, II, London, 1797, p. 246.

9. The two earliest sketches in which Reynolds records the overall arrangement of light and shade in a picture occur in the sketchbook he used while travelling from Rome to Florence, now British Museum, MS 201 a 10. They are after pictures in the church of Santa Maria degli Angeli, near Assisi (f. 21r), and (probably) the Palazzo Pitti, Florence (f. 20r). In neither sketch are the figures as fully subordinated to the patterns of chiaroscuro as they would be in sketches made later in Reynolds's trip. At much the same time Reynolds was sketching landscapes as patterns of light and shade, among them views near Assisi (ff. 4v, 5r), of Perugia (22r), and of the Boboli Gardens behind the Palazzo Pitti (40v). The earliest sketches in which the compositions of pictures are rendered entirely as patterns of light and shade occur in the sketchbook Reynolds used next, while he was in Bologna (now Sir John Soane's Museum, London, ff.. 27r, 28v, 30r, 37v, 38r, 39r; an example is reproduced in G. Perini, 'Sir Joshua Reynolds a Bologna (1752)', *Storia dell'arte*, 73, 1991, p. 373, fig. 15, see also p. 371). Reynolds did not, however, make an extensive use of this sketching practice until he reached Venice.

10. Reynolds later recommended that travellers carry a Claude Glass, a small convex mirror that similarly had the effect of lowering the tone and harmonizing the composition of a landscape (Yale Center for British Art, MS Reynolds 39, notebook kept in the Netherlands in 1785, f. 21r, see also Reynolds, *A Journey to Flanders and Holland*, ed. H. Mount, Cambridge, 1996, p. 200).

This was not Reynolds's normal sketching method. Both during his Italian tour and later, he usually sketched single figures, as in a sketch after Van Dyck's *Charles V* (Fig. 3).[11] Occasionally in Italy, and more commonly in his later sketch books, he sketched entire compositions, giving a rough indication of the positioning of figures within a picture.[12] After leaving Venice, however, Reynolds hardly ever used his chiaroscuro sketching method again. That he developed it at all does, nevertheless, give a significant insight into his attitude to composition, especially when considered alongside the accompanying notes in his sketchbooks. These confirm that this sketching method was not merely a notational device, but a manifestation of a distinctive and perhaps original mode of attention to pictorial composition. This is Reynolds's verbal description of Tintoretto's *St Agnes Raising Licinius*:

> She in the Middle in white, the lambs head on the white, this mass is surrounded with figures in dark colours, but on each side toward the edges is a little light a white cap or a shoulder with a bit a linnen and that the botom of the Picture might not be heavy the legs of the figure lying lightish two womens heads & breasts over St Agnes are light to join the Architecture behind which is light on a light sky a Mass of dark Architecture on one side near the Eye. all the Angels above dresst only in sky blue lights white, the same as the sky which is white & blue.[13]

This description has several notable features. The first is the lack of interest in subject matter. Reynolds is unconcerned with what the figures are doing, seeing them only as constituents of patterns of light and shade. Because the angels are the same colour and tone as the sky behind them they disappear altogether in the sketch, despite being prominent in the picture. The second point to notice is the reduction of colours to tonal values. Almost the only colours mentioned are those of the angels and the sky, and then only because they are of the same colour, thus forming an area of common tonal value. Third, note how Reynolds, in attending to the patterns made by light and shade, shows no interest in chiaroscuro's capacity to convey depth. For example, when mentioning the mass of dark architecture to one side he does not say that it acts as a repoussoir, creating a sense of recession when combined with the lighter architecture and sky in the middle of the picture. Conversely, he speaks of a single mass of light being formed by the women above St Agnes and the architecture which, in the fictive space of the painting, stands behind them. In this concern with surface pattern rather than depth Reynolds departed from earlier theorists, in particular the French seventeenth-century writers whose works were so important in the development of art theory in Britain. For these writers, chiaroscuro's capacity to convey relief and depth was one of its

11. For further examples see Perini, 'Reynolds a Bologna' (n. 9 above); Perini, 'Reynolds and Italian Art' (n. 6 above).

12. For examples see Reynolds, *Journey* (n. 10 above), pp. 50, 80.

13. British Museum, MS 201 a 9, f. 67r.

174

most important functions.[14]

Reynolds's awareness of what earlier theorists had had to say about chiaroscuro and composition is evident from the *Discourses* he delivered to the Royal Academy. The *Discourses* drew heavily upon earlier theory, and much of what they have to say about chiaroscuro is received opinion. In Discourse Eight (1778), for example, Reynolds echoes Du Fresnoy and de Piles in arguing that the eye is 'perplexed and fatigued' by a composition in which 'the objects are scattered and divided into many equal parts.' The painter should therefore use large masses of light and shade to unify his work and give it 'repose'.[15] Some earlier English theorists had made similar comments. Hogarth, for example, repeated de Piles's analogy between a composition in which the light and shade is scattered in spots rather than arranged in masses to a gathering in which everyone talks at once.[16]

However, Hogarth, like earlier theorists, also stressed how light and shade may, through their contrasts, help to organize a composition in depth and give relief to figures.[17] These qualities were of little interest to Reynolds. Indeed, in Discourse Eight he questioned the importance placed by de Piles on relief, arguing that when painters contrast the colour or tone of the entire outline of a figure with that of its background the result is a dry manner of the sort seen in art's primitive phase (his examples are Dürer, Mantegna and Perugino). Such a manner appeals mainly to the 'vulgar', who like to see 'a figure, which, as they say, looks as if they could walk round it.'[18] Instead, Reynolds favoured a 'fulness of manner' produced by merging the shadows of foreground objects with those of the background, as in the works of Correggio.[19]

To cast de Piles as straw man was disingenuous, given that Reynolds's argument apparently owed much to de Piles's own contrast between the prominent outlines

14. E.g. Henri Testelin, *The Sentiments of the Most Excellent Painters Concerning the Practice of Painting*, London, 1688, Fourth Table: 'Clair-obscure'; Roger de Piles, *The Art of Painting*, London, 1706, p. 5; id., *The Principles of Painting*, London, 1743, p. 221. British writers reiterated the same point, see Jonathan Richardson, *An Essay on the Theory of Painting*, London, 1715, p. 138; William Hogarth, *The Analysis of Beauty*, ed. Joseph Burke, Oxford, 1955, pp. 118–23 (1st edn 1753); Daniel Webb, *An Inquiry into the Beauties of Painting*, London, 1760, pp. 110–12, 105, 108.

15. *Discourses on Art*, ed. R. R. Wark, New Haven and London, 1975, p. 147. Cf. Charles Alphonse Du Fresnoy, *De Arte Graphica* (with notes by R. de Piles), transl. John Dryden, London, 1695, pp. 22–3; de Piles, in ibid., pp. 161–2; de Piles, *Art* (n. 14 above), p. 5. For Reynolds's early reading of Dryden's translation of Du Fresnoy see his commonplace book kept between the ages of seven and eighteen, Yale Center for British Art, MS Reynolds 33, f. 60r.

16. *Analysis of Beauty* (n. 14 above), p. 124. On the dislike for spots of light and shade see B. M. Stafford, *Body Criticism: Imaging the Unseen in Enlightenment Art and Medicine*, Cambridge, Mass., 1991, pp. 324–7. For the analogy to everyone talking at once see de Piles, *Principles* (n. 14 above), pp. 65–6; Richardson, *Theory* (n. 14 above), p. 128.

17. *Analysis of Beauty* (n. 15 above), pp. 118–23.

18. *Discourses* (n. 15 above), p. 160. He probably had in mind de Piles's praise for Titian's use of Ariadne's red scarf to separate her from the blue sea behind her in *Bacchus and Ariadne* (*Art of Painting* [n. 14 above], p. 38). Reynolds had earlier equated prominent relief with vulgar naturalism in *The Idler*, no. 79, 20 October 1759, see *Works* (n. 8 above), I, p. 353.

19. *Discourses* (n. 15 above), p. 160.

of pre-Raphaelite art and the superior styles of later painters, in which outlines 'insensibly melt into their grounds, and artfully disappear', thus serving to 'bind the objects, and keep them in union.'[20] Reynolds perhaps wished to signal that, even when compared to de Piles, he was far more interested in chiaroscuro's capacity to unify a composition than its capacity to convey depth. Indeed, in Discourse Eight he went still further, contending that the masses of light and shadow should be 'compact and *of a pleasing shape*' (my italics).[21] Here, for the first time in Reynolds's writings, was an overt recommendation that pictorial composition should be understood in terms of patterns of light and shade. In the Eighth Discourse this is but a passing remark, but the idea was, as we shall see, of more than passing relevance to Reynolds.

It is in Reynolds's other writings, those less directly designed to promote the grand style of history painting than the *Discourses*, that we find a greater interest in such formal qualities as composition and chiaroscuro and less interest in such traditional priorities as the choice and presentation of subject matter.[22] It was, for example, in his annotations to William Mason's new translation of Du Fresnoy's *De arte graphica*, published in 1783, that Reynolds first made public the sketching method he had used in Italy. The passage quoted above on p. 2 continues thus:

> By this means you may likewise remark the various forms and shapes of those lights, as well as the objects on which they are flung; whether a figure, or the sky, a white napkin, animal, or utensils, often introduced for this purpose only. It may be observed likewise what portion is strongly relieved, and how much is united with its ground; for it is necessary that some part (though a small one is sufficient) should be sharp and cutting against its ground, whether it be light on a dark, or dark on a light ground, in order to give firmness and distinctness to the work; if on the other hand it is relieved on every side, it will appear as if inlaid on its ground. Such a blotted paper, held at a distance from the eye, will strike the spectator as something excellent for the disposition of light and shadow, though he does not distinguish whether it is a history, a portrait, a landscape, dead game, or any thing else; for the same principles extend to every branch of the art.[23]

This passage indicates that Reynolds did still place some importance on the capacity of chiaroscuro to convey relief; it would be a mistake to think of his attitude to chiaroscuro as a precocious manifestation of the twentieth-century tendency to understand composition entirely in terms of the two-dimensional relationship of forms. Nevertheless, this passage also suggests that Reynolds was

20. *Principles* (n. 14 above), pp. 214–16. Cf. Du Fresnoy, *De Arte Graphica* (n. 15 above), pp. 38–9; William Aglionby, *Painting Illustrated in Three Diallogues*, London, 1685, p. 19; Webb, *Inquiry* (n. 14 above), p. 104. However, for all these theorists chiaroscuro's capacity to give depth and relief was at least as important as its role in unifying compositions.

21. *Discourses* (n. 15 above), p. 161.

22. For further discussion see H. Mount, Introduction, in Reynolds, *Journey* (n. 10 above), pp. xxix–lvi.

23. 'Art of Painting' (n. 14 above), p. 247.

capable of abstracting patterns of light or shade from any picture, regardless of its genre or the objects depicted within it, and that his principal concern was above all, with the overall distribution of light and shade.

Still more revealing are the remarks on pictures in Reynolds's *Journey to Flanders and Holland*, based on notes taken in 1781 but first published posthumously in Reynolds's *Works* in 1797. Here, predictably, we find attacks on pictures in which the light is not massed but scattered in small patches, as in Van Dyck's *St Augustine in Ecstasy*, or in which there are excessive contrasts between figures and their backgrounds, as in Gaspar de Crayer's *Virgin and Child with Saints*. More surprising is Reynolds's repeated concern with the notion, only touched on in Discourse Eight, that the 'masses' of light and shade should form attractive shapes, regardless of what they represent. Thus, he writes of a *Crucifixion* by Van Dyck (Fig. 4) that:

> The conduct of the light and shadow of this picture is likewise worth the attention of a Painter. To preserve the principal mass of light, which is made by the body of Christ, of a beautiful shape, the head is kept in half shadow. The under garment of St. Dominick and the angel make the second mass; and the St. Rosaria [St Catherine of Siena]'s head, handkerchief, and arm, the third.

This example confirms Reynolds's ability to abstract 'masses' of light and shade from a variety of objects or figures within a picture. That he conceived these masses as, essentially, flat shapes is indicated by his contention that a single mass of light is formed by St Dominic's undergarment and the angel, despite the fact that the latter is in front of the former.

The sort of shape that Reynolds preferred the masses of light and shade to take is further indicated by his remarks in the *Journey* on two depictions of *The Raising of the Cross*. In that by Rubens, Reynolds claims that the artist improved the shape of the main 'mass of light' on Christ's body by illuminating the shoulder of the bald man beside him. In Rembrandt's *Raising of the Cross*, conversely, Christ makes 'a disagreeable string of light.'[24] These instances suggest that the shapes that Reynolds seems to have favoured in masses of light and shade were those that were relatively compact and regular, not jagged, attenuated or dispersed in spots. Examples like these from the *Journey* indicate that Reynolds retained throughout his career that capacity to understand pictorial composition in terms of patterns of light and shade that he had first demonstrated in Italy in 1752.[25]

This peculiar sensitivity to the abstract shapes made by light and shade is not, to my knowledge, shared by any of the French theorists whose ideas were so important for Reynolds's ideas and for British art theory in general. Two other possible sources might be suggested. Elsewhere in this volume, Philip Sohm shows how

24. Reynolds, *Journey* (n. 10 above), pp. 61, 114, 44–5, 43, 126.
25. Closely related was his tendency to understand compositions as patterns of warm and cold hues, for which see Reynolds, *Discourses* (n. 15 above), p. 158; Reynolds, *Journey* (n. 10 above), p. xxxix.

certain seventeenth-century Italian artists had already begun to recommend that compositions should be thought of in terms of masses of light and shade, an idea contested by critics who felt that such a use of shade led to the fragmentation of figures.[26] It was an idea that Reynolds might have learnt from Italian artists in Rome and then applied on his trip to Venice. Reynolds's receptivity to such an idea would, however, have been enhanced by his early exposure to the writings of Jonathan Richardson, the theorist whose works, on Reynolds's own account, inspired him to become a painter.[27] In Richardson's 1715 *Essay on the Theory of Painting*, the chapter on composition shows its debt to de Piles by focusing largely on the use of chiaroscuro to harmonize the *tout-ensemble* of the painting. Much more markedly than de Piles, however, Richardson believed that the masses of light and shade should be attractively shaped, regardless of what they depicted, or whether they were formed by foreground objects or backgrounds: 'the Forms of these Masses must be Agreeable, of whatsoever they consist, Ground, Trees, Draperies, Figures, &c. and the Whole together should be Sweet, and Delightful.' In a passage that foreshadows Reynolds, Richardson remarks that the figure of Christ in Raphael's cartoon of *Christ's Charge to Peter* would make 'a Mass of light of a Shape not very pleasing' but for the introduction of a garment that breaks the straight line of his body'.[28] Despite the reference to the Raphael Cartoons, this mode of attention may perhaps be attributed to the fact that Richardson, never having left England, owed most of his knowledge of canonical paintings to monochrome prints, in which it is easier to perceive a composition as a pattern of light and shade than it is in a relatively large polychrome painting.[29]

Reynolds may have imbibed this idea from Richardson, although he went far further than the older writer in departing from the traditional theoretical concern with the choice and presentation of subject matter. Like Richardson, Reynolds would have owed much of his initial knowledge of past art to prints, and the importance of this factor in forming his own attitude to composition is further suggested by his acute sensitivity to the use of chiaroscuro in engravings. This is evident in the close attention he paid to the reproduction of his own portraits in mezzotint,[30] a technique which, like his youthful sketching method, employs light and shade rather than line. The same sensitivity emerges in the *Journey to Flanders and Holland*, where Reynolds contends that Rubens, while supervising the engraving

26. See in this volume P. Sohm, 'Baroque Piles and Other Decompositions', pp. 71–2, 84–5.

27. See Samuel Johnson, *Lives of the English Poets*, I, Oxford, 1905, p. 2 (1st edn. 1779).

28. *Theory of Painting* (n. 14 above), pp. 126, 119, 138; cf. pp. 129, 133, 137.

29. During this colloquium's concluding discussion Charles Hope suggested that a knowledge of art gained primarily through monochrome reproductions may have exerted an analogous effect on the ideas on composition held by such later writers as Wölfflin. John Gage has suggested that Ruskin's stress on the importance of chiaroscuro for Turner may be attributed to the fact that he had come to know Turner's works 'chiefly through black-and-white engravings' (*Colour and Culture*, London, 1993, p. 8).

30. See N. Penny, 'The Career and Achievement of Sir Joshua Reynolds', in *Reynolds*, Royal Academy exhib. cat., London, 1986, p. 36.

after his *Coup de lance* by Boëtius Bolswert (Fig. 5), decided to make the figure of the Magdalen darker than she is in the painting in order to keep the relatively light mass formed by the drapery of the Virgin and St John 'compact and of a beautiful shape'.[31]

The willingness of British writers to go far further than de Piles in their tendency to understand composition as the arrangement of patterns of light and shadow in a flat or shallow plane may thus have owed much to the relative importance of monochrome prints within the British art world.[32] Reynolds did not, it should be stressed, pre-empt Maurice Denis in trying to elevate Vasari's description of a painting as patches of colour on a plane surface into the basis for a theory of art.[33] However, he did take a step towards this modern position by showing both the inclination and the capability to assess pictures as abstract patterns of chiaroscuro.

* * *

Did Reynolds's novel attitude to composition affect his own artistic practice? I will argue that it did, although it must be remembered that Reynolds's freedom to manoeuvre was limited, both by the wishes of specific sitters and, initially, by the conventions of portraiture. When Reynolds began his career the conventions for using chiaroscuro in portraits were well established. The preeminent portraitists in London in the 1740s, Thomas Hudson and Allan Ramsay, tend to illuminate their sitters from the front (usually at a slight angle) by a bright, even light which clearly separates them from a duller background (Fig. 6). There is, typically, some shadow to the side of the face and the back of the figure and, in whole-lengths, often to the lower body. The extent and density of this shadow may vary, but it rarely obscures more than a small proportion of the sitter. The shadow serves to set off the brightly lit face and upper body and bring them forward, and, to a lesser extent, links

31. Reynolds, *Journey* (n. 10 above), pp. 66–7. De Piles had also remarked on the judicious use of chiaroscuro in prints after Rubens's paintings (Du Fresnoy, *De Arte Graphica* (n. 15 above), p. 166).

32. To point to such a source is to neglect a very different and perhaps more exciting explanation; namely that this tendency might be traced back to the famous observation by the surgeon William Cheselden that the fourteen-year-old boy blind from birth whose sight he had cured perceived the world first as a flat plane of colour modulated by light and shade, and only later learned to understand it in three-dimensions ('An Account of Some Observations Made by a Young Gentleman Born Blind', *Philosophical Transactions of the Royal Society*, 35, 1727–8, pp. 447–50, discussed by P. D. Funnell, 'Richard Payne Knight 1751–1824: Aspects of Aesthetics and Art Criticism in Late Eighteenth and Early Nineteenth Century England', DPhil diss., Oxford University, 1985, pp. 24–5). However, as celebrated as this case became with British philosophers (see ibid., pp. 25–7), its implications do not seem to have interested Reynolds, and still less Richardson, whose *Theory of Painting* appeared thirteen years before Cheselden's discovery. The first writer to draw upon this discovery in formulating a prescriptive theory of painting was probably Richard Payne Knight in 1805, although interestingly enough he also valued the massing of light and shade and styles in which these masses are 'harmoniously melted into each other' (*An Analytical Inquiry into the Principles of Taste*, London, 1805, pp. 58–60, 146–8, see also Funnell, 'Knight', pp. 24–9).

33. For Denis, whose remarks were made in 1890, see *Theories of Modern Art*, ed. H. Chipp, Berkeley, Los Angeles and London, 1968, pp. 94, 98. For Vasari see *Vasari on Technique*, transl. L. Maclehose, ed. G. Baldwin Brown, New York, 1960, pp. 208–9.

background and sitter, albeit without interrupting the clarity of the sitter's outline.[34] The result is, typically, a convex composition of the sort admired by de Piles.[35] Reynolds himself often used this format, especially in bust and half-length portraits which offered little room to manipulate patterns of chiaroscuro without compromising the sitter's appearance.

However, as Gainsborough observed, Reynolds was nothing if not various, and in some of his full-length portraits he showed a highly original approach to chiaroscuro, in which, perhaps in part to make his works more distinctive in a competitive marketplace,[36] he imported devices from history painting. This development may be traced to 1753, when, with the masterpieces of chiaroscuro he had seen in Venice still fresh in his mind, he painted his portrait of *Commodore Keppel* (Fig. 7). This picture makes a far more radical use of chiaroscuro than, say, the work to which it is often compared, Ramsay's near-contemporaneous *Chief of Macleod* (Fig. 8). The upper body and face of Ramsay's *Macleod* are brightly lit, and while his legs and lower body are more shaded, even these parts are backed by a light sky, so that it is only at the feet that the outline of Macleod's body merges with its background. By contrast, while parts of Keppel's body are also brightly lit, and set off still more dramatically by the dark background, elsewhere his body is in deep shadow, especially down his right-hand side, where the body's outline is hard to discern.

One function of this powerful chiaroscuro is, unquestionably, the traditional one of giving relief and depth. The fall of light upon the waves in the middle distance breaks the darkened sea and allows the eye to understand it as a plane receding to the horizon. Keppel, when compared to the poised Macleod, seems to stride towards us, an effect that owes much to the placing of the forward foot and shin in light and the other in shadow, and much also to the placing of the brightly lit right hand amidst an area of shade. This gives the hand great force; we might liken the effect to that supposedly created by Apelles in a picture of Alexander in which, as theorists extolling the relief-giving properties of chiaroscuro liked to affirm, 'the fingers seem to shoot forward'.[37] We might also compare Keppel's hand to that of

34. Among many other examples see Hudson, *Theodore Jacobsen*, 1746, Thomas Coram Foundation for Children, London; Ramsay, *Flora Macdonald*, 1749, Ashmolean Museum, Oxford.

35. In Du Fresnoy, *De Arte Graphica* (n. 15 above), pp. 165–6; see also Puttfarken, *Roger de Piles Theory of Art* (n. 3 above), p. 95.

36. *Commodore Keppel* remained in Reynolds's studio for some time as an advertisement for his talents, and was, more than any other, the picture that made his name (*Reynolds* [n. 30, above], pp. 181–2). For the importance of the market see M. Pointon, 'Portrait Painting as a Business Enterprise in London in the 1780s', *Art History*, 7, 1984, pp.187–205(203). Competition may also help to explain the experiments in chiaroscuro that Ramsay was carrying out at this time in some of his own full-length portraits, for example *Dr Richard Mead* (1747, Thomas Coram Foundation for Children), or *Archibald Campbell, 3rd Duke of Argyll* (1749, Glasgow Art Gallery and Museum). Ramsay, however, never achieved an effect of chiaroscuro as dramatic as that seen in Reynolds's *Keppel*.

37. Webb, *Inquiry* (n. 14 above), p. 105. For the source of the anecdote in Pliny's *Natural History* (XXXV.36.92) see *The Elder Pliny's Chapters on the History of Art*, transl. K. Jex-Blake, London, 1896, pp.

Christ in Caravaggio's *Calling of St Matthew*, a picture which Reynolds must have seen in the church of S. Luigi dei Francesi during his two years in Rome. Macleod's right hand is also lit and placed against shade, but because the shade does not encircle it it has much less force; we feel that the dark rock behind is simply there to maintain the clarity of Macleod's outline.

While giving relief and depth, the chiaroscuro of *Commodore Keppel* also serves to unify the picture. Reynolds both merges parts of Keppel's figure with the background, thus avoiding the cutting outline he so disliked, and subjects his body as a whole to the same patterns of light and shade as the rest of the scene. While Ramsay's background is just a backdrop, Reynolds manages to place Keppel within the scene. The backdrop becomes a setting. This is not to say that the setting was worked out first and then the sitter placed in it, as in British conversation pieces. *Keppel*'s background remains subordinate to the sitter, and is clearly painted in afterwards. However, through his use of chiaroscuro Reynolds does manage to gather figure, foreground and background into one unified composition.

In doing so he invites the viewer to imagine that Keppel is actively engaged in some drama within the depicted scene. Indeed, according to Reynolds's first biographer James Northcote, the picture represented an incident in which Keppel was shipwrecked in France, a suggestion seemingly confirmed by the wreckage in the sea.[38] *Keppel* thus stands as one of the first manifestations of Reynolds's desire to elevate portraiture through the assimilation of elements derived from history painting.[39] Discussions of Reynolds's attempts to fulfil this desire usually emphasize his allusions to past art, or his casting of sitters as mythological characters, or his generalizing of their features. As important as all these tactics, however, is Reynolds's use of compositional devices borrowed from history painting to incorporate his sitters within scenes, rather than placing them before a passive backdrop which acts as no more than an accessory to the sitter.

We may contrast a work by the painter who succeeded Ramsay as Reynolds's greatest rival, Gainsborough. Gainsborough's *Commodore Hervey* (Fig. 9) echoes Reynolds's *Keppel* in placing a naval officer on a sea shore. Hervey leans against an anchor, with a ship in the background. Both objects refer to his profession, but there is no suggestion that Hervey is participating in an actual scene involving a ship and an anchor. Similarly, he is separated from the background by the play of light. While the background manifests a dramatic arrangement of light and shade, Hervey himself is evenly lit in the foreground, the outline of his body clearly differentiated by tone and colour from the backdrop. This effect is emphasized,

128–9. Pliny did not attribute the effect to chiaroscuro, an association that probably derived from Franciscus Junius's mention of the picture in his section on the relief-giving properties of chiaroscuro (*The Painting of the Ancients*, London, 1638, reprinted in Junius, *The Literature of Classical Art*, eds K. Aldrich, P. Fehl, R. Fehl, Berkeley, Los Angeles and Oxford, 1991, I, pp. 243–4).

 38. *The Life of Sir Joshua Reynolds*, I, London, 1819, p. 64; see also *Reynolds* (n. 30 above), p. 182.

 39. See Discourses IV (1771), V (1772), *Discourses* (n. 15 above), pp. 72, 88.

here and in other portraits by Gainsborough, by a faint nimbus that seems to ring the outline of the sitter.[40] This, on closer inspection, turns out to be caused by a change in the direction of the brushstrokes used to fill in the background. Near the edge of the figure these tend to follow the shape of the sitter's body, and little attempt is made to merge them with the horizontal or diagonal strokes that make up the rest of the background. The effect is to further emphasize the outlines of the sitters and their disjunction with their surroundings, producing something close to the relief effect of which Reynolds disapproved.

In attempting to unify the composition of the *Keppel* Reynolds also drew upon that awareness of the abstract shapes made by masses of light and shade that he had first shown in Italy. Thus, the main mass of light extends from Keppel's body and face across the background, incorporating the light on the sea and that in the sky. Lesser lights are formed in the top right and bottom centre of the picture and around Keppel's right hand, while all these lights are kept compact and 'of a pleasing shape' by the broad areas of shade that surround them.

While the chiaroscuro in the *Keppel* functions as much to convey depth as it does to produce a flat pattern of light and shade, it is the latter property that becomes increasingly important in Reynolds's later works. In the portrait of Mrs Lloyd (Fig. 10), painted in 1776, the sitter even more strongly subjected to patterns of chiaroscuro than Keppel, to the extent that two strips of shade cut right across her body.[41] This results in broad masses of light and shade which both form attractive abstract shapes and emphasize Mrs Lloyd's setting *amidst*, rather than *before*, the trees whose shadows slant across her body. This work may be contrasted with Gainsborough's *Giovanna Baccelli* (Fig. 11), another female sitter in a sylvan setting painted six years later. Gainsborough does not allow light and shadow to break the form of Baccelli, but keeps her outline intact against the background. Sitter and background are united not through chiaroscuro but through the dashing brushwork that animates the entire picture, and by the way in which the colours of Baccelli's dress are picked up by those of the sky.

Reynolds still, to an extent, uses chiaroscuro to convey depth in *Mrs Lloyd*, the alternating strips of light and shade on the ground behind her giving a sense of recession. In some of the pictures Reynolds painted in the 1780s, however, the use of chiaroscuro to create flat abstract patterns almost entirely supercedes its function of conveying depth. In the portrait of *Lieutenant-Colonel Tarleton* (Fig. 12), the sitter's body is given relief by the placing of his white breeches against dark shadow, and his dark jacket and hat against white smoke. However, little attempt is made to suggest that Tarleton is standing in rational space, the impression given being

40. Cf. many other portraits by Gainsborough, e.g. *Viscount Kilmorey*, c. 1768, and *Sir Benjamin Truman*, c. 1770–4, both Tate Gallery.

41. Cf. Reynolds's portrait of *Georgiana, Duchess of Devonshire*, 1775–6, Huntington Library and Art Gallery, San Marino, CA.

rather that sitter, horse, banners, cannons and smoke all occupy the same shallow plane. The banners and cannon suggest that Reynolds may have derived the idea from the sculptured reliefs he had seen and sketched on monuments to Dutch admirals in churches in Rotterdam and Delft a few months before he painted the *Tarleton*.[42] Unlike the sculptors of the monuments, Reynolds was able to use broad masses of light and shade in attractive shapes to harmonize his essentially flat composition.

Reynolds's attention to the patterns made by light and shade at the expense of their capacity to convey depth is still more evident in his late history paintings, in which he was liberated from the need to emphasize the sitter. Two extreme cases painted in the late 1780s are *Macbeth and the Witches*[43] and *The Infant Hercules* (Fig. 13). While the pigments in both pictures have darkened it is, I think, still possible to say that their compositions are primarily intelligible as patterns of chiaroscuro, rather than as arrangements of figures in rational space. Understanding the relationships between the figures and the determinants of the spaces they inhabit is, at times, next to impossible.

While Reynolds's pronouncements on chiaroscuro and composition were rapidly overtaken by the more self-consciously novel ideas of Richard Payne Knight and the other theorists of the Picturesque, his ideas do seem to have had some impact, especially among his fellow Royal Academicians. Two of the Academy's Professors of Painting in the early nineteenth century, John Opie (Professor 1805–7) and Thomas Phillips (Professor 1825–32), placed more stress on the use of chiaroscuro to unify a composition than on its capacity to lend relief. Opie defined chiaroscuro as 'the proper division and distribution of the whole surface of a picture into bright or dark masses', and stressed that painters should attend to the shapes of those masses.[44] The reference to the 'surface' of the picture further suggests the extent to which Reynolds and his Academic successors conceived of patterns of light and shade in two-dimensional terms. This is confirmed by the remarks of Phillips, who seems to have seen a contradiction between the notion that chiaroscuro might cause relief and the notion that it should form an attractive pattern. He tried to resolve this paradox by denying that 'the relief afforded by light and shade', as seen in Apelles' *Alexander*, had any 'relation to Chiaro-oscuro, as now understood and employed'. Chiaroscuro, according to Phillips, lay rather in the 'arrangement of light and dark', and 'may be produced by a mere blot, which has no relation to any thing', or by forms either 'near or afar off'. By 1829, when this lecture was delivered, it had thus become possible to present Reynolds's capacity to understand chiaroscuro as a flat pattern of light and shade as an academic orthodoxy.[45]

42. Notebook kept in the Netherlands in 1781, Collection Frits Lugt, Institut Néerlandais, Paris, MS 6169, ff. 5v, 7r, see also Reynolds, *Journey* (n. 10 above), p. 192.

43. 1786–9, National Trust, Petworth House.

44. *Lectures on Painting*, London, 1809, pp. 100, 101, 104.

45. *Lectures on the History and Principles of Painting*, London, 1833, pp. 387–8, 396. Phillips also stated

Well before this date, Reynolds's theory and practice of composition appear to have had a profound effect on British art. Opie's own compositions make liberal use of smoke, fog and darkness to produce strong patterns of light and shade which, like those of Reynolds, show little interest in the placing of figures in rational space.[46] Similar characteristics are evident in the subject paintings of other contemporaries, notably Henry Fuseli[47] and George Romney.[48] A greater contrast to the works of David and his followers in France, who self-consciously moved towards a clear disposition of figures in an emphatically rational space, can hardly be imagined. While the difference might be attributed in part to the efforts of the British artists to disguise their technical shortcomings, they were, I think, also making positive artistic choices, opting for compositions dominated and unified by powerful patterns of light and shade. Reynolds's importance in this development, both through his writings and his paintings, should not be underestimated. Neither, however, should the fact that many British history paintings of this period were designed primarily to serve as the basis for prints, in such publishing ventures as John Boydell's Shakespeare Gallery.[49] Here again, the development in Britain of a mode of attention to composition that stressed the patterns made by light and shade may have owed much to the importance of monochrome prints within the artistic culture of this country.

that 'blotches of light and dark' might suggest 'ideas to the mind' (ibid., p. 389), a notion that recalls both Leonardo's comments on the suggestive capacities of discoloured walls and Alexander Cozens's blot landscapes, and indicates that a switch of attention from two-dimensional pattern to three-dimensional form might be as readily made in this period as its opposite.

46. For examples see W. H. Friedman, *Boydell's Shakespeare Gallery*, New York and London, 1976, pp. 169–72, fig. 88.

47. E.g. *Percival Delivering Belisane from the Enchantment of Urma*, 1783, Tate Gallery, London. See also Friedman, *Shakespeare* (n. 46 above), pp. 203–10, figs. 264, 270.

48. For *The Tempest* and other works see ibid., pp. 128–38, 169–72, figs. 24, 35.

49. For Reynolds's *Macbeth* see ibid., pp. 121–3, fig. 20; see also nn. 47, 48, 49 above. A still more novel use of patterns of chiaroscuro to organize composition was being pioneered concurrently in Spain by Goya in his *Caprichos*, experiments which Barbara Maria Stafford has suggested were inspired by the potentialities of another monochrome print medium, aquatint ('From "Brilliant Ideas" to "Fitful Thoughts": Conjecturing the Unseen in Late Eighteenth-Century Art', *Zeitschrift für Kunstgeschichte*, 48, 1985, pp. 352–63).

Fig. 1. Sir Joshua Reynolds, black chalk sketch after Tintoretto, *St Agnes Raising Licinius* (Madonna del Orto, Venice), sketchbook, 1752. British Museum, 201 a 9, f. 66v.

Fig. 2. Reynolds, black chalk sketch of landscape, sketchbook, 1752.
British Museum, 201 a 10, f. 42v.

Fig. 3. Reynolds, black chalk sketch after Van Dyck, *Charles V* (Uffizi, Florence), sketchbook, 1752, British Museum, 201 a 10, f. 49r.

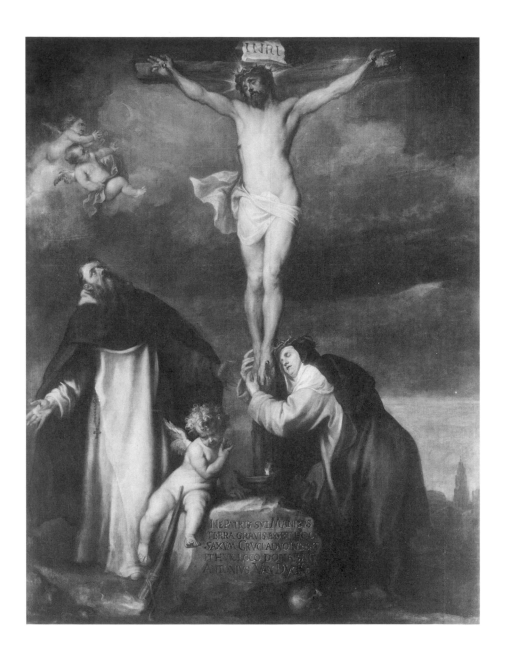

Fig. 4. Van Dyck, *Crucifixion*, c. 1626, oil on canvas, 314 x 245 cm, Koninklijk
Museum voor Schone Kunsten, Antwerp.

Fig. 5. Boëtius Bolswert, after Peter Paul Rubens, *Crucifixion* (*'Le Coup de lance'*), engraving.

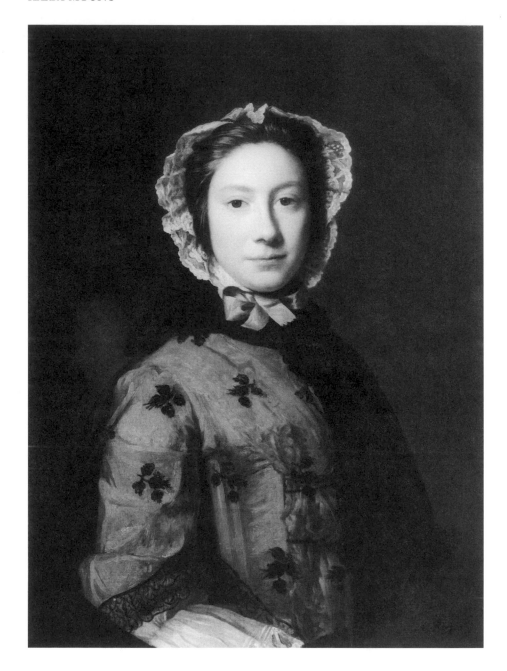

Fig. 6. Allan Ramsay, *Rosamund Sargent*, 1749, The Holburne Museum and Craft Study Centre, Bath.

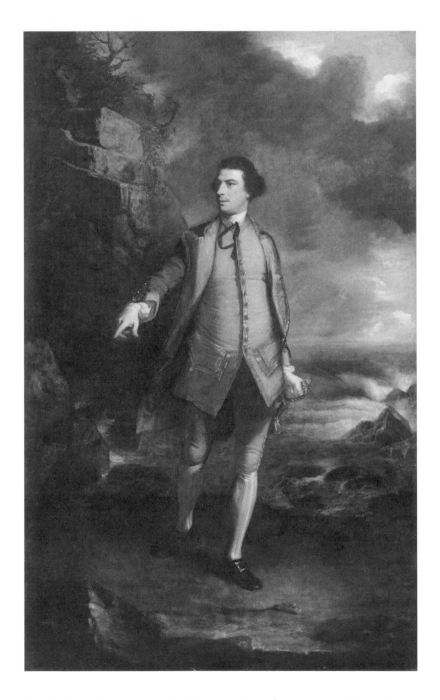

Fig. 7. Reynolds, *Commodore Keppel*, 1753, oil on canvas, 239 x 147 cm,
National Maritime Museum, London.

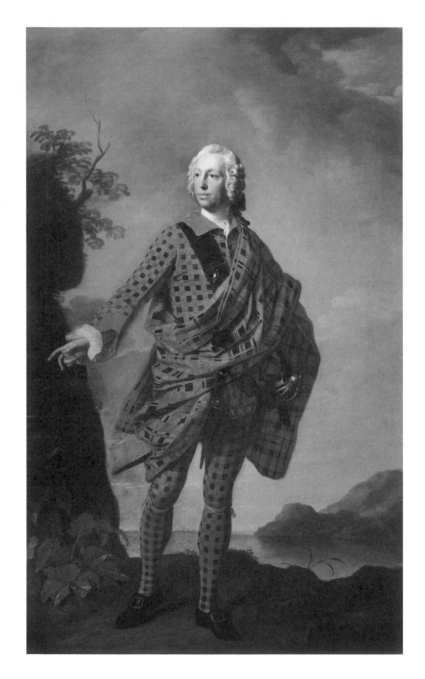

Fig. 8. Ramsay, *Norman, 22nd Chief of Macleod*, c. 1747, 240 x 135 cm,
in the collection of Macleod of Macleod, Dunvegan Castle.

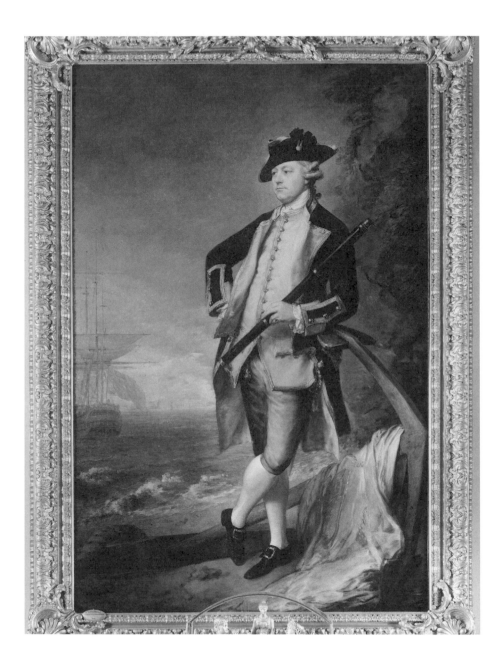

Fig. 9. Thomas Gainsborough, *Commodore Augustus John Hervey, later 3rd Earl of Bristol*, 1768, oil on canvas, 232 x 152 cm, The National Trust, Ickworth.

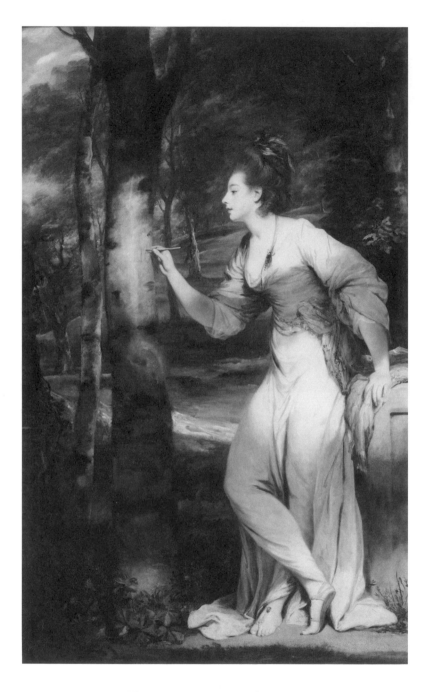

Fig. 10. Reynolds, *Mrs Lloyd*, 1776, oil on canvas, 236 x 146 cm.
Private collection.

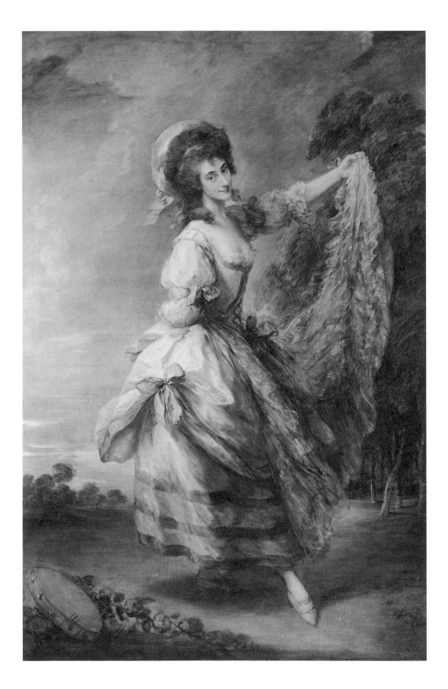

Fig. 11. Gainsborough, *Giovanna Baccelli*, 1782, oil on canvas, 227 x 149 cm,
Tate Gallery, London.

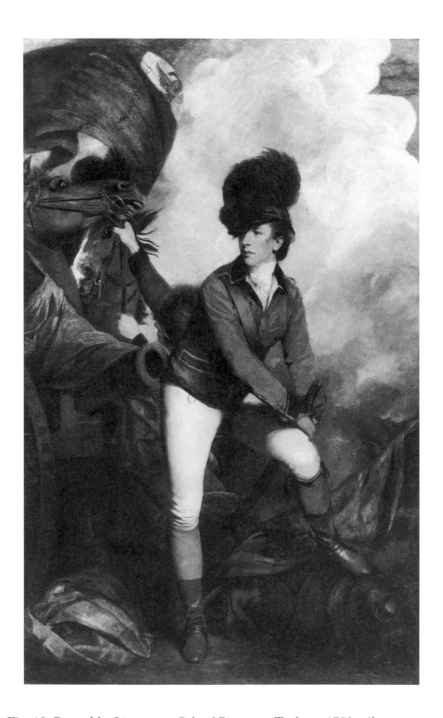

Fig. 12. Reynolds, *Lieutenant-Colonel Bannastre Tarleton*, 1782, oil on canvas,
236 x 145 cm, National Gallery, London.

Fig. 13. Reynolds, *The Infant Hercules*, 1788, oil on canvas, 303 x 297 cm.
The Hermitage, St Petersburg.

The Politics of Composition: Reflections on Jacques-Louis David's *Serment du Jeu de Paume*

Richard Wrigley

If history painting's position at the top of the hierarchy of the genres was unquestioned in eighteenth-century France, then composition was agreed to be at one and the same time the most important, and also the most difficult to master, of its theoretical and practical components. Composition represented a kind of inner core to art theory, embracing all aspects of the conception and elaboration of art works. When introducing the entry on composition in his *Dictionnaire portatif de peinture, sculpture et gravure* (Paris, 1757), Antoine Joseph Pernety explained that it was almost impossible to summarize the full extent of its ramifications:

> Ce seroit entreprendre de traiter de tout ce que concerne la Peinture, que de vouloir entrer dans le détail de toutes les parties qui ont un rapport direct ou indirect avec la composition.[1]

It will become clear that there is an almost paradoxical relation between the supreme importance attached to the idea of composition and the obstacles that this created when it came to the realisation of individual art works. Composition is identified with the heart of the creative process, yet it occupies an all but unattainable plane, scarcely within reach of practising artists, accessible only to those to whom the term genius might apply.

In order to explore certain aspects of this ubiquitous phenomenon, I will discuss a single work from the very end of the century, Jacques-Louis David's *Serment du Jeu de Paume* (Fig. 1).[2] This approach will facilitate an understanding of how general matters of the theory and practice of composition work out in terms of a specific artistic project. I shall suggest how we might understand David's inflection of existing conventions governing the nature of composition as a response to the circumstances of artistic production prevailing in 1791.

The 'Serment du jeu de paume', or 'Oath of the tennis court', was sworn by the deputies of the Third Estate on June 20th 1789. This episode marks a crucial moment in the process whereby the Estates General, which had been summoned gir to meet at Versailles by Louis XVI to find a way out of France's gathering economic and political crisis, gave way to a new form of constitutional government.

1. Antoine Joseph Pernety, *Dictionnaire portatif de peinture, sculpture et gravure*, Paris, 1757, p. 86.
2. See Philippe Bordes, *Le Serment du Jeu de Paume de Jacques-Louis David*, Paris, 1983; *Jacques-Louis David*, exhibition catalogue, Paris, 1989; entries on the paintings by Antoine Schnapper, on the drawings by Arlette Sérullaz.

It signalled a shift of the centre of political gravity away from the crown, and was necessitated by the claims of the Third Estate to an active role in determining France's future. Having designated themselves the Assemblée Nationale on 17 June, on 20 June the members of the Third Estate found the doors of the Estates General closed after Louis XVI had summarily cancelled a session without consultation. After adjourning to the nearby tennis court, the deputies swore not to dissolve until a constitution had been written. David worked on the drawing from late 1790; it was exhibited in his studio in May 1791 and then in the Salon in September. This was a monochromatic *modello* for a monumental painting to be 22 x 32 feet in size – half as big again as David's major history paintings of the 1780s, and larger even than the *Sacre* of Napoleon – and it was intended to hang in the Assemblée Nationale.

How are we to characterize the composition that David has elaborated? Obviously, it is not simply a matter of reading off a recognizable formula, but rather of historicizing the selection of a compositional strategy, and considering David's motives and the intended effects of a pictorial 'statement' about the Revolution. In 1790, Girodet, one of David's leading protégés, referred to David's 'tableau de la Révolution',[3] as if such a project was to function as a kind of synoptic commemoration of the inception of a new era. Consideration of the image's reception at the 1791 Salon adds to our sense of the significance attached to the compositional structure of the image .

A useful point of departure is to consider the *Serment* in terms of the notion of *péripéties* – the supplementing of the core narrative by inclusion of details which allude to preceding circumstances and succeeding consequences – since attention to this aspect of the compositional structure recurred in reviews of the *Serment* when it was shown at the 1791 Salon. *Péripétie* entered French art terminology in the seventeenth century, borrowed from its usage in dramatic theory to refer to the constituent elements of a story. The *locus classicus* for their discussion in relation to painting is the lecture delivered by Charles Lebrun to the Académie royale de peinture et de sculpture on Poussin's *Gathering of the Manna*.[4] The prime issue associated with *péripétie* is the relative importance of a picture's central action and its subordinate parts. This provided a vocabulary which enabled the delivery of nuanced judgements about the degree of variety appropriate in the depiction of a given subject. Although the term itself may not necessarily be used, this kind of

3. Bordes, *Serment du Jeu de Paume* (n. 2 above), p. 39. Girodet might, however, have been referring to an earlier unrealised project associated with Nantes.

4. André Félibien, *Conférences de l'Académie royale de peinture et de sculpture* in *Entretiens sur les vies et sur les ouvrages des plus excellens peintres anciens et modernes*, V, Trévoux, 1669, pp. 400–428. See T. Puttfarken, *Roger de Piles' Theory of Art*, New Haven and London, 1985, pp. 15–21, and J. Thuillier, 'Temps et tableaux: la théorie des "péripéties" dans la peinture française du XVIIe siècle', in *Akten des Internationalen Kongresses für Kunstgeschichte: Bonn, 1964*, III, Berlin, 1967, pp. 191–206.

theoretical yardstick continued to be ubiquitous in criticism and theory throughout the eighteenth century.

At first sight, one could hardly find a better, if somewhat foursquare, example of a work whose structure depends on a centripetal compositional logic. As Philippe Bordes has emphasized in his fundamental monograph on the *Serment*, the moment of the oath elicits diverse reactions radiating out from the central, elevated group around Bailly, who stands on a table facing the spectator, but driven back to the centre by gestures of oath-swearing. Peripheral incident is focused in the windows above the massed deputies: in the top left corner, figures visible in the windows struggle with the storm-force wind that lifts the curtains into a dynamic serpentine shape; beyond them lightning can be seen striking the chapel at Versailles; in the top right, a balcony full of excited spectators includes royal guards and children, and also a diminutive Marat transcribing an account of the action into a notebook labelled 'L'Ami du peuple'. In the left foreground, we see a group made up of the ailing deputy Maupetit de la Mayenne being carried in to the tennis court to participate in the oath, and behind him a darkened gallery of spectators; in the extreme left foreground a racquet and tennis balls have been abandoned, alluding to the original function of the tennis court having been replaced by that of an *ad hoc* political assembly – courtly tennis players have given way to newly enfranchised citizens. David's inclusion of such carefully orchestrated peripheral details conforms to expectations of the way such elaborate multi-figure images should be structured. In one anonymous pamphlet, it was complained that David had fallen short of Poussin's example by not including enough in the way of variety in his 'péripéties'. As a result, it was argued that the action was not as perspicuous as it should be. This absence of variety was contrasted with a more dramatic conception of the oath, which would have included soldiers threatening the deputies, 'le peuple' rushing to their aid, and 'le despote' (Louis XVI) directing operations.[5] The author of *Lettres analytiques, critiques et philosophiques sur les tableaux du Salon* made a similar observation, arguing that the spectacle of the oath-swearing deputies did not contain enough visual evidence to explain to the spectator what was taking place and why.[6]

On the one hand, these comments illustrate the ready journalistic currency of such art-theoretical notions in the later eighteenth century, and the way that they were habitually defined and brought into play in terms linked to great art of the past. To that extent, it is not unusual to find that when 'péripéties' are remarked on in criticism of contemporary art, this is only to criticize their inadequacy. That this

5. *Essai sur la méthode à employer pour juger les ouvrages des beaux-arts du dessin, et principalement ceux qui sont exposés au Salon du Louvre, par une société d'artistes*, Paris, 1790 [1791], pp. 7–8.

6. *Lettres analytiques, critiques et philosophiques sur les tableaux du Salon*, Paris, 1791, pp. 2–3. The point was amplified referring to comments made earlier in the pamphlet about a work by the history painter Taillasson regarding the need to evoke clearly the moments preceding and following the main action.

is the case with the *Serment* might be read as being symptomatic of the critic's expectations being focused on the enactment of the oath by the central protagonists. The only peripheral detail which is repeatedly referred to both in 1791 reviews and also in early nineteenth-century writings on David is the lightning which strikes the roof of the chapel at Versailles (a point that will be discussed later).

On the other hand, and perhaps more significantly, this apparently curious denial of, or deliberate inattention to, the presence of diversity amongst the image's peripheral figures alerts us to the fact that, when referring to a narrative such as that of the *Serment* – a large number of figures involved in a contemporary event – recognition, or misrecognition, of the range of protagonists depends on ideas about the representation of social and political difference. The focus on the central figures presumably corresponds to the desire to recognize in this representation of the oath evidence of a newly forged political unity understood primarily in terms of its prominent actors. In the summer of 1791, the celebratory recollections of the achievements of 1789 found in criticism on the *Serment* have as a negative subtext a critique of the increasing political fragmentation that beset revolutionary politics after 1789. To some extent, this came to the surface in comments on representatives of political views which challenged the consensus enshrined in the oath.[7] But it is striking that, despite the mixed reception that the *Serment* received at the 1791 Salon, relatively little attention was paid to the image's peripheral ingredients, perhaps because they provided potential raw material for evocation of elements of divergence from the oath's consensual spirit.

Enthusiasm for the patriotic subject – and, to the chagrin of some observers, this was claimed to be almost the only such subject in the 1791 Salon – clearly did not diminish the likelihood of critical remarks. For one critic, enthusiasm for the *Serment* was based on the 'élans du patriotisme' that united critic, artist, and deputies:

> Rien de plus ingénieux, de plus grand, de plus sublime et de plus poétique que la composition de ce dessin. C'est un poème qui réunit plusieurs actions dans un même jet.

Yet, a few lines further on, David is reproached for having Bailly, the central figure, turn his back on most of the deputies, and also because Maupetit's feet are confusingly positioned.[8] The dovetailing of political and artistic judgement is also evident in postrevolutionary views of David's general conduct and art. For example, his pupil and biographer, Etienne Delécluze, suggested that David's unfortunate

7. See Bordes, *Serment du Jeu de Paume* (n. 2 above), pp. 69–76.

8. *Explication et critique impartiale de toutes les peintures, sculptures, gravures, dessins, etc. exposés au Louvre, d'après le décret de l'Assemblée nationale, au mois de septembre 1791, l'an III de la liberté*, Paris, 1791, pp. 20–21; the author signed himself 'M.D..., citoyen patriote et vérifique'.

embroilment in the 'événements terribles' of the Revolution had caused a kind of artistic regression: 'son esprit et sa main même eussent oublié alors ce qu'ils avaient appris précédemment sur la théorie et dans la pratique de l'art'.[9] According to Delécluze, in works such as the *Serment*, the *Marat mort*, and *Lepeletier*, he abandoned the artifice of the *Horaces*, *Socrate* and the *Brutus*, and returned to a simpler imitation of nature. A return to nature would normally be seen as a desirable regenerative transition; Delécluze uses it as an exculpatory strategy to absolve his master from responsibility for his involvement in the Jacobin Republic.[10]

From an art-historical point of view, the other most noticeable aspect of the composition is its debt to some of the canonical figures of the grand tradition on which history painting relied – Michelangelo, Raphael, Poussin. Virginia Lee has documented this most thoroughly in her study of David's preparatory sketches for the picture.[11] For David in 1791, this recourse to the Italian Renaissance tradition and its most celebrated seventeenth-century French inheritor was not simply an artistic matter of selecting suitable models with which to build up an effective compositional foundation. The use of traditional elements modernized by contemporary dress was also appropriate to the prospective site of the picture in the Assemblée Nationale, reminding deputies of the founding moment of a new order of which they were the guardians. The aura of artistic authority which attached to references to great art of the past would have helped to legitimize the political authority invested in the Assemblée. We can see David's compositional strategy as being pragmatic, designed for both the Salon and the Assemblée. To this extent, we can understand the commitment to compositional simplicity as being informed by David's desire to maximize the image's impact on a large audience – an audience which had graduated from a role as artistic public to politically enfranchised People, but yet without jettisoning the signs of his mastery of the traditions at his disposal.

Nonetheless, when compared with his innovative compositional practices of the 1780s, the *Serment*'s reliance on a symmetrical frieze comes as something of a shock – and that comparison would have been easy to make as the *Horaces*, *Socrate* and *Brutus* were shown alongside the *Serment* at the 1791 Salon. As Thomas Puttfarken has shown with particular reference to the *Brutus*, David manipulated compositional conventions – splitting the composition in two and placing the main figure in shadow to one side – in a way that was provoking both to academic authority and to sensibilities schooled in its compositional conventions, but which also presented the spectator with the responsibility for making a daunting moral choice: whether to condone or condemn Brutus for his actions.[12] This was consistent with David's

9. É. J. Delécluze, *Louis David, son école et son temps*, Paris, 1855, p. 133.

10. A very similar point is made in P. A. Coupin, *Essai sur J. L. David, peintre d'histoire*, Paris, 1827, p. 23.

11. V. Lee, 'Jacques-Louis David: the Versailles Sketchbook', *Burlington Magazine*, 111, 1969, pp. 197–208, June 1969, pp. 360–69.

12. 'David's *Brutus* and Theories of Pictorial Unity in France', *Art History*, 6, no. 3, 1981, pp. 291–304.

manipulation of almost every aspect of his career as a history painter at this time so as to cast himself in the role of independent spirit (changing commissions' subjects, adjusting their stipulated format,[13] demanding higher prices, and deliberately delivering works late) – benefitting from the kudos and privileges of academic membership, but consolidating what we might call his 'private practice'.

At first sight, this working of variations on academic compositional conventions seems all the more curious in the context of David's post-revolutionary antagonism to the Academy. On the one hand, after 1789 he was working against the established constitution of the Academy, and aligned himself with the moves to reform the institution in the light of new democratic principles. On the other hand, in his first major project since the *Brutus* of 1789, we find the acknowledged presiding genius of the French School employing a form of pictorial cliché. Indeed, he not only used a pyramidal composition in the *Serment* (of precisely the kind referred to by Jean-Baptiste Pierre, the prickly but perspicacious *Premier Peintre*, when he encountered the *Brutus* in 1789, as representing the norm from which David had provocatively deviated[14]), but also made it broadly symmetrical, which almost all commentaries on composition specifically warned against because it gave the appearance of an artificial, ready-made compositional formula.[15]

David has employed another traditional pictorial device in his use of repoussoir figures to frame the frontal frieze – something Diderot, for example, had particularly criticized as redolent of banal academic 'routine',[16] and Dandré Bardon had condemned as 'affectations triviales'.[17] Again, in the context of David's earlier works, it is possible to see this as a calculated appropriation of an aspect of history painting's art-theoretical baggage. But this is no mere exercise in the display of mastery of an elaborate academic pose. David gives to the repoussoir grouping on the left foreground which includes Maupetit de Mayenne an active narrative role which binds it to the central drama. The muscular figure in front of Maupetit is distracted from his physical task by the spectacle of the oath, and thus made to seem an integral part of the action.

David's approach to the selection of a compositional mode can be understood as being consistent with the reputation he had established in the 1780s as a self-regulating, independent artist. He could not only bend and break rules when he saw fit, but he could also align himself with them, without at the same time compromis-

13. Antoine Schnapper, 'David et l'argent' in *David contre David*, ed. R. Michel, Paris, 1993, pp. 909–26; U. van de Sandt, 'David pour David: *Jamais on ne me fera rien faire au détriment de ma gloire*', ibid., pp. 115–40.

14. Jacques Louis Jules David, *Le Peintre Louis David 1748–1825*, 2 vols, Paris, 1880, I, p. 57.

15. Watelet and Levesque note that the choice of pyramidal compositions should only be used when they could be made to seem a plausible natural effect of nature, *Dictionnaire des arts de peinture, sculpture et gravure*, 5 vols, Paris, 1792, I, p. 427.

16. See E. M. Bukdahl, *Diderot, Critique d'art*, 2 vols, Copenhagen, 1980–82, 2, pp. 45–7.

17. M. F. Dandré Bardon, *Traité de peinture*, 2 vols, Paris, 1765, I, p. 122.

ing himself, *if* this answered the needs of the project in hand. This was approvingly recognized by a commentator in the *Journal de Paris*: 'les talens de M. David sont toujours nouveaux'.[18] In fact, this had been evident even at the time of *Brutus*, as he had simultaneously exhibited *Les Amours de Pâris et Hélène* which was in a wholly different mode – both 'antiquisant' and 'sentimental', and in the form of a *tableau de cabinet* writ large.

Of course, support for the idea of artists having the license to fashion their compositions as they deemed appropriate – subject to the usual rules of plausibility and resemblance – was hardly a concept invented in the later eighteenth century. Encouragement in this respect was available from the example of Poussin, in that discussions of his pictures in the seventeenth century had acknowledged that such license was permissible when the pictorial results were sufficiently impressive. Similarly, Henri Testelin, the secretary to the Académie, writing on 'ordonnance' had observed that composition:

> dépend entièrement de la qualité et de la liberté des génies; c'est pourquoi l'Académie n'a pas cru en devoir faire des décisions ni en établir des règles précises, jugeant plus à propos d'en donner quelque idée aux élèves par des exemples'.[19]

Although separated by more than a century, there is, in a sense, a similarity between the two cases. Testelin's comments come from a lecture designed to consolidate the early Académie's intellectual credentials, against a background of seeing off competition from the *maîtrise*. In 1791, the claim to professional pre-eminence can be seen as one possible response to the disrupted and uncertain commercial conditions that the Revolution brought with it. In this period, perhaps no artist was as successful as David in repositioning himself in relation to the most promising and prestigious sources of patronage – something which was characteristic of David throughout his career. In the early 1790s, this had become all the more necessary because the institutional base – i.e. the Académie and its official channels of patronage – had been seriously undermined. Precisely because of the remarkable reputation that he had established for himself by 1789, David had more at stake than most of his contemporaries in the new world of the Revolution. Having succeeded in steering the *Serment* project towards gaining the sponsorship of the Assemblée Nationale, he had not only to provide a work which would inspire his audience's political imagination, but also one which would live up to the artistic standards that he had established during the preceding decade. By opting for an image of monumental and dramatic simplicity, he could be said to have successfully satisfied both requirements.

18. Letter by 'L'Inconstant', *Journal de Paris*, 27 Sept. 1791, pp. 1100–101.
19. Henri Testelin, 'L'Ordonnance' (5 November 1678), *Conférences de l'Académie royale de peinture et de sculpture*, ed. H. Jouin, Paris, 1883, p. 187.

The other constituency which needs taking into account in seeking to understand the nature of composition in eighteenth-century French art theory is that of students and assistants. Indeed, as we have seen in Testelin's remarks, discussion of composition often includes reference to students and how they were expected to acquire knowledge of the workings of composition. Consideration of this dimension to David's practice will open on to discussion of what has been a largely unexplored phenomenon, that is, the teaching and learning of composition. We will see that David's practice is entirely consistent with the way that the dominant language of art theory, exemplified by the key notion of composition, excludes any recognition of the mechanics of execution and the practical, professional world of the studio, and focuses instead on what we might call ideal composition.

In their *Dictionnaire des arts de peinture, sculpture et gravure*, Watelet and Levesque make a contrast between, on the one hand, composition as something for the young student to learn in terms of conventions and formulae, and on the other hand, composition as handled by a master, whose works must bear no trace of secondhand elements. In relation to the use of certain standard ways of grouping figures they state:

> 'Il y a pour des groupes des préceptes d'école, qu'il faut connoître sans les recevoir comme des lois. Ces règles ont leur mérite et leurs avantages; mais elles n'ont pas le droit d'asservir le génie et doivent céder souvent à d'autres convenances. . . . Il faut convenir qu'excepté le grand principe de l'unité de sujet et d'intérêt, toutes les règles de composition ne sont que des conseils qu'il est bon de se rappeller souvent, mais qu'on ne s'astreint pas à suivre toujours.'[20]

In his 1750 lecture to the Academy, 'De la composition', the comte de Caylus played up this disjunction between two levels on which composition should be understood in a way that was hardly designed to instil confidence amongst the artists in his audience. Composition was 'la partie la plus difficile de l'art'.[21] It was synonymous with the expression of genius, and was therefore painting's essence, which Caylus termed 'la poésie de la peinture'. On the one hand, it was easy to recognize 'composition ordinaire, d'habitude, de réminiscence géométrique pour ainsi dire'. This was no more than the manifestation of a ubiquitous 'goût régnant', as demonstrated by the fact that 'toutes les écoles . . . fourmillent de tableaux de ce genre'.[22] That compositions of the latter type could be summarily described in terms of conventions and rules was symptomatic of their inferior nature. By contrast, 'composition sublime' transcended any statement about rules. In both cases, it is striking that the nature and practice of composition was curiously

20. *Dictionnaire des arts de peinture, sculpture et gravure*, 5 vols, Paris, 1792, I, pp. 426–7.

21. Comte de Caylus, *Vies d'artistes aux XVIIIe siècle. Discours sur la peinture et la sculpture. Salons de 1751 et de 1753. Lettre à Lagrenée*, ed. A. Fontaine, Paris, 1910, p. 168.

22. Ibid., p. 162.

inaccessible to concrete analysis. The encounter by students with a repertoire of conventions and formulae was beyond the scope of a discussion of principles in so far as it corresponded to the banal matter of assembling, grafting together and appropriating the building blocks of compositional structure. 'Composition sublime' escaped the restrictive vocabulary of pictorial analysis by virtue of having achieved an undeniable but indefinable synthetic unity.

This kind of disjunction in perceptions of composition (at best a sign of genius, at worst merely evidence of learning by rote) had been signalled at the beginning of the eighteenth century by Roger de Piles. In the education of young artists, he stated, composition came last, only to be engaged with once the fundamental techniques involved in drawing and colour had been mastered. By contrast, for the accomplished artist, composition came first, understood as comprising 'invention' – the careful choice of appropriate ingredients – and 'disposition' – the arrangement of those elements subject to the dictates of narrative and expression.[23] De Piles treats these components as if they were successive phases of the conception and elaboration of the image, without exploring the more pragmatic business of how the accomplished artist might transmit knowledge of composition to advanced students (or the latter become transformed into the former). This is hardly unusual in the context of eighteenth-century art theory and criticism, for it was extremely rare for any discussion of the mechanics of art practice to surface in the public language of art. The language artists themselves used for describing such matters inevitably remained within the studio because, as commentators repeatedly emphasized, it was incomprehensible to any but professional artists. For the *Encyclopédie*, the gulf between the general observations that could be made about the handling of composition and the practical application of such conventions in the form of persuasive and pleasing art works could not easily be bridged. At the end of the entry on composition, it was concluded:

> Telles sont à-peu-près les règles générales de la composition; elles sont presques invariables; et celles de la pratique de la Peinture ne doivent y apporter que peu ou point d'altération.'[24]

In effect, this was a way of emphasizing the fundamental divide between the domain of imaginative creation, or invention, and the more mundane business of the material realization of such ideas. That is, artists could not evade the judgements of spectators who laid claim to knowledge of the abstract principles of art theory. It was in response to such assertions that Charles-Nicolas Cochin took the artists' part, speaking with all the force of a practising artist familiar with the complex techniques involved in making art works. He reminded his readers of a fact that

23. R. de Piles, *Cours de peinture par principes*, Gallimard, Paris, 1989 [1708], pp. 29–30.
24. Diderot et D'Alembert, *Encyclopédie, ou Dictionnaire raisonné des sciences, des arts et des métiers*, Paris, 1753, III, pp. 772–4.

artists knew all too well, namely that the successful rendition of a given subject depended as much on the effective handling of the technical ingredients of pictorial style as on the fidelity of the image to the textual point of departure, and that the former was not merely a subordinate adjunct to the latter.[25]

The most tangible manifestation of the transition from the initial working out of a picture's composition to its full-scale realization was, of course, in the form of drawing. In the case of the *Serment*, the vast majority of the many studies for it are focused on individual figures and groups. According to Philippe Bordes, there is no overall compositional drawing as such, in which we can see the final composition achieving a resolved form. The nearest thing is the Fogg sheet, which is specifically concerned with establishing the architectural framework, probably produced in collaboration with Charles Moreau, a pupil, friend and architect as well as a painter (Fig. 2).[26] In a sense, the drawing shown at the Salon *is* the compositional drawing. This was the design whose expansion would result in the final work. In the interim, it functioned as the source for the engraved plate, sales of which were to finance the project. It contains enough approximation in the central mass of deputies to allow for future adjustment – notably in the respect that, within the overall compositional design, the identity of particular individualized figures could be altered. The scale of the projected painting would have necessitated extensive involvement of assistants, allocated to complete the image's constituent parts in a way that had become established practice for David.[27] David's role was to conceive the overall compositional framework, to marshal the elaboration of its details, and to take the credit for the whole project.

David's position as the head of the most successful history painting studio in later eighteenth-century France – an enterprise conceived amongst other things to translate his conceptions into finished history paintings – seems to correspond to a fundamental distinction between 'composition poétique' and 'composition pittoresque' which runs through eighteenth-century French art theory, criticism and practice. Essentially, these two terms distinguished between the notion of invention – the realm of ideas – and execution – its translation into pictorial form. In the eighteenth century, attitudes to this distinction were symptomatic of a divide between, on the one hand, proponents of the poetic or intellectual side of art who distanced themselves from the mundane matters of execution, and on the other hand, those who spoke for artists and their resentment at being on the receiving end of such domineering judgements. The gratuitous way in which *littérateurs* opined authoritatively on artists' productions exacerbated the idea that the practical, professional world of artists within the studio was at one remove from the wider

25. Christian Michel, *Charles-Nicolas Cochin et l'art des lumières*, Rome, 1993, chapter 16, 'L'autonomie du discours pictural' and chapter 17, 'La Pré-eminence du faire', pp. 253–78.

26. *Jacques-Louis David* (n. 2 above), p. 248.

27. See T. E. Crow, *Emulation: Making Artists for Revolutionary France*, New Haven and London, 1993.

cultural world beyond.

David, it may be said, identified himself with the generation of 'composition poétique', and did little to enhance the status of the elaborate processes which went towards the business of execution which correspond to 'composition pittoresque'. In this respect, the co-option of leading younger artists in David's studio, subordinate to the master, was a sign of his artistic authority. The Académie may have fallen victim to the forces of revolutionary democratization, but a more traditional, strongly hierarchical form of division of labour prevailed in David's studio. David kept tight control of the origination of 'composition poétique'; his assistants were relegated to the role of auxiliary executants. Although they might, in fact, assume almost total responsibility for certain figures, this was still in an essentially subordinate role. The preoccupation of criticism with 'composition poétique' meant that David's reputation was strongly personalized, in so far as it was based on a desire to celebrate his individual creative persona. In the case of the *Serment*, the fact that the work on exhibition was only a drawing denied commentators the opportunity to assess how successful the elaborate process of working up the image to full scale had been. The responsibility for ensuring that the final work would live up to expectations was assumed to be exclusively David's. One antagonistic review illustrates the currency of this assumption by claiming that David had drawn on a group of helpers to devise the composition's contents; this was construed not as constructive collaboration, but rather as a compromising loss of independence.[28] This was precisely the kind of accusation that had been levelled at some of the less popular history painters in the later eighteenth century, in so far as accepting ready-made subjects from patrons or *littérateurs* could be claimed to signal unimaginative subservience. Those critics who adopted a pose of skepticism did so in part as a reaction to the *idée reçue* that David was the leading artist of his day. The way David fashioned the *Serment*, and the perception in criticism of his responsibility for it, corresponds not to the espousal of 'composition pittoresque' (which would have encouraged an association with those aspects of art practice to do with the habitually invisible studio-based complexities and skills of professional artists, misunderstood and undervalued by literary commentators), but rather with 'composition poétique', the domain of genius, exercising a learned and imaginative control over compositional ingredients.[29] Yet this ideology of the dominating genius in no way seems to have compromised his political credentials, rather the reverse, in that it was extremely useful to be able to claim France's greatest living artist as a revolutionary enthusiast. This example suggests that, however new might

28. *Lettres analytiques, critiques et philosophiques sur les tableaux du Salon*, Paris, 1791, p. 52.

29. Charles-Nicolas Cochin's annotations to Abbé Marc Antoine Laugier's posthumously published as *Manière de bien juger les ouvrages de peinture*, Paris, 1771, nicely illustrate an unusually forceful resistance to the ill-informed imposition of a language of art expressed in terms suited to the armchair aesthetics of *littérateurs*.

be the language of politics introduced during the Revolution, there was a prevailing dependence on established concepts and patterns of thought in the realm of artistic ideas.

Composition as such was not formally taught in academic pedagogy. The emphasis was overwhelmingly on mastery of the convincing and expressive rendition of single figures, and the constituent parts of which they were made up. Students and artists setting out on a career where they would have to fashion paintings independently were therefore reliant on precedent in order to learn how to design compositions. Young artists were likely to turn to recent works (whether those in the Salon or the studios of senior artists), and canonical works from the past. In this respect, the *croquis* made while inspecting works in sales, collections, and when travelling in Italy and elsewhere provided valuable guidelines.

The prime difficulty that followed from this process of synthesis was to avoid accusations of being derivative in so far as a composition's prototype might remain too clearly visible. However, it was easier to deprecate such over-reliance on models than to transform them successfully into an individual manner. Injunctions against falling into pallid paraphrase were based on the primordial obligation that art should imitate the spectacle of Nature through a process of distillation and idealization, and not recycle ready-made formulae. Hence the exhortations to be alive to the way nature offered its own spontaneous, authentic compositional language, which artists should strive to observe, not in the studio, but in the diverse spaces of the wider world – ports, churches, markets, factories, processions, ceremonies.[30] This kind of language tended to ignore the lengthy studies which provided the foundation for the evolution of an individual manner based on a synthesis of earlier models. The notion that mastery of composition could not be achieved by patient study alone was expressed in the assertion articulated both by those critical of academic routine and those who acknowledged its virtues in providing a sound artistic education, that only those suitably endowed by nature with superior abilities were truly capable of making unquestionably impressive art works. In the opinion of Delécluze: 'Celui qui est vraiment destiné par la nature à devenir un artiste, apprend l'art de composer successivement *et presqu'à son insu*' [my italics].[31] In the case of David's *Serment*, the absence of any censure of the sources used for some of the figures might be taken as testimony to his success in fusing such ingredients within a persuasive whole. Thus, Coupin was prepared to

30. For example, Étienne Jean Delécluze, *Précis d'un traité de peinture*, Paris, 1828, pp. 151–2. Delécluze's remarks rework a trope found in eighteenth-century criticism, used to recommend attentiveness to the spontaneous variety found in 'nature'. For example, in explaining the force of Greuze's imitation of nature, Diderot described him as being 'sans cesse observateur dans les rues, dans les églises, dans les marchés, dans les spectacles, dans les promenades, dans les assemblées publiques ...' (D. Diderot, *Salons*, ed. J. Seznec, Oxford, 1975), I, p. 236 [1763]). See also Anon., *Dialogues sur la peinture*, Paris, 1773, pp. 99–100.

31. Delécluze, *Précis d'un traité de peinture* (n. 30 above), p. 150.

overlook what he claimed was the 'obvious' derivation of the central group because of the highly effective way in which David had put it to use.[32]

In the Revolution, the role of naïveté in creating compositional design took on a political significance. We can see this in the way that criticism celebrates the oath by applauding David's image as a direct transcription of the events of the day, harmonized through the heroizing vision of history painting.[33] Asserting the simplicity of the image's composition was a way of reinforcing the compelling political resonance of the oath. Enthusiasm for the image's persuasiveness was both justified and amplified by asserting that its composition bore the hallmarks of genius, in that it appeared natural, and conveyed a dramatic immediacy. It is striking that, as noted above, the composition has been consistently characterized as an arrestingly immediate depiction of the events it records, also manifest in the implication that David had been a witness to the oath itself. Alternatively, viewed from a more distanced, retrospective vantage point, as we saw with Delécluze, compositional simplicity was seen as having been determined by David's sincere, but, in retrospect, ultimately ill-advised commitment to the Revolution. Similarly, for Jules David, the artist's grandson and biographer, David had triumphed over the limitations imposed by the subject:

> le mérite de l'artiste était d'avoir su animer sans confusion cette immense composition et répandre le mouvement et la variété parmi ces nouveaux personnages concourant tous dans le même esprit à une même action.[34]

Indeed, he goes on to emphasize the way that the artist has succeeded in making an interesting picture out of a subject which might have been spoiled by too great an impression of uniformity, resulting from the obligation to produce a faithful depiction of the occasion. Miette de Villars also saw the impressiveness of the result as following from the way David had triumphantly dealt with artistically challenging raw material: 'Alors son pinceau exécuta la composition la plus imposante qui soit sortie d'un cerveau humain.'[35] For Jules David, artistic concerns took precedence over the political rationale of the image. For Miette, David's artistic success was merely the means by which a resounding political statement was articulated.

The language of politics and art can also be seen to intersect in the way that use

32. Coupin, *Essai sur J. L. David* (n. 10 above, pp. 24–5) does not identify the source he found so obvious. Philippe Bordes adds Michelangelo's *Last Judgement* and Poussin's *Gathering the Manna* to the suggestion made by Virginia Lee of Fra Bartolommeo's *Salvator Mundi* (Pitti Palace, Florence) (*Serment du jeu de paume*, n. 2 above, p. 60).

33. Publicola Chaussard described the drawing as an unfinished 'page mémorable de notre histoire': *Le Pausanias français, ou Description du Salon de 1806; état des arts du dessin en France, à l'ouverture du XIXe siècle*, Paris, 1808, p. 159.

34. David, *Le Peintre Louis David* (n. 14 above), I, p. 97.

35. *Mémoires sur David, peintre et député à la Convention*, Paris, 1850, p. 102.

of the term *tableau* suggested an analogy between the two realms. This is not accidental. For the language of art offered not only a much needed stabilizing element in evocations of the achievements of the Revolution, but also enabled their translation into familiar descriptive and metaphoric figures.[36] For example, some accounts of the Revolution employ the term *tableau* either to assert the unified interrelation of a set of descriptive episodes (in the sense of tabulation), or to enhance the sense that such a series manifested an overall progressive coherence (in the sense of pictorial integration).[37] The constitution of narrative unity depended, of course, on the political point of view of the author. Indeed, one might read the diverse critical responses to the *Serment* as a 'tableau de la Révolution' as articulating just such an ambiguity: either celebrating the oath as a political triumph by means of praising David's drawing, or casting doubt on the artist's political probity by expressing reservations about the pictorial treatment of the subject.

Various critical remarks illustrate the way that reservations about the image's degree of pictorial unity merge with objections to the political correctness of David's representation of the oath. Two aspects of the composition in particular indicate some of the tensions which interfere with the plausibility of a direct equivalence between pictorial and political unity – and it is no coincidence that these correspond to details that would have been worked out late on in the composition's elaboration, since they correspond to aspects of the Revolution that postdate the oath itself. The problematic relation between the pictorial and the political can be seen to be unravelling, not only in the need to foreground a selective set of leading *dramatis personae* adapted to suit the nature of the political landscape in 1791 (which David attempted to obscure by claiming disingenuously that he had not sought to depict recognizable individuals), but in the treatment of the foreground figure carrying Maupetit de la Mayenne.

Reading this figure is made more problematic by the fact that none of the 1791 reviews mention it. Later commentators have made up for this, predominantly repeating the assertion that the figure should be identified as a *sans-culotte*. Such terminology is anachronistic, since *sans-culotte* only entered political vocabulary to refer to exponents of militant populism in 1792.[38] Yet it is probably right to see in this figure an unresolved attempt by David to find a new kind of iconographical language by means of which to provide a positive, or at least relatively prominent, representation of the 'peuple' in a history painting dealing with contemporary events. David clearly found this difficult, as one would have expected, since there

36. See R. Paulson, *Representations of Revolution (1789–1820)*, New Haven and London, 1983, pp. 37–56. On the interplay between pictorial and rhetorical versions of the 'tableau', see J. Lichtenstein, *La Couleur éloquente: rhétorique et peinture à l'âge classique*, Paris, 1989, pp. 129–51.

37. See R. Wrigley, *The Origins of French Art Criticism: the Ancien Régime to the Restoration*, Oxford, 1993, pp. 244–5.

38. See, for example, Arlette Sérullaz's entry on the drawing in *Jacques-Louis David* (n. 2 above), p. 255.

was no pre-existing vocabulary in history painting to fulfil this function. As has been pointed out by several modern commentators, the cap worn by this figure is probably to be undertood as a liberty cap. As preparatory studies illustrate, the figure was given a liberty cap late on in its evolution. However, investing the figure with an added emblematic dimension at one and the same time dignifies it, but also obscures what it might be understood as referring to in terms of the depiction of the oath. The odd mix of dress, pose and cap stand out from the contemporaneity of the deputies' dress. At first sight we might wish to read this figure as a generalized token of popular participation in political action, but such a proposal is at best extremely sketchy, given the fact that this kind of notion was not yet in play in the political language of the day. A more convincing reading of the figure is to link it to the idea of exceptional cross-class collaboration associated with moments of crisis (as had been the case with the excavation of the Champ de Mars for the first Fête de la Fédération in July 1790). Nonetheless, even though we must recognize the figure's tentativeness and lack of an explicit emblematic register, it seems possible that its inclusion corresponds to David's desire to refer to an incipient aspect of the political landscape which, as it took more developed form through 1792, was in conflict with the unifying idea of constitutionalism which was the ideological foundation which the oath established, and which images of it celebrated.[39]

The other peripheral feature of the narrative which, in terms of the image's reception, took on a dissonant prominence was the royal chapel at Versailles shown being struck by lightning, visible through the window to the left. This detail was given different meanings, ranging from no more than an evocation of the occasion's meteorological context, to the claim that it was a polemical reference to the demise of royal authority. To this extent, it literally and symbolically overshadowed the act of political unification in the *jeu de paume* below in so far as the violent elimination of royal authority went beyond the constitutionalist narrative of the oath, however dramatic its enactment. By the time the Revolution had progressed through its more violent stages, and as these came to fill the political field of vision of retrospective views, so this detail was taken to be an emblematic presage of David's identification with Jacobinism and Robespierre.[40] Of course, this perspective on the image is not without foundation, but as with the anachronistic application of the term *sans-culotte*, it has the effect of confusing a later context with the image's original circumstances of production and reception. It was not until Philippe Bordes's 1983 monograph on the *Serment* that the project's evolution was placed within a clearly differentiated picture of changing revolutionary circumstances.

39. I intend to discuss this point in relation to the evolution of the image of the *sans-culotte* in a separate study; on the symbolic context for the liberty cap, see R. Wrigley, 'Transformations of a Revolutionary Symbol: the Liberty Cap in the French Revolution', *French History*, 11, 1997, pp. 131–69.

40. Coupin, *Essai sur J. L. David* (n. 10 above), p. 25.

Generally, one might suggest that the process of rapid, unpredictable revolutionary change altered the significance of *péripéties* in images of the Revolution. The compositional convention whereby framing elements, which dovetailed aspects of earlier and subsequent actions and reactions, should be woven into the overall narrative, was rendered much more difficult by the fracturing of the Revolution into embattled factions and parties. One syptom of this practical and conceptual impasse was the increased resort to predominantly allegorical images, which allowed much greater flexibility of interpretation of the linkage between visual vocabulary and political referent. The way that David seems to have invested the figure carrying Maupetit with an emblematic register, primarily in his addition of an incongruous liberty cap, anticipates this form of pictorial solution to the problem of representing the Revolution.

Once the Revolution was deemed to have ended, and the unity, or otherwise, of David's artistic and political careers became a matter of biographical exegesis, inconsistencies within his works tended to be downplayed so as not to interfere with the authorative sweep of general interpretations which asserted that David was either a revolutionary from his earliest days, or a dedicated artist who was briefly embroiled in matters he did not understand. The language of art theory itself was employed to evoke the resolution of diversity within the overarching unity of the artist's life. Writing in the Second Republic, Miette de Villars opens his biographical study by anticipating a review of 'les péripéties qui composent la vie étonnante de David'.[41] In biographies such as Miette's, a concept of unity which was at once historical and aesthetic was employed in order to assert the veracity of the balance struck between David's political and artistic careers.[42] Miette's promise to discuss the 'péripéties' of David's life reveals the way in which the terms of biographical narrative had been coloured and shaped by fundamentally pictorial concepts.

* * *

The concept and practice of composition have to be understood both as depend-ing on long-term continuities, accentuating its reliance on an accumulated body of specialized art knowledge, and also in relation to the resonances and associations it had in the wider cultural and political environment at specific historical moments. The foregoing reflections make it clear that the interplay between these two dimensions takes place on several levels. This is all the more the case in relation to eighteenth-century France, where the notion of composition was a central premise of art-theoretical orthodoxy. However, the simplistic association of composition with a generic picture of academic conformity has obscured the way that, as with the general vocabulary of art language used by theorists, critics, and artists when

41. Miette de Villars, *Mémoires de David, peintre et député à la Convention*, Paris, 1850, p. 1.
42. See N. McWilliam, 'Les David du XIXe siècle', in *David contre David* (n. 13 above), 2, pp. 1115–35.

speaking or writing within the public domain, this notion is heavily weighted towards a literary conception of art, all but disconnected from the practicalities of production. The politically transformed conditions of production and reception surrounding David's making of the *Serment du jeu de paume* reinforced this dislocation. Despite the use of modern dress, the *Serment* emerges as a project whose radical political import was built upon a framework of time-honoured artistic conventions. The project consolidated David's established reputation as the leading history painter of his time, and added a further dimension to it by presenting him as being able to put his magisterial command of the specialized domain of fine art at the service of Revolution.

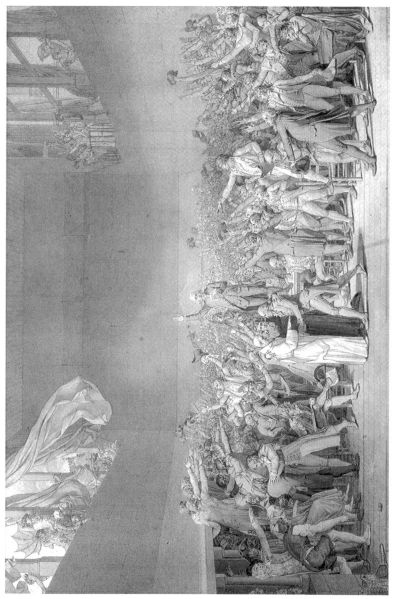

Fig. 1. Jacques-Louis David: *Le Serment du Jeu de Paume*, 1790–91, pen and brown ink, with black ink, brown wash, white chalk and pencil, 66.6 x 101.2 cm. Versailles, Musée national du château; on deposit from the Musée du Louvre, Paris.

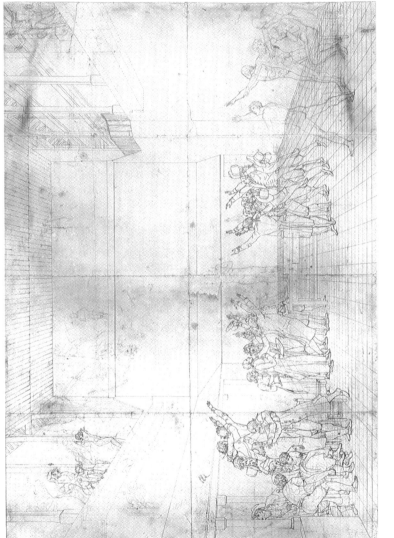

Fig. 2. Jacques-Louis David: study for *Serment du Jeu de Paume*, 1791, pencil, black ink and bistre, 65.8 x 98.8 cm. Harvard University, Fogg Art Museum, Grenville L. Winthrop Bequest (inv. 1943–7).

Towards a Science of Art: the Concept of 'Pure Composition' in Nineteenth- and Twentieth-Century Art Theory

Hubert Locher

The protagonists of modern art and their first historiographers liked to stress the revolutionary novelty of the art of their epoch. Today, we are more interested in the fact that many of these new ideas were based on concepts rooted in the past. To be sure, traditional terms were used in new contexts, and some were redefined, with secondary meanings becoming central to the words' new senses. A process of transformation like this can be observed in the case of the old term 'composition', which was to play an important role in the theory of abstract painting.

The word 'composition' had begun to develop new connotations in the first years of the twentieth century. This can be seen most clearly, perhaps, from the fact that it was used in the title of various paintings. In 1905, Adolf Hölzel called one of his pictures *Composition in Red I* (Fig. 1), and in 1910 Vassily Kandinsky began regularly to use the word as the name of certain of his works. In that year he painted *Composition I*,[1] *Composition II* (Fig. 2) and *Composition III*, and over the next three years he continued with the series, from *Composition IV* to *VIII*. After a ten-year pause he produced *Composition VIII*, before turning to *Compositions IX* and *X* during the thirties.[2]

Kandinsky did not choose this title so many times because he was unable to think of a subject, as one critic thought;[3] rather, he was using the word *Composition* in a specific sense. In his book *On the Spiritual in Art*, which was written in 1909 and 1910 and first published in 1912, he provided a justification for the practice of calling pictures *Compositions*, and distinguished paintings so named from other kinds of work. He wrote that *Impressions* are those images which have their origin in our 'direct impression of "external nature"'. *Improvisations*, on the other hand, are 'chiefly unconscious, for the most part suddenly arising expressions of events of an inner character, hence impressions of "internal nature"'. *Compositions* are a further development of *Improvisations*: they are, as Kandinsky puts it, the

> expression of feelings that have been forming within me in a similar way (but over
> a very long period of time), which, after the first preliminary sketches, I have
> slowly and almost pedantically examined and worked out. ... Here, reason, the

1. H. K. Roethel, J. K. Benjamin, *Kandinsky. Catalogue Raisonné of the Oil Paintings*, I, 1900–1915, London, 1982, no. 327. The picture is lost. For works after 1915 see vol. II, 1916–44, London, 1984.

2. See M. Dabrowski, *Kandinsky Compositions*, exhib. cat. Museum of Modern Art, New York, 1995.

3. Georg Jakob Wolf, *Kunst für alle*, 1 November 1910, pp. 68–70; quoted P. Weiss, *Kandinsky and Munich. The Formative Jugendstil Years*, Princeton, 1979, p. 187, n. 143.

conscious, the deliberate, and the purposeful play a preponderant role.[4]

From the large format of the *Composition* series and fom the long process of preparation that went into all of them, we might infer that Kandinsky thought it the highest calling of the artist to produce such works; and this inference is borne out by the last sentences of *On the Spiritual in Art*, where the artist proclaims that the future will belong to the 'conscious, reasoned system of composition', and that the painter 'will be proud to be able to explain his works in *constructional* terms'.[5] When Kandinsky uses the word *composition* he is referring to the work of art as a finished whole, but at the same time he is alluding to the artistic process that brought it about. In his own words:

> Composition, ... is the juxtaposition of colouristic and linear forms that have an independent existence as such, derived from internal necessity, which create within the common life arising from this source a whole that is called a picture.

The difference between this and earlier definitions is considerable: since Alberti, who was the first to use the word in art theory, 'composition' had referred not to the work of art itself but to the process of combining parts.[6] In Kandinsky's understanding, however, 'composition' has become a generic term which includes the entire artwork.

The prehistory of Kandinsky's constructive concept of composition can, again, be traced back through picture titles. A figure who has not always been thought a herald of modernism is of importance here. James Abbot McNeill Whistler was one of the first artists to give his pictures 'abstract' titles, which laid more emphasis on form than on content. When he showed his *White Girl* in the *Salon des refusés* of 1863, one of the few positive reviews praised it as a 'symphony in white'.[7] The

4. On the Spiritual in Art, in: *Kandinsky. Complete Writings on Art*, ed. K. C. Lindsay and P. Vergo, London, 1982. p. 218. For the German text, see Vassily Kandinsky, *Über das Geistige in der Kunst*, ed. M. Bill, Berne, 1965. p. 142. The editors of the translation note that this passage was apparently added only after the completion of the main text. It is not in the original typescript of 1909.

5. Kandinsky, *Spiritual* (n. 4 above), p. 219: id., *Geistige* (n. 4 above) p. 142.

6. For a discussion of Kandinsky's notion of composition see F. Thürlemann, *Kandinsky über Kandinsky. Der Künstler als Interpret eigener Werke*, Berne, 1986, pp. 96–9. The author stresses the 'architectural analogy'; however, when speaking of the 'constructive dimension' Kandinsky never hints at an architectural connotation. See also the fundamental study of P. Weiss (n. 3 above), especially chapter X, 'Ornament and Art without Objects', pp. 109–17. As a possible source for Kandinsky's notion of composition Weiss refers to Paul Schultze-Naumburg, *Das Studium und die Ziele der Malerei: ein Vademecum für Studierende*, Leipzig, 1900, which contains a chapter on composition that had already been published in 1899 in the Journal *Kunst für Alle*, pp. 74ff. Another possible source was Rudolph Czapek, *Grundprobleme der Malerei. Ein Buch für Künstler und Lernende*, Leipzig, 1908. On Alberti and composition, see my article 'Leon Battista Alberti's Erfindung des "Gemäldes" aus dem Geist der Antike: der Traktat *De pictura*' in *Theorie und Praxis. Leon Battista Alberti als Humanist und Theoretiker der bildenden Künste*, ed. K. W. Forster and H. Locher, Berlin, 1999, pp. 75–107(93–9); also papers by Charles Hope and Philip Sohm in this volume.

7. Paul Mantz, 'Salon de 1863', *Gazette des beaux-arts*, 15, 1863, pp. 60–61.

picture became known later as *Symphony in White No. 1: The White Girl* (Fig. 3).[8] Two more pictures followed, entitled *Symphony in White No. 2* and *No. 3*. In the 1860's he painted pictures with titles like *Caprice*, *Harmony*, *Variations*, often made more precise by the indication of a colour or a tone or a pair of tones. In the 1870's he went on to paint works with names like *Arrangement* and *Nocturne*.[9]

Obviously, Whistler was borrowing these titles from musical terminology. It had been common practice amongst musicians for some hundreds of years to give their works formal titles, to number them, and, from the middle of the nineteenth century onwards, to classify them by indicating the key.[10] This seems to mark the growing formal concern in music at that time: from the middle of the century *absolute Musik* was contrasted to *Programmusik*, music that wanted to translate a story or a feeling programmatically into music.[11] It had also been common, since the late sixteenth century, to refer to writers of music as 'composers' and to their productions as 'compositions'. By the eighteenth century, the word 'composition' was usually understood in both French and German as being related to music.[12] Jacques Lacombe for example defines the word in this sense in his *Dictionnaire portatif des Beaux-Arts* of 1752.[13] Diderot and d'Alembert's *Encyclopédie* discusses the

8. A. McLaren Young, M. F. MacDonald, R. Spencer, H. Miles, *The Paintings of James McNeill Whistler*, New Haven and London, 1980, no. 38. R. Dorment, M. F. MacDonald eds, *James McNeill Whistler*, exhib. cat. Tate Gallery, London, 1994, no. 14, pp. 76–8. During Whistler's lifetime this picture was never exhibited under this title. But since he later described pictures as *Symphony in White*, *No. 2* and *No. 3*, Whistler was presumably referring to the earlier picture in this way by 1867. Whistler believed that the titles of his paintings were of considerable importance. See *Whistler on Art. Selected Letters and Writings of James McNeill Whistler*, ed. and intr. N. Thorp, Glasgow, 1994, p. 12, doc. no. 6. In a letter to the *Athenaeum*, 1 July 1862, Whistler complains that his painting 'The White Girl' has been referred to incorrectly by a critic as 'The Woman in White'. Whistler objects to this title because he does not want his painting to be considered as an illustration to the 'sensation novel' by Wilkie Collins, published in 1860.

9. See *Whistler on Art* (n. 9 above), doc. no. 14, pp. 46–7, a letter to F. R. Leyland dated November 1872: 'You have no idea what an irritation it [the title *Nocturne*] proves to the Critics and consequent pleasure to me – besides it is really so charming and does so poetically say all I want to say and *no more than I wish!*'

10. Formal titles for instrumental music had been in use since the sixteenth century. In the seventeenth century, editors and composers began to distinguish individual pieces by means of opus numbers. It was only in the middle of the nineteenth century that it became common to describe a work by means of its key. Beethoven, for example, did not usually indicate the key in the titles of his pieces – Whistler was wrong about that (see below, p. ???) – but by the 1860's and 70's composers like Brahms normally did.

11. See A. Massow, 'Absolute Musik', in *Terminologie der Musik im 20. Jahrhundert*, ed. H. H. Eggebrecht, Stuttgart, 1995, pp. 13–29; L. Finscher, 'Instrumentalmusik. 5. Gattungen und Formen', in *Die Musik in Geschichte und Gegenwart. Allgemeine Enzyklopädie der Musik*, Sachteil IV, ed. L. Finscher, Basle and London 1996, pp. 894–911.

12. Though Goethe used the word regularly in his writings on art, *Composition* was considered a foreign word in German until the second half of the nineteenth century. In vol. II of J. and W. Grimm's *Deutsches Wörterbuch*, Leipzig, 1860, p. 633, only the verb *componieren* is mentioned in a very short entry. In French and English the verb 'to compose' was originally used in a very general way, and in both languages it could designate the process of literary writing. See *The Oxford English Dictionary*, second edn, III, 1989, pp. 621–2.

13. Lacombe, *Dictionnaire portatif des Beaux-Arts, ou abrégé de ce qui concerne l'Architecture, la Sculpture,*

term extensively in its application to music, and only then goes on to explain its meaning in painting, albeit that the entry is equally detailed.[14] The Swiss encyclopedist Johann Georg Sulzer tries to distinguish two different notions. He treats in his *Allgemeine Theorie der schönen Künste* of composition in architecture and painting under the heading *Anordnung*, a German version of the rhetorical term *dispositio*. But in his chapters on *Composition* and *Componist* he devotes all his attention to music.[15] Of course, there is no entry *Anordner*. Unlike *Anordnung* in painting, composing music is understood as an independent mental activity that can be distinguished from the musical performance of the *virtuoso*.

Although Whistler and Kandinsky gave their paintings titles alluding to the world of music, this does not imply that their images were, so to speak, visualizations of music or of musical impressions. The conceptual borrowings reveal instead a new understanding of the painter's task. The aim of painting is no longer to put representations of natural objects into some kind of order, so that the things or narratives depicted can be shown as clearly and gracefully as possible; rather, the task of the painter has been redefined in analogy to music: to impose order on the artistic elements themselves.[16] When Whistler publicly defended his musical titles in an interview, he adopted the old rhetorical figure of the *paragone*, the comparison of different genres of art, to emphasize that narrative was no longer the aim of painting:

> As music is the poetry of sound, so is painting the poetry of sight, and the subject-matter has nothing to do with harmony of sound or colour. The great musicians knew this. Beethoven and the rest wrote music – simply music: symphony in this key, concerto or sonata in that … This is pure music as distinguished from airs – commonplace and vulgar in themselves, but interesting from their associations, as, for instance, 'Yankee Doodle' or 'Partant pour la Syrie'. Art should be independent of all clap-trap – should stand alone, and appeal to the artistic sense of eye or ear, without confounding this with emotions entirely foreign to it, as

la Peinture, la Gravure, la Poesie & la Musique, Lyon, 1752, p. 170: 'Composition: Terme de musique. C'est l'art d'inventer de beaux chants, de mélanger plusieurs sons ensemble qui produisent un bon effet, & de donner à chacun de ces sons une progression convenable; il faut pour cela connoître le rapport que tous les intervalles & tous les accords ont entr'eux, & sçavoir mettre en pratique tout ce qui peut servir à rendre une Musique parfaite.'

14. *Encyclopédie ou dictionnaire raisonné des sciences, des arts et des métiers*, ed. by D. Diderot and J. Le Rond d'Alembert, Paris, III, 1753, pp. 772–4: 'Composition en peinture'. See also the entry 'Compositeur', p. 769: 'quoique composition se dise dans tous les arts liberaux, compositeur ne se dit guère qu'en *Musique* & en Imprimerie.' [Italics in the original.]

15. J. G. Sulzer, *Allgemeine Theorie der schönen Künste …* , erster Theil, Leipzig, 1792, (= second ed.), 'Anordnung (schöne Künste)', pp. 150–71. See also I. Jeitteles, *Aesthetisches Lexikon. Ein philosophisches Handbuch zur Theorie des Schönen*, Vienna, 1835–7, who discusses 'Composition (Aesthetik, vom Lat.)' in vol. I, pp. 156–8. He defines the term first in painting, but then states that it is used first and foremost in music (p. 156).

16. The history of this idea is discussed by K. Schawelka, *Quasi una musica. Untersuchungen zum Ideal des Musikalischen in der Malerei ab 1800*, Mittenwald, 1993; for Kandinsky, see pp. 270–89.

devotion, pity, love, patriotism, and the like.[17]

Kandinsky too compared painting and music with a similar intention, namely to explain the idea of 'pure painterly composition'. But, in doing this, he stressed the importance of expressing 'inner contents', and he pointed out that, just like music, painting could touch the soul directly.[18] This shift in emphasis shows the difference between the 'modernist' Kandinsky, with his sense of mission to set the world to rights, and the 'aestheticist' Whistler, whose art, at the beginning of the twentieth century, was already being written off by some people (for example the symbolist painter Maurice Denis) as 'decadent'.[19] Despite these fundamental differences, the two painters share basically the same notion of 'composition', insofar as they understand a painting in the first place as an arrangement of colour and form.

The main topic of this theory of 'pure' painterly composition is – as it is in musical theory – the notion of harmony.[20] Harmony had been associated with music since antiquity, and musical examples had usually been cited when authors wanted to exemplify it. In the eighteenth century it began to be discussed in colour theory, though the connection to musical theory served to describe the nature of harmonious relation.[21] Now, in the last quarter of the nineteenth century, harmony is understood as a counterpart to – indeed as the essential component of – pictorial composition. As it had been possible to develop a scientific theory of musical harmony, Kandinsky believed it would be possible to invent a similar theory of painting. Goethe had already observed (as Kandinsky points out) that painting too had its 'figured bass'.[22] In another passage Kandinsky speaks of a 'purely graphic "counterpoint"' – this, too, an expression borrowed from musical theory – but also of a 'grammar of painting' (*Malgrammatik*).[23] Yet the underlying interest is the

17. Part of an interview, 'Mr Whistler at Cheyne Walk', *The World*, 22 May, 1878, *Whistler on Art* (n. 9 above), doc. no. 18, p. 52.

18. Kandinsky, *Spiritual* (n. 4 above), p. 161: id., *Geistige* (n. 4), p. 66.

19. M. Denis, 'De Gauguin, de Whistler et de l'excès des théories', in: *L'Ermitage*, 15, novembre 1905, reprinted in *Théories 1890–1910. Du symbolisme et de Gauguin vers un nouvel ordre classique*, Paris, fourth ed., 1920 (first ed. 1913), pp. 199–210, on Whistler, pp. 200–201.

20. There are different interpretations, though, e.g. in Delacroix, Cézanne, Seurat, Signac, Matisse, Hölzel and Kandinsky. Kandinsky's notion of harmony, expressed in immediate connection with his definition of composition, emphasizes the contrasts and oppositions rather than stressing the necessity of bringing them into line: 'opposites and contradictions, this is our harmony'. Kandinsky, *Spiritual* (n. 4 above), p. 193: id., *Geistige* (n. 4), p. 109. It is a variation on the traditional meaning of harmony as the *coincidentia oppositorum*; but the aim is no longer to show the harmonious 'sound' of two matching opposites – as for example in Whistler's harmonies of colour – but to show their dissonance.

21. See Sulzer, *Allgemeine Theorie der schönen Künste* (n. 15 above), II, pp. 470–83: 'Harmonie (Musik)', and 'Harmonie (Mahlerey)'.

22. Kandinsky, *Spiritual* (n. 4 above), pp. 162, 176, 196: id., *Geistige* (n. 4 above), pp. 66, 85, 114. The editors of the English edition have traced the Goethe passage. It is from a conversation with Riemer, 19 May 1807, *Goethe im Gespräch*, ed. Deibel, Gundelfinger, Leipzig, 1907, p. 94. 'Malerischer Generalbass' is translated by Vergo and Lindsay as 'set procedures of pictorial harmonisation'.

23. Kandinsky, *Spiritual* (n. 4 above), p. 176: id., *Geistige* (n. 4), p. 85.

same, since 'music too has its own grammar':[24] Kandinsky is searching for a scientific theory of painterly composition.

II

It was 'scientific method' – understood in the nineteenth-century sense – that played the crucial part in the redefinition of the aims of painting. It became effective first and foremost in the formal analysis of the possibilities of visual design, carried out in the main by representatives of a newly emerging historical 'science of art' or *Kunstwissenschaft*.[25]

We can find signs of the new approach for example in the work of John Ruskin, especially in his attempt to describe analytically the artistic form of historical as well as contemporary works of art. In the second volume of his *Stones of Venice* (1853), he defines the art of composition as an independent, abstract task, and this is explained with reference to music: 'We are to remember, in the first place, that the arrangement of colours and lines is an art analogous to the composition of music, and entirely independent of the representation of facts.' In a footnote he remarks that the word composition was often 'misused in the general parlance respecting art.' He ends by giving quite an open definition, but he already stresses the rational, constructive and even – he uses the word – scientific aspects:

> Painters compose in colour, compose in thought, compose in form, and compose in effect; the word being of use merely in order to express a scientific, disciplined, and inventive arrangement of any of these, instead of a merely natural or accidental one.

If, in Ruskin's opinion, 'the noblest art' lies in 'the exact unison of the abstract value, with the imitative power, of forms and colours', he acknowledges that pure form has some kind of expressive power and that regardless of its representative function, it shows the particular creative power of an artist. He even admits with regret that very often only one or the other is required: 'Facts are often wanted without art, as in a geological diagram; and art often without fact, as in a Turkey carpet'.[26] Interestingly enough, his main example for abstract art is an oriental

24. Kandinsky, *Spiritual* (n. 4 above), p. 197: id., *Geistige* (n. 4), p. 114.

25. I use 'science of art' (*Kunstwissenschaft*) as a generic term which incorporates the work of the art historian (*Kunstgeschichte*), as well as contemporary art theory (*Kunstlehre*), which was published in the form of books of considerable length, and written more and more by specialists who were not necessarily artists. *Kunstwissenschaft* would exclude most of the journalistic art criticism (*Kunstkritik*) which, of course, made use of the former, but worked in a different way. For a further discussion of some of the topics developed below see now my book *Kunstgeschichte als historische Theorie der Kunst 1750–1950*, Munich, 2000.

26. *The Stones of Venice*, II (1853), in: *The Works of John Ruskin*, eds E. T. Cook, A. Wedderburn, Library edition, London, 1903–1912, X, pp. 215–217, paras 42–44. This passage is referred to by W. Hofmann, *Grundlagen der modernen Kunst. Eine Einführung in ihre symbolischen Formen*, Stuttgart, 1966, pp. 166–7. It must be stressed that Ruskin was not a supporter of 'art without facts'. The passage seems to be inspired by a disagreement between Ruskin and the representatives of the 'Department of Practical

carpet, which – as we shall see – was to become a topos.

Some years later, Ruskin gave a systematic introduction to the notion of composition in his *Elements of Drawing* (1857), which was both a course for amateurs, and a theory of art.[27] It proceeds from the simplest task, the holding of the pen, to more complex issues. The formal laws of composition are dealt with thoroughly in the third part, with examples drawn mainly from landscape painting (Fig. 4).[28] Though Ruskin assumes, even here, an art closely tied to the imitation of nature, the treatise ends with a list of nine formal principles that have nothing to do with representation: *principality, repetition, continuity, curvature, radiation, contrast, interchange, consistency* and *harmony*. A tenth law – and not the least important, *symmetry* – is hidden in the entry on *repetition*. These laws are intended to define what Ruskin had earlier called 'art without facts', the ornamental structure of a picture.

Ruskin's scientific approach may have been influenced by the empiricist philosophy of the late eighteenth and early nineteenth centuries. It was from this context that William Robson's *Grammigraphia; or the Grammar of Drawing* (1799) emerged. Without taking into account works of art at all, the treatise develops a science of drawing which has the philosophical intention of leading the reader to a better understanding of the difference between reality and appearance, and to render 'visual observation more correct and interesting'.[29] The new science should

Art', Richard Redgrave and Henry Cole. See para. 48, p. 220: 'The third form of error is when the men of facts envy design; that is to say, when, having only imitative powers, they refuse to employ those powers upon the visible world around them; but, having been taught that composition is the end of art, strive to obtain the inventive powers which nature has denied them, study nothing but the works of reputed designers, and perish in a fungous growth of plagiarism and laws of art.' See also Ruskin's *The Two Paths. Being Lectures on Art and its Application to Decoration and Manufacture* (1859), in *Works*, XVI. In vol. V of his *Modern painters* (1860) Ruskin again elaborates on the two sides of the process of composition. In parts VIII and IX (*Of ideas of relation*) he distinguishes 'invention formal' and 'invention spiritual' respectively (*Works*, VII, part VIII, pp. 201–50; part IX, pp. 251–464. See also W. Kemp, *The Desire of My Eyes. The Life and Work of John Ruskin*, London, 1991, chapter 4, pp. 205–66.

27. J. Ruskin, *Elements of Drawing in Three Letters to Beginners*, (1857), in *Works* (n. 26 above), XV, 1–228; Third letter, 'On colour and composition', on composition pp. 161–211, paras 188–246. Ruskin's theory of education through drawing is expounded lucidly in the preface, pp. 9–19. It has been discussed by W. Kemp, *'Einen wahrhaft bildenden Zeichenunterricht überall einzuführen'. Zeichnen und Zeichnen der Laien 1500–1870. Ein Handbuch*, Frankfurt am Main, 1979, pp. 169–74, 314 ff., and Kemp (n. 26 above), pp. 244–58.

28. Ruskin refers in the treatise to several paintings, and especially recommends the study of Turner's *Liber Studiorum*, but in explaining the laws of composition he returns each time to one central example, a watercolour by Turner of *The Mosel Bridge at Coblenz* (see Fig. 4). It was owned by Ruskin, but is now untraced (A. Wilton, *The Life and Work of J. M. W. Turner*, London, 1979, no. 1530). There is a sample study of the subject in the Turner Bequest (TB CCCLXIV, 1841–2), inscribed on the verso 'J. Ruskin, Junr, Esq'. See C. Powell, *Turner in Germany*, exhib. cat., Tate Gallery, London, 1995, no. 123, pp. 193–4.

29. W. Robson, *Grammigraphia; or the Grammar of Drawing. A System of Appearance which by Easy Rules Communicates its Principles, and Shews, how it is to be Presented by Lines*, London, 1799. Robson is especially concerned with the problem of the difference between the 'real figure in nature' and its 'appearance'.

help 'to understand and express what is constantly seen' (p. 148); and it is in this respect a precursor of the theory of Ruskin, who also thought the most important aspect of his drawing course was that it taught people to see.[30] Robson discusses mainly the problem of optical distortion through distance, but the treatise also contains some remarks on the expressive power of lines, and at the end he gives a list of ten laws of composition (pp. 141–2). This somewhat eccentric booklet – it contains for example a fold-out model so the reader can reconstruct a series of experimental situations – does not stand alone. In these decades the field of visual signs and optical phenomena began to be explored in a new kind of scientific research.[31]

A contribution that had a huge impact on nineteenth century art theory was the book by the chemist Michel-Eugène Chevreul *Les Lois du contraste simultané des couleurs etc.*.[32] Published for the first time in 1839 it became widely known almost immediately. In 1840 the first German translation appeared, and in 1854 the first English edition under the suggestive title *The Principles of Harmony and Contrasts of Colours, and their Application to the Arts*.[33] Chevreul, director of the dyeing department of the state-owned Manufacture des Gobelins, was interested first and foremost in problems of colouring which occurred in connection with the production of tapestries. However, he considered his findings relevant for all the fields of art. Towards the end of his book, we find a passage concerning the 'principles common to different arts which address the eye by various coloured and colourless materials', where he lists ten purely formal, general laws. Chevreul distinguishes the laws of *volume, form, stability, colour, variety, symmetry, repetition, general harmony, fitness of the object for its destination*, and, finally, the *principle of distinct view*.[34] We can assume that Ruskin knew this treatise. It had received a great deal of attention since the Great Exhibition of 1851.[35] The rigorous approach of the

30. See the preface of *Elements of Drawing* (n. 27 above), p. 13: 'I believe that the sight is a more important thing than the drawing.'

31. Associationist philosophers were trying to formulate the precise laws which regulate the process of association. Some of these philosophers were interested in the concrete relations between visual signs and resultant associations in the mind. Such theories were of considerable importance to Charles Blanc (see below), who also formulated 'laws of composition'. See B. Stafford, *Symbol and Myth. Humbert de Superville's Essay on Absolute Signs in Art*, Cranbury (N.J.) and London, 1979, pp. 49–51.

32. M. E. Chevreul, *De la loi du contraste simultané des couleurs et de l'assortiment des objets colorés, considérés d'après cette loi dans ses rapports avec la peinture, les tapisseries des gobelins, les tapisseries de Beauvais pour meubles, les tapis, la mosaïque, les vitraux colorés, l'impression des étoffes, l'imprimerie, l'enluminure, la décoration des édifices, l'habillement et l'horticulture*, Paris, 1839.

33. M. E. Chevreul, *The Principles of Harmony and Contrasts of Colours, and Their Application to the Arts*, trans. C. Martel, London, 1854. I quote from the reprinted edition with introduction and notes by F. Birren, New York, Amsterdam and London, 1967.

34. Ibid., pp. 221–2.

35. *The Industry of All Nations: The Art Journal Illustrated Catalogue*, London, 1851, contains an essay by Mrs. Merrifield on 'The Harmony of Colours', in which Chevreul's treatise is mentioned as the basic study of the subject. The translation by C. Martel was published in 1854, and reprinted in 1855 (twice) and 1859. In London in 1857 another translation, by J. Spanton, was published, with the more accurate

professor of chemistry was considered a perfect example of scientific method.[36] In general chemistry was understood as a model of analytical and exact science. Ruskin himself had compared his analytical method of describing a style of the past with chemical analysis in his chapter 'The nature of Gothic' in the second volume of *The Stones of Venice* – a metaphor that would be used again by Kandinsky and Paul Klee.[37] Thus, it is probably not by chance that Ruskin's laws of composition in many respects remind one of Chevreul's *Principles*. However, the most important difference lies in the fact that Ruskin does not simply assert his laws – Chevreul never revealed the reasoning which led to his laws of vision – but explains them to the reader by analysing historical and contemporary examples. Composition could not, Ruskin felt, be taught by rules; but he believed that good composers observe laws, and that by analysing their productions one can be helped to see the qualities of a work of art, and thus to understand it: 'by tracing them [the laws of composition] in the work of good composers, you may better understand their grasp of imagination.'[38]

Ruskin was not alone in his effort to trace the elementary principles of artistic composition. From the end of the 1830's onward, William Dyce, Henry Cole, Richard Redgrave, Ralph Nicholson Wornum and others strove for a reform of the applied arts by implementing new methods of teaching at the state-run Schools of Design.[39] The design of ornament was the main focus from the outset. Ornament was understood as the added artistic value which transformed a useful object into a work of art. This terminological separation of the object itself and its artistic envelope mirrors the industrial manufacturing process. The design of ornament became an independent activity, and developed its own theory. Students of design should no longer just practice their future trade by copying older models; rather, by joining formal analysis with systematic historical study they should learn the principles of good design. It was the restricted nature of pure ornament that made

title *The Laws of Contrast of Colour*; this was reprinted four times, in 1859, 1860, 1869 and 1883. A new French edition was published only in 1889.

36. Chevreul, *The Principles of Harmony* (n. 33 above), p. 50: 'Thus this work is really the fruit of the method *a posteriori*: facts are observed, defined, described, then they become generalised in a simple expression which has all the characters of a law of nature. This law, once demonstrated, becomes an *a priori* means of assorting coloured objects so as to obtain the best possible effect from them, according to the taste of the person who combines them...'

37. J. Ruskin, *The Stones of Venice*, II, in *Works* (n. 26 above), X, pp. 182–4. The metaphor of the chemical analysis is used by Kandinsky in his early essay 'Über Kunstverstehen' (*Der Sturm*, 1912), in *Writings*, (n. 4 above) pp. 286–90; and by Paul Klee in his *Beiträge zur bildnerischen Formlehre* (*Contribution to the teaching of design*), 1921/22; see the facsimile edition by J. Glaesemer, Basel and Stuttgart, 1979, pp. 1–2.

38. *Elements of Drawing*, (n. 27 above), para. 192, p. 164.

39. On the history of the Schools of Design see Q. Bell, *The Schools of Design*, London, 1963, and, as a shorter but in some ways less satisfactory study, S. Macdonald, *The History and Philosophy of Art Education*, London, 1970. Macdonald downplays the potential of the genuinely scientific approach of the art teachers in mid-century.

this synthesis possible: divorced from the object it embellished, ornament could be analysed in an abstract manner, and it was then relatively easy to make comparative studies of ornament over long timescales – not least because ornament from all periods of civilisation has survived.[40]

In 1842, William Dyce stressed in his introduction to the *Drawing Book of the School of Design* that the prospective designer should study the ornaments of the past in order to learn those principles that had been discovered in earlier times.[41] By copying the simplest geometrical shapes first, and progressing from there to the tracing of ever more complex combinations, the students were supposed to exercise their faculty of perception. This would enable them later to perceive underlying geometrical structures in the natural world, as well as in ornament. And, finally, they should be able to apply those principles in ornamental compositions of their own. In Dyce's *Drawing-Book* we mostly find material for the teaching of the first steps, from the simple line to the more complex, composed ornamental structure. These are followed by outline drawings of plants which, in the following plates, are shown combined as ornaments in some classical friezes. In the last part, dedicated to drawing 'from the round', Dyce added a few historical examples, but these too are classical ornaments only.

It seems that the Great Exhibition provided a great stimulus to the historical study of ornament. The first 'scientific' books on the history of ornament were

40. This combination of formalist *and* historical approaches has, in my opinion, not been taken sufficiently into account in art historical research. The study of Victorian design started more or less with N. Pevsner's *Pioneers of the Modern Movement from William Morris to Walter Gropius*, London, 1936, rev. ed. 1960. This study fixed the approach for much of the later research. The best introduction to the theories is still A. Bøe, *From Gothic Revival to Functional Form. A Study in Victorian Theories of Design*, Oslo, 1957. See also the books by Bell and Macdonald (n. 39 above) and the useful thesis by A. Schlieker, *Theoretische Grundlagen der 'Arts and Crafts'-Bewegung. Untersuchungen zu den Schriften von A. W. N. Pugin, J. Ruskin, W. Morris, C. Dresser, W. R. Lethaby und C. R. Ashbee*, Ph.D. diss., Universität Bonn, 1986; and *Von Morris bis Mackintosh. Reformbewegung zwischen Kunstgewerbe und Sozialutopie*, ed. G. Breuer, exhib. cat. Mathildenhöhe, Darmstadt, 1994, which includes a bibliography. For an illustrated history of the theories of ornament see S. Durant, *Ornament. A Survey of Decoration since 1830*, London, 1986.

41. William Dyce's introduction to the 'Drawing Book of the Government School of Design', was first published in 1842–43 and later republished as *The Introduction to the Drawing Book of the School of Design, published in the Years 1842–3*, London, 1854, the edition from which I quote, p. xii: 'In the first place, the beauties of form or of colour abstracted from nature by the ornamentist, from the very circumstances that they are abstractions, assume, in relation to the whole process of the art, the character of principles or facts that tend by accumulation to bring it to perfection. On this account the *inductive* method (if the term may be allowed in an artistical sense), though altogether inapplicable to fine art (every work of which is isolated and identified both with the object represented and the individual artist), becomes a necessary element in ornamental design. The accumulated labours of each successive race of ornamentists are so many discoveries made – so many facts to be learned, treasured up, applied to a new use, submitted to the process of artistic generalisation, or added to.' Macdonald (n. 39 above), pp. 118–24, comments on Dyce's methods in a rather negative way. His rigid system of 'ornamental design [as] a kind of practical science' (a quote from the *Journal of Design and Manufacture*, March–August 1849, I, p. 65) was probably not very popular among some artists. Yet its impact on art education was huge.

Ralph Nicholson Wornum's *Analysis of Ornament*[42] and Owen Jones's *Grammar of Ornament*,[43] both of which were published in 1856, and which expressed the convictions of the design reformers around Henry Cole. Wornum's treatise combines in an exemplary way analytical theory and historical research. In the first chapter, he discusses some basic notions of ornamental theory, while the second and larger part deals chronologically with the ornamental styles of Egypt, Greece, the Middle Ages etc. up to the style 'Louis Quatorze'. It is crucial, as the author states himself, that he is concerned with theory, with science and not with the application of ornament:

> We should, therefore, ... study ornament, for its own sake, theoretically and scientifically, and not in that limited narrow sense which would restrict it in one place as applied to cotton, in another to iron, and in a third as to clay, and so on.[44]

Jones's *Grammar* is not really a rival to Wornum's treatise; rather, they complement each other. The *Grammar of Ornament* is indebted to a number of earlier publications, such as illustrated pattern books and collections of ornamental engravings,[45] but it is the first work to achieve a systematic and encyclopaedic overview of the subject.[46] In the introduction there are thirty-seven universal laws of design ('propositions') which sketch the outline of a general theory of ornament. Twenty chapters, partly written by specialists, explain the one hundred chromolithographic plates (later editions contain 112). These show the ornaments of different times and places, arranged in a similar way and divorced from their original contexts, so that styles from all over the world could be compared. The formal characteristics and the structural similarities of the various styles are thus easily perceived (Fig. 5).

So far as I am aware, Jones was the first person to use the word 'Grammar' in the

42. R. N. Wornum, *Analysis of Ornament. The Characteristics of Styles. An Introduction to the Study of the History of Ornamental Art*, London, 1856, (I quote from the second edn, 1860).

43. O. Jones, *The Grammar of Ornament, Illustrated by Examples from Various Styles of Ornament*, London, 1856. See now the thesis by Shai-Shu Tzeng, *Imitation und Originalität des Ornamentdesigns. Studien zur Entwicklung der kunstgewerblichen Musterbücher von 1750 bis 1900 in Frankreich, Deutschland und besonders England*, Ph.D. diss., Munich, 1994, with a useful study of the theories of Jones, pp. 140–70.

44. Jones, ibid. pp. 6–7.

45. E.g. Charles Ernest Clerget and 'Martel', *Encyclopédie universelle d'ornements grecs, romains, égyptiens, arabes et mauresques, chinois, japonais, persans, turcs, indiens, gothiques, moyen-âge, rocailles, nieilles, renaissance et modernes, depuis les gaulois jusqu'au 19e siècle*, Paris, [1840?]. This title promises much more than the publishers actually delivered in ten instalments. There is no systematic partition and no commentary at all. Most periods or styles mentioned in the title do not occur in the plates. In the first five instalments almost half of the plates (coloured engravings) are taken from the Alhambra, Granada.

46. In his *Introduction* (n. 41 above) Dyce seems to say that he hoped the second part of his *Drawing Book* would act as a handbook of this kind, pp. v–vi: 'The work will, accordingly, be divided into two principal parts; one having reference to the study of design, the other to its application to industry. The former will contain a series of progressive lessons in drawing, so far as the art may be taught, by means of copies on paper; and the latter, a collection of designs, which it is hoped will form *a complete book of reference for examples of all the various modes and styles of ornamental art*.' [My italics]

title of a book on ornament. This title shows his particular theoretical ambition.[47] Jones believed universal structural laws could be found even in those forms of art which had nothing to do with representation or narrative: and he seems also to have felt that these laws might represent the fundamental principles of the fine arts – he sees a continuous line from the tattoos of 'savage tribes' via the decoration of the 'rude tent or wigwam' to the 'sublime works of a Phidias and a Praxiteles'. We find in the 'propositions', among others, the laws of *radiation*, *continuity*, *contrast*, and, of course, *harmony*, all of which we have met in Ruskin's theory of drawing. Thus, Jones does not think of ornament as playing a subsidiary role in the visual arts, just taking its cue from the star players. Rather, he believes that the history of ornament reflects the history of art as a whole – and may give ideas for future artistic developments.

In the middle of the nineteenth century there was a widespread feeling that art had lost its way, and Jones, Wornum, and others looked to history for new inspiration. Not that they felt inspiration could be drawn from the individual works of the past, since each age had to find its own artistic expression. As Jones put it: 'The principles discoverable in the works of the past belong to us; not so the results. It is taking the end for the means.' By studying history and by comparing the old with the new, he hoped to uncover the common principles of aesthetics, which would remain binding in future eras. It would no longer be a case of imitating old models, so much as of building on earlier history.

This discussion of ornamental art in England had a considerable impact on the continent. Some important ideas were mediated by the architect Gottfried Semper to the German-speaking public. At the time of the 'Great Exhibition' Semper had been staying in London, where he met Jones and Cole and had the opportunity to teach at the School of Design.[48] In his most important theoretical work, *Style in the Technical and Tectonic Arts*, which in the subtitle is called a 'practical aesthetic', he wanted 'to trace the conformity to laws and the order which occur in the origin and the process of development of phenomena of art' and 'to derive from these findings general principles, the essential features of an empirical art theory'.[49] He was explicitly attempting to describe the history of art by emulating the scientific

47. It seems that the term 'grammar' was used with reference to the visual arts for the first time by William Robson in his *Grammigraphia. Or the Grammar of Drawing* (n. 29 above). It was also used by George Field in his well known book *Rudiments of the Painter's Art. Or, a Grammar of Colouring, Applicable to Operative Painting, Decorative Architecture, and the Arts*, London, 1850; Wornum uses it in his *Analysis* (n. 42 above), p. 14.

48. See the biography by H. F. Mallgrave, *Gottfried Semper. Architect of the Nineteenth Century*, New Haven and London, 1996. On Semper's reception of the English discussion of ornament see M. Olin, 'Self-Representation: Resemblance and Convention in Two Nineteenth-Century Theories of Architecture and the Decorative Arts', *Zeitschrift für Kunstgeschichte*, 49, 1986, pp. 376–97 (377–86).

49. Gottfried Semper, *Der Stil in den technischen und tektonischen Künsten oder Praktische Ästhetik. Ein Handbuch für Techniker, Künstler und Kunstfreunde*, 2 vols, Frankfurt am Main, 1860–62, I, p. vi.

approach of the 'exact sciences'[50] – and he did so by writing a history of decorative or ornamental art. At the same time he strove to integrate philosophical aesthetics into his theory. In the 'prolegomena' the treatise gives a list of some 'basic notions of Aesthetics' (*Grundbegriffe der Ästhetik*), set up 'a priori', which can be understood as laws of composition: *regularity*, *symmetry*, *proportion* and *direction*.

In France the English ideas were developed further by Léon de Laborde and Charles Blanc. After the Great Exhibition the Comte de Laborde wrote a *rapport* of one thousand pages, published in 1856 under the title *De l'union des arts et de l'industrie*. In this he propagated a reform of art and industry through general art education.[51] It was for such a purpose, to educate a bourgeois public, that Charles Blanc wrote his *Grammaire historique des arts du dessin*, which was meant as a comprehensive scientific aesthetic theory, that could be read and understood by any cultured person.[52] He treats the three 'high' genres of art, architecture, sculpture and painting, but includes the art of gardening and the graphic arts. We may assume that Blanc knew Jones's *Grammar of Ornament* (from which he borrowed the title) and Chevreul's treatise on colours. Even though he treated all the arts more or less as equals, Blanc was undoubtedly best informed about painting, and it was this part of his book that reached the largest audience.[53] In his section on painting there is a chapter on composition, which Blanc calls *ordonnance*.

Blanc's theory is clearly based on the representation of the human figure, but – like Ruskin – he applies formal criteria as well. He defines painting as follows: 'Painting is the art of expressing all the conceptions of the soul, by means of all the realities of nature, represented upon a smooth surface by their forms and colours.'[54] Following Diderot, Blanc states that the main purpose of painting is to move the soul morally by representing actions. Nevertheless, his notion of composition is more abstract, and he refers to the purely formal arrangement of 'elements'.[55]

50. Ibid., I, p. viii.

51. L. de Laborde, *De l'union des arts et de l'industrie. Rapport sur les beaux-arts et sur les industries qui se rattachent aux beaux-arts*, Paris, 1856. Laborde represented France in the Jury of the Great Exhibition in 1851. On Laborde see Nikolaus Pevsner, *Academies of Art. Past and Present*, London, 1940, pp. 249–50. See also Kemp, (n. 27 above), pp. 165–9.

52. C. Blanc, *Grammaire des arts du dessin. Architecture, sculpture, peinture*. [Continued in smaller type] *Jardins – gravure en pierres fines – gravures en médaillons – gravure en taille douce – eau-forte – manière noire, aqua-tinte – gravure en bois – lithographie*, Paris, 1867. The title is slightly changed on p. 5, where it reads: 'Grammaire *historique* des Arts du dessin. Architecture, Sculpture, Peinture'. Before being edited as a book the *Grammar* was published as a series of articles in the *Gazette des beaux-arts* (of which Blanc was the general editor), 1860–1867, vols VI–XXI. On Blanc see M. Song, *Art Theories of Charles Blanc 1813–1882*, Ann Arbor, 1984. Blanc's concept of a general grammar of *all* the visual arts (see below) seems to be based on the ideas of the Comte de Laborde, *De l'union des arts et de l'industrie* (n. 51 above), who was convinced that 'L'art est un; il est la source de tous les progrès' (II, p. 1) and who did not accept the separation of 'ornamental art' – or, as he called it, 'art industriel' – from the fine arts.

53. The section on painting was translated by K. N. Doggett as *The Grammar of Painting and Engraving*, New York and Cambridge, 1874. In 1886 it was published separately in France as well.

54. Ibid. p. 1.

55. Blanc uses the French word *ordonnance*, translated here as 'arrangement', since he wishes to avoid

Taking as his starting-point the principle that the work of art forms an organic unity, Blanc acknowledges that the formal structure of this whole, which can be described as some kind of linear grid, has expressive power:

> Straight or curved, horizontal or vertical, parallel or divergent, all the lines have a secret relation to the sentiment. In the spectacles of the world as in the human figure, in painting as in architecture, the straight lines correspond to a sentiment of austerity and force, and give to a composition in which they are repeated a grave, imposing, rigid aspect. ... If it is necessary to represent a terrible idea, – for instance, that of the last judgement; if one wishes to recall the memory of a violent action, like the rape of the Sabines or Pyrrhus saved, such subjects demand lines vehement, impetuous, and moving.[56]

To achieve this aesthetic unity of a picture, painters of different epochs have employed different means. Blanc now makes use of a historical argument as he states that in the 'Gothic Age' painters only knew the law of strict symmetry. Eventually Giovanni Bellini and Raphael discovered another principle, which does not abandon symmetry but rather brings it to life – *equilibrium*, the dynamic balance of a composition. This notion, the historical evolution of which is described by Blanc, was already formulated in Ruskin's *Elements of Drawing* as 'balance of harmonious opposites',[57] and both Ruskin and Blanc explain it by using the analogy of the human figure.[58] *Equilibrium* as a condition of harmonious composition was destined to become one of the key terms in the theory of modern painting – especially in the writings of Paul Klee and Piet Mondrian.[59] Charles Blanc's

the more general notion of 'composition'. By 'arrangement' he means the processes of indicating the principal lines, of sketching the figures and their draperies, of representing their gestures, and of balancing the masses. This, Blanc continues, 'we also call composition; but this latter word, the significance of which is more extended, includes the invention of the painter and the economy of his picture, so that it is often used as a synonym for the picture itself. In its more restricted sense, the composition is only the arrangement, that is to say, the art of putting in *order* the elements of the picture, of disposing them, combining them, or, if one pleases, of distributing the rôles to the actors of the painter's *drama*, that is the *mise en scene*...': ibid., p. 34.

56. Ibid., p. 40. For much of his formalist theory Blanc is indebted to three authors: Humbert de Superville, *Essai sur les signes inconditionnels dans l'art*, Leiden, 1827–39; Joseph-Henri Bernardin de Saint-Pierre, *Etudes de la nature*, London, 1799, and for the quoted passage concerning the expressive force of lines to Archibald Alison, *Essays on the Nature and Principles of Taste*, London, 1790. See Stafford, *Symbol and Myth* (n. 31 above), pp. 180–81, and Song, *Art Theories of Charles Blanc* (n. 52 above), pp. 53–61. Blanc's merit lies in combining these philosophical approaches in a comprehensive aesthetic theory, and applying them directly to the visual arts.

57. Ruskin, *Works* (n. 26 above), XV, p. 170.

58. The notion is central to the concept of harmony. Blanc does not explain this in the chapter on *ordonnance*, but only in the introduction, which is entitled *Principes*. 'Ainsi le corps humain, offrant l'opposition dans la symmétrie et la diversité dans l'equilibre, réalise ce principe de l'antique initiation: "L'harmonie naît de l'analogie des contraires."': Blanc, *Grammaire des arts du dessin* (n. 52 above), p. 28.

59. This topic has been discussed in *Equilibre. Gleichgewicht, Äquivalenz und Harmonie in der Kunst des 20. Jahrhunderts*, ed. T. Bezzola, A. M. Müller, L. Müller, B. Wismer, Baden, 1993. See in particular the article by B. Wismer, 'Stationen zum Gleichgewicht', pp. 63–239. C. Blanc, *L'Art dans la parure et dans le vêtement*, Paris, 1875; English translation *Art in Ornament and Dress*, London, 1877. In 1882, the

Grammaire des arts du dessin must be considered as part of a more comprehensive project; to provide a general grammar of visual art. It was to be continued in the *Grammaire des arts décoratifs*, which remained unfinished at Blanc's death. In the introduction to the first part – published as *L'Art dans la parure et dans le vêtement*, – Blanc summarized the 'general laws of ornament'; and it is hardly surprising that the list of laws found here is quite similar to those given by Chevreul and Ruskin. A novelty, however, is his pairing of terms: primary principles are *repetition*, *alternation*, *symmetry*, *progression* and *confusion*; to be related to them are the secondary ones: *consonance*, *contrast*, *radiation*, *gradation* and *complication* (Fig. 6).[60] Like Ruskin's laws of composition, Blanc's principles – as usual, their number is ten[61] – can be interpreted as an attempt to describe the purely formal dimension of visual design in terms of law-governed relations. He obviously believes in the validity of these elementary laws for all forms of art, which can be inferred from the examples he uses to illustrate them: the greater part of them belongs in fact not to the decorative arts but to the 'high' arts: the most prominent and important one is – as in the chapter on composition in the *Grammaire des arts du dessin* – Raphael's *School of Athens*.[62]

English ideas of reforming the applied arts were also spread on the continent by the newly founded museums of decorative arts. One of the first was Vienna's *Österreichisches Museum für Kunst und Industrie*, founded in emulation of the South Kensington Museum (later the Victoria and Albert Museum) for the express purpose of promoting the visual arts by studying its past.[63] One of its employees was the art historian Alois Riegl, whose most important writings were on the subject of ornament. However, Riegl did not aim at improving current artistic practice at all; he saw himself as serving the purposes of pure science. But he was aware of ideas current in art theory. It is not by chance that his very first book deals with the subject of the oriental carpet – the one example that had been picked by Ruskin as

year of Blanc's death, the second part was published under the title *Grammaire des arts décoratif*. The subtitle *Décoration interne de la maison* makes clear the limits of the topic treated in this part. In the same year a second edition was printed which now included the introduction of part one on the *Lois générales de l'ornement*.

60. Blanc, ???(n. 59 above), pp. 1–48.

61. I have mentioned above that Ruskin lists only nine laws in the *Elements of Drawing* (n. 27 above). He hides the law of symmetry under the heading of repetition, supposedly because this was the favourite law of the people around Henry Cole to whose teaching by principles Ruskin was strongly opposed (see n. 26 above).

62. Further examples from the 'high arts': The view into the nave of a mediaeval church illustrates the principle of alternation; the principle of progression is exemplified by the Egyptian pyramids. A picturesque ruin, a round Japanese painting – probably a painted fan – and Raphael's *School of Athens* are examples of *confusion* (understood in a positive sense). Consonance of form is illustrated by Christopher Wren's St. Paul's Cathedral, consonance of colour by Titian's *Assunta* and Veronese's *Marriage at Cana*. Examples of the principle of contrast are the paintings of Rubens and Rembrandt, while radiation can be seen in the Pantheon in Rome, in St. Peter's, and in the Dôme des Invalides.

63. See B. Mundt, *Die deutschen Kunstgewerbemuseen im 19. Jahrhundert*, Munich, 1974, pp. 39–40.

the best illustration of 'art without facts'.[64]

In many respects Riegl was indebted to the initiators of the English reform of the applied arts, and in some ways he continued their work on a different level. Owen Jones's *Grammar of Ornament* is one of the few books he mentions in his seminal work *Problems of Style. Foundations for a History of Ornament* (1893).[65] Seeing himself as a 'positivist' art historian, Riegl worked also on a book entitled *A Historical Grammar of the Visual Arts*, which was only published after his death in incomplete form.[66] If the title seems to have been borrowed from Charles Blanc, Riegl was surely influenced more by Semper, whose theories were inspired by his English experience. In his most ambitious book, *The Late Roman Art Industry* (1901),[67] Riegl strongly opposed Semper's ideas, but in fact it was the latter's work that first gave Riegl the idea of writing a universal history of art, conceived as a description of the way basic formal principles of design change over time. Riegl was convinced that he would find the same laws of formal construction in ornament as in the other genres of art. Taking his point of departure in the analysis of ornament, he aimed at uncovering the common factor of form in the works of a given period, by analysing art with the simplest concepts he could construct, reducing his tools basically to the dialectical terms 'haptical' and 'optical', which might be applied to works of any type. This simple conceptual analysis of single works, series of works and entire historical processes must surely be seen in the context of the then lively discussion of basic notions of art in German art history.[68] But Riegl's approach is

64. A. Riegl, *Altorientalische Teppiche*, Leipzig, 1891 (reprinted with a bibliographical introduction by U. Besch, Mittenwald, 1979). In the preface of this book Riegl refers to the work of the English reformers, a fact noted by M. Iversen, *Alois Riegl. Art History and Theory*, London and Cambridge MA, 1993, pp. 37–8. See also M. Olin, *Forms of Representation in Alois Riegl's Theory of Art*, University Park, PA, 1992, pp. 55–9.

65. A. Riegl, *Stilfragen. Grundlegungen zu einer Geschichte der Ornamentik*, Berlin, 1893. This has now been translated by E. Kain: *Problems of Style. Foundations for a History of Ornament*, Princeton, 1993. Riegl shows an illustration of the acanthus taken from Jones on p. 214, fig. 112, of the German edition.

66. A. Riegl, *Historische Grammatik der bildenden Kunst*, ed. posthumously by K. M. Swoboda und O. Pächt, Graz, 1966. The term *Grammatik* is explained on p. 211: 'Man hat sich längst gewöhnt die Metapher von einer 'Kunstsprache' zu gebrauchen. Man sagt: jedes Kunstwerk redet seine bestimmte Kunstsprache, wenn auch die Elemente der bildenden Kunst natürlich andere sind als diejenigen der Sprache. Gibt es aber eine Kunstsprache, so gibt es auch eine historische Grammatik derselben, natürlich auch nur in metaphorischem Sinne;' [One has long become accustomed to the metaphor of a 'language of art'. One says: every work of art speaks in its own artistic language, even though, of course, the elements of the visual arts are different from those of language. If there is a language of art, then there is an historical grammar of the same, only in a metaphorical sense, of course.]

67. Originally published as 'Die spätrömische Kunstindustrie nach den Funden in Österreich-Ungarn im Zusammenhange mit der Gesamtentwicklung der bildenden Künste bei den Mittelmeervölkern dargestellt I. Teil', *Jahrbuch der kunsthistorischen Sammlungen des allerhöchsten Kaiserhauses* 22, 1901. Engl. ed. *Late Roman Art Industry*, transl. by R. Winkes, Rome, 1985. On Semper and Riegl see Olin (n. 64 above).

68. I have discussed the history of the 'Grundbegriffe' in my article 'Wissenschaftsgeschichte als Problem-geschichte. Die "kunstgeschichtlichen Grundbegriffe" und die Bemühungen um eine "strenge Kunstwissenschaft"', in V. Peckhaus, C. Thiel (eds), *Disziplinen in Kontext. Perspektiven der Disziplingeschichtsschreibung*, Munich, 1999, pp. 129–61.

just as strongly influenced by the literature on ornament, which must have provoked him to consider form regardless of its representative qualities, or its application to any specific type of art.

In Heinrich Wölfflin's *Kunstgeschichtliche Grundbegriffe* (1915) Riegl's ideas were developed further.[69] In this book Wölfflin tried to establish an objective scientific description of the historical development of style, and he proposed a set of elementary and universal basic terms to be applied in the analysis of painting, sculpture, and architecture. These well known *Grundbegriffe* are, in fact, descriptions of formal principles of composition: *linear and picturesque, plane and depth, closed form and open form, multitude and unity, distinctness and indistinctness* – and here again, of course, we have ten terms.

In contrast to his law-making predecessors, Wölfflin did not claim that his principles were of timeless validity; but he characterizes the basic principles of design of one example by comparing it to a counterpart from a different time or place – a procedure which shows that there is always an alternative method of design. It also shows that to establish a historical discourse it is necessary to make comparisons: if at some times one principle dominates, it can only be defined by contrasting it with its opposite. There are parallels to Blanc's dialectical general laws of ornament, but Wölfflin believes that each period composes in its own way. At any rate, he continued to believe that the various eras were bound by the laws of their own time, and that it was possible to conceive of some kind of elementary grammar of visual art.

III

We now need to turn to the question of how these developments in the theoretical discourse were related to the production of art itself. In the texts I have just cited, the analyses of art tend strongly towards 'abstraction', in the sense that formal principles tend to be studied in isolation from subject matter and even from the genre or function of the particular work of art. It appears obvious that this way of looking at art in isolation, as a historical but basically formal phenomenon, may have a parallel in Whistler's 'art for art's sake', as well as in the increased sensitivity to questions of form amongst artists and art historians around the turn of the century.[70] These obvious parallels[71] did not occur by chance. It can be shown that

69. H. Wölfflin, *Kunstgeschichtliche Grundbegriffe. Das Problem der Stilentwicklung in der neueren Kunst*, Munich, 1915. Translated as *Principles of Art History. The Problem of the Development of Style in Later Art*, sixth edn, New York, 1995.

70. E.g. Ruskin's and Whistler's understanding of formal or 'abstract' composition and their notion of harmony was quite similar, though their opinions differed widely in other respects. They became bitter enemies in the well known legal controversy concerning Ruskin's critical remarks on Whistler's *Nocturne in Black and Gold: The Falling Rocket* (Detroit Institute of Arts, 1875, exhibited 1877). In 1878 Whistler published the pamphlet *Whistler vs. Ruskin: Art and Art Critics*, republished in his collection of letters and essays *The Gentle Art of Making Enemies*, London, 1890. See L. Merril, *A Pot of Paint.*

the two branches of art history and modern art theory grew from the same trunk, even though they diverged towards the end of the century. The way the arguments are developed seems to indicate that the theories of the historians form the counterpart to those of the artists.

The common denominator of all the authors I have mentioned is their commitment to a scientific approach, and it seems that all of them share a similar understanding of what 'scientific' would mean. They try to comprehend the field of visual design and even the realm of art in a rational and objective way, in accordance with the model given by the exact sciences. This meant, first of all, eliminating everything that might call into question the autonomy of visual art: for example, the necessity of representing a literary subject, and even the task of picturing nature. It was this scientific approach that led to the emphasis on the formal elements of art, on the finding of laws that would govern the artistic process of creating a new aesthetic organism. Art teachers, art historians and aestheticians – first in England and France, but by the last quarter of the nineteenth century mainly in Germany – began to explore the expressive power of pure form, of lines, planes, colours; and from the outset, the study of ornament played a central role.[72] Around the middle of the century the reformers of design education had established a method of analysis of ornament that made it possible to discuss form and colour regardless of content or symbolical function. They received impulses not only from the natural sciences – exemplified in the work of Chevreul – but also, increasingly, from art history: they tried to classify ornament according to the formal principles of particular epochs, and endeavoured to find out about the laws of historical evolution. Even Ruskin – who became a bitter enemy of the industrial designers – worked in the same direction, as he tried to reconcile the new analytical approach with his idea of art as primarily an imitation of nature. He demonstrated that the formal analytical approach could be applied to 'high art' as well as to ornament: in fact, he seems to have been the first person to have used the analysis of pure form in order to gain a better *understanding* of painting and architecture.

But the analytical study of ornament led also to a better understanding of this art, and especially to the discovery of its pictorial or expressive qualities. In other words, science changed the object it was analysing. Dyce had emphasized that ornamental art could have nothing to do with communicating ideas, which, on the other hand,

Aesthetics on Trial in Whistler vs. Ruskin, Washington DC, 1992.

71. They have long been recognized. See e. g. W. Hofmann, 'Studien zur Kunsttheorie des 20. Jahrhunderts', *Zeitschrift für Kunstgeschichte*, 18, 1955, pp. 136–56.

72. F. L. Kroll, *Das Ornament in der Kunsttheorie des 19. Jahrhunderts*, Hildesheim, 1987. D. Morgan, 'The Idea of Abstraction in German Theories of the Ornament from Kant to Kandinsky', *The Journal of Aesthetics and Art Criticism*, 50, 1992, pp. 231–42. Some aspects of the discovery of expression through the 'abstract' forms of ornament are also mentioned by E. H. Gombrich, *The Sense of Order. A Study in the Psychology of Decorative Art*, Oxford, 1979.

was the main task of painting.[73] Christopher Dresser, however, who in his earlier years had worked for Owen Jones and inherited many of his ideas, was one of the first artists ever to experiment with the creation of picture-like compositions out of more or less abstract ornamental elements. Dresser claimed that ornamental art was also able to express feelings and even complex thoughts (Fig. 7).[74] In the last decade of the century, such ideas found their way to France and Germany, and were developed further in the theories of *Art Nouveau*.[75] They were communicated to a large group of artists by artist-theoreticians such as Walter Crane, or art-historians like Julius Meier-Graefe, who also worked as an art critic. For several artists, among them Kandinsky, these theories gave the decisive impulse which finally led to the development of the concept of 'pure composition'.[76]

Very few art historians at the end of the century were involved in any way with contemporary artistic production. Nevertheless, in the writings of Alois Riegl, Heinrich Wölfflin and August Schmarsow,[77] the most important and popular art historians in the German-speaking countries at their time, the same tendencies are recognizable as in art theory: their interest lies in the *artistic* aspects of a work of art, and they sought to grasp it by formal analysis. Even if it is true that many art historians did not have much understanding of the avantgarde art of their own time,[78] the affinity of their interests to those of the artists was sufficient to enable contacts and inspirations. Moreover, artists often felt the need to use art historical terminology to express their own thoughts, and thus gave that terminology more importance then they might have liked.[79]

73. Dyce, *Drawing Book* (n. 41 above), p. viii: ' … the fine arts, as dealing with history, poetry, and generally with moral expression, occupy a field into which the ornamentist has no claim whatever to enter'.

74. See for instance his book *The Art of Decorative Design*, London, 1862, which contains a chapter on 'The Power of Ornament to Express Feelings and Ideas', pp. 165–77. On Dresser see W. Halen, *Christopher Dresser. A Pioneer of Modern Design*, London, 1990, and S. Durant, *Christopher Dresser*, London, 1993.

75. This has been emphasized by R. Schmutzler, 'The English Origins of Art Nouveau', *The Architectural Review*, February 1955, pp. 109–116. See also his book, *Art Nouveau*, London, 1964 [first German edn, Stuttgart, 1962].

76. For the reception of Crane in Munich and of the impact that ornamental theories had on Kandinsky see Weiss (n. 3 above), pp. 22–7, 107–17.

77. August Schmarsow (1853–1936), professor of art history at Leipzig, was in his time as influential as Riegl and Wölfflin. Schmarsow was the first to write a book on basic notions of art history: *Grundbegriffe der Kunstwissenschaft am Übergang vom Altertum zum Mittelalter*, Leipzig, Berlin, 1905. One of his favourite topics was the problem of composition, which he discussed e.g. in *Kompositionsgesetze in der Kunst des Mittelalters*, Leipzig and Berlin, 1915–22. See my article on the 'Grundbegriffe', (n. 68 above). Wölfflin seems to have been by far the most popular of the three among the general public.

78. As has been emphasized by G. Boehm, 'Die Krise der Repräsentation. Die Kunstgeschichte und die moderne Kunst', in: *Kategorien und Methoden der deutschen Kunstgeschichte 1900–1930*, ed. L. Dittmann, Stuttgart, 1983, pp. 113–28. Boehm's results have been criticised by K. Hoffmann, in the review of this book, *Kunstchronik*, 41, 1988, pp. 602–10.

79. See e.g. J. Metzinger and A. Gleizes, *Du 'cubisme'*, Paris, 1912. Cubism is defended in historical terms as the unavoidable result of the stylistic development of painting since Courbet. Similar

Contacts were liable to occur in two areas: first, in the quest to define the elementary means of artistic expression, and, secondly, in dealing with the problem of the 'decorative'. Both are closely related.

Some of what Kandinsky writes in his second art theoretical treatise, *Point and Line to Plane* (1922), sounds like a response to the work of historians from Owen Jones through Riegl to Wölfflin. He explicitly asks the new 'incipient science of art' to deliver a penetrating analysis of the whole history of art. On the one hand it should examine the elements of art, the methods of construction and composition employed at different times by different peoples. On the other, it should seek to determine the nature of growth in each of these three areas.[80] The aim of all this is to gain insights into the future of art by studying its history and development, and to give the artist the 'scientific' means to push ahead with the evolution of art; a notion in which Kandinsky believes as firmly as did Jones and Riegl.

Kandinsky may have been aware of the fact that the scholarly effort he called for had already begun. However, scholars and artists were finding it increasingly difficult to communicate, because of the attempts of art historians to introduce scientific rigour into their subject (*strenge Kunstwissenschaft*).[81] Academic art historians, especially in German-speaking countries, were trying to establish a discourse which would be independent of any influence from artistic practice, and in particular, from journalistic art criticism.[82] Here, too, it was the commitment to 'pure science' that required scholars to define their field as narrowly and specifically as possible. Art historians began to contrast their subject with the allegedly 'intuitive' practice of artists. Thus, Alois Riegl states in his *Historical Grammar of the Visual Arts* that an artist would not need a grammar of art, and neither would someone who only wanted to understand (Riegl's words are *'sachlich genießen'*) an art work. He continues:

> ... one does not need a historical grammar if one wants to understand why a
> language has developed in this and no other way, or what part it has played in the
> whole of human culture: if one wants, in a word, to *comprehend this particular*

arguments, using the categories of a formal history of style, are used in most of the modernist theoreticians: e.g. in their attempts to establish 'new' contemporary styles, or '*Kunstismen*'.

80. Kandinsky, *Writings*, (n. 4 above), p. 535. Id., *Punkt und Linie zu Fläche. Beitrag zur Analyse der malerischen Elemente*, seventh ed., Berne, 1973, p. 16.

81. Wölfflin himself hints at this problem of communication between artists and art historians in *Gedanken zur Kunstgeschichte. Gedrucktes und Ungedrucktes*, Basel, 1940, p. 1. See O. Bätschmann, 'Logos in der Geschichte. Erwin Panofskys Ikonologie', in: *Kategorien und Methoden* (n. 78 above), pp. 89–112, esp. pp. 101–4.

82. See H. Dilly, *Kunstgeschichte als Institution. Studien zur Geschichte einer Disziplin*, Frankfurt am Main, 1979. W. Beyrodt, 'Kunstgeschichte als Universitätsfach', in *Kunst und Kunsttheorie 1400–1900*, ed. P. Ganz, Wiesbaden, 1991, pp. 313–34. Some hints on the international aspects of this tendency are given by G. Kauffmann, *Die Entstehung der Kunstgeschichte im 19. Jahrhundert*, Opladen, 1993. See also Locher, *Kunstgeschichte als historische Theorie der Kunst* (n. 25 above).

language in a scientific manner.[83]

However, many artists in the first decades of the twentieth century, among them Kandinsky, were interested in precisely this: comprehending the language of art in a scientific way. Around the turn of the century, there were artists and teachers in art colleges, as well as historians, who practised the new 'science of art'. The best known example is probably the treatise by the sculptor Adolf Hildebrand, *The Problem of Form in Painting and Sculpture* (1893). This had an immense impact on Wölfflin and Riegl, a fact which neither denied.[84] Further examples are Adolf Hölzel's important article of 1901, called 'On Forms and the Arrangement of Mass in Painting',[85] and a book (which deserves more attention than it has received hitherto) by Hans Cornelius, professor at the School of Applied Arts in Munich. This was called *Elementary Rules of the Visual Arts. Fundamental Principles of Practical Aesthetics* and was published in 1908, and it shows that the boundaries between painting and the decorative arts had by then been suspended in the teaching of applied arts. Although Cornelius's treatise is now little known, it received a favourable review from Heinrich Wölfflin.[86] He recommended it strongly to his fellow art historians because, as he says, 'art history is now beginning to reflect on its own aesthetic preconceptions'.

There was some exchange of ideas between art history and the art schools, even though the encounters may have been scarce; and there was a similar interest in the understanding of genuinely artistic problems.[87] In any case, the artists occasionally

83. The italics are mine. Riegl, *Historische Grammatik* (n. 66 above), p. 211: 'Wer eine Sprache bloß sprechen will, bedarf der Grammatik nicht; und ebensowenig derjenige, der sie bloß verstehen will. Wer aber wissen will, warum eine Sprache diese und keine andere Entwicklung genommen hat, wer die Stellung einer Sprache innerhalb der Gesamtkultur der Menschheit begreifen will, wer mit einem Worte die betreffende Sprache wissenschaftlich erfassen will, der bedarf der historischen Grammatik.'

84. A. v. Hildebrand, *The Problem of Form in Painting and Sculpture*, transl. and rev. with the author's co-operation by M. Meyer and R. M. Ogden, New York, 1907. The German text, *Das Problem der Form in der bildenden Kunst*, appears in: A. v. Hildebrand, *Gesammelte Schriften zur Kunst*, ed. H. Bock, Cologne and Opladen, 1969, pp. 199–265. See my article on the 'Grundbegriffe' (n. 68 above).

85. A. Hölzel, 'Über Formen und Massenverteilung im Bilde', *Ver Sacrum*, IV, 1901, pp. 243–54. On Hölzel and Kandinsky see Weiss, *Kandinsky in Munich*, (n. 3 above), pp. 40–7. Weiss considers Hölzel as 'a prefiguration of Kandinsky', p. 41. In the article quoted Hölzel analyses the compositions of pictures by van der Goes, Botticelli und Rubens. See also his article 'Über künstlerische Ausdrucksmittel und deren Verhältnis zu Natur und Bild', *Die Kunst für Alle*, 1904, pp. 81–8, 106–13, 121–42, where, as Weiss, p. 43, remarks, he traces 'the history of art in terms of the primary artistic elements ... from Giotto to his own contemporaries'.

86. *Elementargesetze der bildenden Kunst. Grundlagen einer praktischen Ästhetik*, Leipzig, Berlin, 1908. Wölfflin's review was published in *Repertorium für Kunstwissenschaft*, 32, 1909, pp. 335–6. Another example is Czapek's book (n. 7 above) on *Grundprobleme der Malerei* (1908), which was reviewed by the art historian Wilhelm Worringer, *Kunst und Künstler*, VIII, January 1910, p. 236. Czapek's book seems to have been a main source for Kandinsky's *On the Spiritual in Art*.

87. Though it might be true that many art historians did not bother at all with modern art, some of them did. See Boehm, 'Die Krise der Repräsentation' (n. 78 above). The total ignorance of many art historians in matters of modern art in the first half of this century is partly due to an increasing specialization that started as soon as the subject was institutionalized at the universities. Contrary to what

did make use of the scientific research of the historians in order to work out their own science of artistic design. Thus, in France, the *Grammaire* of the art historian Charles Blanc seems to have been an important source for artists.[88] It is highly probable that it was Charles Blanc's treatise that made available the colour theory of Chevreul to Impressionists and Neoimpressionists.[89] Theo van Doesburg's pedagogical treatise *Grundbegriffe der neuen gestaltenden Kunst* ('Basic Concepts of the New Formal Art'), published in 1925 in the series of 'Bauhausbücher', was also inspired by art history.[90] It is probably no coincidence that this title is quite similar to the one Wölfflin used for his book of 1915. Like Wölfflin, Van Doesburg presents us with oppositions which are as elementary as possible, albeit that his intention is not to analyse art works from the past – although he uses older paintings as examples on occasion – so much as to benefit modern art with an analysis of form of the greatest possible objectivity: his aim is to explain his art in a 'scientific' way not only to art students but also to the public.

The fact that this task was now being claimed in a rather aggressive way by the artists themselves[91] is not to be taken as proof of a difference in approach between

is usually believed, most of the art historical curricula – as represented e.g. in the art historical handbooks – included contemporary art in so far as it could be considered as the continuation of earlier styles. See my article, 'Das Handbuch der Kunstgeschichte. Die Vermittlung kunsthistorischen Wissens als Anleitung zum ästhetischen Urteil', in *Memory and Oblivion. Proceedings of the XXIX International Congress of the History of Art, Amsterdam, 1.–7. September 1996*, ed. W. Reinink, and J. Stumpel, Dordrecht, 1999, pp. 69–87. The fact that many art historians could not approve of modern art is due to their being shocked by the way that some artists had broken with the traditional Western European understanding of art as representational. But if, at first, it seemed to be impossible to see a continuation of, say, Renaissance painting in impressionist and abstract art, it was precisely the formalistic approach of Riegl and Wölfflin that made it possible, as many later books show, to write the history of modern painting in the very manner of a Vasarian history of progress: the new aim of the evolution became abstract art.

88. See Song, *Art Theories of Charles Blanc* (n. 52 above), chapter 3; John Gage, *Colour and Culture: Practice and Meaning from Antiquity to Abstraction*, New Haven and London 1993, p. 205 (Van Gogh), p. 247 (Seurat).

89. Chevreul's book *The Principles of Harmony* (n. 33 above) was not easily accessible in France in the second half of the century until it was reprinted in 1889. See the basic study by W. I. Homer, *Seurat and the Science of Painting*, Cambridge, 1964. On the reception of Chevreul by the Impressionists see G. Roque, 'Chevreul and Impressionism. A Reappraisal', *The Art Bulletin*, 78, 1996, pp. 26–39.

90. T. van Doesburg, *Grundbegriffe der neuen gestaltenden Kunst*, (= Bauhausbücher 6), Munich, 1925. The treatise was first published in the journal *Het Tijdschrift voor Wijsbegeerte*, 1919, I, II.

91. Van Doesburg claims that it is the task of the artist himself to explain his works to the public and that he does not need any other mediator (*Grundbegriffe*, n. 90 above, p. 9). Similar remarks can be found in Kandinsky's writings, e.g. in *Über das Geistige* (n. 4 above) p. 26: ' "*Verstehen*" ist Heranbildung des Zuschauers auf den Standpunkt des Künstlers.' ('"Understanding" is a process in which the spectator learns to adopt the standpoint of the artist'. Cf. the slightly inexact translation in *On the Spiritual* (n. 4 above) p. 131.) 'Heranbildung' requires teaching – by the artist himself, Kandinsky believes. This can be inferred from Kandinsky's description (chapter III) of what art historians do as explaining to the public only art of the past, while avant-garde art has already progressed to new dimensions which are out of the reach of the *Kunstgelehrter* (translated as 'art historian' by Vergo and Lindsay, ibid., p. 141). Even worse off in Kandinsky's opinion is the *Kunstkenner* or Connoisseur, who thinks he is an expert, but is unable to feel the 'inner life' of a painting (ibid., p. 130). See also Kandinsky's essay 'Über Kunstverstehen' (n. 37 above), in which he claims that a good explanation of painting can help the

the artists and the professional interpreters of art – art historians and critics with art historical interests – but rather of a similarity in their aims and methods. Both claimed the scientific understanding and explanation of art as their own field of research, and both proceeded by formal analysis.

The second area in which artists and theoreticians were bound to come into contact was the problem of the 'decorative' in art. Much of the historical development here can only be understood by taking into account the discussion in the emerging science of art of the nineteenth century. The debate on ornament played a decisive part in the formation of the modern notion of a work of art and of composition. In the writings of Léon de Laborde, Charles Blanc, and, in particular, Alois Riegl, applied art and 'high art' were thought to be governed by the same laws, the same '*Kunstwollen*' of a certain period and people – and a similar theory had become common in art education by the 1890's. Decorative art was now considered a genuine genre of art in its own right, and the fact that it was highly appreciated began to undermine the hierarchy of the arts.

At the end of the day, the decoration of the everyday environment was considered by many artists to be the central task of modern art. In consequence, to many critics, easel painting seemed to have become obsolete. This was expressed in very clear terms by the art critic Gilbert-Albert Aurier in an article in the *Mercure de France*, where he celebrated the painting of Paul Gauguin as 'symbolisme'. 'La peinture décorative', Aurier wrote, 'c'est, à proprement parler, la vraie peinture. La peinture n'a pu être créée que pour *décorer* de pensées, de rêves et d'idées les murales banalités des édifices humains. Le tableau de chevalet n'est qu'un illogique raffinement inventé pour satisfaire la fantaisie ou l'esprit commercial des civilisations décadentes.'[92]

It was Whistler who had helped to pave the way to this new attitude. Whistler had devoted himself to formal harmonies in his painting: it seems pertinent that he threw himself with equal intensity into designing interiors on the basis of refined harmonies of colour, an activity which presented him with a similar set of challenges.[93] Thus the work of art 'escapes the frame',[94] and takes possession of the

viewer to grasp some of its inner meaning. He rejects a 'positivist' approach but concedes: 'one can explain form and make clear what forms have been employed in a work and for what reasons. Not that this actually enables one to hear the spirit.' His opposition to the rationalistic approach diminishes in his later writings.

92. G.-A. Aurier, 'Le Symbolisme en peinture', *Mercure de France*, no. 3, March 1891, pp. 155–65(163).

93. Whistler did not just follow this strategy in his interior design; he sold his paintings as single works in an overall arrangement. His first single exhibition of 1874 was entitled 'Arrangement in Grey, White and Yellow'. See E. Mendgen, 'James McNeill Whistler. "Carrying on the particular harmony throughout"', in *In Perfect Harmony. Picture and Frame 1850–1920*, ed. E. Mendgen, exhib. cat. Amsterdam and Vienna, Zwolle, 1995, pp. 87–94.

94. See C. Traber, 'In Perfect Harmony? Escaping the Frame in the Early Twentieth Century', in *In Perfect Harmony* (ibid.), pp. 221–48.

living environment. In Whistler's celebrated *Peacock-Room* (1876, Fig. 8) the easel painting has not yet been abolished, but it has been integrated firmly into the all-embracing ornament of the room.[95] Henry van de Velde developed this approach even further, and – being familiar with the writings of Riegl[96] – wrote the theory of this principle of designing interiors on the basis of regularly repeated ornamental structures. The principle of overall design was to remain valid both at the *Bauhaus* and later.[97] As Oskar Schlemmer put it in 1919:

> Pictures are no longer … canvases on which a piece of nature, a world, has been captured in all its sense of space and light, and then pressed into a gilded frame in order to lead a special existence; they are surfaces which break their frames and unite with the wall in order to become part of something larger than themselves … .[98]

And in 1942 Piet Mondrian expressed similar ideas:

> In the future, the realization of pure plastic expression in palpable reality will replace the work of art. But in order to achieve this, orientation toward a universal conception and detachment from the oppression of nature is necessary. Then we will no longer have the need of pictures and sculpture, for we will live in realized art.[99]

The process which led to these concepts had begun with the idea that all true works of art of one period would embody the same 'spirit'. It was this idea – the central dogma of art history since Winckelmann, spread by the philosophy of Romanticism – that now began to take root in art production. In order to unite art and life, artists tried to realize totally designed environments, first in the ornamental styles of the past, and then in a new style of their own time. The debate on ornament, fostered by the English design reformers, played a crucial role in this process. They paved the way towards a better understanding of the possibilities of

95. Whistler executed the decoration for F. R. Leyland, who already possessed the painting *La princesse du pays de la porcelaine*. The room was to be used as a dining room and to house Leyland's collection of porcelain. It is said that Whistler cut the carpet and altered the colour of the walls because they did not harmonize with the painting. See *The Whistler Peacock Room*, The Freer Gallery of Art of the Smithsonian Institution, Washington DC, 1951.

96. It is known that Van de Velde had read the works of Alois Riegl. See Kroll, *Das Ornament* (n. 72 above), p. 112, n. 241.

97. See B. Kerber, 'Bild und Raum. Zur Auflösung einer Gattung', *Städel Jahrbuch*, 8, 1981, pp. 324–45.

98. 'Bilder sind nicht mehr im bekannten Sinne Leinwände, auf denen ein Stück Natur, Welt mit allen Illusionen des Raums und Lichts eingefangen ist, um, in Goldrahmen eingepreßt, ihr Sonderdasein … zu führen; es sind vielmehr Tafeln, die den Rahmen sprengen, um sich der Wand zu verbinden und ein Teil der größeren Fläche, des Raumes als sie selbst zu werden': T. Schlemmer, ed., *Oskar Schlemmer. Tagebücher*, Stuttgart 1977, p. 36. Quoted after Traber, *In Perfect Harmony* (n. 94 above), p. 242.

99. P. Mondrian, 'Pure Plastic Art' (1942), in *The New Art – The New Life. The Collected Writings of Piet Mondrian*, ed. H. Holtzman, M. S. James, London, 1986, pp. 342–4 (344). See also B. Wismer, 'Stationen zum Gleichgewicht', pp. 63–239, in *Equilibre* (n. 59 above), on Mondrian, p. 103.

formal design, and they began to demand a truly contemporary style of art. It was on their method, the formal analysis of design, that the invention of *Art Nouveau* was based – a purely ornamental 'style' whose main principle it was to emulate historical styles in the way they delivered (in some supposedly essential manner) a stylistic unity between all the objects of an ensemble.

The idea that it was the task of the artist to design the totality of an environment – from door-handle to teaspoon – as a condition for achieving a perfect work of art, remained influential for decades. But there was also opposition, right at the beginning of the century. The first to protest against the suffocation of life by the over-planned environment was the Viennese architect Adolf Loos: Henry van de Velde served him as the exemplary incarnation of this tendency.[100] Loos, instead, asked for the separation of the spheres of '*Kultur*' (which would include the useful arts and be ruled by the demands of the people) and true art, '*Kunst*', which would be the domain where the artist could operate freely according to individual inspiration.

The Cubists Metzinger and Gleizes also spoke out against the impending abolition of the easel painting. In their pamphlet *On 'cubism'* of 1912 they defended the unity of the harmoniously composed, autonomous, framed work of art. They expressly opposed the monopolization of painting by *décoration*, while claiming that the new cubist painting was independent of any environment, but 'total' as well – it could embrace the totality of the world in a composition of colour and form.[101] They also made use of the historical or evolutionary argument (as, incidentally, did Loos): the decoration of a room by painting its walls was an archaizing habit and not appropriate to modern life, which could only be reflected in the new form of the cubist oil painting.

We should now return to Kandinsky's constructive notion of composition as explained in *On the Spiritual in Art*, and discuss it in the context of the theoretical debate on the assessment of ornamental art. His comments on composition also show a concern about the threat posed to painting by the ornamental or decoration.

100. See my article, ' "Enough of the original geniuses! Let us repeat ourselves unceasingly!" Adolf Loos, the New and "The Other" ', *Daidalos*, 52, 1994, pp. 76–85. Two decades after Loos it was Le Corbusier who tried to reconcile the principle of the interior as ensemble and the position of Loos by way of the *montage* technique; this was not composition on the basis of formal similarity, but a practice of putting together objects which embodied a similar ideology of design (*Haltung*). See A. Rüegg, 'Das Haus als Stilleben: Le Corbusiers Innenräume um 1925', *Zeitschrift für Schweizerische Archäologie und Kunstgeschichte*, 45, 1988, pp. 27–32.

101. Metzinger and Gleizes, *Du 'cubisme'* (n. 79 above), pp. 10–12: 'Beaucoup estiment que les préoccupation décoratives doivent gouverner l'esprit des peintres nouveaux. Sans doute ignorent-ils les signes flagrants qui de l'oeuvre décorative font le contraire du tableau. L'oeuvre décorative n'existe que par sa *destination* … . C'est un organe. Le tableau porte en soi sa raison d'être. Essentiellement indépendant, nécessairement total il n'a pas à satisfaire immédiatement l'esprit mais au contraire à l'entraîner peu à peu vers les fictives profondeurs où veille la lumière ordonnatrice. Il ne s'accorde pas à tel ou tel ensemble, il s'accorde à l'ensemble des choses, à l'univers: c'est un organisme.'

Unlike the Cubists, who defined the difference between their notion of a picture and decorative art on the grounds of the latter's being dependent on its application, Kandinsky refers to concepts of artistic meaning and value. In his view, ornament's lack of content, its often purely decorative character, was a flaw, but at the same time he accepted that there was a parallel between the ornamental and abstract modes of construction. He writes:

> If, even today, we were to begin to dissolve completely the tie that binds us to nature, to direct our energies toward forcible emancipation and content ourselves exclusively with the combination of pure colour and independent form, we would create works having the appearance of geometrical ornament, which would – to put it crudely – be like a tie or a carpet.[102]

One can interpret these remarks of Kandinsky as a reaction to contemporary criticism of his painting *Composition II* (Fig. 2). One critic – the one who had accused him of being unable to think of a subject[103] – had ridiculed the picture, saying that it was like a sketch for a tapestry. But the comparison of a work of art with an ornamental tapestry or carpet has long been a topos, and its connotations are not necessarily negative. Thus, Franz Marc used a similar comparison to praise the same painting; it reminded him of Islamic ornamental tapestries, which had impressed him with their 'art of colour and composition which is a thousand times profounder than our own'.[104] And John Ruskin, as we have already seen, had spoken of a Turkish carpet as 'art without facts'. Now, in an art that increasingly concentrated on its own intrinsic elements, this alleged lack of content in purely formal structures became a problem. Kandinsky, in the passage following on from the one I have just quoted, elaborates on the original content of ornament. He appreciates the expressive character of the best exotic and ancient ornaments, even acknowledges their 'hieroglyphic' character. In spite of his initial scepticism, he ends up explicitly seeing the future of art in a 'new ornamental art'. Only 'a few "hours" separate us from this pure composition.'[105]

The Symbolists' and Kandinsky's reasons for finding ornament interesting were similar to those that had led the historians towards their involvement with decoration. Abstract ornamental designs which can be distinguished precisely according to their date, place, and culture, facilitate the consideration of basic formal artistry; and the accidental factor of individual artistic ability becomes less important. As anonymous, popular art, their value as testimony to the unconscious 'spiritual' tendencies of a period is guaranteed. And it seems obvious too that it was,

102. Kandinsky, *Spiritual* (n. 4 above), p. 197: id., *Geistige* (n. 4), p. 115.
103. See n. 3 above.
104. F. Marc, *Schriften*, ed. K. Lankheit, Cologne, 1978, pp. 126–7. Quoted by P. Weiss, 'Kandinsky in München. Begegnungen und Wandlungen', in *Kandinsky in München. Begegnungen und Wandlungen 1896–1914*, exhib. cat. Lenbachhaus, Munich, 1982, pp. 29–83 (pp. 66–7).
105. Kandinsky, *Spiritual* (n. 4 above), p. 197: id., *Geistige* (n. 4), p. 115.

not least, the debate on ornament which led Kandinsky towards the discovery of the expressive power of pure form.[106] Ornament could serve him as a model for his new art of 'pure composition', a model that was admittedly 'incomprehensible' or seemingly illogical (*planlos wirkend*), but which unites those dimensions which Kandinsky thought to be essential. Ornament uses pure form and colour, and has no intention of representing things which can be seen in nature; but it is not mere, empty decoration, having an intrinsic, 'hieroglyphic', 'spiritual' content and the power to reach the spectator: 'And yet, despite this incomprehensibility or inability ever to be understood, ornament has an effect upon us, albeit at random.'[107]

This seems to demonstrate that Kandinsky could not have conceived of his abstract painting without the discussion on ornament that started in England around the middle of the last century. Nor could he have written his theory of composition – in *Point and Line to Plane*, which he modestly described in the subtitle as 'A Contribution to the Analysis of Pictorial Elements' – without the earlier scientific research on the analysis of form. It is not by chance that he describes his theory in a somewhat later essay with the same word that was applied to the visual arts by Owen Jones, Charles Blanc and Alois Riegl: 'Even today' Kandinsky writes in 1928, 'one is entitled to assume that pictorial theory has set foot on a scientific path in order to lead without doubt to precise instruction.' And, as always when he talks in this vein, he speaks in the future tense:

> Theory will have to: 1. Establish a well-ordered vocabulary ... 2. Found a grammar that will contain rules of construction. Plastic elements will be recognized and defined in the same way as words in language. As in grammar, laws of construction will be established. In painting, the treatise on composition corresponds to grammar.[108]

106. To illustrate both points, Kandinsky wrote in *On the Spiritual in Art*: 'Internally, Oriental ornament is altogether different from Swedish or Negro or ancient Greek ornament, etc. It is, e.g., not without reason that we generally describe pieces of patterned material as gay or serious, sad, lively, etc. – i.e., employing the same adjectives as are always used by musicians (*allegro, serioso, grave, vivace*, etc.) to determine how a piece is performed.' Kandinsky, *Spiritual* (n. 4 above), p. 199: id., *Geistige* (n. 4), p. 116.

107. Kandinsky, *Spiritual* (n. 4 above), p. 199: id., *Geistige* (n. 4), p. 116.

108. 'Analysis of the Primary Elements of Painting', in *Writings*, (n. 4 above), pp. 851–5, (p. 852), originally in French 'Analyse des éléments premiers de la peinture', *Cahiers de Belgique*, 1928.

Fig. 1. Adolf Hölzel *Composition in Red I* (1905), 68 x 85 cm, Sprengelmuseum, Hannover.

Fig. 2. Wassily Kandinsky, *Composition II* (1910), 200 x 275 cm, lost, illustrated in *Über das Geistige in der Kunst* (1912).

Fig. 3. J. A. M. Whistler, *Symphony in White No. 1. The White Girl*,
214.7 x 108 cm, National Gallery of Art, Washington.

<u>Christmas vacation opening hours at Birkbeck College Library</u>

Saturday 13 December	12.00 – 17.00
Sunday 14 December	Closed
Monday 15 – Thursday 18 December	10.00 - 20.00
Friday 19 December	11.00 - 20.00
Saturday 20 December	12.00 – 17.00
Sunday 21 December	Closed
Monday 22 December	10.00 - 20.00
Tuesday 23 December	10.00 – 16.00

Wednesday 24 December – Sunday 4 January inclusive CLOSED

Monday 5 – Thursday 8 January	10.00 - 20.00
Friday 9 January	11.00 - 20.00
Saturday 10 January	12.00 – 17.00
Sunday 11 January	Closed

Term time hours resume on Monday 12 January

Fig. 4. J. Ruskin, *Elements of Drawing* (1857), fig 34. *The Mosel Bridge at Coblenz*, after a watercolour by J. M. W. Turner, illustrating the 'law of curvature'.

Fig. 5. Owen Jones, comparing the different styles of ornamental 'frets', *Grammar of Ornament* (1856).

60 L'ART DANS LA PARURE ET DANS LE VÊTEMENT.

La figure qui suit sera, si l'on veut, une image mnémonique des vérités développées dans cette Introduction, et les rendra visibles.

De tout ce qui précède, il résulte, en résumé, qu'il n'est pas de décoration, dans les ouvrages de la nature, comme dans les inventions de l'homme, qui ne doive sa naissance à l'un des principes générateurs que nous avons énoncés, savoir : la répétition, l'alternance, la symétrie, la progression,

Fig. 6. Charles Blanc, 'The General Laws', from *L'Art dans la parure et dans le vêtement*, (1875).

Fig. 12.

Fig. 7. Christopher Dresser, 'Evening Star', colour plate from *The Art of Decorative Design* (1862).

Fig. 8. J. A. M. Whistler, *Harmony in Blue and Gold. The Peacock-Room* (1876), which includes the painting *La Princesse du pays de la porcelaine* (1863–4), Freer Gallery, Washington.

INDEX OF NAMES